CZECH

modernism

1900–1945

CZECH

THE MUSEUM OF FINE ARTS, HOUSTON

EXHIBITION CURATORS
JAROSLAV ANDĚL
ANNE WILKES TUCKER
ALISON DE LIMA GREENE
RALPH McKAY
WILLIS HARTSHORN

modernism

1900–1945

BULFINCH PRESS

LITTLE, BROWN AND COMPANY
BOSTON · TORONTO · LONDON

Published on the occasion of the exhibition
Czech Modernism: 1900–1945
organized by the Museum of Fine Arts, Houston
and made possible by generous grants from

Lufthansa German Airlines
with additional support from
Isabell and Max Herzstein
Drexel Burnham Lambert Incorporated
Joan and Stanford Alexander
CRSS
and the National Endowment for the Arts

The catalogue has been funded by an anonymous donor,
Gay Block, the Vaughn Foundation, Mr. and Mrs.
Alexander K. McLanahan, Betty Moody, and Eve France.

The Museum of Fine Arts, Houston
October 8, 1989–January 7, 1990

The Brooklyn Museum (painting and sculpture)
March 2–May 7, 1990

International Center of Photography, New York (photography)
March 2–May 13, 1990

Anthology Film Archives, New York (film)
March 18–May 13, 1990

Akron Art Museum (photography)
June 23–August 26, 1990

First edition

Title-page illustration adapted from Karel Teige, Karel Paspa, and
Vítězslav Nezval, *The Alphabet* (cat. no. PH156).

Library of Congress Cataloging-in-Publication Data
Czech modernism, 1900–1945 / Jaroslav Anděl...[et al.], curators.—
 1st ed.
 p. cm.
 "Published on the occasion of the exhibition Czech modernism,
1900–1945, organized by the Museum of Fine Arts, Houston."
 Exhibition to be held: The Museum of Fine Arts, Houston, Oct. 8,
1989–Jan. 7, 1990; Brooklyn Museum (painting and sculpture) Mar.
2–May 7, 1990; International Center of Photography, New York
(photography) Mar. 2–May 13, 1990; Anthology Film Archives, New
York (film) Mar. 18–May 13, 1990; Akron Art Museum (photography)
June 23–Aug. 26, 1990.
 Includes bibliographical references.
 ISBN 0-89090-048-5.—ISBN 0-8212-1763-1 (Bulfinch Press :
hard)
 1. Modernism (Art)—Czechoslovakia—Exhibitions. 2. Arts,
Czech—Exhibitions. 3. Arts, Modern—20th century—
Czechoslovakia—Exhibitions. I. Anděl, Jaroslav. II. Museum of Fine
Arts, Houston.
NX571.C9C94 1989
700'.9437'07473—dc20 89-13017
 CIP

Copublished by The Museum of Fine Arts, Houston, and Bulfinch Press
Bulfinch Press is an imprint and trademark of Little, Brown and
Company (Inc.)
Published simultaneously in Canada by
Little, Brown & Company (Canada) Limited

Printed in Japan

Contents

Acknowledgments

Partnership with colleagues in Czechoslovakia has been essential to this exhibition, and I extend profound thanks to Professor Jiří Kotalík, Director of the National Gallery, Prague (Národní galerie v Praze), for his commitment to this worthy joint endeavor. His support and assistance have ensured the success of this exhibition, and we are grateful to him and members of the staff of the National Gallery including Dr. Dagmar Šefčíková, Dr. Lubomír Slavíček, Jaroslav Eliášek, Jana Brabcová, Eva Bužgová, and Gabriela Kesnerová.

Our gratitude extends also to the Ministry of Culture, Milan Kymlička, minister, and to his staff officers, Dr. B. Somogyiová, Dr. Petr Koutný, and Mrs. Lenka Landová, who greatly assisted us. To Miroslav Houštecký, Ambassador of the Czechoslovak Socialist Republic, Washington, D.C., and to First Secretary Vladimír Húska, we add our thanks for help and encouragement.

In research and development of the exhibition, we were assisted by numerous institutions in Czechoslovakia, and we recognize with sincere gratitude the generosity of professionals within these organizations: Museum of Decorative Arts, Prague (Uměleckoprůmyslové muzeum v Praze), Dr. Dagmar Hejdová, former director, Dr. Jaroslav Langr, director, Kateřina Klaricová, Jan Rous; National Museum of Literature (Památník národního písemnictví), Dr. Radomír Pospíšil, director, and Dr. Rumjana Dačeva; Moravian Gallery, Brno (Moravská galerie v Brně), Dr. Jiří Hlušička, director, Slavoj David, Dr. Karl Holešovský, and František Sysel; Czechoslovak Film Institute—Film Archive (Československý filmový ústav—Filmový archiv; ČSFÚ-FA), Prague, Hvězdoslav Stefan, director, Věroslav Hába, Václav Merhaut, Vladimír Opěla, Jitka Panznerová, Stanislav Ulver, and especially Eva Kačerová; Czechoslovak Film Export (Československý Filmexport), Prague, Mirjana Kabrhelová.

We would like to thank in addition the Gallery of the City of Prague (Galerie hlavního města Prahy); Aleš's Gallery of South Bohemia, Hluboká nad Vltavou (Alšova jihočeská galerie, Hluboká nad Vltavou); Regional Gallery of Benedikt Rejt, Louny (Oblastní galerie Benedikta Rejta v Lounech); Regional Gallery of Fine Arts, Gottwaldov (Oblastní galerie výtvarného umění Gottwaldov); Regional Gallery Hradec Králové (Krajská galerie v Hradci Králové); Regional Gallery, Jičín (Okresní galerie, Jičín); North Moravian Gallery of Fine Art, Ostrava (Severomoravská galerie výtvarného umění v Ostravě); Regional Gallery, Liberec (Oblastní galerie Liberec); City Museum and Gallery of Jindřich Průcha, Chotěboř (Městské muzeum a galerie Jindřicha Průchy, Chotěboř); and Gallery of Central Bohemia, Prague (Středočeská galerie, Praha).

For their advice and professional guidance, we recognize other Czech professionals: Anna Fárová, Olga Hilmerová, Dr. Vilém Jůza, Dr. Vojtěch Lahoda, Dr. Miroslav Lamač, Anna and Herberta Masaryková, Daniela Mrázková and Vladimír Remeš, Jana Paulová, Hana Rousová, Dr. and Mrs. Václav Rupeš, Dr. Miloš Šejn, Jan Sekera, Vladimír Šlapeta, Dr. Jaroslav Slavík, and Dr. Tomáš Vlček. For their contribution to the general research, selection process, and translations, we acknowledge Antonín Dufek, Zdeněk Kirschner, Michal Schonberg, Zdeněk Štábla, and Pavel Taussig as well as for their essays published in this catalogue. We wish to pay special tribute to the achievement of Dr. František Šmejkal, who died in December 1988. He did not review the edited translation of his essay published here, and we hope that it is worthy of his exacting standards.

To our colleagues at the American Embassy in Prague we offer our thanks. William Luers, former ambassador, Wendy Luers, Carl W. and Rika Schmidt, Sam Westgate, and especially Mary E. Gawronski graciously assisted our efforts. Rex Moser of the United States Information Agency (USIA) also expedited arrangements for us.

Additionally, we thank Pierre Apraxine, Jean-Claude Binoche, Sonja Bullaty and Angelo Lomeo, George Dahlsheimer, Jaroslav Dostál, Brenda Edelson, Alain and Nicole Faure, Marcel Fleiss, Bernard Galateau, Miles Glaser, Alexander Hackenschmied, Peter Hames, Manfred Heiting, Radovan Ivšić and Annie Le Brun, Rudolf Kicken, Jiří Kolář, František Krejčí, Bohumil Krčil, Peter Kussi, Jiří Lehovec, Antonín Liehm, Jan Lukas, Lee Marks, Peter and Inge Maier-Oswald, Richard Menschel, Toby and Lilyan Miller, Meda Mladek, Jan Pelánek, Eugene and Dorothy Prakapas, Howard Reed, Vilém Reichmann, Mark Roberts, Charles Salaquarda, Gerd Sander, Leonard and Marjorie Vernon, Thomas Walther, Michael Weintraub, and Hanns Zischler. Each of these persons played a role in the research and organization of the exhibition and catalogue. Finally, we thank our skillful translators Dana Hábová, Robin Ptáček, Jitka Salaquarda, Rachel Stella, Paul Wilson, and Michael Young for their vital contribution.

Professional collaboration with institutions in Europe and the United States was invaluable: Museum Folkwang, Essen, Ute Eskildsen; Musée National d'Art Moderne, Centre Georges Pompidou, Paris, Jana Claverie and Alain Sayag; Bibliothèque Nationale, Paris, Jean-Claude Lemagny; Société Française de Photographie, Paris, Christiane Roger; The Solomon R. Guggenheim Museum, New York, Thomas Messer, former director, and Thomas Krens, director; The Museum of Modern Art, New York, Kirk Varnedoe, John Szarkowski, Audrey Isselbacher, Susan Kismaric, Charles Silver, and Eileen Bowser; International Center of Photography, New York, Cornell Capa, director, Steven Rooney, Ann Doherty, Bedřich Grunzweig, Lisa Dirks, Patricia Boustany, and especially Willis Hartshorn, who collaborated on the selection and organization of the photography section; Anthology Film Archives, New York, Jonas Mekas; The Brooklyn Museum, New York, Robert T. Buck, director, and Charlotta Kotik; Hirshhorn Museum and Sculpture Garden, Smithsonian Institution, James Demetrion, director, and Valerie Fletcher; Philadelphia Museum of Art, Anne d'Harnoncourt, director; The J. Paul Getty Museum, Malibu, John Walsh, director, Dr. J. M. Edelstein, Weston J. Naef, Judith Keller, Joan Dooley, and Gordon Baldwin; San Francisco Museum of Modern Art, Van Deren Coke and Sandra Phillips; Los Angeles County Museum of Art, Earl A. Powell III, director; Museum of Fine Arts, Boston, Clifford Ackley; New Orleans Museum of Art, Nancy Barrett; International Museum of Photography at George Eastman House, Rochester, Marianne Fulton; Art Institute of Chicago, David Travis; Minneapolis Institute of Art, Carroll T. Hartwell and Christian Petersen; Akron Art Museum, Mitchell Kahan, director, and Barbara Tannenbaum; and The Houghton Library, Harvard University, Roger E. Stoddard.

Every department in this museum participates in the work of organizing and presenting an exhibition. Cited for their particular effort on this project are Celeste Adams, Gwen Goffe, and Margaret Skidmore, associate directors; Karen Bremer, administrator; Charles Carroll, registrar, and Sara Garcia, assistant registrar; Barbara Michels, grants writer; Hannah Baker and Anne Lewis, publicists; Karen Luik and Beth Schneider, educators; Jack Eby and Lorri Lewis, designers; and for research and technical assistance, Wanda Allison, Patricia Clark-Faenger, Mathilda Cochran, Roberto Cofresi, Kathleen Crain, Betty Gerhart, Susan Giannantonio, MariAlice Grimes, Kathryn Kelley, Kelly Kelsey, Maggie Olvey, Anne Rosen, and especially Carrie Springer. Our publications editors, Carolyn Vaughan and Polly Koch, whose work on this project has been outstanding, are also recognized.

This exhibition was created by the Museum of Fine Arts, Houston, in keeping with its encyclopedic collection and exhibition policies. In our estimation the arts of Czechoslovakia have been too long undervalued in the history of Western art. The project was prompted by the museum's holdings in Czech photography and formally begun in 1985. The exhibition and catalogue have been carried through with persistence and vision by guest curator Jaroslav Anděl and members of the museum staff—Anne Wilkes Tucker, Gus and Lyndall Wortham Curator, Alison de Lima Greene, associate curator of twentieth-century art, and Ralph McKay, former director of the film program.

In conclusion, we recognize with pride and thanks the support of the National Endowment for the Arts and express our gratitude to Lufthansa German Airlines, and to Isabell and Max Herzstein, Drexel Burnham Lambert Incorporated, Joan and Stanford Alexander, CRSS, Gay Block, the Vaughn Foundation, Mr. and Mrs. Alexander K. McLanahan, Betty Moody, and Eve France. Only through such enlightened patronage are projects of this scope possible.

Peter C. Marzio
Director, The Museum of Fine Arts, Houston

Director's Statement

To write new chapters in the history of creativity and to add artists to the pantheon of artistic leaders has been the mission of the Museum of Fine Arts, Houston, since it opened in 1924. *Czech Modernism: 1900–1945* is a major effort in that tradition.

We do not propose to tell the entire story of art in Czechoslovakia but to slice across the disciplines of painting, sculpture, photography, cinema, and graphic art in an effort to capture the spirit of the avant-garde artists of the first five decades of the twentieth century. Those daring men and women often encouraged an interdisciplinary approach to art, and—as we have seen repeatedly throughout history— while some were appreciated within the international avant-garde in their own lifetimes, only a few of these artists and filmmakers have been recognized since World War II in European museums. Too few have received the attention they deserve in the United States. The Czech contribution to the European avant-garde has been undervalued.

The difficulties of learning about the art of Czechoslovakia have led some American critics and historians to assume that little beyond the creative genius of František Kupka was worthy of serious note. We hope that this exhibition and catalogue will change that opinion and lead to a finer appreciation of the significant contributions that Czech artists have made to the many international art movements of our century.

The cultures of Czechoslovakia exude a sense of antiquity, a deep and distant past with a powerful tradition, a rootedness that, despite a bewildering history of military conquests and occupations by invaders, shimmers with an acute intelligence. Within the boundaries of modern-day Czechoslovakia, archeologists have found some of the oldest human settlements in Europe, and ancient trade routes linking northern, southern, eastern, and western Europe pass through the heartland that we call Czechoslovakia. Prague has the oldest university in central Europe; its cathedrals are among the finest achievements of European builders. Its medieval ground plan and buildings began with monumental castles, stone churches, and bridges and melded during the centuries with other grand-scale works of outstanding artistic merit, particularly of the Baroque period. Spared during the bombing of both world wars, the layers of architectural styles are the expressions of a sophisticated culture with roots in

that period ineptly dubbed the "Dark Ages." The high aesthetic standards that the people of Czechoslovakia have created in architecture, literature, music, painting, sculpture, and decorative arts comprise a treasury of artistic genius that challenges new generations. What a burden and what a glorious opportunity this deep heritage provides!

I mention tradition in a catalogue about the avant-garde because the artists in this exhibition placed themselves in a constant struggle with the distant past, the present, and the challenging future. This dialogue had emotional and intellectual qualities, and it produced the thoughtfulness and sense of serious purpose that characterize so much of the work you will see in this book. A disciplined striving for originality and truth and a desire to produce contemporary art within an ancient civilization created a classical thesis-antithesis-synthesis pattern, which made the artistic achievement both fragile and timeless.

The full brilliance of Czech art, past and present, is displayed vividly in the museums of Czechoslovakia. There, despite difficult economic periods since World War II, beautiful museums have been established to display works of art ranging from antiquity to 1900; a museum of twentieth-century art is scheduled to open in the 1990s. This achievement is due in large part to the vision and work of Professor Jiří Kotalík, Director, Národní Galerie v Praze, whose full cooperation in this project made it possible in the first place. His warm hospitality and full support encouraged us to work even harder. To Professor Kotalík and his colleagues we owe an enormous debt.

P.C.M.

Foreword

The present exhibition does not claim to present Czech art of the twentieth century in its historical entirety, listing encyclopedically and objectively all creative trends and achievements—an impossible goal within the space of a single exhibition. Instead, the selection of works concentrates on the most typical trends and leading personalities that determined the course of creative evolution from 1900 to the mid 1940s, that decisive stage of modern art in the context of European development.

The selection encompasses painting, sculpture, drawings, prints, photography, and film. This interdisciplinary aspect of the exhibition aptly expresses an important quality of Czech Modernism; since the turn of the century Czech artists have striven for a comprehensive conception of the visual arts—including architecture and applied art—in the unity and appurtenance of individual forms.

The second aspect of the exhibition is a concentration on works of a lyrical or imaginative nature. This is fully in keeping with Czech culture in general, which is dominated by poetry and music, the standard of which only rarely is matched by that of literature and drama. Yet—and I feel that this is a distinguishing characteristic of our visual arts—the poetic vision is always in balance with a well-constructed approach to the work's formal and spatial structure.

The developmental aspect of the exhibition is determined by the role played by three generations whose works evolved both consecutively and simultaneously. These artists felt responsible for the state of Czech art. The first generation—as documented by František Kupka and Vojtěch Preissig—emerged from Impressionism, Symbolism, and Art Nouveau, movements in which the beginnings of the modern view and expression are firmly rooted. The generation of Czech Expressionists and Cubists is represented richly by the painters Emil Filla, Bohumil Kubišta, Josef Čapek, and Jan Zrzavý and the sculptor Otto Gutfreund. Surrealism played a dominant role for the generation of the 1920s and 1930s and is represented by artists who associated with their Paris contemporaries—including Jindřich Štyrský, Toyen, and others—as well as the independent, aggressive vision of Zdeněk Rykr and the novel formulations of light and movement in the sculpture of Zdeněk Pešánek.

Typically, modern Czech photography is closely allied to these developments, and its greatest masters were always closely linked to the problems of fine art. Some photographers were painters as well, such as Alfons Mucha, Jindřich Štyrský, and František Vobecký, or such younger ones as Karel Valter and Václav Zykmund. Others, who worked exclusively in photography, including František Drtikol, Josef Sudek, and Jaromír Funke, expressed an affinity in form and thought with the trends followed by painting and graphic art.

The final aspect of the presentation is a reminder that culture and art in Bohemia were always involved with the events of changing times and in particular with the struggle of the years of Nazi occupation during World War II.

I feel that the individual works presented here are a convincing example of an art that has grown out of the traditions and continuities of the homeland, an art that also addresses the topical problems of European developments. In this sense, the ideas and principles of the times were most profoundly defined by F. X. Šalda in his critical essays published from the late nineteenth century until his death in 1937. He found that modern Czech culture, in its desire for social significance and vitality, was not only mirroring the individual strivings of its creators but was also an expression of the nation's fate: hence its function was not merely to be decorative but also to be an active and integral component of history.

Czech art has tried to be true to these principles, throughout the complex development of the first decades of the twentieth century. It remains true to them today, as our culture reflects the continuity of modern art in the organic progression of generations, up to and including our youngest, ascending generation of artists.

The National Gallery in Prague greatly appreciates the invitation to collaborate in this exhibition, which gives an insight into four decades of development in Czech modern art. We are grateful to our colleagues and friends at the Museum of Fine Arts, Houston, for their initiative and for all the work they undertook in the preparation and organization of this exhibition, carried out in the spirit of true cooperation and friendly understanding.

My thanks are addressed in particular to Peter C. Marzio, director of the Museum of Fine Arts, Houston, to Anne Wilkes Tucker, Alison de Lima Greene, and Ralph McKay, to guest curator Jaroslav Anděl, and to their coworkers. I also wish to thank all those who helped in Czechoslovakia in

selecting the works and preparing the exhibition: The National Gallery in Prague, The Decorative Arts Museum in Prague, the Institute of Art Theory and History of the Czechoslovak Academy of Sciences, the National Museum of Literature, and a number of regional galleries. The exhibition could be organized only thanks to the goodwill of museums, galleries, and private collectors, who readily lent works from their holdings for this purpose.

This exhibition should not merely serve to inform those interested in the complexity and achievements of modern Czech art which are relatively unknown in the world, but it should also serve as an impulse to further cooperation in the fine arts between the United States and Czechoslovakia; to consolidate and extend such cooperation is the sincere wish of all of us in Prague and the whole Czechoslovak Republic.

Jiří Kotalík
Director, National Gallery, Prague

The Czechoslovak Film Archive

This year marks the ninety-second anniversary of the origin of Czechoslovak cinema. More than ninety years have passed since the Prague premiere of the architect, photographer, cameraman, and film director Jan Kříženecký's first moving images. Appearing less than three years after the Lumière brothers' famed cinema show in the Grand Café in Paris, these first films heralded the beginning of the history of cinema in Czechoslovakia. Although the history of most national cinemas is recorded in written annals, the prints of many minor films have been lost beyond recall. Czechoslovakia is unusual in that the early films of Kříženecký and his followers have been preserved in the film archive of Československý filmový ústav—filmový archiv (ČSFÚ-FA). This attests to a Czech respect and care for the cultural heritage of the country.

The Czechoslovak Film Archive was founded by the Bohemian-Moravian Film Center in 1943, at the culmination of the Fascist occupation. When Czech cinema was nationalized in August 1945 by a decree of the President of the Republic, the film institute was established and assumed responsibility for the film archive. Safeguarding and preserving film prints and material connected with the history of cinema has become the archive's main duty.

In the course of more than four decades, the film institute has gradually changed its structure and goals, but its primary mission has remained the same. ČSFÚ-FA is now an independent establishment within "The Czechoslovak Cinema" enterprise. It encompasses several spheres of interest. One department of the archive deals with the history of Czech cinema through analysis and theory. It also participates in, or independently organizes, sociological research whose aim is to define the role of cinema in the lives of people today, especially the young.

Information and publishing are other important activities. ČSFÚ-FA publishes information for filmmakers and other film specialists, various materials for film societies, and books for the public at large. The editorial plan embraces, in equal shares, Czechoslovak and translated film literature and books that present either profiles of outstanding film personalities or national filmographies. In addition, ČSFÚ-FA publishes the fortnightly *Záběr* and *Zpravodaj československého filmu*. In the sphere of culture and education, ČSFÚ-FA stimulates dialogue between filmmakers, theorists, and critics; presents films made by students and graduates of the Filmová a televizní fakulta Akedemie músických umění (Film and Television Faculty of the Academy of Performing Arts; FAMU); and prepares courses, film seasons, lectures, and materials for film society leaders, lecturers, and members. Teaching cinema in school is another important activity; at present, cinema studies are taught at five teachers' training colleges.

Because of the quantity and quality of its holdings, the Czechoslovak Film Archive enjoys international prestige. It currently contains more than 70 million meters of film. Every year some 1,500 new titles are acquired. Features, documentaries, animated films, and in part, newsreels are being catalogued and preserved. The archive keeps virtually all works comprising the history of Czech cinema as well as important collections of films representing various trends and schools in international cinema. The film archive acquires classic foreign films for study through exchange with other members of the International Federation of Film Archives (FIAF). ČSFÚ-FA has been a member of the federation for a long time, participating in its activities, projects, and technical committees.

Important Czech films of the past are screened regularly for study and education; re-releases are an important part of film theater showings and television broadcasts.

The regular presentation of reciprocal "Weeks of Films," retrospective film seasons, technical seminars, and symposiums are some of the ČSFÚ-FA international activities. Through the development of international collaboration, ČSFÚ-FA makes a specific contribution to international cultural exchange and a unique acquaintance with life in other countries.

For the future, ČSFÚ-FA has many important imperatives: to provide increasingly favorable guidelines for preserving valuable archival material and for the optimum use of computer technology; to carry out publishing activity and research; and through film societies and various cultural and educational activities, to contribute to a deep and permanent interest in the cinematic arts.

Hvězdoslav Stefan
Director, Czechoslovak Film Institute—Film Archive

Translated by Jitka Salaquarda

PAINTING AND SCULPTURE

František Kupka, *Disks of Newton (Newtonovy kotouče)*, 1911–12, oil on canvas, 39½ x 29 inches, Philadelphia Museum of Art, The Louise and Walter Arensberg Collection, cat. no. PS42.

František Kupka, *The Beginning of Life (Počátek života)*, 1900,
colored aquatint, 13⅝ x 13⅝ inches, Národní galerie v Praze, cat.
no. PS36.

In Search of Redemption: Visions of Beginning and End

JAROSLAV ANDĚL

Two central ideas paved the way for the rise of modern art and influenced its development: progress and primitivism. As the appeal of progress has diminished during the last two decades, however, critics have tended to revise both the Modernist aesthetic and its concept of history. This tendency encourages both critics and historians to question Modernism and to outline a more complex picture of twentieth-century art, taking into account not only Paris but also Berlin, Moscow, Vienna, Prague, and other centers.

This introduction to Czech twentieth-century art focuses on the specific themes of the beginning and end, birth and death, which are woven into the fabric of Modernism. These themes reflect Modernism's premises, its underlying concepts of history such as progress and primitivism, and the Modernist belief in the transcendental power of art. A discussion of these themes, which are so significant for Czech Modernism, not only helps to rediscover Czech artists but at the same time contributes to the ongoing reassessment of Modernism in general.

Several premises lie behind this discussion. First, nineteenth-century modernization, which resulted in the rapid growth of individualism, pluralism, and a historical consciousness, also generated relativism, alienation, and uprootedness, resulting in a social and spiritual insecurity.[1] During the second half of the last century, Friedrich Nietzsche proclaimed that God is dead, the sociologist Ferdinand Tönnies made a distinction between *Gesellschaft* (Society) and *Gemeinschaft* (Community), Karl Marx linked political economy with secular eschatology, and Sigmund Freud articulated the concept of the unconscious. These developments in philosophy and social sciences had a far-reaching impact on twentieth-century art. Nietzsche's and Freud's theories corresponded with and often directly stimulated the primitivist tendencies of Modernism. Marx's theories inspired a strong tradition of social and political radicalism in modern art.[2]

Second, this insecurity stimulated the Modernist emphasis on transcendence. The Modernist drive to go beyond the boundaries of reality was powered by the loss of eternal truths and by a metaphysical uncertainty and anxiety. Behind the urge to transcend limits, which is so deeply embedded in the Modernist sensibility, is the fear of nothingness and of death as the ultimate limitation of the self.[3] Thus, apocalyptic imagery and eschatological motifs and themes are inherent in Modernism.[4]

Third, in coping with this spiritual and social insecurity, artists and the intelligentsia in general sought a new vision of the world. This explains why the themes of beginning and end—birth and death—played a pivotal role in the rise and development of Modernism. It also explains why the Modernist artists and critics embraced holistic theories and teleological concepts of history.

Fourth, this teleological historicism of Modernism, which is implicated in the apocalyptic imagery as well as in the collectivist dreams of progress, has its complement in a sort of reverse teleology. In this scheme history regresses to its beginning, represented by elemental entities and by such important notions of twentieth-century art as the archetypal, the primitive, and the spiritual.[5]

The work of František Kupka illustrates the importance of these concepts and their role in the transition from naturalism and literary symbolism to abstraction. The early drawing *Enigma of Life (Hádanka života*, 1894, location unknown) demonstrates the artist's metaphysical concerns by means of traditional symbols and allegories: two nude women, one of them with the attributes of Vanitas, sit in front of a sphinx, a symbol of the enigma of life, and are surrounded by a circular segment representing the wheel of life. In the circle figures rise from an embryo and the early stages of life to the top of the segment and then fall to death. In the inscribed comment the artist poses the question: "And I ask why all this struggle, why joy, love and sorrow, why this life of ours at all?"[6]

Although still relying on literary symbolism, a later series of prints *The Voices of Silence (Hlasy ticha*, 1900–1903, National Gallery, Prague) expresses the same metaphysical theme in more visual terms.[7] *The Beginning of Life (Počátek života*, 1900, cat. no. PS36), the most innovative picture of the series, represents fetal forms in two overlapping circles flowing above a water lily. Inspired by theosophical theories, the picture links the prenatal state of being with a symbol of the creation of the cosmos.[8] This image of primal unity contrasts with other pictures of the series that represent an isolated individual standing against

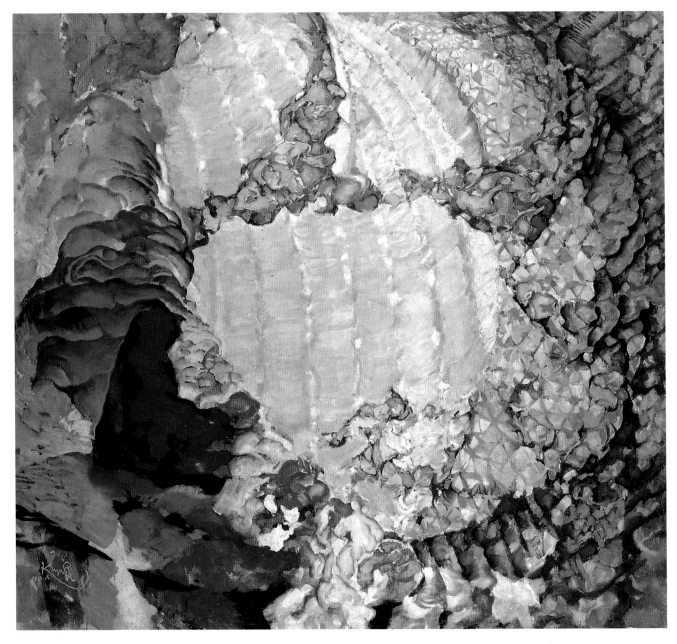

František Kupka, *Cosmic Spring I (Kosmické jaro I)*, 1911–20(?), oil on canvas, 43¹¹⁄₁₆ x 49¼ inches, Národní galerie v Praze, cat. no. PS44.

the silent universe.[9] *The Beginning of Life* counters the metaphysical nightmare with a vision of the unity of human life and the cosmos. It is highly significant that this vision provided Kupka with new expressive devices and became the formative motif and theme of his abstraction.

The intersecting curves that appeared for the first time in *The Beginning of Life* were crucial in articulating Kupka's first abstract paintings, including *The First Step (První krok*, c. 1909–13, cat. no. PS37), *Disks of Newton (Newtonovy kotouče*, 1911–12, cat. no. PS42), *Red and Blue Disks (Červené a modré kotouče*, 1911–12, cat. no. PS40), and *Amorpha, Fugue in Two Colors (Amorfa, Dvoubarevná fuga*, 1912, National Gallery, Prague). As the titles of these paintings indicate, Kupka's concept of abstraction was also associated with the representation of movement and the

interplay between light and color. However formal they may seem, these concerns reveal close links with Kupka's cosmological vision.[10] Thus, even the most basic expressive elements retain a latent symbolic meaning. For instance, Kupka believed that the curves "by each part, concave or convex, remind us of some living form: they generate life."[11]

The organic theme and its metaphors pervade Kupka's paintings and writing. The principles of organic continuity and vital energy that link individual beings and entities together with the cosmos are central to Kupka's aesthetic and philosophy.[12] These principles enabled Kupka to link different motifs and themes so that they often overlap in thematic series as well as in single paintings.[13] For example, *Cosmic Spring I* and *Cosmic Spring II (Kosmické jaro I*, 1911–20[?], cat. no. PS44, and *Kosmické jaro II*, 1911–

20/1934[?], National Gallery, Prague), which elaborate the generative flower-cosmos metaphor initiated by *The Beginning of Life*, combine forms derived from such different motifs as planets, clouds, crystals, petals, and other vegetal forms. In Kupka's vision each form tends to transform into another.[14] The result is a polymorphic and cosmologic symbolism that blends together microscopic and astronomic images, organic and inorganic forms, physics, physiology, biology, and the occult sciences.[15]

The principle of organic continuity also explains why Kupka so often returned to his earlier works for inspiration as well as why he worked on his pictures for many years and sometimes repainted them after they were finished.[16] Kupka saw an affinity between the creation of the cosmos and artistic creation: to him the principles regulating the cosmos also worked in art.[17] For this reason, his most frequent themes can be read as symbols and metaphors of artistic development. Evoking the theme of *Cosmic Spring*, Kupka contended that "art lives by budding, by its Springs, by permanent regeneration."[18]

In this context the motif of an embryo symbolizes a new artistic vision and the regenerative power of art. Kupka often linked the embryo with the creation of the cosmos so that the embryo also became an emblem of the ultimate return to the very beginning. Consequently, the motif can also function as a symbol of the need to return to the primal elements of art. In this respect the embryonic imagery in Kupka's abstraction plays the same role as the apocalyptic imagery in Wassily Kandinsky's formulation of abstract art.[19] Although Kupka's and Kandinsky's visions looked in opposite directions—one to the beginning, the other to the end—they fulfilled the same function: to initiate a radical reassessment of the artistic means and ends and thus to stimulate a regeneration of art.

The themes of cosmic unity and biological inspiration also dominate the work of the painter and printmaker Vojtěch Preissig. As the project *Art Fundamental* (c. 1915–1925, see cat. no. PS57) and the paintings *Birth of the World* (*Zrození země*, c. 1936, cat. nos. PS65, PS66) indicate, Preissig's work shows an affinity with Kupka's cosmological vision. However, it is concerned less with metaphysical speculation and more with specific explorations of the parallels between nature and art. For instance, the series of works *Art Fundamental* consists of images inspired by microscopic tissues and cells, and their titles relate to the interplay between artistic and natural processes: *Inspiration, Imagination, Invention, Individuality, Sensibility, Enthusiasm, Energy, Concentration, Balance, Proportion,* and *Rhythm.*[20]

Preissig's explorations of natural tissues, structures, and processes, seen in his early drawings of biological tissues and in transfer prints from tobacco leaves (c. 1900, cat. nos. PS51, PS52), led the artist to new techniques and methods. After 1915 he created a number of collages from natural and man-made objects and materials, such as pine needles, plant roots, threads, and steel shavings; later in the 1930s he also

František Kupka, *Study for Cosmic Spring,* 1911(?), ink and gouache on paper, 15⅜ x 17⁵⁄₁₆ inches, collection Mladek, Washington, D.C., cat. no. PS41.

made transfer prints from similar materials. In the 1910s and 1920s he photographed natural structures and textures, including vegetal forms and sand dunes. Exploring the role of mathematical concepts of rhythm, progression, proportion, and symmetry in nature, he created numerous geometric drawings in the 1920s. He painted and drew on industrial materials such as sandpaper and masonite. More importantly, he pioneered a number of informal painting techniques, including spilling and dripping.

As in Kupka's abstractions, these explorations developed around a few themes, the most important being motifs of a tree (or floral structures) and a cell. As the embryo was for Kupka, the tree was a unifying cosmic symbol for Preissig.[21] Floral structures and tissues provided a transition to the motif of a cell, which is an emblem of organic unity and continuity. Processes and principles such as fertilization, division, symmetry and asymmetry, growth, proportion, and rhythm became models that Preissig explored and simulated in his drawings, prints, and paintings. Preissig's method of abstraction prefigured later artistic preoccupations with natural structures and processes in art that took place after World War II.[22]

Kupka's and Preissig's abstractions can be described in psychological terms as sublimations of a spiritual crisis, projecting a cosmic unity onto the twentieth-century reality of fragmentation and alienation. Artists who were about ten years younger than Kupka and Preissig addressed this spiritual crisis more personally and directly. Most of these artists found their hero in Edvard Munch, who had an important exhibition in Prague in 1905. Emil Filla as a spokesman of this later generation said, "Munch's work exploded in our heart like a petard."[23] The young artists also admired Vin-

Vojtěch Preissig, *Birth of the World (Zrození země)*, c. 1936, oil on masonite, 23⅞ x 28⅜ inches, Národní galerie v Praze, cat. no. PS65.

cent van Gogh, Paul Gauguin, and Paul Cézanne. They recognized in the work of these artists the same impulse to return to the primal forces of creativity that they embraced. The young painters regarded Naturalism, Impressionism, and decadent Symbolism as superficial, trivial, and inauthentic.[24] They demanded that the artist must "solve always his creative tasks from scratch."[25] Significantly, the young generation identified art with "the direct expression of the artist's inner state."[26] In other words, they sought to engage their existential experience directly in the artistic process. In releasing the psychic forces through the process of creation, they attempted to transcend the fundamental contradictions of existence. They wanted to confront the human predicament, not to avoid it.

The reclaiming of the existential experience through the creative process, involving elements of destruction and violence, stimulated immediacy and directness in artistic

expression. This is true of Pablo Picasso's *Les Demoiselles d'Avignon* (1907, The Museum of Modern Art, New York) and, to a lesser extent, of *Reader of Dostoevsky (Čtenář Dostojevského*, 1907, National Gallery, Prague) by Filla. Although these paintings' specific formal devices and their rupture with tradition differ significantly, as do their size, theme, and international impact, the underlying concepts and the social and psychological implications are comparable. Both paintings have been associated with the beginning of the avant-garde movement in their respective contexts, and both epitomize central Modernist principles and objectives: to reject tradition, to explore the medium, to develop a new form and an original means of expression, to tap primal energies, and to transcend the relativity of time and history—in short, as Filla said, "to create new values and redeem oneself."[27]

Driven by a longing for the absolute and by a need to

Vojtěch Preissig, *Birth of the World (Zrození země)*, 1936, oil on masonite, 23⅞ x 28⅜ inches, private collection, Prague, cat. no. PS66.

transcend the limits of the self, Modernism sought redemption. Although this ultimate goal of Modernism was often hidden, it emerged explicitly in certain moments and places—for instance, between 1905 and 1915 in Prague, and in Central Europe in general. The Industrial Revolution and the process of modernization started later in Central Europe than in Great Britain and France and consequently heightened the alienation of this generation of Czech artists and writers.[28] Modernization resulted in an acute spiritual crisis and often prompted radical political and artistic stances that envisioned the end of the old world and the beginning of a new one.[29]

The artists in the groups Osma (The Eight, 1907–1908), Skupina výtvarných umělců (Group of Fine Artists, 1911–16), and Sursum (1910–12) articulated concepts that emphasized the redemptive value of creativity and its relation to the critical existential experience, or the experience of being and

non-being.[30] No other Czech artist exemplifies these existential roots of Modernism better than Josef Váchal. His work represents several significant developments in the history of Modernism: the interest in popular culture and photography, spiritual concepts and theories, primitivism, artists' books and the interplay between word and image in general, secondary and chance images, ambiguity, and, in Frank Kermode's words, "the sense of an ending"[31] manifested in eschatological themes and motifs.

Growing up an illegitimate child, Váchal developed a strong anti-authoritarian attitude.[32] In his teens he created satirical drawings, illustrated treatises, and made handwritten books and journals that reflect his predilection for primitivisms of all kinds. These works reveal a tendency to parody and subvert established values, including the contemporary concepts of art and artist. He was one of the few pioneers of Modernist primitivism. As early as 1906–1907 he was mak-

Josef Váchal, *Three Columnar Figures (Tři figurální sloupy)*,
c. 1910–11, wood, varnished and gilded, 35½ x 2¾ and 22⅛ x 2⅜
inches, private collection, Prague, cat. no. PS113.

ing primitive wooden idols and carvings of everyday objects, thus paralleling Picasso's discovery of tribal art. Both Picasso and Váchal took their initial inspiration from Gauguin,[33] but their interests in tribal art differed. To Váchal tribal art was only one of many different manifestations of the primitive, which also included children's drawings, crude forms of popular art and folk art, and psychotics' drawings. Characteristically, the tribal art influence in his work often appears combined with a number of other sources, primitivist or otherwise.[34]

Váchal was both an artist and a writer, and the interplay between word and image, writing and painting, held a pivotal role in his work and developed into a passion for making books. His first published book, *Vision of the Seven Days and Planets (Vidění sedmera dnů a planet,* 1910, cat. no. PS112), consists of block prints recalling medieval block-books—which preceded the invention of the printing press—and demonstrates again the primitivist impulse toward beginnings. As the titles of this and Váchal's other books indicate,[35] an interest in various spiritual concepts including alchemy and the occult permeates Váchal's work. However, his approach was not uncritical; he explored these concepts with the same spirit of independence and irreverence he brought to other sources.[36] Parody, secondary and chance images,[37] and combinations of incongruous elements were Váchal's favorite strategies.

The principle of ambiguity underlies all these strategies. By subverting established meanings and values, ambiguity both questions and evokes the process of making and perceiving. Thus, ambiguity is closely related to both disintegration and creativity. This connection is evident in Váchal's favorite motifs.[38] He acknowledged threatening psychic forces through verbal and visual representation and tamed them through ambiguity and subversion. In fact, this is one definition of magic. Significantly Váchal's work displays many concepts, themes, and motifs linking image-making to magic. Váchal's strategy was to turn the destructive powers against themselves and to release creative energy from this clash. His creative process may be described in psychoanalytic terms as the destruction or de-sublimation of the existential anxiety as opposed to its sublimation and suppression.

This characterization, which could be extended to other leading artists of Filla's and Váchal's generation, partially explains the preoccupation with psychic forces and concepts such as anxiety, pain, and the subconscious. This preoccupation manifested itself most explicitly in the iconography of their works. In addition to themes of pain and suffering, Filla, Bohumil Kubišta, Jan Zrzavý, and other artists frequently painted themes representing healing and recovery. These themes and motifs symbolize the healing and consequently the redemptive power of art.[39] Similar themes and motifs appeared in the work of contemporary young German and Austrian artists, notably members of Die Brücke in Dresden (and several years later also Der Blaue Reiter in Munich) and Oskar Kokoschka in Vienna. The German, Austrian, and

Josef Váchal, pages from *In Memoriam Marie Váchalové,* 1923, illustrated book, wood engravings, 9¼ x 8½ inches, private collection, Prague, cat. no. PS119.

Bohumil Kubišta, *Murder (Vražda)*, 1912, oil on canvas, 35⅛ x
37 x 1⅝ inches, Oblastní galerie výtvarného umění Gottwaldov,
cat. no. PS31.

Czech artists arrived independently at early forms of Expres-
sionism, making Prague between 1905 and 1910 an impor-
tant center of this movement.[40]

As early as the beginning of the 1910s, however, Cubism
became the dominant tendency in Czech art, and Prague
emerged as the Cubist capital of Central Europe. Czech Cub-
ism or, more exactly, Cubisms were very different from the
French prototype. The existential concerns expressed in the
themes of death, pain, and suffering as well as in the dra-
matic conflict of light and darkness were unthinkable in
French Cubism. Also, the Czech Cubists often emphasized the
interplay between form and content. Taking Cubism as a
point of departure, some Czech artists attempted to develop
"the spiritual content of the new form."[41] For this purpose

they felt free to complement Cubism with other concerns and
strategies—for example, those manifested in Futurism.
Rather than follow one stylistic principle, they sought to syn-
thesize various formal preoccupations and relate them to the
spiritual character of the modern age. In exploring the rela-
tionship between modernity and Modernism, they empha-
sized the relevance of existential and ethical issues in art.[42]
Thus, their idiosyncratic expression and ideas reflect a
number of key concepts and issues of twentieth-century art
and culture.[43]

Kubišta's work is a case in point. His self-portraits from
between 1907 and 1910 (see cat. nos. PS27, PS28) show the
artist countering ignorant critics and viewers with spiritual
energy and stubborn will. In these and other paintings,

Bohumil Kubišta, *Hypnotist (Hypnotizér)*, 1912, oil on canvas,
23⅞ x 22⅞ inches, Severomoravská galerie výtvarného umění v
Ostravě, cat. no. PS30.

Jan Zrzavý, *Madman (Šílenec)*, c. 1918, charcoal on paper, 16⅝ x 13⅞ inches, Moravská galerie v Brně, cat. no. PS131.

Kubišta employed the motif of an aura representing psychic and vital energy that emanates from living organisms and determines their place in the cosmos.[44] It is illuminating to compare Kubišta's paintings with contemporary works by Marcel Duchamp. For instance, the motif of the aura also appears in Duchamp's *Portrait of Doctor Dumouchel* (1910, Philadelphia Museum of Art, The Louise and Walter Arensberg Collection). Both artists criticized what Duchamp called retinal painting and emphasized the spiritual nature of art and its conceptual elements. This emphasis is evident in paintings like *The Chess Players* (1911, Musée National d'Art Moderne, Paris) by Duchamp and *Hypnotist (Hypnotizér,* 1912, cat. no. PS30) by Kubišta, which have similar compositions and themes. The paintings also manifest different interpretations of Cubism. While the painting *The Chess Players* advances the concept of play, *Hypnotist* draws on more dramatic notions such as power, will, and violence. Kubišta compared the interplay of these forces to gravitation and sought to create its equivalent in the internal rhythm of forms and in a geometric structure relying on the symbolism of numbers.[45] He also exploited the symbolism of color and light, often juxtaposing complementary colors and lights and shadows.

In Kubišta's still lifes from 1910–11, light seems to emanate from ordinary objects as if they could reveal the truth of existence. These still lifes are among the first of Kubišta's works influenced by Cubism. They are more relevant, however, to the later movements of Magic Realism and Metaphysical Painting, which they anticipated. The concept of the inner light as well as the dramatic contrast of light and shadow persisted in his Cubist paintings. As Kubišta indicated in his writing, he wanted to penetrate the surface of the visible world to the inner principle of modern life, which he identified with the peculiar character of modern ethics, specifically in its drive "to penetrate further and further," to be on the cutting edge, to go beyond the existing boundaries.[46] He saw in Cubism, Expressionism, and Futurism an expression of this principle and even coined the term *penetrismus* ("penetratism") for these movements.[47] But he argued that contemporary art drew upon this core of modern ethics unconsciously and that modern life "has left the whole complex of the subconscious mystical forces of the human spirit to lie fallow."[48]

This emphasis on the subconscious sources of creativity and ultimately on the unconscious itself made Kubišta sympathetic to the program of the group Sursum. The notion that art exteriorizes inner space had its most vocal representative in Kubišta's close friend, the painter Zrzavý. In the catalogue of his first exhibition, Zrzavý aptly described his work: "My art is a presentation of those states of the soul, which are anchored in the darkness of the unconscious of the human being and in which all human activity and its external manifestations originate. In painting, it means to elevate matter into the spiritual sphere and to endow it with psychic forces."[49] In *Madman (Šílenec,* c. 1918, cat. no. PS131), the artist saw himself as a medium of these psychic forces and, like Váchal, was interested in various extrasensory phenomena. In spiritualistic practices a human medium channeled extrasensory perceptions and in this state of psychic automatism produced messages and drawings. Many of Zrzavý's paintings and drawings, including *Obsession: Lovers (Posed-lost—Milenci,* 1914, cat. no. PS129) and *Murder (Vražda,* 1918, location unknown) show peculiar embryonic forms that are often reminiscent of mediumistic drawings[50] or children's drawings. As in Váchal's work, these embryonic forms reflect the artist's interest in forming images in both the subconscious and the unconscious and in capturing the moment when an image emerges. For Zrzavý, paintings and drawings became mental screens, directly linking the subconscious processes and image-making.

This interest in the primal forces of imagination explains primitivism's importance in the redefinition and invention of new pictorial procedures. Artists like Zrzavý and Váchal focused on the moment when the unintelligible configuration turns into an image, and they sought to reenact this magical metamorphosis. As we know from our childhood, it is exactly this metamorphosis that endows pictures with magical power. The concept of magic, or more precisely the notion of image-making as a magical operation, attracted the pioneers of Czech Modernism. It was at the heart of their fascination with various forms of the primitive as well as with popular cul-

Josef Čapek, *Man with a Top Hat (Hlava muže v cylindru)*, 1915,
linocut on newsprint, 11 x 9¹³⁄₁₆ inches, collection Dr. Jaroslav
Dostál, Prague, cat. no. PS5.

ture. Their work and writing demonstrate the closeness of the
tie between a return to the fundamentals of artistic expres-
sion and the interest in archetypal forms of representation.

According to Josef Čapek, one of the more eloquent
spokesmen of Modernist primitivism, the concept of magic
and wonder was at the root of all creativity.[51] Magic was seen
not as the opposite of the world of everyday objects and
objectivity in general but rather as its very substrate. Magic
and objectivity complemented each other. Čapek, Kubišta,
and other artists and critics recognized in objectivity one of
the essential characteristics of the modern age.[52] They
sought "the feeling of revelation and at the same time the
feeling of truth and existence" in the most ordinary everyday
objects.[53] They associated this transcendental experience
with the search for the sacred, which they did not relate to

religion but to the primal wonder at the fact of being, to the
expression of the mystery of existence.[54]

The interest in everyday objects led artists to pay atten-
tion to various forms of popular culture and art, including
film and photography. Numerous essays on this subject as
well as plays, stories, and novels by Karel and Josef Čapek[55]
indicate that objectivity and magic informed the recognition
of these new mediums, which anticipated the avant-garde of
the 1920s. In advancing objectivity on the one hand and the
unconscious and magic on the other hand, Czech artists pre-
pared the ground for two opposing movements that domi-
nated the period between the two world wars: Functionalism,
or the International Style, and Surrealism.

A comparison of the groups Tvrdošíjní (Stubborn Ones)
and Devětsil, which represented two different generations,

Josef Šíma, *Island I (Ostrov I)*, 1931, oil on canvas, 23⅝ x 28¾ inches, Národní galerie v Praze, cat. no. PS81.

demonstrates the transition from the avant-garde movement of the 1910s to the avant-garde of the 1920s. The Tvrdošíjní, founded in 1918 by artists who had established themselves during the 1910s, complemented earlier issues and themes with social motifs. The Umělecký svaz Devětsil (Artistic Association of Devětsil), founded in 1920, represented the next group of artists who sought to distance themselves from older generations. They subscribed to the idea of political revolution and a new role of the artist in society. At the beginning of the 1920s, it was their radical political stance that

distinguished them from the Tvrdošíjní rather than their artistic procedures, which elaborated on the concepts of magic and naive realism developed by the previous generation.

This contradiction disappeared in 1922 when the Devětsil adopted a new artistic ideology manifested in the anthologies *Devětsil* and *Life II. Anthology of the New Beauty (Život II. Sborník nové krásy)*. The photomontage cover of *Life II*, juxtaposing a Doric column with an automobile wheel, is emblematic of their new artistic program

Toyen, *Surrealist Composition (Surrealistická kompozice)*, 1933, watercolor and airbrush on paper, 12¾ x 17⅜ inches, Národní galerie v Praze, cat. no. PS100.

that sought to replace traditional art forms with film, photography, and other mediums based on modern technology and mechanical reproduction. In 1923 the Devětsil artists developed image poems and film poems—combinations of collage, photomontage, typographical designs, and film scripts—in which they saw a fusion of modern painting and poetry and a solution for artistic problems relevant to blueprints for the new society. The negative reviews of the Devětsil activity written by older critics and artists demonstrate the width of the ideological gap between generations.[56] The political radicalism and machine aesthetic, the vision of a social and technological utopia, and the central position of the concept of progress were difficult for the older artists to accept. Indeed, the young generation's stance appeared to invert the convictions of their predecessors. While the first generation of the avant-garde believed in individualism and in the priority of the spirit, the second emphasized the concepts of collectivism, function, and the machine.

Kubišta, Čapek, Zrzavý, Váchal, and their contemporaries saw artistic creation as a medium of individual

redemption. In reclaiming archetypal forms of expression, they sought to invoke the primal forces that link an individual with the universe and help to transcend time and history. The avant-garde of the 1920s reversed this strategy. By affirming the primal forces in society and technology, they shifted focus from the collective unconscious to the collective consciousness. They associated their cause with a political philosophy centered on the teleology of history and sought redemption by identifying with a collective movement that represented the march of history. By rejecting individualism, they sought to regain a lost sense of community, and artistic activity became an invocation of social and political change. Projecting themselves into a social and technological utopia, they believed in fulfilling the historical mission. While the artists of the 1910s looked back to the beginning of history, the avant-garde of the 1920s envisioned its end.

However incompatible these two approaches seem to be, the history of the avant-garde indicates that in the long run they complemented rather than excluded each other. The rise and development of Poetism, a position defined by Devětsil, is one of the best examples of the alliance of opposite approaches in the context of one particular movement. The Devětsil program promoted two complementary principles, construction and poetry. To some extent these principles reflected concerns of Dadaism (and later Surrealism) and Constructivism, as well as the fundamental polarities that shaped modern culture, including the two concepts of history represented by progress and primitivism. In the manifesto "Our Basis and Our Path: Constructivism and Poetism (Naše základna a naše cesta: Konstruktivismus a poetismus)," Karel Teige wrote: "The psychological ability to experience special contrasts, which are almost paradoxically sharpened, is indispensable for man in the epoch whose heart boils with contradictions.... Life needs as much reason as poetry. The contrasts: Nature-civilization, sentiment-intellect, imagination-rationality, freedom-discipline, construction-poetry, the public-the private; explicitly and clearly, they do not destroy the value of individual elements but multiply it."[57]

Between the two world wars, the Devětsil program explicitly reflected Modernism's polarity between rationalism and irrationalism, specifically between Dadaism and Constructivism or between Surrealism and Functionalism. Devětsil represented probably the only movement that attempted to synthesize these opposing principles, concerns, and strategies. For instance, the image poems combined an orthogonal grid with fragments of modern life, usually represented by photographic cutouts that served to incite the imagination (see cat. no. PH153). Teige called these fragments "touches of reality" and described their effect as follows: "The less is hinted, the more is suggested."[58] The image poems by such leading Devětsil artists as Jindřich Štyrský differ from both Dadaist and Constructivist collages and photomontages (see cat. nos. PH126, PH127). To see Devětsil only as an extension of Constructivism on the one hand or Dadaism and Surrealism on the other hand is to miss the essential character and singular contribution of this group. The uniqueness of Devětsil and its concept of Poetism rests in the interplay between opposing principles that were more or less separated in other movements.

Zdeněk Pešánek, the artist closest to Constructivist ideals, found himself on the fringes of Devětsil. Focusing on the themes and mediums of motion and modern technology, he developed various forms of kinetic art. Besides three different versions of the color piano, which followed or paralleled similar experiments abroad, he created light fountains and kinetic sculptures. Combining motion, light, sound, and even smoke, his innovative kinetic projects explore such themes as electricity or flight. At the beginning of the 1930s, he was probably the first artist to employ neon light in sculpture. He used it with other new mediums, including programmed electric bulbs, rotors, and plastic. He was also the author of pioneering publications on kinetic art, including the first book ever devoted exclusively to the subject.[59]

In the 1930s he introduced the figurative theme of the torso and integrated it with Constructivist mediums and devices (see cat. no. PS50). In these sculptures Pešánek confronted and fused male and female elements in transparent plastic forms and in programmed light combinations. By introducing the archetypal theme of the androgyne, a motif rooted in the collective unconscious, he extended the future-oriented collectivist concept of Constructivism. This more complex vision balances opposing principles and reveals the legacy of Devětsil.

The motif of the torso in Pešánek's work also relates to the work of Josef Šíma, who among the Devětsil artists in the second half of the 1920s stood closest to Surrealism and furthest from Pešánek's Constructivism. Living in Paris, Šíma witnessed the rise of the Surrealist movement, although he remained outside its ranks. Instead he befriended numerous poets and writers, including Pierre Jean Jouve, Georges Ribemont-Dessaignes, Roger Gilbert-Lecomte, Roger Vailland, and René Daumal, who did not accept Surrealism's systematic interpretation and its penchant for orthodoxy. In 1927 Šíma and his circle founded the group Le Grand Jeu, which the Surrealists considered heretical. Le Grand Jeu addressed the collective rather than the individual unconscious. Animated by myths, archetypes, and the cosmic elements, Šíma's paintings would attract Carl Jung and Gaston Bachelard rather than Freud. Cosmic symbols of crystal, egg, and tree became leitmotifs in Šíma's work (see cat. nos. PS77, PS78). The transformation of his paintings in the mid 1920s testifies to a deep Modernist undercurrent of monism. He eventually turned from collectivist consciousness and the individual unconscious to dreams of the beginning of the universe, visions of cosmic unity, and imagination of elements.

The work of Štyrský and Toyen, leading painters of Poetism, also transforms the collectivist vision of the avant-garde during the 1920s and 1930s. In the second half of the 1920s, they lived in Paris, where they developed a lyrical abstract style they called Artificialism, which represents the second

stage of Poetism (see cat. nos. PS86–PS89, PS98, PS99). By emphasizing the concept of poetry, Artificialism sought the "maximum of imagination."[60] Artificialist paintings can be seen as the offspring of image and film poems in the same sense that René Magritte's paintings are heir to Surrealist collage. With other Devětsil artists, Štyrský and Toyen perfected the strategy of "touches of reality" in image and film poems.[61] Artificialist paintings are recollections distilled into abstract configurations of the subtlest shades, colors, and textures. These visual "extracts and condensations"[62] show photographic sources not only in the frequent use of airbrushing and stenciling but also in more general affinities. Processes such as the photogram and photomontage, as well as the concepts of the latent image and the celebrated capability of photography to capture the invisible, influenced the artists both directly and indirectly.[63] For Štyrský and Toyen, these processes and qualities served as a potent metaphor for the complex relationship between reality and its mental image.

Although this exploration led them to the Surrealist movement in the early 1930s, through the 1920s they explicitly distinguished their work from Surrealism. Artificialism prospected the territory of the subconscious rather than the unconscious. As Štyrský and Toyen traced emerging or disappearing mental images lingering on the threshold of consciousness, they indirectly introduced the theme of origin and end. Artificialist paintings often allude to water and display various embryonic forms, including the egg.[64] With Surrealism these themes of the beginning and end became explicit. For example, the first distinct echo of Surrealism appeared in Štyrský's series of drawings *Apocalypse (Apokalypsa*, 1929, National Gallery, Prague), which depicts imaginary scenes of a cosmic deluge. In this respect it is highly significant that *The Trauma of Birth (Trauma zrození*, 1936, cat. no. PS92), a key work of Štyrský's, further developed the concept of the oneiric object and explicitly related the theme of origin and end. Various objects are represented, including a leather glove, the claws and skull of some prehistoric animal, and a human embryo. The black background of the painting may be seen not only as the darkness of the unconscious and the primal generative matter but also as devouring nothingness. The title of the painting as well as its ominous ambiance convey the alliance of origin and end.[65]

This and other of Štyrský's paintings symbolize the desire for the lost paradise of childhood and a return to the prenatal state; they also evoke death. The motif of death is frequent throughout Štyrský's work; for example, in his Cubist painting *Cemetery (Hřbitov*, 1919, location unknown) the artist's signature and the date appear on the tombstone.[66] The eschatological motifs in Štyrský's work often refer to a traumatic experience of his childhood, when he witnessed the death of his beloved twenty-one-year-old sister-in-law. The artist consciously cultivated this trauma, as a number of his titles indicate, including *The Dead Girl (Mrtvá dívka*, 1923, private collection, Prague), *The Drowned Girl (Utonulá*, 1926, private collection, Prague), and *A Cigarette by the Dead (Cigareta u mrtvé*, 1931, North Moravian Gallery of Fine Arts in Ostravě). That trauma, combined with the Surrealist predilection for psychoanalysis, led Štyrský to embrace the Freudian duality of eros and thanatos and contributed to the frequent conflation of erotic and eschatological elements in his work.[67]

The Trauma of Birth and other paintings demonstrate not only the inner linkage between images of origin and end but also the complexity and polymorphism of these themes. Štyrský's work suggests that the monistic proposition of original unity had a counterpart in the eschatological theme and that one could easily emerge as the other. Although crossovers of the two themes appeared earlier—for instance, in Váchal's work—Štyrský's and Toyen's Surrealist work linked the themes explicitly. These artists bridged the propositions of the two previous generations: Kupka's and Preissig's cosmic monism on the one hand and Váchal's, Kubišta's, and others' existential concern on the other. The convergence of the monistic and the eschatological themes in Surrealism corresponded to the movement's joining of the ideas of progress and primitivism. But this connection, which is manifested in the Surrealist marriage of Marxism and psychoanalysis and in the phrase "revolution/revelation," had problematic results that became obvious in the face of the reality of emerging totalitarian societies and World War II. These events brought not only the political and consequently the cultural restructuring of Central and Eastern Europe but also concluded the heroic period of Modernism. These events, including the fate of the artistic avant-garde in Czechoslovakia after the war, testify to the elusive goal of the Modernist search for redemption as well as to the conflicting concepts of history, progress, and primitivism, which have lingered through the present.

Kubišta's review of the Sursum exhibition in 1912 contrasts not only two rival artistic groups, Sursum and Skupina, but also two visions of history:

> I consider it incorrect to apply the same criteria to the works exhibited here as to the works of the Skupina and to demand of these painters to change their character and to express themselves in a way that is alien to their beings. At first glance it seems that none of them brings anything original and that, as a consequence of this shortcoming, they simply imitate the art of clearly defined past epochs. In the present time we have acquired the habit, under the influence of German Aesthetics, to assess individual epochs and their artistic creations on the external basis by examining and analyzing their formal elements and to evaluate them accordingly; the meaning and substance of the work are usually explained on the basis of vague conditions, which could be imported into the art works when the true reason of their origin remains hidden. It may be possible to come closer to it, but it has lost its generally widespread validity, intelligibility and self-evidence.[68]

Jindřich Štyrský, *The Trauma of Birth (Trauma zrození)*, 1936, oil on canvas, 39¾ x 100⅜ inches, collection Maître Binoche, Paris, cat. no. PS92.

Toyen, *Before the Spring (Předjaří)*, 1945, oil on canvas, 35¹⁄₁₆ x 57½ inches, Musée National d'Art Moderne, Centre Georges Pompidou, Paris, cat. no. PS106.

Surprisingly, Kubišta's condemnation of the effects of reductive formalism is more urgent today than seventy-five years ago. One of the consequences of the institutionalization of Modernism in recent decades has been the canonization of certain art works, artists, and movements. Isolating formal concerns and resolutions from the processes, dilemmas, and options of a given period—as well as from its underlying psychological, sociological, and philosophical issues—has limited and impoverished our understanding of modern history and, consequently, our understanding of the present issues.

Dr. Jaroslav Anděl is a free-lance curator working in New York City.

• NOTES

1. This insecurity became a standard explanation in postwar sociology for almost every new social phenomenon. Curiously enough, few historians of Modernism have elaborated on this theme. One of them was the late Donald E. Gordon in his essay "German Expressionism," in *"Primitivism" in 20th Century Art*, exh. cat. (New York: The Museum of Modern Art, 1984), vol. 2, pp. 369–403.

2. See Donald D. Egbert, *Social Radicalism and the Arts—Western Europe* (New York: Knopf, 1970).

3. This view of Modernism is elaborated in Daniel Bell, "Beyond Modernism, Beyond Self," in *The Winding Passage: Essays and Sociological Journeys 1960–1980* (New York: Basic Books, Inc., 1980), pp. 275–302.

4. For a discussion of the eschatological patterns in Modernism, see Frank Kermode, *The Sense of an Ending: Studies in the Theory of Fiction* (London, Oxford, and New York: Oxford Univ. Press, 1966).

5. The recent exhibitions *"Primitivism" in 20th Century Art* (The Museum of Modern Art, New York, 1984) and *The Spiritual in Art: Abstract Painting 1890–1985* (Los Angeles County Museum of Art, 1986), which explored the notions of the primitive and the spiritual, testified to the enduring appeal of these ideas.

6. The drawing is reproduced with commentary by Meda Mladek in "Prevailing Inspiration: Metaphysical Questions," in *František Kupka 1871–1957: A Retrospective*, exh. cat. (New York: The Solomon R. Guggenheim Museum, 1975), p. 42. (For additional discussion, see František Šmejkal, "The Enigma of Life. Migrations of a Motif [Zagonetka života. Putovanje jednog motiva]," in *Zbornik Narodnog muzeja XI/ist. umetnosti* [Belgrade, 1982], pp. 125–31.)

7. The Guggenheim catalogue does not mention the series and includes only the print *The Beginning of Life*. The cycle consists of six prints (three themes executed in two variants) of which the Prague National Gallery catalogue (1968) lists four prints of the same size (*The Way of Silence, The Beginning of Life*, and two variants of the *Defiance or Black Idol*). The catalogue *Czech Art 1878–1914: On the Way to Modernity (Tschechische Kunst 1878–1914: Auf dem Weg in die Moderne,* Darmstadt: Mathildenhöhe, 1984) also includes a variant of *The Way of Silence.*

8. See Margit Rowell, "Catalogue of the Exhibition," in *František Kupka 1871–1957: A Retrospective*, p. 86, and Maurice Tuchman, "Hidden Meanings in Abstract Art," in *The Spiritual in Art: Abstract Painting 1890–1985*, exh. cat. (Los Angeles and New York: Los Angeles County Museum of Art and Abbeville Press, 1986), pp. 79–81. Although Kupka's involvement with spiritualism and his interest in the occult sciences represented a prominent part of his education and experience, these interests alone could hardly explain the unique characteristics of his abstraction. Many other contemporary artists, including Alphonse Mucha, one of the pioneers of Art Nouveau, shared the same interests but developed a very different style.

9. The prints *The Way of Silence I, II* are variations of the lost painting *Why Are We Here? (Quam ad Causum sumus).*

10. For example, consecutive and cyclical motion is often related to the theme of biomorphic growth and consequently to the generative forces. Sexuality or the interplay of the feminine and the masculine elements saturates Kupka's work and represents a major theme neglected in previous interpretations. See, for example, František Kupka, *Creation in Fine Arts (Tvoření v umění výtvarném,* Prague: S.V.U. Mánes, 1923), p. 69.

11. Kupka, *Creation in Fine Arts*, p. 126.

12. "It is always the cause and the effect, it is a continuity in which effects become the causes of other effects, etc. Further, let us not forget that one cannot ever separate an individuum from the cosmic set; in creating organisms, the vitalistic mechanism advances by linking causality as a chain, a link by link, by stretching and loosening, by loading and unloading. And this is always, we contend, always in relation with the total cosmic set" (Kupka, *Creation in Fine Arts*, pp. 160–61). Kupka's definition of continuity alludes to the idea of a chain of being, one of the fundamental concepts of Western metaphysics. See Arthur O. Lovejoy, *The Great Chain of Being: A Study of the History of an Idea* (Cambridge: Harvard Univ. Press, 1936, 1961).

13. Almost all of Kupka's series contain works showing a transition from one series to another or a combination of two or more themes. Even such different series as *Vertical Planes* and *Amorpha, Fugue in Two Colors* contain pictures combining both themes, such as *Vertical Planes* (1911–12, titled also *Curving Verticals* or *Preliminary Study for the Vertical Planes*, The Museum of Modern Art, New York).

14. Kupka's book *Creation in Fine Arts*, which has never been translated,

has received little attention, although it contains numerous references to the artist's iconography. See, for instance, the following excerpt that, in explaining formative processes of the organic and inorganic matter, could be seen as an apt description of motifs and themes of many of Kupka's paintings, including *Cosmic Spring*: "Spermatic cells connect to other cells and these cells again connect to others. Thus every organism masters its environment, expands, grows, and adapts a visible resemblance of its dynamism struggling with the surrounding dynamism. The same is true about clouds, accumulations of vapor carried and driven by direct or whirling air streams. Shapes of elastic, elongated, or folding lines with a distinct delineation or with the outlines that diffuse while we look at the encounter of both elements, which are bouncing against each other or penetrating each other. Salt, lime caves with stalactites and big-bellied laps, which elongate drip by drip, water-falls in winter and icicles hanging from tree branches, fantastic, pristinely clear, glassy forms, an enhanced condensation, the same one from which a rich white vegetation grows on the window panes. Water freezing in centrifugal lines in puddles, diamond, topaz, and sapphire crystals that are condensed gases" (p. 75). Compare Kupka's contention that "the work of formal cor-relation will look equally good under the microscope as in front of New York skyscrapers or in an astronomical observatory" (quoted in Jana Šálková's catalogue entry in *Tschechische Kunst 1878–1914: Auf dem Weg in die Mod-erne*, p. 180).

15. Despite their idiosyncratic character, Kupka's paintings as well as writings contain ideas and themes that show a remarkable affinity with some theories and models on the cutting edge of contemporary science. For instance, Kupka's favorite theme of the growth and expansion inspired by observation of various natural forms and processes, including whirling and rippling water, formations of clouds, boiling liquids, condensing gases, etc., makes us think of Benoit Mandelbrot's fractal geometry and computer simulations derived from concepts of the same processes Kupka so avidly studied. Kupka empha-sized the interaction between the chain of organisms and processes, which has its model in osmosis, and thus not only implied the mutual interde-pendency between organisms and their environment but also explained the complexity and plenitude of life very much as did some leading contemporary scientists.

16. This was the case with several key paintings, including *The First Step* (1909–13), *Cosmic Spring II* (1911–20/1934[?]), and *Around the Point* (c. 1925–30, reworked c. 1934, dated by Kupka 1911–1930). Most motifs and themes as they appeared between 1910 and 1930 or later can be traced back to earlier paintings and drawings. See, for instance, the comparisons in Meda Mladek, "Search for Beautiful Form" and "Metaphysical Question," in *Fran-tišek Kupka 1871–1957: A Retrospective*, pp. 38–45.

17. "When nature paints or sculpts, the visible result is only a work of the inner creation coming from the innermost interior to the surface. Let painters and sculptors attempt to work as nature does" (Kupka, *Creation in Fine Arts*, p. 77).

18. Kupka, *Creation in Fine Arts*, p. 41.

19. See Reinhold Heller, "Kandinsky and Traditions Apocalyptic," *Art Jour-nal*, vol. 43 (Spring 1983), pp. 19–26.

20. Preissig developed his theory of *Art Fundamental* in virtual isolation dur-ing the years he spent in America, 1910 to 1931. Works from this period are titled in English.

21. See Gaston Bachelard, "La Rêverie et cosmos," in *La Poétique de la rêverie* (Paris: Presses Universitaires de France, 1968), pp. 149–83. For a dis-cussion of the motif in visual art, see *Tree (Strom)*, exh. cat. (Brno: Dům umění, 1976), essay by Jaroslav Anděl. Tomáš Vlček examined this motif in Preissig's work in "Der Baum in Schaffen Vojtěch Preissigs," in *Jahrbuch der Hamburger Kunstsammlungen* (Hamburg, 1976), p. 165.

22. Parallels can be found between Preissig's prints from natural textures and similar explorations by Jean Dubuffet or between Preissig's geometric draw-ings, which are based on numerical series related to natural processes, and comparable themes in the work of Robert Smithson, Mario Merz, and others.

23. In 1938 Filla wrote an article, published in *Literary Newspaper (Literární noviny)*, which contains a moving description of Munch's impact on his genera-tion: "However, Munch became for us an inevitable fate. It was the end of the school discipline, the end of all authorities, the end of dispensing with courage. Munch's work exploded in our heart like a petard. It shattered our foundations and all of a sudden all our desires, loves and hopes seemed to be materialized, we were in a constant ecstasis, because we felt then, as we feel today, that the *artist* came to us, that is, the artist of our times, our hearts and our will. The spirit of authentic, direct art descended upon us at that time, we saw in him a Guardian Angel of our future journey and a blessing of our decision to be artists of today. We thought and felt that Munch came just because of us" (Emil Filla, "Munch and Our Generation [Munch a naše generace]," in *Reflec-*

tions on Fine Arts [Úvahy o výtvarném umění, Prague: Karel Brož, 1948], p. 68).

24. In 1916–17 Filla described Symbolists and Decadents as follows: "They are analysts of the past and invocators of the dead spirits. They are Modernists and grave-diggers of old cemeteries at the same time. They do not have yet the direct relation to the world because they do not believe in its purposeful and independent existence" (Emil Filla, "The Path of Creativity [Cesta tvořivosti]," in *Reflections on Fine Arts [Úvahy o výtvarném umění*, Prague: Karel Brož, 1948], p. 404).

25. Filla, "The Path of Creativity," p. 380.

26. Emil Filla, "Life and the Work (Život a dílo)," *Artistic Monthly (Umělecký měsíčník)*, vol. 1, no. 12 (October 1912), p. 321.

27. Filla, "The Path of Creativity," p. 380.

28. In this respect Filla's description of his generation's beginnings is illu-minating: "The monster of indifference and grey dullness gazed at us, boys, from all corners. Without any help, we had to unite to be able to breathe, to believe, to hope and, first of all, to love our newly born desires for our own ges-ture both in life and in art. A sharp and uncompromising critical attitude to everything and foremost to ourselves bonded us most of all; we were ripening in the courage to follow a steeper path" ("Munch and Our Generation," p. 66).

29. It is significant that this sense of an ending was most urgent in Russia, one of the least developed countries in Europe, where the middle class was almost nonexistent and thus most alienated. It was in Russia where the messianic notion of the artist's role in society reached its peak.

30. For instance, Filla's 1916–17 essay "The Path of Creativity," which sums up the philosophical standpoint of his generation, demonstrates some remark-able parallels to the philosophy of Existentialism, especially to Jean-Paul Sar-tre's version of it. Filla identified concepts of freedom and creativity that have to be born again and again in confrontation with nothingness: "Every true artist is also a rebel. For his work is always redeemed by a lived experience again. Such experience of action in art is painful and joyful at the same time, for it is gained through the experience touching always being and non-being. In gaining the experience, the artist goes to the border of death" (pp. 380–81).

31. In multiplying the artist's image and role in the symptomatic ending, Vá-chal's drawing *How J. Váchal Portrayed Himself: As an Anarchist, Philoso-pher, Satanist, Ironic Person, Poet, How He Would Look With a Moustache, As the Editor of "The Cult of the Young," As a Protestor, Bon Vivant and After His Death* (1904) reflects the artist's estrangement and identity crisis as well as the existential anxiety behind them.

32. In his teens Váchal also suffered from attacks of anxiety and nightmares, which he learned to overcome by exercises in meditation and automatic draw-ing. He was an avid reader of anarchist writers such as František Gellner and Stanislav K. Neumann and an admirer of various primitive and popular art forms as well as occult concepts and theories.

33. Like Gauguin, Váchal carved utilitarian objects such as clubs, pipes, paperweights, etc. In this respect Váchal's description of one of his first sculp-tural works is relevant: "I transformed an old, worm-eaten shoemaker's last, which had served several generations, into the figure of an idol and varnished it with various blue-stone solutions in such a way that it had the appearance of a miniature ship's prow from olden times" (*Memoirs of Josef Váchal, a Wood Engraver [Paměti Josefa Váchala, dřevorytce]*, in the National Museum of Liter-ature [Památník národního písemnictví] in Prague, access no. 54/71–2, p. 130). It shows Váchal's predilection for chance and secondary images, which also characterizes Gauguin's work.

34. Váchal's interest in popular art was so strong that he became a collector and expert in some fields, including dime novels, nineteenth-century wood engravings, and countenance broadsheets.

35. For instance, *Mysticism of Smell (Mystika čichu*, 1920, cat. no. PS116), *Magic of the Future (Magie budoucnosti...*, 1920), and *Sorcerer's Kitchen (Čarodějnická kuchyně*, 1928).

36. The artist's use of photography in his self-portraits based on double or multiple exposure (1901, 1915) and inspired by the so-called spirit pictures of the period is a good example of this independence. The ambiguity of the over-lapping images of the artist's body challenges the notion of identity and intro-duces the motif of secondary images. Like some of Váchal's other photographic self-portraits, they question the role and image of the artist.

37. Here again, Gauguin's work probably helped Váchal to develop the device he had used intuitively from the beginning. The use of secondary and chance images corresponds to the iconic character of Váchal's imagination—i.e., to his capacity to find and generate various images in a single plastic configuration. Thus, one can read some forms in Váchal's paintings, drawings, and sculptures

in two different ways, seeing, for instance, a figure in a tree, a face in other body parts, etc.

38. It is interesting to compare the motifs of embryo and tissue in Váchal's and Preissig's or Kupka's work. Váchal's early prints and drawings often represent embryo-like forms and shapes interwoven in tissue-like structures. Váchal called them "under-developed bodies and ideas."

39. A psychoanalyst would describe these works as typical examples of projection. To use the metaphor, one can say that in projecting their feelings (including violence, pain, and suffering) into their work, artists acted as both patients and therapists. Their paintings and sculptures were a couch on which they challenged the unconscious to speak up. For instance, Kubišta argued in his seminal essay: "The new life is stretching the human spirit too much in one direction, interested in the individual as long as there is a material relation with him, and neglects an entire complex of subconscious mystic powers of the human spirit, which keep piling up until they finally find a passage.... Penetrate into these depths of modern underworld, modern artist, and you shall find there something we call artistic regeneration. Here, observe modern man and you shall see that he is searching for what the modern age does not give to anybody: the fluid of life—love" ("On the Spiritual Essence of the Modern Age [O duchovní podstatě moderní doby]," *Czech Culture (Česká kultura)*, vol. 2, nos. 14–15 [April 1914], p. 221).

40. See John Willett, *Expressionism* (London: Weidenfeld and Nicolson, 1970).

41. In a letter (dated March 28, 1915) to Zrzavý, Kubišta wrote: "*What matters now is the spiritual content of the new form.* What Picasso introduced is somehow already common knowledge on whose basis it is necessary to further advance to the spiritual sphere" (*Bohumil Kubišta: Correspondence and Essays [Bohumil Kubišta. Korespondence a úvahy*, Prague: SNKLHU, 1960], p. 155).

42. See, for instance, Bohumil Kubišta, "On the Spiritual Substrate of the Modern Age (O duchovém podkladu moderní doby)," *Czech Culture*, vol. 1, no. 2 (October 1912), pp. 52–56; Kubišta, "On the Spiritual Essence of the Modern Age," pp. 217–21; Filla, "Life and the Work," pp. 314–28; and Filla, "The Path of Creativity," pp. 345–407.

43. The fading of the sacred in modern society seems to be the central issue underlying other concepts in which the Czech artists were interested. For example, the themes of violence and murder appeared in the work of Kubišta, Váchal, Zrzavý, and other artists and was also frequent in their writings. In a letter to Zrzavý, Kubišta wrote: "Therefore what is modern indeed exists, but it is not correct to derive modern art, for instance, from machines. It is necessary to derive modern art from this inner ethical state. And a relationship with modern art is manifested rather in modern criminal phenomena and other incidents, because they apparently reveal the inner state of contemporary society from which art unconsciously grows" (*Bohumil Kubišta: Correspondence and Essays*, p. 148). Kubišta relates modern art directly to the great questions of modern ethics raised by Dostoevsky and Nietzsche, which were implied in the proposition "God is dead!"

44. "Once the revolt against God took place and man elevated himself to his place, drawing the fluidic power from endless sources of the cosmos, the breath of nature that Indians call 'zhivatma,' the unified structure of human society changed, because each individual became a definite center of action power and, based on its quantity, acted on the other individual, following a law very similar to the law of gravity" (Kubišta, "On the Spiritual Substrate of the Modern Age," p. 54).

45. Bohumil Kubišta, "On the Prerequisite of Style (O předpokladu slohu)," *Přehled*, vol. 10, no. 2 (October 1910), pp. 37–38. For a discussion of Kubišta's compositions, see Mahulena Nešlehová, *Bohumil Kubišta* (Prague: Odeon, 1984), pp. 123–50.

46. "There is the reason why the modern age is stripped of all decorations, somehow bare and hard, free of illusions and mercy, and each of its participants is carrying this seal on his forehead. A modern artist, like every member of the modern society, is also driven by this idea. Penetrate further and further, that is his motto. Penetrate even there, where no one has managed to enter, create there, where no one else has created, understand more than the artist-rival. And here, dear friend, you have the reason why so many -isms originate. That is why you cannot create the way the old ones did, why you cannot be a romantic, idyllic, impressionist in the old sense of the word and why you have to be new, because only he who penetrates further and further creates. Therefore, if you want to, if you are able to and if you can find a different and better expression for the emotional states of the modern man, then you may not be an impressionist or even a picassoist, futurist or cubist" (Kubišta, "On the Spiritual Essence of the Modern Age," p. 221).

47. Bohumil Kubišta, "The Necessity of Criticism (Nutnost kritiky)," *Free Directions (Volné směry)*, vol. 17, no. 5 (March 1913), p. 82.

48. Kubišta, "On the Spiritual Essence of the Modern Age," p. 221.

49. *Jan Zrzavý*, exh. cat. (Prague: Topič Salon, 1918). Quoted from Miroslav Lamač, *Jan Zrzavý* (Prague: Odeon, 1980), p. 22.

50. See Jaromír Zemina, *The World of Jan Zrzavý (Svět Jana Zrzavého*, Prague: SNKLU, 1963). Váchal owned two copies of the book *The History, Origin and Purpose of Mediumistic Drawing in General and in Bohemia in Particular (Dějiny, původ a účel kreseb medijních vůbec a v Čechách zvláště*, Podmoklice, 1913). Two mediumistic drawings have been preserved in Váchal's estate at the National Museum of Literature in Prague.

51. "For each truly formative procedure is magic; it contains the wonder, so strange and difficult to comprehend wonder of trans-substantiation—see, is it anything but magic?—a trans-substantiation precisely in the direction of the substance, not contrary to it or outside of it, but right in it, in its material, in its form, in its content" (Josef Čapek, *The Art of Tribal Peoples [Umění přírodních národů*, Prague: František Borový, 1938], p. 108).

52. They used the term *věcnost*, which is an equivalent of the German *Sachlichkeit* and is usually translated either as objectivity or as sobriety.

53. In a letter from April 8, 1913, Čapek wrote to his future wife: "And what appeals to me most is when the subject is not princesses or nymphs but when something most ordinary dispenses a feeling of revelation and at the same time a feeling of existence and truth" (*The Double Fate [Dvojí osud*, Prague: Odeon, 1980], p. 127).

54. See, for instance, Josef Čapek, "The Creative Character of the Modern Age (Tvořivá povaha moderní doby)," *Free Directions (Volné směry)*, vol. 17 (1913), p. 113, and Vlastislav Hofman, "For a New Classicism. Chapters on Civil Holiness (O nový klasicismus. Kapitoly o civilní svatosti)," in *Musaion*, vol. 1 (Prague: Aventinum, 1920), pp. 24–27.

55. Josef Čapek, *The Most Modest Art (Nejskromnější umění*, Prague: Aventinum, 1920); Josef Čapek, *A Little about a Lot (Málo o mnohém*, Prague: Aventinum, 1923); and Karel Čapek, *The Things Around Us (Věci kolem nás*, Prague: Československý spisovatel, 1970). See also Jaroslav Anděl, "Artists as Filmmakers" and "Modernism, the Avant-garde, and Photography" in this book.

56. See, for instance, Václav Nebeský, "The Artistic Defeatism (Umělecký defétismus)," *Tribuna* (March 27, 1921), p. 12, and Ferdinand Peroutka, "On That Avant-garrde Rrrevolutionairre (O té avant-garrde rrrevolutionairre)," *Tribuna* (January 6 and 9, 1923), p. 1.

57. Karel Teige, "Our Basis and Our Path: Constructivism and Poetism (Naše základna a naše cesta: Konstruktivismus a Poetismus)," *Zone (Pásmo)*, vol. 1, no. 3 (September 1924), p. 2.

58. Karel Teige, "The Revival of Cinematic Art (Obroda filmového umění)," 1924, in *Film* (Prague: Václav Petr, 1925), p. 96.

59. Zdeněk Pešánek, *Kinetic Art (Kinetismus*, Prague: Česká graficka unie, 1941).

60. Jindřich Štyrský and Toyen, "Artificialism (Artificialismus)," *ReD (Review of Devětsil)*, vol. 1, no. 1 (October 1927), p. 28.

61. Teige's descriptions of image poems show numerous parallels with Štyrský's and Toyen's manifestos of Artificialism. Teige also coined the term artificial poetry (artificielní poesie) in his essays on film and photography. See "The Revival of Cinematic Art," p. 96.

62. Jindřich Štyrský and Toyen, "Artificialism," p. 29.

63. Among the sources of Artificialist imagery were scientific photographs of all kinds, including microphotographs and aerial and nautical views, which were often reproduced in the Czech avant-garde periodicals side by side with Artificialist paintings.

64. It is characteristic that most of the Artificialist titles allude to the element of water: *Flood, Coral Island, Aquarium, Dutch Landscape, Bretagne, Pool, The Sea Tie, The Drowned Girl, Ship-wreck, Fjords, Swamp, Lake Landscape, The Lakes of Cocktails, Sea Anemones,* and *Night in Oceania*. Other titles often imply various levels or strata of reality: *Fata Morgana, Sleepwalking Elvira.*

65. It is relevant that the artist created this important work after he survived a serious illness.

66. Štyrský selected this painting for the opening plate of the representative monograph *Štyrský and Toyen* (Prague: František Borový, 1938).

67. See František Šmejkal, "Štyrský entre Eros et Thanatos," in *Du surréalisme et du plaisir* (Paris: Librairie Josef Corti, 1987), pp. 162–67.

68. Bohumil Kubišta, "The Exhibition of the Free Association of Fine Artists Sursum at the Municipal Building (Výstava volného sdružení výtvarných umělců Sursum v Obecním domě)," *Přehled*, vol. 11, no. 7 (November 1912), p. 120.

Otto Gutfreund, *Anxiety (Úzkost)*, 1911, bronze, 58¼ x 22½ x 19¹⁵⁄₁₆
inches, Hirshhorn Museum and Sculpture Garden, Smithsonian
Institution; Joseph H. Hirshhorn Purchase Fund and Partial Gift
of Mr. and Mrs. Jan V. Mladek, cat. no. PS20.

Czech Modernism 1900-1920

ALISON DE LIMA GREENE

The city of Prague has been lost to the modern imagination. Although home to successive generations of the avant-garde in the laboratory years of Modernism before World War II, Prague is identified primarily with its historical and legendary past. Bruce Chatwin, the city's most recent memorialist, recalls that "Prague was still the most mysterious of European cities, where the supernatural was always a possibility."[1] André Breton first came to Prague in 1935 to find "the magical metropolis of old Europe."[2] Guillaume Apollinaire visited Prague in 1902, and it was the old quarters of the city at twilight, its cathedral, and its taverns that he summoned up in his 1912 autobiographical reverie "Zone."[3]

Yet even the most casual pedestrian strolling through the streets of Prague encounters evidence of a younger spirit. Although the initial impression may be of a city preserved under a geographical and temporal bell jar, a few edifices and monuments attest to a vital current of Modernism as well. The lessons of Otto Wagner and the Austrian Secession were quickly absorbed by such architects as Jan Kotěra at the turn of the century. Cubism left a unique and inventive imprint on Prague through the work of Josef Chochol, Josef Gočár, and Pavel Janák. Functionalism in the 1920s and 1930s not only provided a working model for such new developments as Max Urban's Barrandov terrace and restaurant on the outskirts of the city but also lent an international character to the restaurants, hotels, and storefronts of Wenceslas Square. Public sculpture ranges from the dramatic silhouette of Ladislav Šaloun's *Monument to Jan Hus* (1900–15), to Vlastislav Hofman's Cubo-expressionist 1912 street lamp, to Otto Gutfreund's 1922–23 social-realist frieze on the façade of what is now the Ministry of Industry. Although the radical 1930s installations and neon sculptures of Zdeněk Pešánek (see fig. 1) have been lost, their heirs light up the night along the fashionable shopping boulevards. Typically, these innovative structures and monuments complement rather than contradict their Czech ancestry. For example, despite its cubistic exterior, Gočár's 1911–12 house "At the Black Madonna (U černé Matky boží)" in scale, articulation, and rhythmic structure echoes the buildings of the surrounding Baroque façades.

While architecture provides the most visible evidence of Prague's venture into Modernism, the libraries, archives, museums, and private collections attest to a more complex and varied picture of the Czech avant-garde. As Peter Marzio notes in the introduction to this catalogue, avant-garde tendencies developed in a progression of thesis, antithesis, and synthesis, as Czech art was galvanized through a series of brilliant beginnings in the first decades of this century. Like almost all histories of Modernism, Czech Modernism can be characterized as a series of secessionist movements, schisms, and independent ventures—as well as historical events—that redirected and shaped the arts. For example, the painter Jan Zrzavý issued a personal declaration of independence in 1920: "Do not let the slogans of modernity stun you, follow only your own idea and do not get frightened should the result seem unfashionable. If you are creating, then you are inevitably modern....Believe in and be faithful only to yourself."[4] By 1923 the artist and theoretician Karel Teige was able to envision a complete break and rebirth in the arts: "The new art ceases to be art. New areas are being born and POETRY extends its frontiers, rises out of the banks, and fuses with the multistructured life of the globe."[5]

Nevertheless, the Czech avant-garde inevitably was given character by its geographic and historical context. In 1900 Prague, the capital of Bohemia, was still a satellite of the Austro-Hungarian Empire. West of Vienna, Prague had flourished in the nineteenth century as a Central European crossroads with active ties to the commerce and culture of Paris and Munich as well as Vienna. Nineteenth-century Czech artists responded to both national revival movements and international currents, and at the turn of the century the architect Kotěra signaled a comprehensive orientation with his call to "open the windows to Europe."[6] Indeed, by 1910 Prague had become a receptive center for what at a glance appear to be contradictory currents. A sympathy with the Viennese Secessionists was rapidly replaced by an appreciation of Auguste Rodin and Edvard Munch following their respective 1902 and 1905 exhibitions in Prague. The innovations of Paris Cubism became in the hands of certain Czech artists the culmination of Expressionism. Mysticism and primitivism proved to be complementary facets of the avant-garde, becoming a means at once of charting the past and of mapping out the future. This elasticity was not due to any lack of focus. Rather, as Wolfgang Pehnt has noted of

the years before World War I, "the avant-garde artists of Prague...used their international contacts to increase their regional independence from the political center. Stimuli from Paris were used in Prague as weapons against Vienna and the Austrian Secession."[7]

The declaration of Czech independence from Austro-Hungarian rule on October 28, 1918, confirmed rather than initiated independence in the arts. A number of Czech artists had taken up positions alongside pre-war international movements—František Kupka was closely associated with the Puteaux Cubists, Bohumil Kubišta was invited to be a member of Die Brücke—although their orientation remained specifically Central European. After 1918, however, unallied development was championed more forcefully. The early 1920s, in particular, saw a cross-fertilization in the arts as popular culture was assimilated by the avant-garde and the proponents of Modernism sought greater social relevance.

František Kupka's itinerant career is paradigmatic of one extreme of the Czech integration into European cross-currents: he left Prague for Vienna in 1892 and from there traveled to Paris in 1896, never to take up residence in Czechoslovakia again. However, as Meda Mladek has demonstrated, Central European—and in particular Bohemian—influences defined his development.[8] An early interest in folklore and naive decoration was encouraged by Kupka's first teacher, Alois Studnička. Although Kupka studied only briefly with Studnička, attending his classes at the Jaroměř Academy of Arts and Crafts in early 1888, his working method had a deep appeal for Kupka, who identified Studnička as a significant source for his later abstractions. Studnička emphasized ornamentation over life drawing, and his graphic exercises published in *Czech Draftsman (Český kreslíř*, 1885–88) provided a prototype for Kupka's continuing interest in pictorial themes and variations.[9] The Slavonic revival exemplified by the Bohemian painters Josef Mánes and Mikoláš Aleš also affected the young Kupka, and he assimilated their decorative and narrative style while at the Prague Academy of Fine Arts in 1888–92.[10] Kupka's inclination toward mysticism and spiritualism was rooted in this period as well; from 1889 to 1891 he even worked occasionally as a professional medium.

Like many Bohemian artists and writers of his generation, Kupka completed his education in Vienna, the political center of the Austro-Hungarian Empire. His years in Vienna (1892–96) were spent in a combination of academic practice and autodidactic experimentation. Even as he delved into philosophy and spiritualism, Kupka also sought portrait commissions, academic scholarships, and economic independence. Mladek has observed, "the importance of Kupka's stay in Vienna rests not so much on the advancement of his painting technique as on his exposure to the ideas which were current in Vienna at that particular time."[11] During this period of artistic fermentation, Kupka witnessed rather than participated in the nascent Secessionist movement, although

he undoubtedly was influenced by the defense of ornament over function proposed by Alois Riegl and Karl Diefenbach.[12]

Looking back from Paris in 1897 on his stay in Vienna, Kupka stated, "Vienna was like a sickness of a man who is not physically fit....I became an emotionally sick man. Viennese air is not good for a painter....It was decadent. Here I am once again enjoying the light and warmth of life. I am healed of these diseases."[13] Nevertheless, as a Bohemian, Kupka exhibited by necessity in the Austrian section of the Paris World's Fair in 1900, and much of his graphic work of the next decade parallels the dramatic themes and the Archaic and Attic revival motifs of such Viennese contemporaries as Gustav Klimt.

The Voices of Silence (*Hlasy ticha*, 1900–1903, National Gallery, Prague), a series of brilliantly colored aquatints, marks a turning point in Kupka's career. The neo-Egyptian motifs, the somewhat cloying theatricality of the compositions, and the ambitious thematic program firmly locate these prints within the twilight of the Symbolist movement. Based loosely upon the riddle of the Theban Sphinx—"What walks on four legs in the morning, on two at midday, and on three in the evening?"—the prints reflect the ages of man and the times of day and night. However, Kupka extended the classical query to explore more spiritual than existential states. The pivotal image of the series, *The Beginning of Life* (*Počátek života*, 1900, cat. no. PS36), is a transcendental depiction of birth: an embryo takes shape from a spirit form that rises from a water lily.[14] The overlapping halos of the composition suggest separate spheres, a motif that Kupka returned to in *The First Step* (*První krok*, c. 1909–13, cat. no. PS37). This unique painting, for which no sketches or related works exist, may be interpreted as a decorative rendition of lunar cycles, each phase dependent upon its previous incarnation and at the same time generating its successor. The theme of birth or "the beginning of life" is thus depicted on a universal or cosmic scale. While the unity of the microcosm and the macrocosm is most clearly suggested by *The Beginning of Life, The First Step* is Kupka's first fully realized abstract and cosmological rendition of this theme.

The theme of cosmic birth is explored in depth in the two versions of *Cosmic Spring* (*Kosmické jaro I*, 1911–20[?], cat. no. PS44, and *Kosmické jaro II*, 1911–20/1934[?], National Gallery, Prague) and in the later print series *Four Stories in White and Black* (*Čtyři příběhy bílé a černé*, 1926, cat. no. PS46). As Jaroslav Anděl notes elsewhere in this catalogue, Kupka's development of cosmological and teleological themes was paralleled by his own organic vision of the process of artistic creation. Although similar themes were explored by the Orphists after 1912, Kupka insisted that his own artistic evolution occurred independently of the mainstream of the Paris avant-garde. Working in Paris among the Cubists—Jacques Villon, Albert Gleizes, and Apollinaire were among his circle of acquaintances—Kupka remained aloof from formal associations. His vivid and acidic palette distinguished his paintings from the early work of the Cubists and his pur-

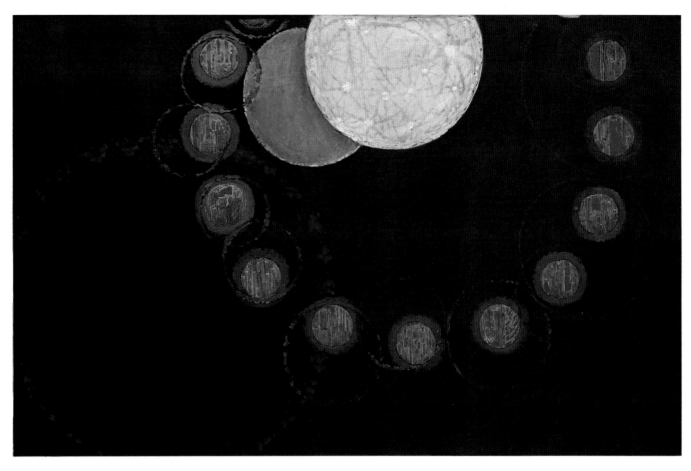

František Kupka, *The First Step (První krok)*, 1910–13(?), dated
on painting 1909, oil on canvas, 32¾ x 51 inches, The Museum of
Modern Art, New York, Hillman Periodicals Fund, 1956, cat.
no. PS37.

František Kupka, *Study for Around the Point,* 1910–12, gouache
on paper, 7⅞ x 8¼ inches, collection Mladek, Washington, D.C.,
cat. no. PS38.

František Kupka, *Study for Around the Point,* 1911–12, gouache,
watercolor, and pencil on paper, 7½ x 8½ inches, collection Mladek,
Washington, D.C., cat. no. PS43.

František Kupka, *Study for Around the Point,* 1919, gouache,
watercolor, and pencil on paper, 7⅞ x 8⅞ inches, collection
Mladek, Washington, D.C., cat. no. PS45.

František Kupka, pages from *Four Stories in White and Black (Čtyři příběhy bílé a černé)*, 1926, woodcuts, 13 x 10 inches, The Museum of Modern Art, New York, gift of Mr. and Mrs. Alfred H. Barr, Jr., cat. no. PS46.

suit of universal themes is without specific parallel among Paris painters.[15] Writing Arthur Roessler in 1913, he stated, "In the last Salon d'Automne I had a beautiful place of honor, unfortunately in the room with the Cubists with whom I am almost on a parallel. It is with me as it was with Degas, who was classified as an Impressionist."[16]

Kupka's independent path is comparable to that taken by Vojtěch Preissig. Like Kupka, Preissig spent the major part of his career outside of Czechoslovakia. After initial training in Prague at the School of Decorative Arts (1892–97), Preissig traveled to Paris, visiting Vienna and Munich en route. He worked briefly with another Czech expatriate, Alfons Mucha, and with the printmaker Emil Delaun; he also made contact with Kupka. An innovator in graphics and book design, Preissig was devoted both to the traditional means of printmaking and to radical departures from this tradition. By the mid 1890s, he had developed a basic language of ornament derived from nature, taking the sinuous forms of Art Nouveau as his point of departure. Preissig's study of nature, however, was predicated on more than formal examples. Among his early experiments is a series of tobacco leaf prints from about 1900 (see cat. nos. PS51, PS52), each sheet being printed directly from actual tobacco leaves. Preissig

was also an amateur photographer, and several studio still lifes survive from this period (see cat. nos. PH94, PH95).

Preissig returned to Prague in 1903, but Tomáš Vlček notes: "For him Paris was not only a short-lived excitement. Under the influence of the French Art Nouveau, Preissig's expression changed into an autonomous creative idiom capable of expressing and molding his emotional life."[17] Of particular importance to Preissig were the examples of James Abbott McNeill Whistler and Maurice Denis, whose synthetic interpretations of landscape suited his own aspirations to harmonize through nature the two spheres of reason and imagination, which he formulated into the two principles of "sentiment and logic."[18]

Over the next seven years Preissig completed a number of printing projects in Prague, publishing both his own work and that of his contemporaries through his *Czech Prints (Česká grafika)* editions. A 1905 portfolio of his prints *Color Etchings and Color Engravings (Barevný lept a barevná rytina*, National Gallery, Prague) was also published in an English edition in 1906 for the American market. The prints in this anthology of his work to date—including views of Prague, landscapes, figure studies, and Czech fairy-tale themes—are characterized by a romantic Pictorialism with

Vojtěch Preissig, *Ornamental Drawing (Ornamentální kresba)*, c. 1903, ink on paper, 13¾ x 9⅞ inches, Památník národního písemnictví, Prague, cat. no. PS54.

Vojtěch Preissig, *Invention: Art Fundamental (Invence—Art Fundamental)*, c. 1915–25, graphite, watercolor, and yellow crayon on paper, 7¹³⁄₁₆ x 10¹⁵⁄₁₆ inches, Národní galerie v Praze, cat. no. PS57.

clear debts to Japanese woodcuts, to the Nabis, and to the decorative cartouches of Mucha.

Seeking the commercial success that his fellow Czech artist Mucha had found, Preissig moved in 1910 to the United States, where his brother was living. He secured teaching positions at the Art Students League and Teachers College in New York (1912–15) before moving to Boston where he took a position on the faculty of the Wentworth Institute (1916–26). Working in virtual isolation, Preissig nevertheless entered a period of fertile experimentation and resolution that parallels Kupka's investigation of mystical cosmology. It was during these years that he began the conceptual project *Art Fundamental*, developing a systematic methodology for identifying all aspects of creation in the visual arts with states of mind. *Invention: Art Fundamental (Invence—Art Fundamental*, c. 1915–25, cat. no. PS57) is annotated in English along the left margin: "Art Fundamentals: Individuality, Sensibility, Enthusiasm, Energy, Concentration, Inspiration, Imagination, Invention, Balance, Proportion, Rhytm [*sic*]." In unpublished notes Preissig elaborated on these themes, dividing them into color studies tied to patterns found in nature and repetition, placing emphasis on harmony as the unifying principle.[19] The cosmological imagery of *Invention: Art Fundamental*

echoes Preissig's early training in Art Nouveau decoration, complementing such works as his circa 1903 sketch of entwined flowers (cat. no. PS54). It was also during this period that Preissig began a series of non-objective collages made of cut paper and found materials (see cat. nos. PS58, PS59).

Although Preissig claimed, "I am a greater interpreter of America of the 20th century than can be understood by my commercially oriented contemporaries,"[20] his efforts in the United States went unnoticed, despite parallels in the design work of Louis Comfort Tiffany and Louis Sullivan. Preissig returned to Prague in 1930 and decided to devote the remainder of his career to abstract painting. While the two versions of *Birth of the World (Zrození země*, c. 1936, cat. nos. PS65, PS66) clearly owe a debt to Kupka's cosmological abstractions, the mirror images and complementary colors employed by Preissig evolved from his experience as a printmaker. Indeed, his most innovative work from these years is a series of informal prints in which the matrixes are sandpaper collages made of found materials (see cat. nos. PS61, PS63). Paralleling the experiments of the Surrealists, he incorporated random methods to tap into the primal forms of nature.

Kupka's and Preissig's transformation of Jugendstil and

Jan Zrzavý, *Self-portrait with Straw Hat (Autoportrét se slaměným kloboukem),* 1907, oil on canvas, 8⁹⁄₁₆ x 12¹¹⁄₁₆ inches, Moravská galerie v Brně, cat. no. PS122.

Josef Váchal, *Satanic Invocation (Vzývači ďábla)*, c. 1909, oil on
canvas, carved wood frame, 37⅜ x 37 inches, Krajská galerie
v Hradci Králové, cat. no. PS111.

Art Nouveau principles into cosmological abstraction is unique to Czech Modernism. While contemporary examples among Munich artists, and in particular in the evolution of Wassily Kandinsky, offer telling parallels, the Czech artists concentrated on uniting the microcosm with the macrocosm through biomorphic abstraction. They found in nature a pattern of creation and regeneration that they could apply to their work, giving it universal meaning while freeing it from the conventions of landscape painting.

If Kupka and Preissig represent the more progressive and optimistic evolution of Czech Modernism at the turn of the century, Josef Váchal embodies a much more introspective approach, one founded upon occultism, primitivism, and contradiction. Educated in private schools as a bookbinder and graphic artist, Váchal remained independent of the Europhile avant-garde currents that dominated Prague in the first decade of the century. Unlike many of his contemporaries, he did not travel to Paris or Vienna; instead he focused on the occult, joining the Prague Theosophical Society and attending seances in Šaloun's sculpture studio in 1903. Váchal's copy of an 1898 edition of Madame Blavatsky's theosophical writings is heavily annotated by the artist, establishing a language of signs and symbols that he returned to throughout his career.[21]

Váchal, however, did not develop within an artistic vacuum. The sculptor František Bílek and the painter František Kobliha, members of the Prague Symbolist movement, provide a context for Váchal's early works. Of particular importance to Váchal was Bílek's revival in about 1905 of woodblock printmaking. The Romantic subjects of Arnold Böcklin and Odilon Redon had a certain influence on these artists, although an emphasis on the Gothic printmaking tradition distinguishes the work of the Czech Symbolists. In 1910 they formed an association called Sursum, from the Latin for "upwards" or "lift up."[22] The Sursum artists, who included Kobliha and Váchal, among others, exhibited together in Brno in 1910 and in Prague in 1912, and the association can be seen as the last formal manifestation of Czech Symbolism.[23]

Váchal began to work in woodblock prints about 1906, but his etched illustration for Josef Šimánek's meditative poem *Gothic Song (Píseň gotiky*, 1907, cat. no. PS108) best typifies the artist's response to the Gothic revival of the Czech Symbolists. Depicting the Crucifixion, the overall composition weaves together text and illustration in a flattened pattern that has no equivalent in actual medieval manuscripts. The etching technique allowed for a more graceful play of line and more detailed marginalia than is found in the more boldly rendered examples of Bílek. Although the themes of sacrifice, passion, and transubstantiation emphasized in *Gothic Song* are consistent with the program of the Czech late Symbolists, Váchal treats these themes with a somewhat satiric distance, emphasizing extreme emotional states over spiritual content.

A second significant influence on Váchal were the primi-tivist carvings of Paul Gauguin. Gauguin's work was included in the exhibition of French Impressionists mounted at the Spolek výtvarných umělců Mánes (S.V.U. Mánes; Mánes Union of Fine Arts) in 1907, and Váchal began experimenting in a similar vein at this time, creating a series of primitivist totems (see cat. no. PS113). Váchal emphasized the subversive and satiric aspects of primitive art, qualities that became evident as he distanced himself from the Symbolist movement.

Satanic Invocation (Vzývači dábla, c. 1909, cat. no. PS111) is a key transitional work. The attenuated figures, the device of the carved frame, and the anthropomorphism of the trees bearing skulls for fruit can be attributed to the influence of Bílek, who executed two similar works in 1899.[24] The brilliant off-key palette, however, and the private and esoteric language of symbols that decorate the frame attest to Váchal's separate development. Where Bílek's imagery is cast in terms dependent upon Christian iconography, with an emphasis on redemption, Váchal depicted more macabre primitive rituals, celebrating the amoral and pagan spirit.

As Anděl demonstrates elsewhere in this catalogue, Váchal continued to pursue an increasingly eccentric and inventive program after 1910. He devoted himself almost exclusively to book design, producing an exceptional body of limited and unique editions. Of particular interest are his "dictionaries": an urge to inventory psychic, symbolic, social, and at times satiric events preoccupied Váchal, and these series of prints range from the esoteric to the slapstick.[25] An anti-Enlightenment encyclopedist, Váchal denied the principles of codification. Rather than reducing phenomena to a system, his dictionaries attest to the impossibility of such an endeavor, a strategy that reflects a crucial aspect of the Czech Modernist quest.

The first twentieth-century association of Modernist artists in Prague was Osma (The Eight), formed in 1907. The leading innovators of the group were Bohumil Kubišta and Emil Filla. As Miroslav Lamač notes elsewhere in this catalogue, the aesthetic program of Osma was formed in response to the Munch retrospective mounted in Prague in 1905. Following the example of Munch, the Osma artists discarded the conventions of late Impressionism and Symbolism in favor of psychologically charged subjects. In formal terms this shift can be characterized by an emphasis on non-descriptive and anti-naturalistic color and a freeing up of pictorial structures.

Two self-portraits from this era are particularly revealing of the positions taken by Osma artists: Filla's 1908 *Self-portrait with Cigarette (Autoportrét s cigaretou*, cat. no. PS12) and Kubišta's *Self-portrait with Overcoat (Vlastní podobizna v haveloku*, cat. no. PS27) of about the same year. Both artists portrayed themselves in shallow and non-specific space, and both figures engage the viewer with a fixed and penetrating gaze. Delineation of form is suppressed while painterly brushwork animates the surface. Color is freed from naturalistic description and instead is used to

Emil Filla, *The Night of Love (Milostná noc)*, c. 1907–1908, oil on
canvas, 28¾ x 43⅜ inches, Národní galerie v Praze, cat. no. PS13.

Emil Filla, *Self-portrait with Cigarette (Autoportrét s cigaretou)*,
1908, oil on board, 26 x 19⅜ inches, Národní galerie v Praze, cat.
no. PS12.

heighten the emotional tenor of the subject. Filla showed himself as very much an urban figure; wearing a hat and smoking, he seems to belong more in a café than in a studio environment. Kubišta, however, approached the convention of the self-portrait with greater freedom. Hatless and romantically cloaked by a greatcoat, the figure is the focal point of a maelstrom of color. The background, rendered in a radiating pattern, creates a psychic aura around the transcendental genius of the artist.

Filla and Kubišta were well traveled, making extensive tours of Europe and repeated visits to Paris. Both artists immediately responded to the experiments of the Cubist avant-garde as it took shape in Paris between 1910 and 1912, and it was in Filla's and Kubišta's work that the particularly Czech movement of Cubo-expressionism was first manifested. Filla, as one of the founding members of the Skupina výtvarných umělců (Group of Fine Artists), and Kubišta working more independently promoted a number of Cubist exhibitions in Prague that introduced Pablo Picasso, Georges Braque, and their contemporaries to a Czech audience.[26] Nevertheless, as indicated by the contrast between their 1908 self-portraits, Kubišta and Filla took different routes toward Cubism despite their common point of departure in the work of Munch.

Between 1910 and 1911, Filla was deeply influenced by El Greco, an interest shared by German and Austrian artists of his generation—including Max Beckmann and Oskar Kokoschka—who found expressionistic precedent in El Greco's compositions. Filla, however, justified his admiration by citing the more formal qualities in El Greco's work. As he later explained, "The present time, characterized by a longing for greater abstraction and discipline both in view and formal demands,...led to El Greco, to his inclination towards firmly coherent composition."[27] *The Dance of Salome (Tanec Salome*, c. 1912, cat. no. PS14; a second version, now in the National Gallery, Prague, was executed the following year), while owing a clear debt to Picasso's 1907 *Les Demoiselles d'Avignon* (New York, The Museum of Modern Art), is dependent upon the Mannerist structure and theatrical framing devices of El Greco. The painting is also one of Filla's last attempts to reconcile Expressionist content with Cubist structure; ultimately rejecting Expressionist tendencies in his work, Filla after 1912 took a doctrinaire approach in assimilating the advances of Braque and Picasso. Although his subsequent career can be seen as a step-by-step appropriation of Picasso's example, he maintained an affinity for the concrete and physical sphere, which infuses his work with a continued vitality and freshness.

Kubišta was the most original theoretician of Czech Cubism. Adapting the formal scaffolding of Cubism to express a synthesis of mystical symbolism and psychological urgency, he produced between 1910 and 1915 a remarkable body of Cubo-expressionist works. While immediately responsive to the innovations of his contemporaries—as well as to the example of such classicizing masters as Nicolas

Poussin and Paul Cézanne—Kubišta stressed that it was spiritual content, rather than any formal device, that was of the first importance: "Although recently there have been frequent upheavals in the fine arts and during the last five or ten years new schools and directions have come into being...I can only say that today the development of the methodical aspect is not the essential thing we demand of the new art, and that only a renewal of the internal spiritual essence can bring us final satisfaction."[28]

Kubišta's exploration of the subconscious and his development of the principle of "penetratism," analyzed elsewhere in this catalogue by Anděl, finds its fullest expression in his last important canvas *The Hanged Man (Oběšený*, 1915, cat. no. PS35). Created during Kubišta's bleak years of military service in Yugoslavia, the painting explores the extreme existential state of a dying man. The figure's head hangs down in a realistic evocation of a broken neck, his spiritual leap into the unknown rendered as a flash of thought. Combining the trompe l'oeil methods of Synthetic Cubism with a proto-Constructivist transparency, the painting points to a new realm of formal invention charged with expressive power. Tragically, Kubišta's early death in the flu epidemic of 1918 prevented further development of what potentially was the most radical solution offered in Czech Cubism.

Otto Gutfreund, slightly younger than Filla and Kubišta, came to Prague to study in 1906. He did not see the Munch exhibition that had such an impact on the Osma artists, and it is unlikely that he saw the landmark Rodin retrospective of 1902.[29] The 1909 S.V.U. Mánes retrospective exhibition of the sculptor Emile-Antoine Bourdelle, however, marked a turning point in his career. Gutfreund was introduced to the French master and followed him to Paris, attending classes at La Grande-Chaumière from 1909 to 1910. Gutfreund's diary from this period records tenets similar to those laid down by Bourdelle: "To be a sculptor it is not enough to be able to model; a sculptor must be a mathematician who fashions his material according to a preconceived plan, thus also an architect."[30]

Gutfreund returned to Prague in 1911 and became one of the founding members of the Skupina. Although his work in Paris was not exceptional, his sculptures after his return to Czechoslovakia acquired a new sophistication. Adopting the planar rhythms of the Paris Cubists, Gutfreund also looked to the dynamics of Baroque sculpture for inspiration. While his first mature work, *Anxiety (Úzkost*, 1911, cat. no. PS20), may be related to Rodin's studies for *Balzac* (1898, Meudon, Musée Rodin), it is more significantly the first three-dimensional realization of the formal problems and existential states explored by the Czech Cubo-expressionists. His work of the following year made a radical leap in Cubist aesthetics. *Embracing Figures (Objímající se postavy*, 1912–13, cat. no. PS24) is the culmination of an extended series of drawings dating back to about 1910 (see cat. nos. PS21, PS22, PS23). The spiraling composition and dynamic planar facture evoke the passion of the couple caught in an explicitly

Bohumil Kubišta, *Self-portrait with Overcoat (Vlastní podobizna v haveloku)*, c. 1908, oil on canvas, 36¼ x 26 x 1⅝ inches, Oblastní galerie výtvarného umění Gottwaldov, cat. no. PS27.

Bohumil Kubišta, *The Hanged Man (Oběšený)*, 1915, oil on canvas,
19¾ x 11¹⁵⁄₁₆ inches, Moravská galerie v Brně, cat. no. PS35.

Jan Zrzavý, *The Good Samaritan (Milosrdný Samaritán)*, c. 1914–
15, oil on canvas, 18⅞ x 13⅜ inches, Národní galerie v Praze, cat.
no. PS130.

Josef Čapek, *Woman over the City (Žena nad městem)*, c. 1917–20, oil on canvas, 31¹¹⁄₁₆ x 17½ inches, Oblastní galerie Liberec, cat. no. PS9.

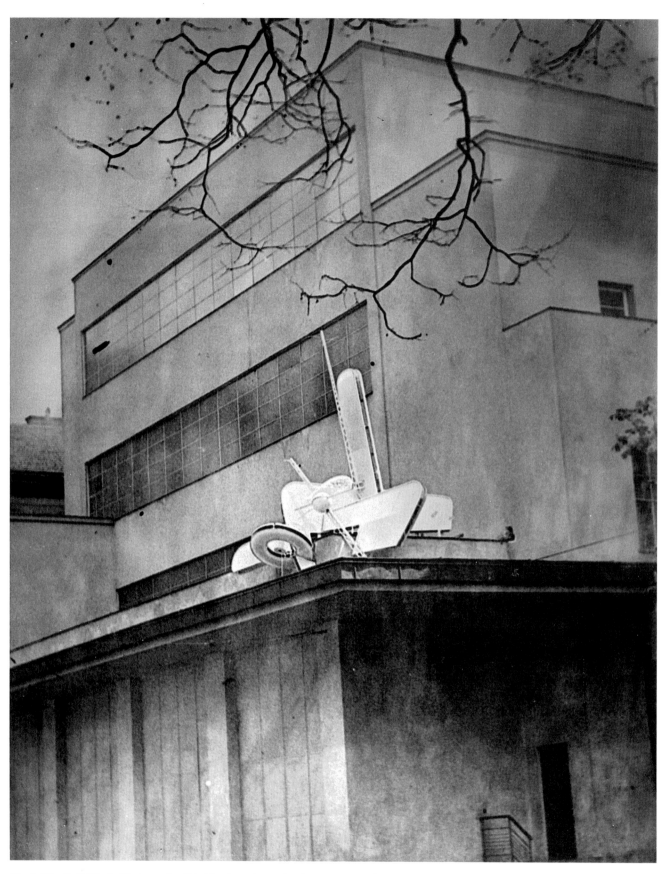

Fig. 1. Zdeněk Pešánek, Photograph of his kinetic sculpture for the
Edison Transformer Station, Prague, c. 1930, The Museum of Fine
Arts, Houston.

sexual embrace. On one level Czech Baroque prototypes continued to be an influence on Gutfreund, and in a 1912–13 article he stated, "The apparent similarity between Baroque and present-day sculpture issues from the wealth of movement and the liveliness of form. In the Baroque period this movement was given by the forces not being balanced, by struggle; today we are endeavoring to develop action freely without any signs of struggle."[31] Indeed, balance is an essential factor in *Embracing Figures* as one planar form is echoed by another and lines of force are carried through the composition. On another level Gutfreund's work parallels Futurist experiments. As František Šmejkal has noted, essentially Futurist concepts of time and space characterize Gutfreund's production during these years, an interpretation confirmed by Gutfreund's statement: "The statue is no longer time stopped, transformed space, but rather an expression of a flowing series of events, in incessant movement, with the same rhythm of the creative process before thought becomes fixed in images."[32]

Gutfreund, who was in Paris at the outbreak of World War I, volunteered for the Foreign Legion. After active duty in the trenches and three years in an internment camp for insubordination, he returned briefly to Paris in 1918. His work of this year demonstrates a response to Synthetic Cubism in its greater emphasis on flattened surface and planar reliefs. However, like Fernand Léger who rejected abstraction in the wake of his war experiences, Gutfreund turned to a new objectivity by 1920. To what extent this transition can be attributed to Gutfreund's return to Prague in 1920 and the new era of Czech independence is debatable. Nonetheless, his avowed aim to forge "a new sculpture for a new country"[33] found expression in both abstract and naturalistic production, a dichotomy that was left unresolved at the time of Gutfreund's untimely death in 1927.

Jan Zrzavý and Josef Čapek, while directly engaged in the Cubist movement in Prague, worked outside of the mainstream of Cubo-expressionist developments. Zrzavý, a close friend and admirer of Kubišta's, had an affinity for the subjects of the Cubo-expressionists. Čapek responded more directly to formal innovations and was drawn to the archetypal figures and simplified compositions of Synthetic Cubism.

Zrzavý's approach to Cubism was strongly colored by his sympathy with the Symbolist movement. A student at the School of Decorative Arts in Prague from 1907 to 1909, he grew dissatisfied with the program and left before completing his degree. Influenced by Váchal and later a member of Sursum, he created from 1907 to 1910 exotic and visionary landscapes peopled by woodsprites, melancholy ladies, and sorcerors. Among his most fascinating paintings of this period is a series of self-portraits (see cat. nos. PS122, PS123). Set in landscapes reminiscent of Paul Gauguin's South Seas or against a flat gold ground, these paintings depict Zrzavý as a primitive mandarin with Oriental features and a broad straw hat. Zrzavý identified the theme of the passionate pilgrim seeking the answer to the "awful questions of life: What and Why" as central to his work at this

time,[34] echoing the themes found in Kupka's print series *The Voices of Silence*. However, where Kupka located his quest in a neo-Egyptian and theosophical realm, Zrzavý identified with a poetic naïveté that has its sources in Gauguin.[35]

Zrzavý met Kubišta in 1911, and with Kubišta's encouragement, he undertook an investigation of Cubist compositional methods. His primary motivation, however, was an imaginative reworking of Renaissance prototypes, in particular the example of Leonardo da Vinci. The composition of Zrzavý's sketch for *Sermon on the Mountain (Kázání na hoře*, c. 1911–13, cat. no. PS127) is broken down into repeated geometric units, like Kubišta's *Saint Sebastian (Svatý Šebestián*, cat. no. PS29) of circa 1912. However, where Kubišta's overlapping circles emphasize shifting spatial planes, heightening the dramatic impact of the arrows that pierce the saint's body, the pyramidal triangles of Zrzavý's sketch convey a sense of mute stasis.

The Good Samaritan (Milosrdný Samaritán, c. 1914–15, cat. no. PS130) is an exquisite example of Zrzavý's jewellike paintings. The theme, which had been addressed in 1910 by Filla (*The Good Samaritan*, National Gallery, Prague), is one of salvation and redemption. Where Filla found drama in the image of the Samaritan rescuing the stranded traveler, Zrzavý depicted the event with a poignant calm. The anonymous traveler becomes a figure for Everyman, and it is tempting to see in this image of refuge an ideal state that would have particular appeal during a time of war.

Josef Čapek, like Zrzavý, was drawn to archetypal and Everyman imagery. The brother of the author Karel Čapek, he was also a prolific writer, theoretician, and polemicist. After initial studies at the School of Decorative Arts in Prague, he completed his education at the Academie Colarossi in Paris (1910–11). He returned to Prague in 1911 and joined the Skupina, although the doctrinaire approach demanded by Filla led to his resignation in 1912. One of the first writers on Futurism and primitivism in Prague, Čapek remained open to a variety of influences that fell outside of a strictly Cubist program.[36]

Figure (Postava), an etching from 1914 (cat. no. PS1), is as close as Čapek comes to orthodox Analytic Cubism. Based on a brilliantly colored painting of the previous year (*Figure*, National Gallery, Prague), the print is a reductivist version of the original image, which conflated a female nude with a violin. More typical of Čapek's production, however, is a series of figure studies that takes pure geometric forms as a point of departure. Many of his compositions between 1914 and 1918, rather than being conceived on a cubistic grid, are characterized by primitivistic figures made up of triangles, circles, cubes, and spheres. These more formal studies are complemented by a series that deals with a cast of urban characters, from sailors to top-hatted gentlemen to beggars and outcasts. This cataloguing of societal types finds its equivalent to some degree in the poetic urbanism of Juan Gris and Léger,[37] but a closer parallel can be found in the work of such German Expressionists as Karl Schmidt-Rotluff, Ludwig Meidner, and Conrad Felixmüller. Indeed,

the German journals *Die Aktion* and *Der Sturm* provided the first international forum for Čapek's work.[38]

After World War I the Czech avant-garde entered a period of self examination as world politics reshaped the Czech nation. While Gutfreund's radical reassessment offers the most dramatic example of transition, a new Civilist spirit infused the arts in general. The associations Tvrdošíjní (Stubborn Ones), formed in 1918, and Devětsil, formed in 1920, summarize this era of change. The Tvrdošíjní, whose members included Čapek and Zrzavý, was dedicated to the preservation of the ideals of the pre-war avant-garde; Čapek's highly graphic *Woman Over the City (Žena nad městem,* c. 1917–20, cat. no. PS9) is typical of Tvrdošíjní production. The retrospective nature of this association was manifested by such projects as Čapek's 1919 illustrations for Apollinaire's "Zone" (cat. no. PS10) and the memorial exhibition of Kubišta's work organized by Zrzavý in 1920.

The Devětsil artists, however, aggressively looked to the future. Embracing the ideals of proletarian art, Devětsil under the direction of Karel Teige adhered to a utopian vision of a harmonious post-revolutionary society. Where the Tvrdošíjní program emphasized individualism, the Devětsil artists sought a collective approach. Their work, influenced to a degree by Kubišta and Čapek, initially was dedicated to a form of Magic Realism, but by 1922 their program had expanded to encompass both Functionalism and the nascent Surrealist movement.[39]

While the Tvrdošíjní had their last group exhibition in 1923 in Czechoslovakia, the Devětsil *Bazaar of Modern Art (Bazar moderního umění)* of the same year opened up a realm of fresh possibilities to the Czech avant-garde. Interdisciplinarian in its presentation, the exhibition included paintings, architectural projects, stage designs, photographs, Dada objects, and non-art material; it introduced a new epoch, featuring the work of Teige, Josef Šíma, Jindřich Štyrský, and Toyen.

As is discussed in detail by Šmejkal and Antonín Dufek elsewhere in the catalogue, the late 1920s and 1930s was a period of more individual experimentation as the two currents of Functionalism and Surrealism came to maturity. The closing chapter of this era is necessarily a somber one as world events in the late 1930s brought an end to the first stage of Czech independence. The Munich agreement, signed on September 30, 1938, and the subsequent invasion of Czechoslovakia by Germany had irreversible consequences. While certain artists were able to maintain a measured degree of activity, World War II brought about a caesura in the Czech avant-garde. The arts in Czechoslovakia after 1945, while no less vital, evinced a change in character as new existential issues came to the fore.

Although it is impossible to assign a single fixed character to the first decades of Czech Modernism, an acute awareness of the imperatives of history and the challenge of innovation shaped these generations of artists. As Jiří Kotalík has recently noted of the dual currents of the avant-garde and tradition in Czech art of the twenties and thirties: "The consciousness of tradition was not a static phenomenon but a dynamic process.... This consciousness of tradition lay not only in the understanding of the sure foundations of the past, but more importantly characterized the search for a specific identity and authenticity."[40] Kotalík further clarifies, "In this sense [Czech] art became not just a resumé of the past or a mirror of history, but also a forecast of the future."[41] The avant-garde artists of Prague found in their culture and heritage a foil for renewal and experimentation. Writing in 1953, Breton aptly identified the Prague of these years as a city "leading out of yesterday into always."[42]

Alison de Lima Greene is associate curator of twentieth-century art at the Museum of Fine Arts, Houston.

1. Bruce Chatwin, *Utz* (New York: Viking, 1989), p. 14. The sets of the German visionary architect Hans Poelzig for Paul Wegener's 1920 film *The Golem: How He Came Into the World (Der Golem: Wie er in die Welt kam)* typify the popular image of Prague as a medieval city of winding streets and magical byways. See Emily D. Bilski, "The Art of the Golem," *GOLEM! Danger, Deliverance and Art*, exh. cat. (New York: The Jewish Museum, 1988), pp. 50–56.

2. André Breton, *What Is Surrealism? (Co je surréalismus?*, Brno, 1937), p. 68. See František Šmejkal, "From Lyrical Metaphors to Symbols of Fate: Czech Surrealism of the 1930s" in this book.

3. Guillaume Apollinaire, "Zone," *Alcools*, trans. Anna Hyde Greet (Berkeley and Los Angeles: University of California Press, 1965), pp. 8–9.

4. Jan Zrzavý, "An Artist's Confession (Vyznání umělcovo)," *Musaion* (1920), pp. 67–68.

5. Karel Teige, "Painting and Poetry (Malířství a poesie)," *Disk*, vol. 1 (1923), p. 20.

6. Vladimír Šlapeta, "Czech Functionalism," in *Czech Functionalism: 1918–1938*, exh. cat. (London: Architectural Association, 1987), p. 8.

7. Wolfgang Pehnt, *Expressionist Architecture* (London: Thames and Hudson, 1973), p. 62.

8. Meda Mladek, "Central European Influences," in *František Kupka 1871–1957: A Retrospective*, exh. cat. (New York: The Solomon R. Guggenheim Museum, 1975), pp. 13–37.

9. Mladek, illustrations, pp. 16, 18.

10. Mladek, illustrations, p. 21.

11. Mladek, p. 23.

12. Mladek, pp. 23–27.

13. František Kupka, letter to Arthur Roessler, March 10, 1897, as quoted by Margit Rowell, "František Kupka: A Metaphysics of Abstraction," in *František Kupka 1871–1957: A Retrospective*.

14. Mladek, Eva Bužgová, and Robert P. Welsh have noted the direct influence of theosophy on this image. Mladek cites Madame Blavatsky's 1877 text: "Man is a little world—a microcosm inside the great universe. Like a foetus, he is suspended by all his three spirits, in the matrix of the macrocosmus; and while his terrestrial body is in sympathy with its parent earth, his astral soul lives in unison with the sidereal *anima mundi*" (p. 86). See also Bužgová's catalogue entry in Jiří Kotalík, *Czech Art 1878–1914: On the Way to Modernity (Tschechische Kunst 1878–1914: Auf dem Weg in die Moderne)*, exh. cat. (Darmstadt: Mathildenhöhe, 1984), p. 195, and Welsh, "Sacred Geometry: French Symbolism and Early Abstraction," in *The Spiritual in Art: Abstract Painting 1890–1985*, exh. cat. (Los Angeles and New York: Los Angeles County Museum of Art and Abbeville Press, 1986), pp. 80–81.

15. Kupka's complex relationship with Apollinaire and the Orphist painters has been analyzed in depth by Virginia Spate, "Mystical Orphism: Frank Kupka," in *Orphism: The Evolution of Non-Figurative Painting in Paris 1910–1914* (Oxford: Clarendon Press, 1979), pp. 83–159.

16. Rowell, p. 47.

17. Tomáš Vlček, *Vojtěch Preissig 1873–1944*, exh. cat. (Prague: Památník národního písemnictví, 1968) n. pag.

18. Vlček, *Vojtěch Preissig 1873–1944*, n. pag.

19. I am indebted to Tomáš Vlček for sharing his unpublished manuscript on Vojtěch Preissig for this information.

20. Vlček, *Vojtěch Preissig 1873–1944*, n. pag.

21. This edition has been preserved in the National Museum of Literature, Prague. According to the annotations on the frontispiece, Josef Váchal purchased the book in 1902.

22. Eucharistic liturgy contains the Latin versicle "Sursum corda" or "Lift up your hearts." The reference to ritual and faith is characteristic of the Sursum artists.

23. An overview of these artists is presented in Kotalík. See also Petr Wittlich, *Czech Secession (Česká secese,* Prague: Odeon, 1982).

24. See *Mother! (Matko!)* and *The Dying Sunbeam on the Tree of Life* (1899, National Gallery, Prague), illustrated in Kotalík, p. 25.

25. While frequently thought of as a recluse, Josef Váchal was not unaware of current art trends, as is demonstrated by his *Carnival of Czech Woodcuts (Karneval českého dřevorytu,* 1919, Moravská galerie, Brno) in which he lampoons the works of his contemporaries, including František Bílek, František Kobliha, Josef Čapek, as well as his own works.

26. For a detailed description of the Czech Cubist movement, see Miroslav Lamač, "Czech Cubism: Points of Departure and Resolution" in this book.

27. Emil Filla, *Reflections on Fine Arts (Úvahy o výtvarném umění,* Prague: 1948), as quoted in *Filla, Gutfreund, Kupka: Och tjeckisk kubism 1907–1927,* exh. cat. (Malmo Konsthall, 1982), p. 127. Filla's interest in El Greco was paralleled by the research of the German art historian Julius Meier-Graefe. In 1912 *Free Directions (Volné směry)*, the journal of S.V.U. Mánes, published Meier-Graefe's landmark survey of El Greco, "Grecův Barok" (vol. 16, pp. 34–74).

28. Bohumil Kubišta, "On the Spiritual Substrate of the Modern Age (O duchovém podkladu moderní doby)," *Czech Culture (Česká kultura)*, vol. 1, no. 2 (October 18, 1912), p. 52.

29. Peter Cannon-Brookes gives an excellent overview of Otto Gutfreund's place in the evolution of Czech sculpture in *Czech Sculpture: 1800–1938*, exh. cat. (Cardiff: The National Museum of Wales, 1983), pp. 82–88, 94–104.

30. As quoted by Cannon-Brookes, p.84.

31. Otto Gutfreund, "Plane and Space (Plocha a prostor)," *Artistic Monthly (Umělecký měsíčník)*, vol. 2 (1912–13), p. 9; as quoted by Cannon-Brookes, p. 86. This article can be seen as a manifesto of Cubo-expressionist sculpture.

32. Gutfreund, "Plane and Space"; as quoted by František Šmejkal in *Futurismo & Futurismi* (Venice: Palazzo Grassi, 1986), p. 487.

33. As quoted by Cannon-Brookes, p. 97.

34. As quoted by Jana Šálková in Kotalík, p. 387.

35. Zrzavý would have seen Gauguin's work in the exhibition of French Impressionists organized by the S.V.U. Mánes in 1907.

36. For further discussion of Josef Čapek's response to the Futurist movement, see Šmejkal, *Futurismo & Futurismi*, pp. 440–41.

37. For further discussion of Josef Čapek in the context of the School of Paris see Miroslav Lamač, *Paris/Prague 1906–1930*, exh. cat. (Paris: Musée National d'Art Moderne, 1966), n. pag.

38. *Die Aktion*, vol. 7, nos. 24–25 (1918) published Josef Čapek's expressionistic reverie *Lelio* along with a special issue devoted to Czech art.

39. The name *Devětsil* defies simple translation. Literally meaning "nine-power," it is also Czech for the flower Butterbur, a plant believed to have magical curative powers. The most complete history of the Devětsil movement has been written by František Šmejkal in *Devětsil: The Czech Artistic Avant-Garde of the 1920s (Devětsil. Česká výtvarná avantgarda dvacátých let,* Prague: Galerie hlavního města Prahy, 1986).

40. Jiří Kotalík, in *Czech Art of the Twenties and Thirties: Avant-garde and Tradition (Tschechische Kunst der 20er und 30er Jahre: Avantgarde und Tradition)*, exh. cat. (Darmstadt: Mathildenhöhe, 1988), p. 38.

41. Kotalík, p. 40.

42. André Breton, "Introduction to the Work of Toyen," *Toyen* (Paris: Editions Sokolova, 1953), p. 79.

Fig. 1. Emil Filla, *Reader of Dostoyevsky (Čtenář Dostojevského)*,
1907, oil on canvas, 38¾ x 31½ inches, Národní galerie v Praze.

Czech Cubism: Points of Departure and Resolution

MIROSLAV LAMAČ

If any one event can be identified with the birth of the Czech avant-garde, it would be the 1905 retrospective of Edvard Munch, organized by the Spolek výtvarných umělců Mánes (S.V.U. Mánes; Mánes Union of Fine Arts).[1] Held in Prague during February and March, the exhibition shaped the direction taken by the nascent generation of modern Czech painters, leading them to explore their perceptions of the world and life. Munch's works captured Czech artists by their painterly strength and by their revolutionary expression of heretofore unknown depths of the human psyche.[2]

The desire to achieve a more profound and far-reaching pictorial significance and a psychologically resonant art preoccupied the young Czech painters. Propelled by the example of Munch, a basic shift in orientation occurred between the years 1905 and 1907, as the expression of internal states gradually took priority over that of immediate perceptions, although the themes of the pictures remained impressionistic. In particular, Munch's exhibition fostered a number of works by Emil Filla, Václav Špála, Antonín Procházka, and others. Filla's 1907 *Reader of Dostoyevsky* (*Čtenář Dostojevského*, fig. 1) is an archetypal example. Leaning back in his chair with his eyes closed, the reader "is completely stunned on the rack of Dostoyevsky's perverse fantasy," as the painter later characterized his own reaction to the work of the great Russian writer.[3]

Expressively rendered in the artist's typical manner of flowing arabesques and sharply contrasting hues and colors, Filla's reader of Dostoyevsky is not merely a man sitting at a table; he also embodies a psychic event. In this case the literary source is not primary but serves to sharpen the basic meaning conveyed by the formal qualities of the painting. Naturally, not all avant-garde Czech art of this era is so sharply defined or conceptually elaborate. Works of a more lyrical nature and sunnier disposition include Procházka's still lifes and portraits, Willy Nowak's landscapes, and the figure studies of Otakar Kubín.

In 1907 and 1908 the work of these artists came to the attention of the Prague public at two exhibitions of the Osma group (The Eight), the first manifestations of the Czech avant-garde. The foremost members of the group were Bohumil Kubišta, Vincenc Beneš, Filla, Procházka, Kubín, and Nowak.[4] Their paintings offer a parallel to the early works of Oskar Kokoschka and Richard Gerstl in Vienna, as well as to members of the Dresden group Die Brücke, and one can speak of a common Central European point of departure, mainly determined by the emphasis placed on existential conflicts throughout the range of pictorial themes.

This early and somewhat homogeneous Czech avant-garde began to show considerable differentiation about 1910 as it responded to and adapted the new concept of pictorial space and compositional construction proposed by contemporary French artists. Kubišta, after Filla the most important spirit of the Osma group, had already assimilated the advances made by Georges Seurat, Paul Gauguin, Paul Cézanne, and André Derain, achieving an original synthesis of the Fauvists' chromatic experiments and the search for a new pictorial definition of form. In early 1910 Kubišta wrote from Paris to his friend Beneš in Prague: "Color is only a relative thing in art, and reaction against it will set in. Braque and Picasso are going to have a very strong influence."[5] This clairvoyant message was valid for Czech art as well. That same year Kubišta, Filla, and other members of the now-defunct Osma group painted their first Cubist-inspired works.

The Skupina výtvarných umělců (Group of Fine Artists), established in 1911, became the organizing center of the already Cubist-oriented Czech avant-garde. Among the founding members were the sculptor Otto Gutfreund, the painters Josef Čapek and Václav Špála, the architects Josef Gočár, Pavel Janák, Josef Chochol, and Vlastislav Hofman, the art historian and critic Václav V. Štech, and writers Karel Čapek and František Langer. Of the Osma group, only Filla, Beneš, and Procházka became members of the Skupina; however, outstanding contributions to Czech Cubism continued to be made by Kubišta.[6] The Skupina published its own journal, *Artistic Monthly (Umělecký měsíčník)*, and sponsored diverse cultural activities. One of the immediate effects of the Skupina's inclusive approach was Cubism's impact upon Czech architecture and the applied arts: Cubist houses, Cubist furniture, and Cubist articles of daily use comprise one of the most original chapters in the history of Modernism, and in its time Prague's contribution to Cubist design was the most influential in Europe.[7] For this reason Prague before World War I may be con-

sidered the most important Cubist center after Paris.

Exhibitions provided a primary forum for international crosscurrents in Modernism. Although the first exhibition of the Skupina in January–February 1912 featured only Czech artists, the second exhibition in autumn 1912 presented Picasso, Derain, and Emil-Othon Friesz, together with members of Die Brücke—Erich Heckel, Ernst Ludwig Kirchner, Karl Schmidt-Rottluff, and Otto Müller. Works by Picasso, Braque, Derain, and Juan Gris were also seen at the 1913 and 1914 Skupina exhibitions in Prague. During the same years the Skupina and other Czech Cubists participated in the *Sonderbund* exhibition in Cologne, in the *Erster deutscher Herbstsalon* in Berlin, and in the Berlin *Neue Secession* exhibitions. The Skupina organized independent exhibitions at the Goltz Salon Neue Kunst in Munich and at Herwarth Walden's gallery Der Sturm in Berlin; individual Czech artists also took part in contemporary surveys in cities that included Vienna, Budapest, Moscow, Paris, Berlin, Dresden, Munich, Düsseldorf, and Cologne. One exhibition of particular significance in Prague was the international survey of modern art held in 1914. Sponsored by the S.V.U. Mánes, and selected by the French critic Alexandre Mercereau, the exhibition included, among others, Alexander Archipenko, Robert Delaunay, the Section d'Or Cubists, Piet Mondrian, and Constantin Brancusi along with a selection of Skupina artists and architects.[8] This was the last major exhibition before World War I caused the breakup of the Skupina, although the group formally lasted until 1917.[9]

Prague's material contribution to the European avant-garde was the confrontation of the spiritual atmosphere of Central Europe with the pictorial structure of the Paris Cubists. Czech Cubism, despite superficial similarities to French developments, significantly differed from both the formal subjects and the expressive themes of its Paris equivalent. Still life, the classical Cubist theme in the work of Braque and Picasso, appeared only rarely in Prague before 1912. Symbolically charged figural compositions, on the other hand, remained of central importance. Examples of the reconciliation of psychological and spiritual themes with Cubist structure include Gutfreund's *Anxiety (Úzkost,* 1911), and *Embracing Figures (Objímající se postavy,* 1912–13); Filla's *The Dance of Salome (Tanec Salome,* c. 1912), and Kubišta's *Saint Sebastian (Svatý Šebestián,* 1912), *Murder (Vražda,* 1912), and *The Hanged Man (Oběšený,* 1915) (cat. nos. PS20, PS24, PS14, PS29, PS31, PS35).

The common denominator of these compositions is the depiction of critical existential states—moments when man is torn out of the common course of events and becomes intensely conscious of himself and his relation to exterior reality. This is not literature in the form of painting. Although the themes are metamorphosed into pictorial dramas, the stagelike aspects of the scenes, the psychology of the characters, and the importance placed on gesture merely accentuate the tension already inherent in the formal structure of the works. This structure, while associated with

Analytic Cubism and its precursors, has a much more dramatic and effective rhythm. Lacking the classicist character so often identified with the French tradition, these baroque and romantic works reflect their Prague origins. Thus the basis from which the Czech avant-garde developed, the symbolic exaltation of expression and theme, reached its culmination in 1912—surprisingly—within the framework of Cubist aesthetics. Therefore, the first chapter of the Czech Cubist school represents an original trend, which may be called Cubo-expressionism.

Characterized by collective effort, the first stage of development came to an end in 1917, but the Czech school of Cubism, or rather Cubo-expressionism, continued to grow, even after World War I, through the personal modifications of individual artists. The inner circle of the Cubist school in Bohemia included Kubišta, Filla, Procházka, and Gutfreund.

When Otto Gutfreund began exploring Cubism in 1911, there was only a single Cubist sculpture in existence—the 1909 *Head* by Picasso (New York, The Museum of Modern Art)—and it is in this context that Gutfreund's achievements must be measured. In his 1911 *Anxiety* (cat. no. PS20), the sharp crystalline forms express an internal tension, creating a dynamic new spatial and volumetric relationship. A year later, however, he turned to the constructive building of the figure from stereometric blocks defined by straight lines, creating a plastic analogue to the basic concept of Analytic Cubism. By 1912, he was already applying the *plans superposés* method: his *The Cellist (Hráč na cello,* 1912) and *Embracing Figures* (cat. no. PS24) are among the first examples of *sculpture-objets* in world sculpture. Although they parallel the wooden and cardboard relief constructions of Picasso, the work emerged from a separate creative development. In the history of Modernism, Gutfreund represents the most organic development of classical Cubism in sculpture.

Kubišta and Filla represent two opposite types in the development of Czech Cubism, although both were founding members of the Osma group. According to Kubišta, Cubism was merely a method that enabled him to penetrate the "spiritual sphere." He was obsessed with the investigation of the laws of pictorial space based on mathematics, an obsession that on occasion was manifested in outright mysticism and numerology (see *Saint Sebastian,* cat. no. PS29). Although the basis of his Cubism was intellectual, in the course of the creative process he arrived at the expression of an irrational and intuitive inner vision. Kubišta therefore belongs to those painters in the history of Cubism who used this movement most expressively to liberate the imagination.

Filla, on the other hand, understood Cubism as a new interpretation of the surrounding world, in distinct opposition to his Expressionist beginnings, which he later condemned as an excessive romanticism. He was a painter who delighted in the physical realm, possessing a fine sensibility stimulated by the world of things. Of the Czech artists he fol-

Emil Filla, *The Dance of Salome (Tanec Salome)*, c. 1912, oil on
canvas, 54 x 32⅝ inches, Krajská galerie v Hradci Králové, cat.
no. PS14.

Josef Čapek, *Figure (Postava)*, 1914, etching on rice paper, 13½ x 8⅞ inches, Národní galerie v Praze, cat. no. PS1.

lowed most closely the examples of Braque and Picasso, rejecting all modifications of what he regarded as pure Cubism. During World War I he lived in the Netherlands, where he was influenced by the works of the seventeenth-century still-life masters.[10] In those years he achieved a refined, intimate synthesis of classical realism with the aesthetics of the *tableau-objet*. While Kubišta linked the newly gained autonomy of the picture to the secret universe of human consciousness, Filla used it to explore a new spiritually sublimated interpretation of the external world.

For Václav Špála, Josef Čapek, and Jan Zrzavý, Cubism served as a stimulus to develop their work in independent directions.[11] Špála and Čapek took from Cubism its new visual structure. While Špála blended form with Orphist color planes, Čapek created an alphabet of expressive, purified, and newly descriptive abbreviations. Both artists focused primarily on themes from everyday life. Čapek's civil approach led him to a strikingly formulated social typifica-

tion. Existential situations are also present in his depictions of new, socially defined types. However, their internal tension usually is softened by a humorous or ironic cast; see *Man with a Top Hat (Hlava muže v cylindru*, 1915, cat. no. PS5). In contrast, Špála's figurative compositions usually reflect an internal sunniness, tied to a synthetic evocation of country women and girls, reflecting the artist's impressions of his youth in a Czech village. Unlike Čapek's urban world of commonplace heroes, Špála created an idyll of village life set in a golden age viewed through the prism of memory.

Jan Zrzavý, standing outside of contemporary groupings, took only the elementary schemata of Cubism for his work. His themes are consistent projections of inner visions. Although typical Cubo-expressionist themes may be found in his work, their existential aspect evolved into a personal, mystical-religious, and phantomlike view of the cosmos. Cubist structure, which Zrzavý approached several times, was gradually replaced by a renewed spatial depth. By devising an imaginary and antinaturalistic projection of an internal theme, Zrzavý created a bridge leading from symbolic expression through Cubo-expressionism to Surrealism.

While the term Cubo-expressionism is most commonly identified with figurative painting and sculpture, it most fittingly characterizes the work of the Czech architects Gočár, Janák, Hofman, and Chochol (see figs. 2, 3)—all members of the Skupina. Their contribution consisted, above all, in bringing a high degree of immediacy and energy to architecture and applied art, converting even the most commonplace object into an expression of a charged reality. Their work is agitated, reflecting an age of upheavals and conflict. The basic effect of their work is one of restlessness, caused by the slanting deflection of levels and edges, which provokes a sense of instability and change, notwithstanding the renewal of equilibrium through complementary opposites. Their work takes an often aggressive stance toward the viewer, upsetting customary ideas about the traditional forms even of familiar items. The relationships between support and weight are dramatized by an emphasis on encounters with gravitational forces or by an exaggeration of plasticity. The result is dynamic, suggesting movement through a rhythmic arrangement of the work's elements.

This dematerialization attacks the continuity of matter. The viewer is awakened from habitual calm to new perceptions as these Cubo-expressionist objects activate a psychological response by introducing conflict and suggesting the existence of forces surpassing the usual dimensions and rhythms of everyday life. The power of spirit that freely shapes matter takes precedence over conventional matter dominated by weight. This produces an existential situation similar to that evoked by the painting of Kubišta and Filla or the sculptures of Gutfreund. With all its contradictory solutions, Czech Cubism in architecture and applied art remains an example of grandiose achievement, born out of the depth of mankind's energy.

The artists of the founding generation of the Czech

Otto Gutfreund, *Embracing Figures (Objímající se postavy)*,
1912–13, plaster with blue pigment, 25⅝ x 12⅝ x 9⅜ inches, The
Solomon R. Guggenheim Museum, New York, cat. no. PS24.

Bohumil Kubišta, *Saint Sebastian (Svatý Šebestián)*, c. 1912,
graphite on paper, 37⅜ x 29 inches, Národní galerie v Praze,
cat. no. PS29.

Jan Zrzavý, *Sermon on the Mountain (Kázání na hoře)*, c. 1911–13,
graphite on paper, 21¼ x 14¹⁵⁄₁₆ inches, Národní galerie v Praze,
cat. no. PS127.

Fig. 2. Josef Chochol, Apartment block, 1913, Neklanova Street,
Vyšehrad, Prague.

Fig. 3. Josef Gočár, Sofa, 1914, woven upholstery from a design by František Kysela, 48⅞ x 91⅓ x 21⅝ inches, Uměleckoprůmyslové muzeum v Praze.

avant-garde were a tempestuous group, trying to free themselves from the limitations of local conditions and to make contact with larger world movements. Nevertheless, their relationships with the traditions of Czech art persisted. For example, their emphasis on the luminous quality of color, dynamic form, and implied action updated the Baroque components of Czech tradition. The art of Zrzavý looks to the past, reaching back to the spiritual sphere of Czech Gothic art. In their work Procházka and Filla reevaluated the traditions of Czech Realism of the mid nineteenth century, represented by the paintings of Karel Purkyně and Josef Navrátil. The work of the Osma and Skupina artists also reflected the achievement of Czech painters at the turn of the century—especially the Impressionist Antonín Slavíček and the Symbolist Jan Preisler—advancing from Symbolism to an original application of ideas derived from the work of Cézanne. Notwithstanding their entry into the mainstream art world at the beginning of the twentieth century, the members of the Czech avant-garde did not lose their links with a national identity; on the contrary, they explored this identity deeply, extending it into new territory. The exacting conception of Czech artists can be seen in direct relationship to the Czech character. Turning their attention to the spiritual in a time of

conflict, the Czech avant-garde effectively expressed the existential dramas of human fate and the experience of situating human events within an infinitely complex universe. They sought new means of expression to reach deeper into the awareness and conscience of their national psyche as well as of contemporary humanity.

Dr. Miroslav Lamač is an art historian working in Prague.

Translated by Jitka Salaquarda

• NOTES

1. This essay was first published in somewhat altered form as the "Résumé" (pp. 527–37) in Lamač's definitive study *Osma a Skupina výtvarných umělců, 1907–1917* (Prague: Odeon, 1988).

2. The exhibition consisted of approximately 120 works, of which 75 were oils and the remainder graphic works. Munch came to Prague for this occasion and many years later still remembered the friendly reception there.

3. Emil Filla, "The Path of Creativity (Cesta tvořivosti)," in *Reflections on Fine Arts (Úvahy o výtvarném umění*, Prague: Karel Brož, 1948) p. 407. This extensive article by Filla was written between 1916 and 1917, when the artist was accounting for the romanticism of his youth.

4. Emil Artur Pittermann (E.A. Longen), Linka Scheithauerová (who later married Antonín Procházka), Max Horb, and Friedrich Feigl also took part in exhibitions by the Osma group. The last two were Prague Germans, like Willy Nowak.

5. Bohumil Kubišta, *Letters and Essays (Korespondence a úvahy*, Prague, 1960), pp. 124–25.

6. The Skupina also included among its members the cartoonist Zdeněk Kratochvíl, the graphic artists Vratislav H. Brunner and František Kysela, the architects Josef Rosípal and Max Urban, as well as the theoreticians Jan Borovička and Vilém Dvořák. Kubišta and Kubín did not become members of the Skupina owing to ideological disagreements. By the end of 1912 different approaches to the fundamental problems of contemporary art (especially with respect to the evaluation of Cubism) resulted in the departure of Špála, Brunner, the brothers Čapek, Hofman, and Chochol. They continued in their avant-garde activity, as did Kubišta and Kubín, within the confines of the S.V.U. Mánes.

7. The most important Cubist buildings of Prague include Chochol's apartment house and family villa at Vyšehrad, Gočár's semidetached houses at Hradčany, and the house "At the Black Madonna (U černé Matky boží)" in the Staré Město (Old Town); outside of Prague, they are Gočár's spa in Bohdaneč and Janák's remodeling of a Baroque house on the square in Pelhřimov. Cubist applied art includes principally stoneware vases, trays, ashtrays, services, toilette sets, metal chandeliers, rugs, book design, and posters.

8. Other participants included Albert Gleizes, Raoul Dufy, Roger de La Fresnaye, Emil-Othon Friesz, André Lhote, and Raymond Duchamp-Villon.

9. During the war, Filla, Gutfreund, and Kubín lived abroad while Špála, Hofman, Janák, Kubišta, and Procházka were on the front. Gutfreund took part in combat against Germany with Czech legions formed in France.

10. Filla stayed mainly in Rotterdam and Amsterdam where he engaged in intelligence activities against Austria and Germany. In the years 1918–20 he became secretary of the Czechoslovak Embassy at The Hague. Enchanted by Dutch art, in 1916 he wrote an essay on Dutch still life, later printed in *Reflections on Fine Arts*, p. 258.

11. These artists, together with a few others, formed the group called Tvrdošíjní (The Stubborn Ones), which organized its first exhibition in the spring of 1918 under the motto "A přece (And Yet)." In its own distinct manner the group built upon the avant-garde efforts of the Skupina.

Josef Šíma, *Double Landscape: Thunderstorm (Dvojitá krajina—
bouřka)*, 1927, oil on canvas, 26⅜ x 53¹⁵⁄₁₆ inches, Musée National
d'Art Moderne, Centre Georges Pompidou, Paris, cat. no. PS77.

From Lyrical Metaphors to Symbols of Fate: Czech Surrealism of the 1930s

FRANTIŠEK ŠMEJKAL

Next to Cubism, Surrealism was the most important tendency in Czech art during the first half of the twentieth century. As Cubism had in the 1910s, Surrealism caught on in Czechoslovakia in the twenties, and by the thirties Surrealism, with Functionalism, dominated the Czech art scene. While Functionalism became the main trend in architecture, design, and some areas of the industrial arts, the influence of Surrealism was felt most strongly in painting, sculpture, poetry, theater, photography, film, and often in life-styles as well. Prague became the primary Middle European center for Surrealism, and its legacy remains, albeit in a much transmuted form, in certain aspects of Czech art to this day.[1]

The importance of Czech Surrealism, however, was not merely local. The founding of the Prague Surrealist group helped to internationalize the movement. The first *Bulletin international du surréalisme* was issued in Prague on April 9, 1935, as a direct result of a mutual understanding between the Prague and the Paris groups that emerged from André Breton's and Paul Eluard's visit to Prague. "Surrealism can flatter itself that today it is going through the same development in Prague as it is in Paris," Breton said in a lecture titled "The Surrealist Situation of the Object" that he delivered at the Spolek výtvarných umělců Mánes (S.V.U. Mánes; Mánes Union of Fine Arts) in Prague on March 29, 1935.[2] He went on to say: "The activity that [members of the Prague group] are engaged in differs in no way from my own activity, and thanks to the ever closer ties that link us to each other, and to the active groups of poets and artists that have already been established or are being established in every country, I expect it will be possible, between us, to set in motion a truly concentrated movement, which will be necessary if we wish Surrealism to have an international voice in the near future."[3]

Breton chose Prague as a place from which to launch his project to internationalize the movement because, among other things, he felt that Prague's genius loci was in special harmony with the spirit of Surrealism. "Prague,

wrapped in its legendary magic, is truly one of those cities that has been able, in a magnificent way, to fix and retain the poetic idea that is always more or less drifting aimlessly through space.... Seen from afar... it appears to us as the magical metropolis of old Europe. If only because Prague has nurtured within itself all the imagery and the enchantment of the past, it seems that it is possible to be heard from this point in the world with less difficulty than from any other point...."[4] Prague, indeed, is a city where almost every old building has an attendant legend: in its winding streets the Golem encountered Ahasver and Doctor Faust, in its subterranean vaults the strange, flesh-eating plants of Gustav Meyrink flourished, and Kafka's Odradek appeared on its staircases. Once, during the reign of the eccentric Emperor Rudolf II, Prague became a European center for art, alchemy, and astrology, so it comes as no surprise that this city was also destined to become one of the capitals of a movement that restored primacy of place to the imagination.

In reality, however, the spiritual climate of "magic Prague" that Breton praised merely provided a fertile soil for Surrealism. The real conditions for Surrealism's reception and development are found chiefly in the Czech art of the immediately preceding period, represented in work by the avant-garde group Devětsil, which focused all its attention on the present and had little in common with the city's legendary traditions.

Devětsil was founded in 1920 as an association of young avant-garde poets, painters, architects, theater artists, and journalists who declared themselves proponents of Marxism and revolution. After an unsuccessful attempt to create a new proletarian art, Devětsil became for a time a forum for the widest possible variety of European avant-garde art. Based on the polarity of Poetism and Constructivism, the Devětsil program crystallized about 1924 or 1925 and was given theoretical expression by the main spokesman of the group, Karel Teige. From 1922 on Devětsil artists actively set about to establish international contacts with avant-garde

groups in the rest of Europe, including the Soviet Union. In Paris they looked mainly to Le Corbusier and the magazine *L'Esprit Nouveau*; to Ivan Goll, Man Ray, Philippe Soupault, Pierre-Albert Birot, and Georges Ribemont-Dessaignes; and later, through the agency of Josef Šíma, to a group called Le Grand Jeu. Throughout the 1920s, however, they never established direct contact with the Surrealists, even though the Devětsil magazines followed Surrealist work, published examples of it, and offered critical commentary on it.

Devětsil's reticence toward Surrealism was a consequence of ideological differences between the two groups. Devětsil had a far broader base of thought, which tried to create a fusion of Apollinaire's approach to modern poetry and the revolutionary program of Soviet Constructivism. Although the latter tendency was utterly antipathetic to Surrealism, Devětsil was relatively close to Surrealism in its approach to poetry. The genealogy of both tendencies can be traced back to the revolutionary Romantics and the *poètes maudits*, even though the end products were markedly different. At this point, too, rivalry entered the picture. Teige's *First Manifesto of Poetism* was published in 1924, several months before Breton's *First Surrealist Manifesto*, and despite great differences in the manifestos, this fact gave Devětsil a certain feeling of priority, amplified by the awareness that Poetism was the first specifically Czech formulation of problems in avant-garde art, a formulation relatively free of foreign influences.

A partial rapprochement between Devětsil and Surrealism did not take place until the late 1920s, when Poetism began to lose its initial optimism about the future of civilization and its lyrical enthusiasm for the beauties of the modern world began to be displaced by echoes from the deeper levels of the psyche, where Thanatos as well as Eros had a voice. At the same time the political positions of both groups began to converge. In his 1930 commentary on Breton's *Second Surrealist Manifesto*, Teige spoke highly of the fact that Breton had embraced historical materialism, but he continued to express reservations about psychic automatism, which he considered too passive an approach to creativity. Instead, he posited a polarity of "construction and the poem" *(stavba a báseň),* demanding that all verbal or visual material drawn from the unconscious be developed and integrated into the work in a conscious, willed fashion.[5]

Not every member of the group shared Teige's reluctance to embrace Surrealism. About 1930, as sharp internal polemics caused a marked weakening in the organizational coherence and unity of opinion in Devětsil, many of its members became increasingly attracted to Surrealism. This was particularly true of Vítězslav Nezval, who had founded in 1930 a magazine called *Zodiac (Zvěrokruh).* Only two issues of the magazine came out, but both featured Surrealism and psychoanalysis. Besides Surrealist texts and pictures, the magazine printed a complete translation of Breton's *Second Surrealist Manifesto*; articles by the young Czech psychoanalyst Bohuslav Brouk appeared alongside studies

by Freud, Jung, and Rank. Between 1930 and 1933 Jindřich Štyrský put out his *Erotic Review (Erotická revue),* in which he published several Surrealist texts and his survey on love. Also in 1932 he established *Edition 69*, a series of books including de Sade's *Justine* and his own and Nezval's erotic texts, accompanied by collages and photomontages that were executed in the spirit of Surrealist poetics.

About 1930 essential changes began appearing in paintings by avant-garde Czech artists. Up to that point Devětsil had understood painting as an independent color poem—a lyrical play of color, line, and form. In the work of Štyrský and Toyen, this became Artificialism; in the paintings of František Muzika, František Janoušek, and Alois Wachsman, a lyrical Cubism emerged. In both cases the picture had been seen as a flat, two-dimensional composition of signs intended to evoke physiological emotion. Under the influence of Surrealism, the picture began to carry deeper meanings that sprang from the artist's unconscious and uncovered hidden levels of being. Flat signs became plastic—three-dimensional symbolic objects located in a deepening imaginary space. At first these were vague objects charged with libidinal energy, but gradually they became more concrete in shape and meaning, as well as localized in an increasingly specific illusory space. The painters also made more frequent use of the chance juxtaposition of two or more irreconcilable realities in an improbable setting. This development from semi-abstract, associative structures to the veristic yet symbolic objects of Magic Realism characterized the work of the first generation of Czech Surrealist painters from 1930 to 1945, though naturally there were individual variations.

By 1932 the trend in Czech art toward Surrealism was so marked that a large international exhibition of Surrealist works by Czech and foreign artists could be held. *Poetry 1932 (Poesie 1932)* took place in the S.V.U. Mánes Union in Prague. The exhibition's title reflected Devětsil's continuing preoccupation with the supremacy of poetry, but both Nezval in his opening remarks and Kamil Novotný in his introduction to the catalogue spoke only of Surrealism. This was the first large-scale manifestation of Surrealism on Czech soil, a precursor of later international Surrealist exhibitions (something that Western historiography has yet to consider). Almost all members of the Paris group took part: Jean Arp, Salvador Dali, Max Ernst, Alberto Giacometti, André Masson, Joan Miró, and Yves Tanguy. It included those who had been in the first Surrealist show in Paris in 1925, such as Giorgio de Chirico and Paul Klee, as well as artists like Alberto Savinio, Gaston-Louis Roux, and Wolfgang Paalen, who was not yet an official Surrealist. The Czech participants were painters and sculptors whose work at the time was largely in a state of transition toward Surrealism or had Surrealist affinities: Emil Filla, Adolf Hoffmeister, Janoušek, Vincenc Makovský, Muzika, Bedřich Stefan, Šíma, Štyrský, Toyen, Wachsman, and Hana Wichterlová.

Poetry 1932 was a milestone in the history of Czech art:

it helped to eliminate—at least in the eyes of Czech artists—the stigma against Surrealism, and it opened a door for many later artists. If Surrealism became the dominant trend in Czech art in the 1930s and left its mark on the work of more than twenty artists, it was largely due to this show. In any case, Surrealism went on to gain a currency in Czechoslovakia that was unprecedented outside of France.

It was not until May 1933, however, that direct contact with André Breton was established, when the Czech poet Nezval and the director Jindřich Honzl visited him in Paris to discuss the possibility of a common approach. Issue five of *Le Surréalisme au service de la révolution* published Nezval's letter of May 10, 1933, to Breton, in which the Czech poet, speaking for Devětsil, affirmed the agreement of both movements on most points and suggested that they cooperate, although this did not happen in any significant way until a year later.

The Surrealist Group in Prague was established under Nezval's leadership in March 1934, and compared with Devětsil, the range of its membership was rather narrow, since it excluded many of those who claimed to be Surrealists or who worked in that spirit. The founding members were Nezval and Konstantin Beibl, both poets, the painters Štyrský and Toyen, the sculptor Makovský, the theater director Honzl, the composer Jaroslav Ježek, the psychoanalyst Brouk, and three less important poets, all friends of Nezval: Imre Forbath, Josef Kunstadt, and Katy King (Libuše Jíchová). After a brief period of hesitation, when the group's ideological positions were clarified, Teige joined and soon became its chief spokesman. The group went on to become the main focus of Surrealist activity in Czechoslovakia, with links to Paris; it occasionally collaborated with people who sympathized with the ideas but were not, properly speaking, Surrealists. But other parallel groups calling themselves Surrealist eventually sprang up alongside it, and many artists set out on the Surrealist adventure on their own.

One characteristic of the original Prague group was its open espousal of revolution and its consistent attempt to interpret Surrealism in the light of dialectic materialism. Symptomatically, Nezval announced in a letter to the Agitprop center of the Communist Party of Czechoslovakia that the entire Surrealist group was joining the revolutionary front, but he added that it reserved "the right to independence in its experimental methods." The letter was reprinted in a pamphlet called "Surrealism in the Czechoslovak Republic (Surrealismus v ČSR)," dated March 21, 1934. This pamphlet also contained the group's manifesto and a letter to Breton, formally marking the beginning of cooperation between the Paris and the Prague groups.

Shortly after it was established, the group organized two evenings of lectures, the first at the S.V.U. Mánes, the second in the Levá fronta (Left Front) headquarters. Both were attended by hundreds of people and widely reported in the press, indicating that Surrealism in Czechoslovakia was not an esoteric movement but a public affair, the subject of lively discussion and one that large numbers of people felt to be rel-

evant. The evening of lectures sponsored by the Levá fronta focused on clarifying the political position of Surrealism and its relationship to Marxism and the leftist intelligentsia. Much attention was paid to the Marxist interpretation of psychoanalysis and the noetic function of Surrealism. At the same time, efforts were made to integrate Surrealism with the notion—which was still a considerably open one at the time—of Socialist Realism.[6]

A brisk correspondence planning further collaboration developed between Prague and Paris, some of which has recently been published.[7] Contacts were mediated occasionally by emissaries like Joan Miró and Roger Caillois, who came to Prague to study Slavic folklore,[8] or Makovský and Hoffmeister, who went to Paris. Midway through 1934 a plan was hatched to hold an international exhibition of Surrealism at S.V.U. Mánes and to sponsor several lectures by Breton. The idea of including painters from abroad had to be scrapped for lack of funds; instead, an exhibition of the Czech Surrealist Group was held in Prague in January 1935. Here, Štyrský, Toyen, and Makovský showed a remarkable collection of paintings, sculptures, collages, and photographs. On March 27, 1935, Breton, his wife, and Eluard, in the company of Šíma, arrived in Prague, where they gave a series of lectures and acquainted themselves with the activities of the Prague group. Breton, well aware that he was going to address an audience already familiar with Surrealism, had prepared two entirely new lectures on the political position of contemporary art and on the Surrealist situation of the object. He completed the series with an earlier lecture first given in Brussels, "What Is Surrealism?"[9]

In the following months this intense cooperation between the two groups continued. By May Štyrský had exhibited his collages at the Surrealist exhibition in Santa Cruz de Tenerife, the Canary Islands. Later, along with Toyen, he took part in most of the international Surrealist exhibitions, although at first he was represented only by works he had given as gifts to Breton and Eluard. In the spring of 1935 Štyrský and Toyen went to Paris to gather material for *Inmate of the Bastille (Obyvatel Bastilly)*, a book on the life and work of the Marquis de Sade.[10] In June they were joined by Nezval, who had come as a delegate to the International Congress of Writers in Defense of Culture and took the opportunity to declare his unconditional solidarity with Breton.

One important activity the Surrealist Group in Prague undertook was translating basic Surrealist works into Czech.[11] In 1936 a series of theoretical texts, poems, and reproductions of works by members of the Paris group was published in an anthology called *Surrealism (Surrealismus)*, edited by Nezval. It also included some theoretical, poetical, and experimental works by the Prague group.

Theater was a remarkable element in Prague Surrealism, indicating how universal a resonance the idea of Surrealism had in Prague, where it influenced areas of creative activity untouched elsewhere in the world, at least in the 1930s. In Paris it was mainly dissidents from the Surrealist movement

such as Antonin Artaud and Roger Vitrac who were involved in theater. In Prague the Surrealist Group had among its members Honzl, who in the late twenties on the stage of the Liberated Theater (Osvobozené divadlo) presented a number of avant-garde works ranging from Alfred Jarry's *Ubu Roi*, 1928, and Apollinaire's *Tiresias's Breasts (Les Mamelles de Tirésias)*, 1926, to Dadaist plays and sketches like Breton and Soupault's *S'il vous plaît* and Ribemont-Dessaignes' *The Dumb Canary* and *The Peruvian Hangman*. During the Prague run of *The Peruvian Hangman,* the critics avidly discussed the Surrealist atmosphere of the performance. After several intervals of working for the commercial theater, Honzl returned to Surrealist dramaturgy with a production of Nezval's *Fear (Strach, 1934)*, staged in the Liberated Theater. A year later in the New Theater, he presented Nezval's *The Oracle of Delphi (Věštírna delfská)*, designed by Štyrský, as well as Louis Aragon and Breton's *The Treasure of the Jesuits*. The latter was a world premiere and remains to this day the only public presentation of that play, which originally appeared in a special Surrealist issue of *Variétés* in 1929. Unfortunately, the New Theater folded in 1935, but Honzl went on to apply the principles of Surrealism both on large stages and in improvised dramatic evenings.[12]

In 1936 another important director, Emil František Burian, and his entire D 36 Theater announced that they were embracing Surrealism. His productions from that time (notably *Hamlet III*) displayed a number of Surrealist techniques. On June 22, 1936, Burian held an evening in his theater for the Surrealist group on the hundredth anniversary of the death of the Czech Romantic poet Karel Hynek Mácha, whom the Prague Surrealists considered their only legitimate precursor. This event was a protest against official commemorations of Mácha's death, just as the Paris Surrealists had protested in 1927 against attempts to turn Rimbaud into an "official" poet when his statue was unveiled in Charleville. An important aspect of this campaign was a collection of writing called *Neither Swan nor Moon (Ani labuť, ani Lůna, 1936)*, which sought to provide a consistently Surrealist interpretation of Mácha's legacy. The contributors included members of the Prague group and several other authors who sympathized with Surrealism, such as Jan Mukařovský.

Another characteristic of Czech Surrealism was its close collaboration with members of the Prague Linguistic Circle (Pražský lingvistický kroužek), especially with Roman Jakobson and Mukařovský. By studying Surrealist works from Structuralist points of view, they provided a very different key to their interpretation than had been common so far, especially in France. Instead of speculative psychoanalytic explications and high-blown poetic paraphrases, they analyzed the work on a strictly scientific, semiological basis.

Jakobson had been in friendly contact with many members of the Czech avant-garde since the early twenties and had followed with interest the establishment of the Surrealist Group in Prague. When they were working on their translation of Breton's *Communicating Vessels (Les Vases communi-*

quants), he drew their attention to the role of dreams in Czech literature.[13] He also spoke at the opening of the 1938 exhibition of work by Štyrský and Toyen in Brno, and he even anticipated the Surrealists in his demystification of Mácha's work in his essay "What Is Poetry? (Co je poezie?," 1934) when he discussed the poetic value of Mácha's encoded erotic diary, which until then had been kept a strict secret from the public.[14]

Mukařovský's collaboration with the Surrealist group was even more direct. Along with generally theoretical works on the problems of avant-garde art—for instance, his 1935 *Dialectic Contradictions in Modern Art (Dialektické rozpory v moderním umění)*—Mukařovský analyzed a number of the works of Šíma, Štyrský, Toyen, and Nezval.[15] He personally took part in many Surrealist manifestations, and in 1938 he invited Štyrský to lecture to his seminar in aesthetics at the Charles University. This collaboration was a great source of inspiration for both sides. Mukařovský provided avant-garde art with a new interpretive instrument, while contact with contemporary work influenced the development of Mukařovský's Structuralist theory that—in harmony with the evolution of Czech art from Poetism to Surrealism—moved away from autonomous signs toward communicative aesthetic signs, thus emphasizing the semantic elements of the work of art. Mukařovský's Structuralist method also had an influence on some of Teige's postwar works.

These contacts with the scholarly and artistic avant-garde who stood outside Surrealism were important to the Prague group because they helped prevent the kind of isolation the Paris group fell into in the years immediately preceding World War II. In 1937 Prague's Levá fronta (Left Front) split into two camps. One camp accepted the Stalinist model of cultural politics and came down heavily in favor of a narrow concept of Socialist Realism, while the other camp—including the Prague Surrealist group—insisted on freedom of creation and defended the right of avant-garde art to exist within the framework of a unified anti-Fascist front. In March 1938 Nezval went over to the Stalinist camp and tried to dissolve the Surrealist group. After unsuccessful attempts at reconciliation, with Breton himself intervening, the Surrealist group announced that it would continue to exist without Nezval, collaborating as before with the international Surrealist movement. The Nezval affair provoked controversy in the press; the Surrealists were attacked from both the left and the right. Teige responded with a polemical pamphlet "Surrealism Against the Current (Surrealismus proti proudu)" in 1938. After Nezval's departure, a new member joined the Surrealist group: the young poet and innovative artist Jindřich Heisler.

The Nazi occupation of Czechoslovakia in 1939 brought all public activity of the Surrealist Group to a halt as Surrealism was officially declared one of the dangerous, decadent arts. Its members continued to meet privately, and they put out a series of illegal publications, most of them on Heisler's initiative. With Štyrský's premature death in 1942, however,

Josef Šíma, *Illustrations for Pierre Jean Jouve's "Paradise Lost (Ztracený ráj),"* 1928, etchings, 14⅞ x 10¹⁵⁄₁₆ inches, Národní galerie v Praze, cat. no. PS78.

the group's activity virtually ceased. After the war only Teige, Toyen, and Heisler went to Paris in 1947 and became members of Breton's Paris group. Heisler prepared a smaller version of the Paris exhibition *Le Surréalisme en 1947*; titled *International Surrealism (Mezinárodní surrealismus)*, it was held in Prague in November of the same year at the Topič Salon (Topičův salón). Breton, who wrote an introduction for the occasion called "The Second Ark," later referred to the show as the *Seventh International Exhibition of Surrealism*.[16]

The demise of the Surrealist Group in Prague in no way meant the disappearance of Surrealist activity in Czechoslovakia. A number of individuals and other groups in the country called themselves Surrealists as well and continued to work in that spirit.[17]

The first Czech artist to approach Surrealism in the early years, 1926–27, was Josef Šíma, who had moved to Paris in 1921. His mythical landscapes with their floating torsos, crystals, and cosmic eggs and his visions of beginnings and primordial unity were in alliance with the poetics of the group Le Grand Jeu. In the fall of 1927, Šíma along with Roger Gilbert-Lecomte, René Daumal, and Roger Vailland, became a founding member of the group and its most important visual artist.[18] It was in this fertile association with these young, philosophically inclined poets that Šíma defined his painterly poetics, based on interrelated notions of illumination, imagination, and unity. By illumination he meant a special kind of inspiration, a moment when the essence and the original unity of the world were suddenly revealed. (Šíma had first experienced this state when he observed lightning strike very close to him.) Unity referred to the unity of matter and energy, of microcosm and macrocosm, and it led Šíma to chart a restitution of the original unity of man and nature. Similarly his concept of imagination turned to the collective unconscious rather than the individual, to the ancient memory of mankind, and to archetypal imaginings and myths. Šíma's landscapes with floating female torsos, trees, crystals, menhirs, and eggs were symbolic of a return to the origins, an evocation of fabled times when people still lived in harmony with nature and the cosmos. An important role in the early works was played by the symbolism of flight, which freed objects from their normal semantic relations and became an expression of the painter's longing for freedom and transcendence.

About 1930 an important change took place in Šíma's painting. For several years he had focused almost exclusively on landscapes. When his imagination was no longer fed by sudden illuminations and soundings into the archaic levels of his memory, but rather by sensory experiences and a poetic contemplation of reality, aiming once again at the essence of things, he began to merge the subject and the object, the inner and the outer world, man and nature. Instead of levitation of more or less realistic objects, Šíma depicted a systematic dematerialization of the world, the dissolution of matter in light and space, merging the elements—earth, air, water, and fire—in a new unity.

Hitler's accession to power in 1933 and a growing tension in the stifling atmosphere of Europe shook Šíma's harmonic vision of the unity of the world and led him again to myth—this time as a source of tragic, prophetic parables. Instead of representing a lyrical state of mind, his work now expressed dramatic tension with narrative qualities, symbolically representing the social conflicts of those stormy times. The dominant motif of this period was the image of falling. His work now reflected both the fall of Šíma's imagination from heaven to earth and the moral decline of European culture. It also evoked the theme of The Fall, symbolizing the loss of original unity and perfection. Šíma, however, did not return to the cosmogenic myth of Creation, but to the classical myth based on notions of Fate as the original model of all human situations and conflicts, as shown, for example, in his variations on the Fall of Icarus.[19]

Jindřich Štyrský and Toyen were undoubtedly two of the most important representatives of Czech Surrealism. Their work evolved in tandem between the two world wars. Both of them had joined Devětsil in 1923 and both shared the group's early preoccupation with Purism and Constructivism. After 1925, however, the geometric structure of their pictures became more organic and colorful, taking on new evocative functions. This was the beginning of Artificialism—the parallel in painting to Poetism.

At the time Štyrský was working in a monochromatic style, painting gently toned compositions of gray or light ochre, whose amorphous structures were articulated with delicate arabesques, geometric configurations, and elementary organic forms. The coloristically darker pictures of Toyen, often enveloped in a deep melancholy, sometimes have an immaterial lightness about them and a nervous vibration of electromagnetic poles. At other times they are characterized by the earthy rawness of heavy impasto and corrugated structures, in which pictorial metaphors for primary telluric processes and forms can be found. Contemporary with these pictures, which according to Nezval were painted with a four-tone palette, Toyen made other, fascinating works by spraying paint through or around objects, meshes, and stencils, a technique related to the photogram. It is as though the canvas became a sensitive photographic plate recording the movement of light, the play of shadows, the ghosts of shapes, and the twisted course of electrical charges.

Toyen's and Štyrský's works are the fullest expression of Artificialist poetics, which may be described as the concrete rendering of nonsubstantive impressions, feelings, memories, and imaginings, all tied to a reality that is seen, experienced, or merely dreamed—a reality that, with the passage of time, appears to have lost its shape and its place in time and space, leaving nothing behind but an inexpressible essence, an uncertain trembling of the senses, a vibration of feelings. This subtle, almost ineffable inner essence of an experience or an idea in Artificialism is the subject of the painting. The process of representing these nonsubstantive, experiential substrata of the artist's consciousness, often rooted in memo-

Jindřich Štyrský, *The Cemetery of Suicides (Hřbitov sebevrahů),*
1925, mixed media on paper board, 15⅜ x 9⁷⁄₁₆ inches, collection
Bernard Galateau, Paris, cat. no. PS85.

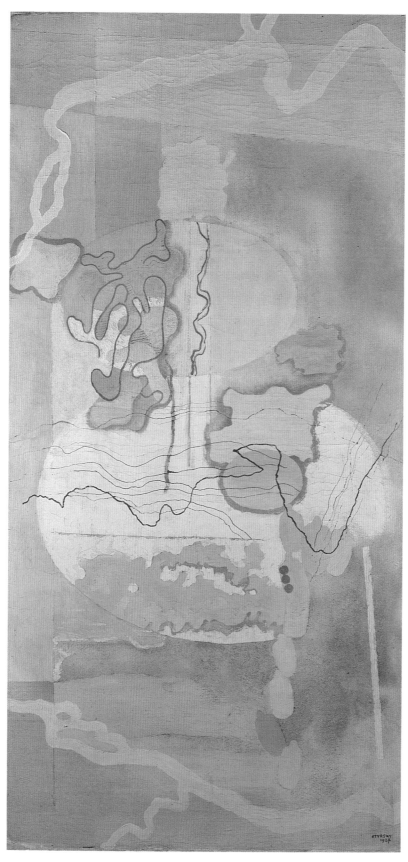

Jindřich Štyrský, *Deluge (Povodeň)*, 1927, oil with sand on canvas,
43⁵⁄₁₆ x 21⅝ inches, Moravská galerie v Brně, cat. no. PS86.

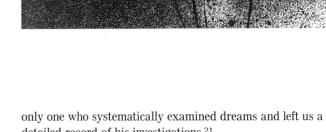

Jindřich Štyrský, *Illustrations for Vítězslav Nezval's "Jewish Cemetery (Židovský hřbitov)"* (Prague: Odeon, 1928), lithographs, 11¹³⁄₁₆ x 9⁷⁄₁₆ inches, Národní galerie v Praze, cat. no. PS87.

ries from childhood, was not a mere transcription but rather a gradual fixing of these substrata in paint. The nature of this process, however, was ambivalent. Its aspect as reproduction merged almost indistinguishably with its aspect as invention—with the discovery of new worlds, objects, and textures born in the artist's imagination. This new, artificial reality was intended to induce in viewers a complex of feelings, memories, and associations, to stimulate their imagination, and to create a lyrical atmosphere that is essentially identical with the atmosphere of Poetism.

By the end of the twenties, the work of Štyrský and Toyen began to show the influence of Surrealism. The first indication of this was Štyrský's illustrations for the Czech translation of Lautréamont's *Les Chants de Maldoror (Zpěvy Maldororovy*, 1928, cat. no. PS88), but long before the founding of the Surrealist Group in Prague, Štyrský was linked with Surrealism by his deep interest in dreams, which became a central inspiration for his work as a poet and a painter. The most eloquent expression of this source is a book called *Dreams (Sny)*, containing both written records and his drawn interpretations of dreams that he had between 1925 and 1940.[20] Štyrský began recording his dreams in this way about the same time that dreams became the chief interest of the Paris Surrealist group. In Paris, however, it was primarily poets, rather than visual artists, who were interested in dreams, and although dreams were often sources of inspiration for Surrealist painters, Štyrský was the

only one who systematically examined dreams and left us a detailed record of his investigations.[21]

In Štyrský's *Dreams* we can follow the whole process, from the original dreams as the source of inspiration through their gradual transformation and final realization in art that was often quite different from the original inspiration. Štyrský was not merely drawn to the bizarre nature of dreams; he tried to find a visual representation of their latent substance, and in this approach Freudian analysis provided him with an instrument. He was selective and analytical about his dreams. He would usually choose a single key moment from a dream, a significant image or symbolic object, which he would then gradually alter in a series of drawings, collages, and paintings until he arrived at the dream's hidden core, where its meaning resided.

For Štyrský dreams were a gateway to the lost paradise of his childhood, at times even to the security of prenatal life. They were also a medium in which the experiences of his waking life were subjected to unconscious processing. Waking life and dreaming were genuinely "communicating vessels" for Štyrský, as he explained in a lecture to Mukařovský's seminar in 1938: "My eyes need to be thrown food constantly. They swallow it crudely and voraciously, and then at night, in sleep, they digest it." Elsewhere he expanded on this idea: "Childhood is my native land. Dreams are my native land, where black snow falls from the clouds."

At the first exhibition of the Surrealist Group in 1935,

Toyen, *The Voice of the Forest (Hlas lesa)*, 1934, oil on canvas, 39⅜
x 28½ inches, collection Bernard Galateau, Paris, cat. no. PS103.

Jindřich Štyrský, *Paris Afternoon (Pařížské odpoledne),* 1935,
Národní galerie v Praze, cat. no. PH134.

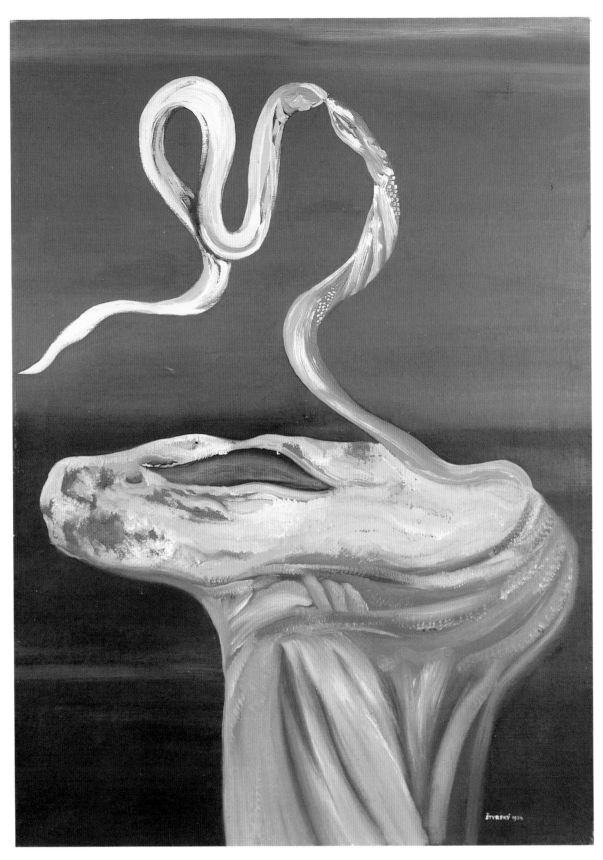

Jindřich Štyrský, *Man-Cuttlefish (Člověk-sepie)*, 1934, oil on
canvas, 39⅜ x 28¾ inches, collection Bernard Galateau, Paris,
cat. no. PS90.

Toyen, *The Handshake (Stisk ruky)*, 1934, oil on canvas, 19¼ x
28¾ inches, Národní galerie v Praze, cat. no. PS104.

Štyrský and Toyen showed the work they had done in 1934. The vague, undefined forms of the previous periods had now solidified into unreal beings and strange objects. These symbolic materializations of latent psychic states distantly recall certain real objects or beings that we cannot fully identify. It is precisely this semantic shift, together with the placement of the objects in inappropriate contexts, that is the source of their new emotive value and their disturbing impact.

In many cases these enigmatic objects have a clear libidinous subtext. Toyen's pictures that capture reality in something like its latent state have their meanings only suggested by the motifs of cracks and rounded shapes, which often have an ambivalent nature and seem to keep their secrets to themselves (*Larva [Larva]* and *Longing [Touha]*, Aleš's Gallery of South Bohemia, Hluboká nad Vltavou, and *Mirage [Miráž]*, all 1934). In Štyrský's work the erotic meanings are far more obvious, as in *Man and Woman (Muž a žena*, 1934, private collection, Paris) where the male and female sexual organs are eloquently represented by an open shell and what looks like a convoluted anatomical specimen.

At the first Surrealist exhibition, alongside these hallucinatory paintings were many pictures of dreamlike phantoms and specters, which both Štyrský and Toyen had added to the Surrealist gallery of fantastic beings whose irrational and improbable existence confirms, again and again, the monsters of our own dreams. If Štyrský's precisely delineated phantoms had a life of their own, independent of what was around them, then the specters of Toyen blended with their surroundings with a chameleon-like mimicry (*The Voice of the Forest [Hlas lesa*, 1934, cat. no. PS103], *A View of Emptiness [Pohled do prázdna*, 1934], and *The Pink Specter [Růžový spektr*, 1934, private collection, Prague]).

The opposite pole of these fantastic pictures is found in Štyrský's collages and photographs, which graphically illustrate Breton's thesis that supra-reality is contained implicitly in reality and not "above" or outside it. In two series of photographs (*Frog Man [Žabí muž*, 1934] and *Man with Blinders [Muž s klapkami na očích*, 1934, see cat. no. PH129]), completed by a third series done a year later called *Paris Afternoon (Pařížské odpoledne*, see cat. no. PH134), Štyrský discovered the fantastical nature of ordinary reality, which in the Surrealist view could be transposed playfully to the miraculous sphere of poetry. These works express his keen awareness of the bizarre aspects of reality, of the magic of coincidences and accidental juxtapositions, of the hidden drama inherent in cast-off things, and of the poetry of defeated lives and forgotten deaths.

Although Štyrský's series of collages *The Portable Wardrobe (Stěhovací kabinet*, 1935) is also based on the principle of coincidence and symbolic transmutation, it forms, technically and methodically, a very different group of work. Štyrský may have been the first among the Surrealists consistently to replace the traditional xylographic material with color reproductions and to develop a new type of object-collage that gave a freer rein to his fantasy than the limited

technique of using real three-dimensional objects. Erotic inspiration, drawing more or less on Freudian symbolism, is the most obvious aspect of this series; in his other collages it is his aggressive imagination, with its explosive charge of black humor, that dominates.

While enabling Štyrský and Toyen to widen their range of expression, collages also had a direct impact on their painting. Collages accelerated the process of making pictorial reality concrete, fostering a veristic Surrealism, and of juxtaposing two or more incongruous things in an unexpected or inappropriate setting. Collages helped Štyrský and Toyen discover the enigmatic and emotive qualities of naked reality that, taken out of its usual context, assumed new symbolic meanings. Consequently, a change took place in their painting techniques. Autonomous structures of color and a free painterly handling were gradually replaced by a precise, impersonal transcription of the objects depicted, which thus took on the persuasiveness of real objects. It is just this terrifying realism and the bewitching quality of the objects situated in absurd contexts that take them out of our normal experience of life, relativizes their empirical meanings, and endows them with a new, secret existence, full of hidden content and allusions.

This new conception was first resolved in two large paintings from 1936: Štyrský's *The Trauma of Birth (Trauma zrození*, cat. no. PS92),[22] based on the positioning of clearly defined but enigmatic objects against the black surface of the canvas, and Toyen's *The Message of the Forest (Poselství lesa*, private collection, Caracas), a terrifying nightmare vision in which the specter of an owl digs his all-too-real talons into the pale face of a somnambulent girl. Štyrský's series *Omnipresent Eye (Všudypřítomné oko*, 1936, see cat. no. PS91) dates from the same year and revives, in an unsettling way, the classical symbol of the eye. Here, the eye is not a symbol of inner meditation but an active and even aggressive object that reflects a whole range of expressions, from the obsessive stare of the voyeur to the anxious glance of the fascinated victim.

But this new pictorial conception was not fully developed until the following year. Štyrský and Toyen still made pictures of mysterious phantoms that have almost no resemblance to the reality of the outer world (Štyrský's *The Traveling Widows [Vdovy na cestách]*, and Toyen's *Dream [Sen]*), but in most canvases chance juxtapositions of familiar objects assume a phantomlike quality in confrontation with their setting. Toyen's pictures began to radiate the deep melancholy of abandoned things, a nostalgia for far horizons, and a kind of undefinable anxiety of solitude, while Štyrský's works were dominated by the absurd atmosphere of allegorical encounters and often reflected the sharp edge of his sarcasm and black humor.

In addition to echoes from the most intimate areas of their psyches, the terrifying events going on in the world were reflected in Štyrský's and Toyen's work. Štyrský responded with a shocking picture of a murdered Spanish poet, *In*

Toyen, *Hide! War! (Schovej se, válko!)*, 1944 (1946 edition), inta-
gliotypes, 12⅝ x 17⁵⁄₁₆ inches, Uměleckoprůmyslové muzeum v
Praze, cat. no. PS105.

Zdeněk Rykr, *Countryside (Venkov)*, 1936, mixed media between
two sheets of glass, 17⁵⁄₁₆ x 13 inches, Národní galerie v Praze, cat.
no. PS70.

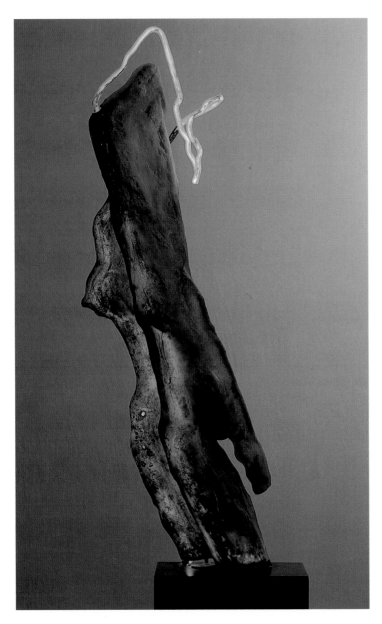

Zdeněk Pešánek, *Torso (Torzo)*, c. 1936, glass, neon, and mixed
media, 19¾ inches high, collection Charlotta and Petr Kotik, New
York, cat. no. PS50.

Zdeněk Pešánek, *Model of the Color-Kinetic Sculpture II (Kontrola
jednotlivých fází barevné kinetické plastiky II)*, 1930–31, mixed
media framed in a shadow box, 6⅛ x 21⅛ x 3⅛ inches, Národní
galerie v Praze, cat. no. PS49.

memoriam Garcia Lorca, and Toyen with a series of drawings called *Specters of the Desert (Přízraky pouště,* 1937–38), apocalyptic visions that fully express the impending threat of world catastrophe.

After Štyrský died in 1942, Toyen remained the most important proponent of Surrealist painting in Czechoslovakia. Her life, and to a large extent her art, now became linked to a newer member of the Prague Surrealist group, Jindřich Heisler. They had begun to collaborate as artists in 1939, when Heisler wrote poetic texts for the publication of *Specters of the Desert* and Toyen illustrated his collection *Kestrels (Poštolky),* which because of the Nazi occupation had to be published illegally. This inspired collaboration continued during the war. Toyen illustrated Heisler's book of poems *From the Dungeons of Sleep (Z kasemat spánku,* 1941) and Heisler wrote texts to accompany two of Toyen's series of drawings *The Shooting Gallery (Střelnice,* 1939–40) and *Hide! War! (Schovej se, válko!,* 1944, cat. no. PS105). In these works both her aggression and her boundless despair are given free rein. These shocking drawings are executed in the impersonal style of textbook illustrations, but they are allegorical parables of the apocalyptic horrors of World War II, projected in *The Shooting Gallery* into the world of children's games and in *Hide! War!* into a world devastated by conflict, a world of abandoned things, fragments, and monstrous skeletons.

Of the artists who were not members of the Surrealist Group, Zdeněk Rykr was one who adopted Surrealism. His work, which is somewhat incoherent in terms of its intellectual content, nevertheless exhibits remarkable flashes of intuition. His 1935 primitivist compositions in boxes (see cat. nos. PS68, PS69) represent the precise opposite of the sophistication and exclusiveness of later boxes by Joseph Cornell. His assemblages from 1934, unfortunately now lost, were made of bizarre and frequently impermanent found materials. Because these compositions are deliberately anti-aesthetic, they form a direct link between Kurt Schwitters' objects and junk art.

Surrealism influenced the kinetic work of the most daring Czech sculptor working between the two world wars, Zdeněk Pešánek. Although his light projections (*The Color Piano [Barevný klavír]*) and "luminodynamic" sculptures from the 1920s were derived from Constructivist aesthetics and morphology, the Surrealist atmosphere of the thirties changed his work. In a series of studies on the theme "One Hundred Years of Electricity" in the early thirties, Pešánek abandoned geometric form and conceived a set of sculptures as vertical, informal assemblages of glass, plastic, metal, machine parts, and fluorescent colors. The definitive installation of these programmed light and sound works (which are lost) never took place, but they were exhibited in modified form in the Czechoslovak Pavilion at the 1937 World's Fair in Paris, where they won a gold medal.

Pešánek made the works for the lighted kinetic fountain in front of the Czechoslovak Pavilion at the same World's Fair. In the middle of the fountain were two female torsos illuminated by multicolored lights and surrounded by bright tubes of neon. In these torsos (and some of the studies for them), which were spectral, transparent phantoms that were constantly changing colors, the Surrealist sense of the marvelous blended with the Constructivist sense for solving technical problems—programming the lights, using new kinds of plastic and sources of light, and particularly bending neon tubes to form spatial drawings, in which Pešánek was several decades ahead of his time.[23] It is Pešánek's work that perhaps best illustrates the magic attraction Surrealism had in Czechoslovakia of the 1930s, even for artists who were so radically different from one another.

Dr. František Šmejkal was a senior fellow at the Institute of the Theory and History of Art at the Czechoslovak Academy of Sciences (Ústav teorie a dějin umění Československé akadamie věd), Prague. This essay has been published posthumously.

Translated by Paul Wilson

• NOTES

1. The following publications have more detailed information about Czech Surrealism or about some of its aspects: Enrico Crispolti, *Il Surrealismo* (Milan: Fratelli Fabbri Editori, 1969, English version, 1970); Herta Wescher, *Die Geschichte der Collage* (Cologne: DuMont Schauberg, 1974); František Šmejkal, *Surrealist Drawings* (London: Octopus Books, 1974); Šmejkal, "Surréalisme et peinture imaginative en Tchécoslovaquie," *Phases*, no. 10 (1965); "Surréalisme international," *Opus International*, nos. 19–20 (1970); "Prague-Athènes," *Change*, no. 25 (1975); "Le surréalisme en Tchécoslovaquie," *Bulletin de liaison*, no. 5 (CNRS, 1976); A. Budík, *La Poésie surréaliste tchèque et slovaque*, ed. Gravida (Brussels, 1972); H. Becker, *Aus den Kasematten des Schlafs: Tschechoslowakische Surrealisten (Gedichte)* (Munich, 1980); *Štyrský-Toyen-Heisler*, exh. cat. (Paris: Centre Georges Pompidou, 1982); *Dictionnaire général du Surréalisme et de ses environs* (Fribourg: Office du Livre, 1982); D. Mayer, "Le Surréalisme tchèque," *Cahiers du Musée national d'art moderne*, no. 10 (1982), pp. 278–95; E. Jaguer, *Les Mystères de la chambre noire* (Paris: Flammarion, 1982); P. Král, *Le surréalisme en Tchécoslovaquie* (Paris: Gallimard, 1983); E. Jaguer and F. Šmejkal, *Peinture surréaliste et imaginative en Tchécoslovaquie, 1930–1960*, exh. cat. (Paris: Galerie 1900-2000, 1983).

2. André Breton, *What is Surrealism? (Co je surrealismus?*, Brno, J. Jícha, 1937), p. 69. Also in Breton, *Position politique du surréalisme* (Paris: Denoël/ Gonthier, 1972), p. 123.

3. Breton, *What Is Surrealism?*, p. 69 (or *Position politique*, p. 123).

4. Breton, *What Is Surrealism?*, pp. 68–69 (or *Position politique*, pp. 121–22).

5. Karel Teige, "Surrealism and Le Grand Jeu (Nadrealismus a Vysoká hra)," *ReD*, vol. 3, no. 8 (1930), pp. 249–55.

6. See, for example, Karel Teige, "Socialist Realism and Surrealism (Socialistický realismus a surrealismus)," *Socialist Realism (Socialistický realism,* Prague: Knihovna Levé fronty, 1935). Nezval took the same position; he was one of the Czech delegates to the First All-Union Congress of Soviet Writers (1934), where contributions by Bucharin and Pasternak aroused hopes that avant-garde art, including Surrealism, might be included under "socialist realism." His own address to the congress, in which he referred to Bucharin and Breton, was in the same spirit.

7. Vítězslav Nezval, *Dispatches from the End of the Millennium (Depeše z konce tisíciletí,* Prague: Československý spisovatel, 1981). Contains sixteen letters from Breton and nine letters and postcards from Eluard to Nezval, along with his replies.

8. Caillois was studying the motif of the midday sprite (*polednice*) in Slavic demonology, which resulted in a scientific study in the *Revue des Etudes slaves* (1936–37) and an article "Le Complex de midi," *Minotaure*, vol. 9, (1936), pp. 9–10. In 1935 Miró showed a big collection of paintings in the first international exhibition at the S.V.U. Mánes and used the opportunity to visit Prague.

9. On March 29 Breton lectured at S.V.U. Mánes on the Surrealist situation of the object; on April 1, at an evening sponsored by the Levá fronta, he spoke about political positions in contemporary art, and Eluard lectured on Surrealist poetry; on April 3 Breton read his lecture "What Is Surrealism?" at the Faculty of Arts of the Charles University, and the following day he repeated his first S.V.U. Mánes lecture in Brno. Eluard's talk was published under the title "Affiliation" in *Doba*, vol. 1, nos. 19–20 (November 1935), pp. 259–61. All of Breton's Prague lectures were published in 1937 in Brno under the title *What Is Surrealism? (Co je surrealismus?).*

10. The unfinished manuscript of this book was published posthumously in *Světová literatura*, nos. 5–6 (Prague, 1969), pp. 435–61.

11. In 1934 the Czech translation of Breton's *Communicating Vessels (Les Vases communiquants)* came out, in 1935 a translation of *Nadja*, and in 1937 *What Is Surrealism?* and *The Spirit of Water (Duch vody)*. In 1936 Nezval's translation of Eluard's *The Public Rose (Veřejná růže)* came out with collages by Štyrský. At the same time the G.L.M. publishers in Paris brought out Nezval's *Antilyrics (Antilyrika)* in Eluard's translation.

12. He even did this in the National Theater, where in a dreamlike stage setting by Muzika, he presented in 1938 Martinů's opera *Julietta*, based on the play *Juliette or the Book of Dreams* by Georges Neveux, which Henri Béhar considers to be one of the authentic Surrealist expressions (in *Le Théâtre dada et surréaliste* [Paris: Gallimard, 1979], p. 338). In 1939 he presented Nezval's third Surrealist play *The Sinister Bird*, originally intended for the New Theater.

13. In his letter to Nezval, dated July 26, 1934, about their common translation of *Communicating Vessels*, Honzl wrote: "Today Jakobson told me that he knows about some interesting material, accounts of Erben's dreams, which

Sabina published and to which he added his own commentaries, very interesting. Ask Roman about it when you speak to him" (V. Nezval, *Dispatches from the End of the Millennium [Depeše z konce tisíciletí*, Prague: Československý spisovatel], p. 198). K. J. Erben (1811–1870) was a Czech post-Romantic poet who in his balladic poetry was influenced and inspired by popular notions and myths.

14. From a lecture at S.V.U. Mánes. Reprinted in *Free Directions (Volné směry),* vol. 30, no. 10 (1933–34), pp. 229–39. A French translation is available in Roman Jakobson, *Questions de poétique* (Paris: Editions du Seuil, 1973), pp. 113–26.

15. For example, "On the Noetics and Poetics of Surrealism in Painting (Knoetice a poetice surrealismu v malířství)" in 1938, "A Semantic Analysis of 'The Absolute Gravedigger' (Semantický rozbor 'Absolutního hrobaře')," in 1938, etc. All these studies are printed in J. Mukařovský, *Studies in Aesthetics (Studie z estetiky*, Prague: Odeon, 1966). A fragment of "On the Noetics and Poetics of Surrealism in Painting" was published in *Change*, vol. 25 (December 1975), pp. 56–57.

16. See G. Rioux, "A propos des Expositions Internationales du Surréalisme," *Gazette des Beaux-Arts*, no. 1311 (April 1978), pp. 163–71.

17. Among the painters of the Devětsil generation were František Janoušek, František Muzika, Alois Wachsman, František Vobecký, Zdeněk Rykr, etc.; among the sculptors, apart from members of the Group of Vincenc Makovský, the main ones were Hana Wichterlová and Josef Wagner. About 1935 the art critic Jindřich Chalupecký gathered several artists of the younger generation who were tending toward Surrealism into an informal group. These included František Gross, František Hudeček, the sculptor Ladislav Zívr, and the photographer Miroslav Hák. During the Nazi occupation of Czechoslovakia, several other Surrealist groups were formed of which the most important was the Skupina Ra (the painters Josef Istler, Bohdan Lacina, Václav Tikal, and Václav Zykmund, the photographers Miloš Koreček and Vilém Reichmann, and the poets Ludvík Kundera and Zdeněk Lorenc). This group also took Czech art from Surrealism to the "informal" style and began collaborating—though this contact was soon ruptured—with COBRA.

18. See M. Random, *Le Grand Jeu I-II* (Paris: Denoël, 1970).

19. See František Šmejkal, *Josef Šíma* (Prague: Odeon, 1988).

20. Jindřich Štyrský, *Dreams (Sny*, Prague: Odeon, 1970). Selected and with a commentary by František Šmejkal. See also František Šmejkal, "L'Oeuvre onirique de Štyrský," *Opus International*, nos. 19–20 (1970), pp. 120–24.

21. See S. Alexandrian, *Le Surréalisme et le rêve* (Paris: Gallimard, 1974), pp. 218–21.

22. Here Štyrský was inspired by the famous psychoanalytic study by Otto Rank called *Das Trauma des Geburt*, from 1924, an excerpt of which was reprinted in the second number of Nezval's *Zodiac* (December 1930), pp. 95–96. For Štyrský the trauma of birth was a key theme, connected to an unconscious desire to return to a prenatal state. See also František Šmejkal, "Štyrský entre Eros et Thanatos," *Du Surréalisme et du plaisir* (Paris: José Corti, 1987) pp. 161–67.

23. See *Electra* (Paris: Musée d'Art Moderne de la Ville de Paris, 1983–84), pp. 178–79, 183–84, 187, 268–70.

PHOTOGRAPHY

Karel Teige, Untitled, 1942, 6⅝ x 5 inches,
Památník národního
písemnictví, cat. no. PH162.

Jaroslav Rössler, *Radio*, 1923–24, Prakapas Gallery, New York,
cat. no. PH107.

Modernism, the Avant-Garde, and Photography

JAROSLAV ANDĚL

Although Modernism had a decisive impact on twentieth-century photography, few comprehensive historical studies have been made of this interdependent relationship. The purpose of this essay is both to introduce Czech avant-garde photography and to contribute to a better understanding of the connection between the Modernist aesthetic and photography. The essay's premise is that the Modernist potential of photography emerged in the cross-fertilization between photography and art and in the convergence of artistic and photographic institutions that peaked with the rise between the two world wars of avant-garde groups concentrating on photography. Works by Czech artists are relevant in this respect because perhaps in no other country was avant-garde photography so well developed and so multifaceted as in Czechoslovakia in the 1920s and 1930s, where more than half a dozen avant-garde groups specialized in photography.

The term "Modernism" has had different connotations for artists and photographers. Modernism in art emerged at the end of the last century, thrived before World War I, and continued after World War II. In photography, however, Modernism is thought to comprise only the period between the two world wars or even only the 1920s, when artists of the avant-garde initiated the ideas, collaborations, and works that critics and historians of photography call Modernism.[1] Limiting Modernism in photography to the avant-garde of the twenties, in fact, is a paradox. The medium of photography, as it advanced modern visual communication in the last century, functioned as a kind of prerequisite of Modernism, because it undermined and questioned traditional aesthetic concepts and encouraged explorations of new territories. Thus artists' efforts to appropriate the new medium became an element in the development of Modernism both in art and in photography.

Artists used and studied photographs, often taking pictures of their models. As Alfons Mucha's photographs show, the informal character of these studies contrasted both with his paintings and with art photographs of the period (see cat. no. PH74).[2] Other artists such as the pioneer of abstract art František Kupka found inspiration in scientific photographs. Kupka also contemplated the impact of photography on art in his writing.[3] Still other artists began to experiment directly with the new medium, as shown in photographs by Vojtěch Preissig and Josef Váchal.

Preissig's still lifes from his Paris studio (c. 1900) play with spatial orientation and rotation (cat. nos. PH94, PH95). Like his photographs of store interiors several years later, they are studies in rhythm and gravitation as well as in displacement and fetishism. Preissig also turned to natural forms and textures for his subjects; his photographs of trees and sand dunes from the 1910s and 1920s correspond with his abstract drawings, collages, and paintings.[4]

Photographs by Váchal even more explicitly opened a dialogue between art and photography in a Modernist exploration of the medium. *Self-portrait with Palette* (*Autoportrét s paletou*, c. 1905, cat. no. PH166) combines a *cliché-verre* drawing with a photographic self-portrait, juxtaposing the photographic image with the handmade image on several levels. The engraved drawing of a tree on the negative plate echoes both the photographed painting of a tree and the shape of the palette in the artist's hand. This juxtaposition leads the viewer to question the representational codes and possibly to read the photograph in different ways. This ambiguity is even more pronounced in Váchal's self-portraits from 1901, 1906, and 1915.[5]

The comparison of Váchal's *Self-portrait as Christ Crucified* (*Autoportret jako Kristus. Ukřižovaný*, c. 1906, cat. no. PH167) with František Drtikol and Augustin Škarda's *Self-portrait as Christ* (*Autoportrét jako Kristus*, 1914, cat. no. PH14) is instrumental. Although both pictures present the same theme (i.e., the artist as Christ), they espouse opposite goals. While Drtikol embraced the turn-of-the-century comparison of the artist to Christ and idealized it, Váchal deconstructed this lofty vision and juxtaposed it with a caricature of himself. Drtikol's choice of this theme, as well as of the bromoil technique, indicate his intention to legitimize the artistic status of the photographer. Contrarily, Váchal employed the camera to question art and the role of the artist—concerns to be taken up by the avant-garde a decade later.[6]

In spite of the division in the 1910s between the institutions of art and photography, numerous contacts were forged between artists and photographers. For example, Váchal befriended a number of leading photographers and critics such as Vladimír Bufka, Jindřich Imlauf, Jaroslav Petrák, and Jan Srp, proponents in Bohemia and Moravia of the Pictorialist movement, which originated in the 1890s.[7] The two

Josef Váchal, *Self-portrait as Christ Crucified (Autoportrét jako
Kristus. Ukřižovaný)*, c. 1906, Moravská galerie v Brně, cat.
no. PH167.

Drtikol & Spol (František Drtikol and Augustín Škarda), *Self-portrait as Christ (Autoportrét jako Kristus)*, 1914, The Museum of Fine Arts, Houston, cat. no. PH14.

foremost photographers of this movement, Bufka and Drtikol, were strongly influenced by Symbolist art and participated in the activity of art organizations,[8] including the exhibition of prints and photographs organized by Artěl in 1911. This artists' cooperative, founded in 1908, pioneered modern design with projects that included producing Cubist furniture and ceramics. Artěl also distributed the portfolio *From the Courtyards of Old Prague* (*Z dvorů a dvorečků staré Prahy*, 1911, cat. nos. PH12, PH13) by Drtikol and Augustin Škarda. Although most of its pictures conform to the conventions of art photography, several prints in their reduction of forms and tones show an affinity with Expressionist printmaking, prefiguring Drtikol's 1920s work.

More significant interplay between art and photography, however, emerged only after World War I, as avant-garde artists and critics questioned both the institution of art and the role of the artist. With ideas of progress and equality would come the use of new technologies, the rejection of the hierarchy of low and high, and—as some manifestos put it—the dissolution of the boundaries between art and life. The avant-garde artists saw photography and film as an ideal means for these ends. They reversed the traditional hierarchy of art forms and transferred photography and other mediums of mechanical reproduction from the periphery of art to its center.

Perhaps the first artist and critic to articulate an extensive interest in popular arts was Josef Čapek.[9] In his essays on this topic, which were published in 1918 and again in 1920 under the title *The Most Modest Art (Nejskromnější umění)* he expressed his admiration of film and documentary and journalistic photography. In 1922 the Czech avant-garde group Devětsil, in its international publication *Life: An Anthology of the New Beauty* (*Život. Sborník nové krásy*, cat. no. PH152), celebrated photography and film as the most contemporary of art forms, calling them "the only interpreter of the new beauty." The magazine, whose photomontage cover juxtaposes a Doric column with a car wheel, includes the essay "Foto Kino Film" by Karel Teige, probably the first avant-garde manifesto devoted to both photography and film.[10]

Teige and his group were much more radical than Čapek. They wanted more than critical acceptance for photography, film, and other mass mediums: they wanted these mediums to replace traditional art forms. Soon after Teige's essay was published, other manifestos followed that further elaborated this program.[11] At the same time Devětsil's members, including Teige, Jindřich Štyrský, and Toyen, were attempting to create new art forms by harnessing new technologies to produce machine-made images and objects that would then replace paintings and other handmade artifacts.

Teige's career further illustrates this development: he started as a painter and became a pioneer of photomontage and modern typography as well as a leading critic and theorist of photography, film, typography, and architecture. He pioneered the "image poems" (see cat. nos. PH126, PH127,

PH153, PH154) and "film poems" created by Devětsil artists between 1923 and 1927, which were inspired by photomontage, collage, typographical designs, pictorial magazines, and film scripts. Using these images and texts, Devětsil artists also attempted to synthesize modern painting and modern poetry.

While the medium of photography attracted avant-garde artists, Cubism and abstract art, in turn, had a decisive impact on photographers emerging after World War I. Jaroslav Rössler, an apprentice of Drtikol, created his first photographic study in abstraction, *Opus 1*, in 1919. This still life made of cardboard was directly influenced by the Cubist *plans superposés*. Rössler further developed this technique between 1922 and 1923 in a series of light abstractions. He also used the bromoil brush technique to create geometric abstractions.

In 1923 Teige invited Rössler to join the Devětsil group. With other Devětsil artists, Rössler shared a passionate interest in the radio, as a medium and as a recurring subject in his work (see cat. nos. PH101, PH107, PH109).[12] From 1922 to 1926 Rössler created a number of photographs that followed and further developed Devětsil's program. They include informal as well as geometrically stylized portraits, light and geometric abstractions, pictures taken from unusual angles, photomontages, photograms, and documentary and street photographs (see cat. nos. PH104, PH105, PH108, PH109, PH110). Rössler's work was the most multifaceted body of work of Modernist photography to emerge in the first half of the 1920s.

Devětsil also decisively influenced Jaromír Funke, another young photographer who advanced Modernism in photography.[13] The Devětsil program combined the principles of poetry and construction, or Poetism and Constructivism.[14] While Rössler's work in the 1920s emphasized construction, the work of Funke epitomized the dichotomy of the Devětsil program. In the first half of the 1920s, Funke photographed standardized industrial objects and abstract compositions made from cardboard, paper sheets, glass panes, and other glass objects (see cat. nos. PH24, PH28, PH30, PH31). These pictures reflect several key terms often cited in Devětsil's manifestos such as *standard*, *construction*, and *poetry*.[15] Nevertheless, Funke's work is too complex to be regarded as merely an offshoot of Devětsil.[16] Additionally, his early work predates the group's interest in the medium. Between 1918 and 1921, Funke made several albums of documentary photographs of the suburbs of his native town of Kolín (see PH23), which represent an early example of the Modernist aesthetic in photography.

By the second half of the 1920s, other photographers, including Funke's friend Josef Sudek (see cat. no. PH136), Adolf Schneeberger (see cat. no. PH120), and Eugen Wiškovský (see cat. no. PH181), also had adopted the Modernist aesthetic, and numerous other amateur photographers and their organizations had come under its influence. For example, Jan Lauschmann, a proponent of Pictorialism in

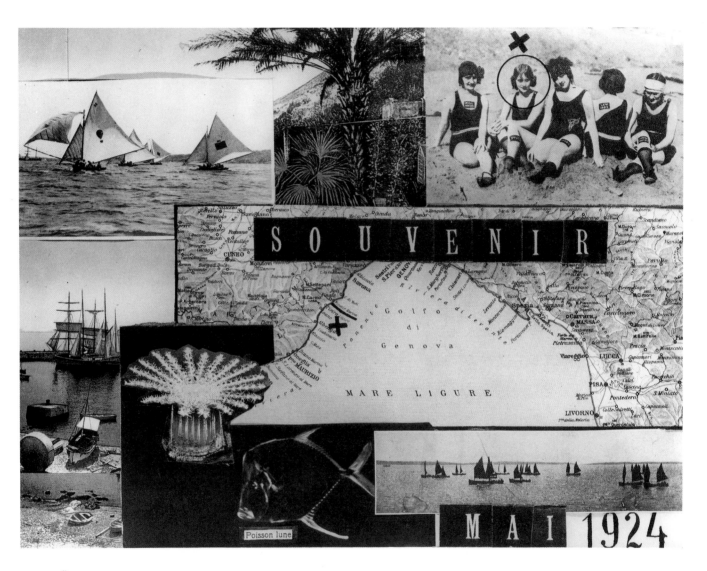

Jindřich Štyrský, *Souvenir*, 1924, Národní galerie v Praze,
cat. no. PH126.

Karel Teige, *Travel Postcard (Pozdrav z cesty)*, 1923, Galerie hlavního
města Prahy, cat. no. PH154.

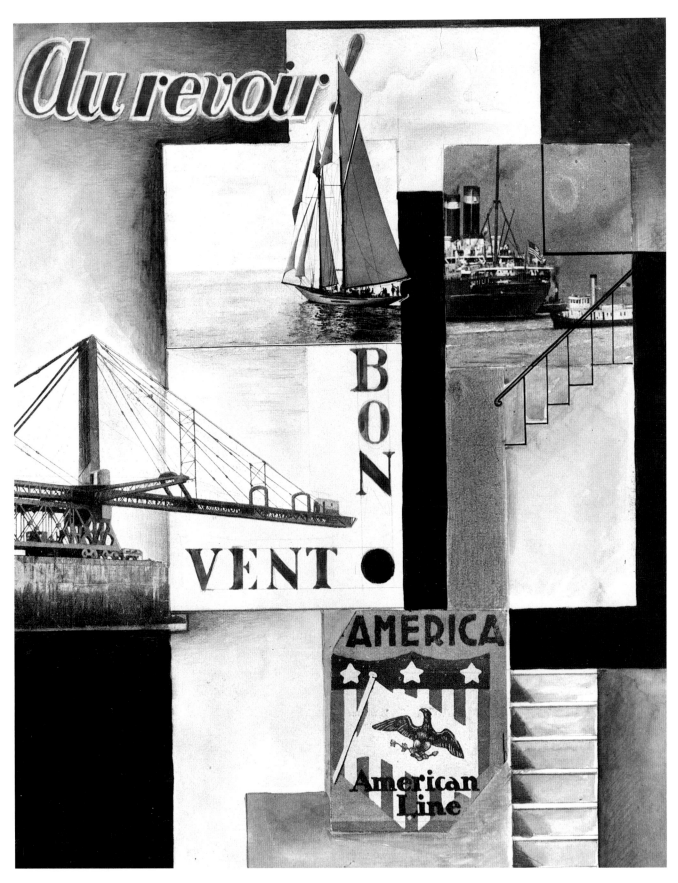

Karel Teige, *The Departure for Cythera (Odjezd na Cytheru),* 1923,
Galerie hlavního města Prahy, cat. no. PH153.

Jaroslav Rössler, *Photograph I (Fotografie I)*, 1923,
Uměleckoprůmyslové muzeum v Praze, cat. no. PH105.

Jaroslav Rössler, *Petřín Tower (Petřínská věž)*, 1922–23, collection
Marjorie and Leonard Vernon, cat. no. PH104.

Jaromír Funke, *Composition (Kompozice)*, 1924, collection Thomas
Walther, New York, cat. no. PH28.

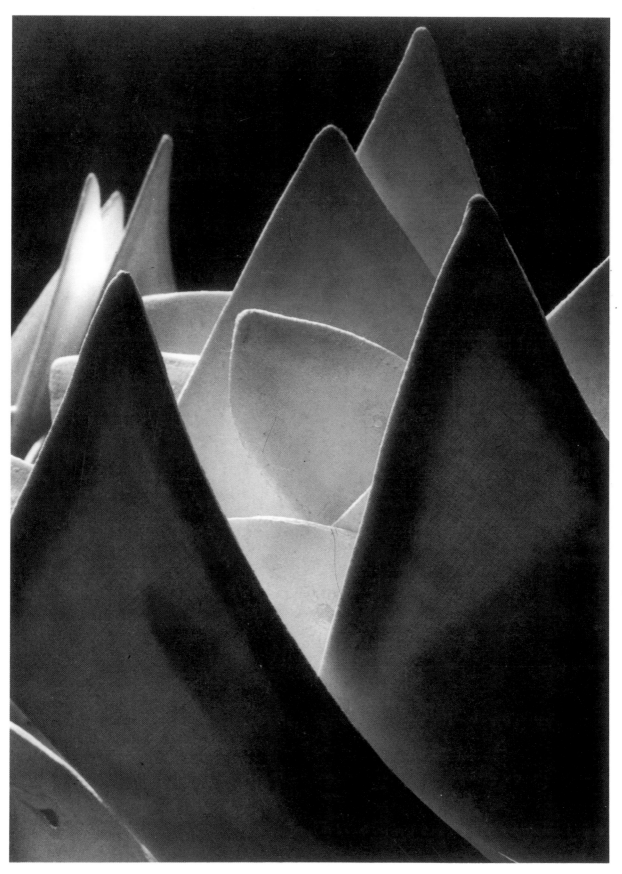

Eugen Wiškovský, *Collars: Lunar Landscape (Límce. Měsíční krajina)*, 1929, Uměleckoprůmyslové muzeum v Praze, cat. no. PH181.

Jaromír Funke, *Composition (Kompozice)*, 1923, The Museum of Fine
Arts, Houston, cat. no. PH24.

Adolf Schneeberger, *Spool Composition (Kompozice s cívkami),*
1930, The Saint Louis Art Museum, cat. no. PH121.

Josef Hausenblas, *Eiffel Tower (Eiffelova věž)*, 1928, private collection, cat. no. PH56.

the Czech Club of Amateur Photographers (ČKFA, Český klub fotografů amatérů) in Prague, photographed pictorial city scenes and still lifes but also took pictures from unusual angles to create dramatically diagonal compositions. Such photographs as *Castle Staircase* (*Hradní schůdky*, 1927, cat. no. PH64) parallel similar works by Rössler, László Moholy-Nagy, and Alexander Rodchenko.

Photographers' clubs underwent a remarkable development and diversification in the 1920s. In 1924 the Czech Photographic Society (ČFS, Česká fotografická společnost) originated from a series of expulsions and secessions from the ČKFA in Prague and from the Photo Club Prague (Fotoklub Praha). Probably inspired by the aggressive style of the Devětsil manifestos, Funke wrote a devastating review of a traveling portfolio of the ČKFA, which led to his expulsion as well as that of Schneeberger and Sudek from the Photo Club Prague and consequently from the Union of Czech Clubs of Amateur Photographers (Svaz československých klubů fotografů amatérů, SČKFA). Although ČFS had not yet identified with the artistic avant-garde, it represented an important step in the convergence of photographic and artistic institutions and the emergence of avant-garde groups that specialized in photography.

This process accelerated toward the end of the 1920s and the beginning of the 1930s when the Modernist aesthetic spread among many more photographers. Various characteristically Modernist terms such as *new, modern, avant-garde, independent, Constructivist,* and *Surrealist* began to appear in photographic and artistic magazines. In 1928 and 1929 the Club of Amateur Photographers (KFA, Klub fotografů amatérů) in the city of Mladá Boleslav organized two exhibitions of "independent photography," which took place in a Constructivist pavilion designed by Jiří Kroha. For the first exhibition in 1928, Josef Slánský and Josef Dašek (see cat. no. PH10) published statements outlining the group's program.[17] Like Rodchenko in his essay "The Paths of Contemporary Photography" from the same year,[18] they argued for explorations of unusual angles and perspectives in looking at everyday objects. Their work also included abstractions—geometric figures and bodies similar to Constructivist paintings and sculptures as well as to contemporary Bauhaus exercises.

These similarities between the Czech avant-garde and the German avant-garde, particularly the Bauhaus, resulted more from parallel developments than from direct contacts and influences, although exchanges occurred between these groups, especially in architecture.[19] Teige had been in contact with the Bauhaus since 1923, when he organized the Czech participation in the *Bauhaus International Exhibition of Architecture*. His radical views were especially dear to Hannes Meyer, the second director of the Bauhaus, who invited Teige to teach a course in the sociology of architecture and appointed him visiting docent.[20] In the second half of the 1920s, several Czechoslovakian artists, mostly architects, studied at the Bauhaus.

In fact, architects dominated the Czech representation in the *Film und Foto* (*FiFo*) exhibition at Stuttgart in 1929. Included were Bohuslav Fuchs, Josef Hausenblas (see cat. no. PH56),[21] Evžen Markalous, Zdeněk Rossmann, and Teige.[22] The participation of architects in this important show was characteristic of the mutual exchange between photography and other art mediums that played a key role in the development of Modernist photography. From the early 1920s, particularly in Czechoslovakia, architects were fascinated by photography, often working in collaboration with photographers[23] and using photographs to design and present their projects and realizations.

In turn, architecture was a favored subject for Modernist photographers. Because modern architecture was probably the most successful and certainly the most visible art form of the Modernist movement in Czechoslovakia, it offered photographers ideas and strategies. The famous dictum "form follows function" and the rejection of ornament in Functionalist architecture inspired photographers to articulate their own principles and programs, such as "photography is not an art."[24] The concept of function encouraged the rediscovery and advancement of various photographic forms and genres, including advertising, journalistic, and documentary photography.[25]

The photographers and filmmakers Alexander Hackenschmied, Ladislav E. Berka, and Jiří Lehovec, who were associated with the publishing house Aventinum, more than any other group demonstrated the close relationship between photography, film, and pictorial magazines.[26] For Hackenschmied, photography was a step to filmmaking. His friends Lehovec and Berka had similar aspirations; all three worked as film critics and contributing editors or co-editors of pictorial weeklies.[27] Hackenschmied and Lehovec went on to make independent and documentary films in the 1930s and 1940s. Hackenschmied, who organized the exhibition *New Czech Photography* (*Nová česká fotografie*) at the Aventinum Garret (Aventinská mansarda) in May and June 1930, several months later had organized the First Week of Avant-garde Film, which included his experimental film *Aimless Walk* (*Bezúčelná procházka*, 1930).

Documentary photography figured in the Aventinum exhibition of *New Czech Photography*, which represented photographers and artists of several groups, including the ČFS and Devětsil. Like the Stuttgart *FiFo*, it contained a number of scientific photographs. Various forms of technical and scientific photography already had appeared in avant-garde periodicals and exhibitions in the early 1920s[28] and in some pictorial magazines, such as *Weekly Variety* (*Pestrý týden*)[29] in the second half of the 1920s.

The ideas of function, standardization, and machine aesthetic were behind artists' appropriation of scientific, technical, and documentary photography, which spread in the early 1920s with Constructivism and Functionalism (the European term for the International Style) and were circulated by L'Esprit Nouveau, Bauhaus, Devětsil, LEF, and

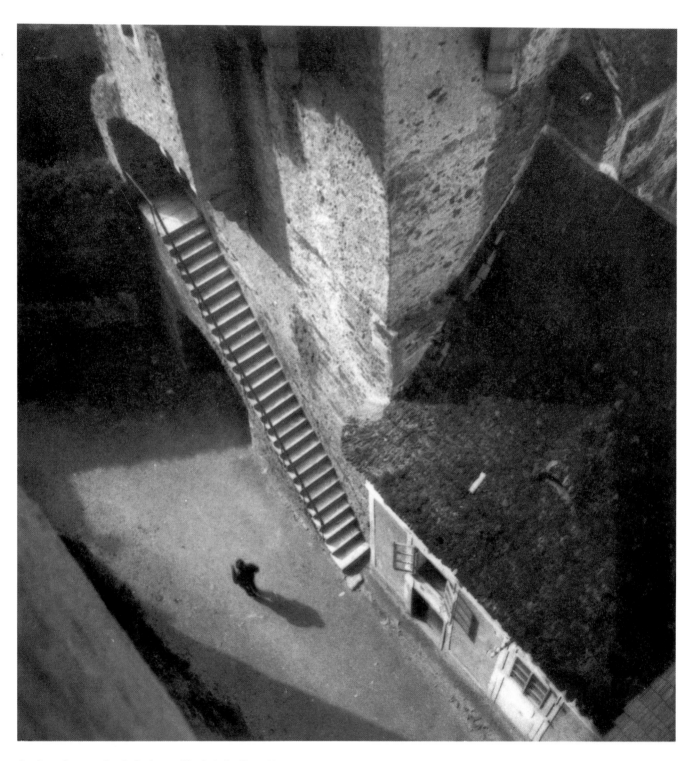

Jan Lauschmann, *Castle Staircase (Hradní schůdky)*, 1927,
Uměleckoprůmyslové muzeum v Praze, cat. no. PH64.

Jaromír Funke, *Scrap Iron (Staré železo),* 1925, Moravská galerie
v Brně, cat. no. PH31.

other groups. In using terms such as *new vision, new objectivity,* or *Neue Sachlichkeit* without considering the original historical context,[30] most books and studies on the history of photography have neglected this contribution of Constructivism and Functionalism to the development of Modernism in photography. The work of artists and photographers like Teige, Rössler, Moholy-Nagy, and Rodchenko manifest the close relationship between photography and these movements. The Constructivist and Functionalist programs led artists away from painting and sculpture to applied art. For this reason, Functionalism and Constructivism dominated both architecture and design and had a major influence on photography.

The relationship between Functionalist typography and photography was also especially visible. Pioneers of new typography regarded photography as intrinsic to their discipline. For example, Teige believed that the use of photography "changed the nature, structure, and quality of modern typography," and, like Moholy-Nagy, he argued for "the synthesis of the two 'black arts,'" coining the term *photo-typography*.[31] Teige and other leaders of Czech Functionalist typography—Zdeněk Rossmann, Ladislav Sutnar, and František Kalivoda—were significant forces in establishing Modernism in Czech photography as avant-garde publications, which they designed and sometimes edited—including *ReD* (*Review of Devětsil*, 1927–31, see cat. no. PH157), *Disk* (*Disc*, 1923, 1925), *Zone* (*Pásmo*, 1924–26), *Front* (*Fronta*, 1927), *Panorama* (1929–39), *Index* (1929–38), *We Live* (*Žijeme*, 1931–33), *Fine Arts Endeavors* (*Výtvarné snahy*, 1928–31), *Center* (*Středisko*, 1930–34), *Ekran* (1934), and *Telehor* (1936)—became the main platform for Modernist photography in Czechoslovakia.

These designers also influenced Czech photographers as critics, pedagogues, and organizers. Sutnar's collaborations with Sudek and Funke exemplify this influence. From 1928 to the late 1930s, Sudek worked for Cooperative Work (Družstevní práce), which under Sutnar's artistic leadership became a leading proponent of Functionalist design. Sudek photographed for the cooperative's magazines *We Live* and *Panorama* and for its gallery Krásná jizba—especially its Functionalist products designed by Sutnar and other artists (see cat. nos. PH138, PH139). Sudek's collaboration with Cooperative Work demonstrated the growing institutionalization of the Functionalist movement and its transformation from the avant-garde to the mainstream; it also embodied the changing role of the photographer in modern industrial society.[32]

Finally, art schools, including the State Graphic School in Prague and the schools of arts and crafts in Brno and Bratislava, also contributed to the spread of Functionalism among young artists and photographers. Sutnar was professor and director of the Prague school (from 1932 to 1946), and on his recommendation Funke became head of the photography department in Bratislava and later in Prague. To showcase Functionalist typography and photography, Funke

and Sutnar published the book *Photography Sees the Surface* (*Fotografie vidí povrch*, 1935).

The Functionalist program of the Prague school had been articulated earlier by Funke in the brochure of the Bratislava school in 1933: "We photograph textures and discover the photogenic quality of objects. We combine objects in space. Documentary and advertising photographs, portraits. Our tenet is the purity of photographic expression!" But more than any other school in Czechoslovakia the School of Arts and Crafts in Bratislava followed the Bauhaus model for Functionalism because of its director Josef Vydra and Rossmann, head of the typography department, who had been a Bauhaus student. During the 1930s they invited several former Bauhaus teachers to lecture.

Emanuel Hrbek influenced the progressive orientation of The School of Applied Arts and Crafts in Brno. Although the school did not have a photography department, some students in the early 1930s, especially those with a specialization in graphic design and advertising who studied with Hrbek, turned to photography as their favorite medium. Of these students, Jiří Kamenický, František Němec, Jaroslav Nohel, František Povolný, and Hugo Táborský formed the Photo Group of the 5 (Fotoskupina pěti), or f5, which organized several exhibitions between 1933 and 1936. The Photo Exhibition of the Three (Fotovýstava tří) or f3 (Karel Kašpařík, Otakar Lenhart, and Nohel) and the Photo Group of the Four (Fotoskupina čtyř) or f4 (Kašpařík, Lenhart, Němec, and Nohel) were offshoots of the original f5.[33] These artists saw photography as the most advanced form of graphic art and often combined photographs with graphic designs.

Their program consisted of constant experimentation, specifically exploring various techniques and their combinations, from montage, multiple exposure, and negative printing to photogram, Sabattier effect, redevelopment, and so on (see cat. nos. PH68, PH69, PH70, PH77, PH79, PH80, PH150, PH151). Rather than emphasize the purity of photography, these artist-photographers sought to stretch the medium beyond its limits. More than function, their works invoke the concepts associated with Surrealism, such as automatism, chance, dream, and distortion. Thus, f5 manifests an important change that occurred in the early 1930s and determined new developments in art and photography throughout that decade.

Although the idea of function was of primary importance for various art forms in the 1920s, including advertising, documentary, and journalistic photography, by the 1930s it had become a part of the mainstream and consequently was less attractive to young artists and photographers. More importantly, the Functionalist solution had fallen short of its original vision, and as the gap between reality and the Functionalist social and technological utopia grew, two complementary and often opposing movements emerged: Levá fronta (the Left Front, an artistic organization committed to social and political change) and Surrealism.

The group Levá fronta reflected the political radicaliza-

Karel Teige, Karel Paspa, Vítězslav Nezval, four pages from *The Alphabet: Choreographic compositions by Milča Majerová (Abeceda. Taneční komposice: Milča Majerová)*, letters E, V, N, H, 1926, private collection, cat. no. PH156.

Jiří Kroha, *Diseases and their Environment (Nemoce a jejich pros-
tředí)*, from *Sociological Fragment of Housing (Sociologický fragment
bydlení)*, 1932–33, Muzeum města Brna, cat. no. PH63.

tion of the avant-garde.[34] Nurtured by the Depression, this
radicalization resulted in artists' collaborations with
political parties, primarily with the Communist Party. As
Levá fronta established individual artistic sections that pur-
sued the political agenda in their respective fields, the
concept of function was redefined in social and political
terms. In this sense, the Levá fronta movement evolved
directly from Functionalism and could be seen as its
continuation—especially in architecture. Many prominent
architects were associated with the Levá fronta and
expressed its concerns in projects devoted, for example, to
collective housing or to economical housing.[35]

This emphasis on the social and political dimension
of architecture contributed to the growing popularity of pho-
tography among architects. In 1931 the Architecture
Section of the Levá fronta (A.S.L.F.) organized the *Exhibition
of Working Class Housing (Výstava proletářského bydlení)*,
which consisted mostly of photographs of substandard hous-
ing. In 1932–33 Kroha, one of the pioneers of Con-
structivist architecture, analyzed social aspects of housing
in an exhibition of photomontages, charts, and diagrams
titled the *Sociological Fragment of Housing (Sociologický frag-
ment bydlení*, see cat. nos. PH61, PH62, PH63).[36] Kroha

also collaborated with the photographer and filmmaker Fran-
tišek Pilát, who was a member of the Film and Photo
Group of the Levá fronta in Brno. The founder of this group,
the typographer and architect Kalivoda, in 1935 organized
C.I.A.M.—Ost, a bloc of the Eastern European groups of the
Congrès Internationaux d'Architecture Moderne.

In 1934 the film critic Lubomír Linhart, who three years
earlier had founded the Film and Photo Group of the Levá
fronta in Prague, published *Social Photography (Sociální
fotografie)*, which seems to be the only book on the subject
of political photography published in this period.[37] Linhart's
group, inspired by the movement of the German Arbeiter
Fotografen groups, organized two international exhibitions
of "social photography" in 1933 and 1934 (see cat. no.
PH67). The exhibitions represented workers' photographs
from Czechoslovakia, France, Holland, Belgium, and the
Soviet Union, including a number of leading Czech photog-
raphers as well as some artists and architects.[38] Although the
organizers highlighted social documentary, they also pre-
sented more experimental works, including numerous prints
by the f5. These international and interdisciplinary col-
laborations attest to the Czech Film and Photo Group's
numerous connections with the artistic avant-garde and dem-

Karel Valter, *Double Image—Snow (Dvojobraz—sníh)*, 1931, Moravská galerie v Brně, cat. no. PH171.

onstrated that the organization was less orthodox than similar groups abroad.

Surrealism, the third major movement to dominate art and photography in the 1930s, presented a counterpart to Functionalism and Levá fronta.[39] In the 1920s Devětsil had anticipated this dichotomy between inward and outward orientations by combining the opposing principles of construction and poetry. This twofold nature of Devětsil explains why some photomontages by Štyrský and Toyen and photographs by Funke show a striking affinity with later Surrealism.[40] Poetism in the work of these artists led almost without a break into Surrealism in the late 1920s and early 1930s.

One group that emerged in the late 1920s and took the Devětsil program as its point of departure was Linie (Line, founded in the city of České Budějovice in 1931), an association of painters and poets. After almost a decade of promotion by Devětsil, photography had become so important for this emerging generation of artists that the members of Linie formed a branch that specialized in photography: Fotolinie (Photoline) in 1933.[41] Its leading member, Josef Bartuška, and his closest friend, Oldřich Nouza, were both poets and painters. Taking their cue from Devětsil and its emphasis on imagination, they highlighted in their work two specific devices, which allude to the parallels between photographic and mental processes. In his photographs Bartuška often confronted shadows and real objects and called these pictures "shadow plays" (see cat. nos. PH3, PH4). Nouza used double and multiple exposures, creating dreamlike images (see cat. nos. PH82, PH83).

The painters Ada Novák and Karel Valter also arrived at unique results by elaborating on the Modernist strategies introduced by the avant-garde in the 1920s. While Novák's portraits and still lifes eloquently express Walter Benjamin's notion of "optical subconsciousness" (see cat. nos. PH85ab, PH87), Valter's double images question our perception of perspective (see cat. no. PH171).

In exploring the link between imagination and specific photographic techniques, these artists paralleled the Surrealist experimentation. Although most of their work could hardly be identified as Surrealist, they share with Surrealism important characteristics such as an ambiguity that engages subconscious mechanisms to produce a disquieting effect. The effect here is subtler than in Surrealism but no less intriguing.[42] More Surrealist-oriented groups such as f5 systematically exploited the ambiguity of the photographic image, making this double entendre more conspicuous.

The relationship between photography and Surrealism is rooted in the equivocal nature of the photographic image.[43] Surrealism recognized affinities with the special features and devices of photography, and its ideas generated a new wave of

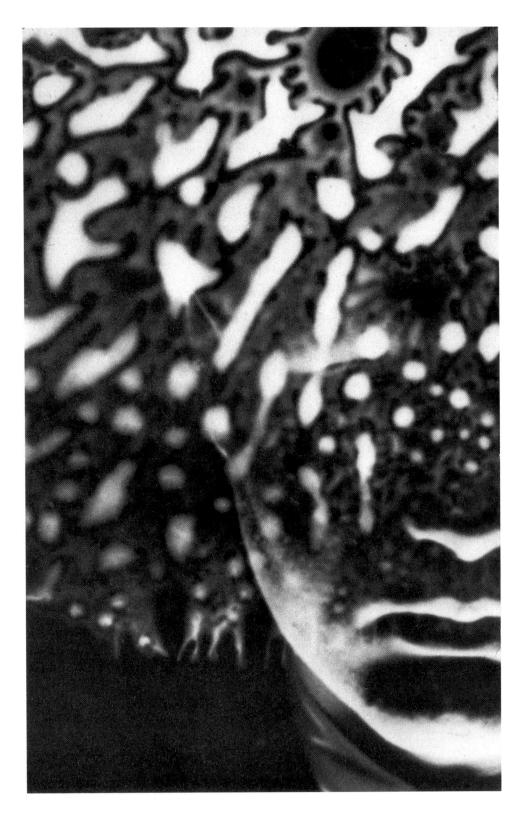

Hugo Táborský, *Self-portrait III (Autoportrét III),* 1933, Moravská
galerie v Brně, cat. no. PH149.

František Povolný, *Photography (Fotografika)*, 1933–34, Moravská galerie v Brně, cat. no. PH93.

artist-photographers. These artists adopted the camera to subvert reality; their goal was to unleash a revolution of thought and to generate poetry defined by terms such as *chance, automatism, dépaysement,* and *convulsive beauty*. Paradoxically, this iconoclastic redefinition of art led to the reversal of the Functionalist principle that "photography is not art": photography became the Surrealist art precisely because it had not before been art.[44]

The medium of photography accommodated a wide range of the Surrealist concepts. The Surrealist photographers and painters operated between the two poles of naturalism and abstraction. While straight (naturalistic) photography in Surrealism thrived on the concept of the found object and of displacement, Surrealist abstraction took its lead from the notions of automatism and chance. The first approach found its proponents in the poet Vítězslav Nezval, the painter Štyrský, and the photographer Funke (see cat. nos. PH41, PH129–PH134). Most younger artists and photographers, including f5 and Miroslav Hák, adopted the other method. Photomontages by Teige, František Vobecký, and Toyen hover between the two approaches (see cat. nos. PH164, PH173). Thus, the work of Czech artists

and photographers represents probably the richest corpus of Surrealist photography produced between the two World Wars.[45]

The influence of Surrealism was pervasive. Through the 1930s it gradually replaced Functionalism and Constructivism as the principal ideology of the avant-garde. For example, not only did Surrealism dominate the international exhibition of avant-garde photography organized by the Spolek výtvarných umělců Mánes (S.V.U. Mánes) in Prague in 1936, the largest presentation of its kind in the 1930s, but it also infiltrated the genres and forms once considered Functionalist territory, including journalistic, documentary, advertising, and fashion photography.[46]

The 1936 exhibition led to the founding of the Photographic Section of the S.V.U. Mánes. This official endorsement of photography by the most prominent artistic organization in Czechoslovakia, which was linked with the beginnings of Modernism at the turn of the century, reflected the growing institutionalization of Modernist photography. The Photographic Section of Mánes included both photographers and artist-photographers—like other groups emerging in the 1930s. Among these new groups were

Karel Teige, Untitled, 1943, Památník národního písemnictví,
cat. no. PH164.

František Vobecký, Untitled: abstraction, 1934, The J. Paul Getty Museum, cat. no. PH173.

the Surrealist Group in Prague (founded in 1934), which at its first exhibition presented Štyrský's series of photographs, and the group including the painters František Gross and František Hudeček, the sculptor Ladislav Zívr, and the photographer Hák that formed the core of the later important Skupina 42 (Group 42, founded in 1940). The exhibitions of young artists at E. F. Burian's avant-garde theater in Prague were also important; one of the participants, Václav Zykmund, with several other painters and poets and with the photographers Vilém Reichmann and Miloš Koreček, later formed the Surrealist group Skupina Ra.[47]

The work of these young artists and photographers, as well as that of f5 and Linie members, represents a new stage in the development of Modernist photography. Participants in the photography scene of Czechoslovakia in the 1930s were rethinking and redefining key concepts of the 1920s at a time when artistic expression was limited in most other countries for political, economic, and cultural reasons.[48] Thanks to a combination of favorable conditions, the Czech artists and photographers were able to explore new territory and so anticipate various developments in postwar art and photography, including Abstract Expressionism and Tachisme, Subjective Photography, Happenings, Body Art, and Conceptual Photography.

Influenced by the concepts of psychic automatism and chance, three artistic groups independently of each other experimented with cameraless images and with photographic processing.[49] As early as the first half of the 1930s, they were creating automatic works based on gestural spontaneity, an approach that heralded Action Painting, or Tachisme.

Hudeček used various sharp objects to attack the emulsion of glass negatives that reproduced paintings and sculptures, thus reinterpreting not only specific photographs and paintings but also photography and painting in general. Like Váchal in his *Self-portrait* (1905), Hudeček adopted and redefined the nineteenth-century *cliché-verre* technique to engage both mediums in a new relationship. Táborský, Povolný (see cat. no. PH93), and a decade later, Koreček explored the same vein.

Hák (see cat. no. PH51), Novák, and Němec randomly splashed, dripped, or spread developer, fixer, and other chemicals on photographic papers; the results in black-and-white reproductions are often indistinguishable from action paintings created two decades later. Although the gestural action in these photographic works was restricted by the limited size of photographic paper, "action photography" (to paraphrase Harold Rosenberg's term) amplified the automatism of the artist's gesture by combining it with random chemical reactions. The fusion of spontaneous gestures with

spontaneous chemical interactions became both a vehicle of automatism and a metaphor for this psychic process, because it seemed to release images hidden in the sub-conscious as well as in the molecular structure of the photographic emulsion.

Zykmund advanced the concept of the Surrealist assemblage in 1937 when he adopted it in his self-portraits. Using unexpected juxtapositions of his own body with various objects, he transformed assemblage into performances that anticipated the Body and Performance Art of the 1970s (see cat. no. PH186). In 1944 and 1945 Zykmund and other artists who formed the Skupina Ra elaborated the concept of assemblage into a collaborative activity, an idea that would reappear in Happenings (see cat. nos. PH189, PH190, PH191).[50]

This brief survey of Czech avant-garde photography from 1900 to 1945 suggests a number of important conclusions. First, the concept of Modernism in photography should be redefined to include the ideas, techniques, and works that directly or indirectly anticipated this movement, especially those that opened new prospects for the medium, thus advancing the exchange between Modernism and photography.

Second, the interplay among ideas, works, and institutions was key to the spread of Modernism in photography. For example, the ideas of technological and social progress, collectivism, the machine aesthetic, and function motivated artists to become photographers and stimulated collaborations between the artistic avant-garde and photographers and their organizations. This synergism resulted in a growing awareness of the medium so dramatic that some critics called it the rediscovery of photography.[51]

Third, the convergence of art and photography between the two World Wars prompted a change in the status of the medium. Photography became respected in the art world and, on a limited scale, even fashionable. Numerous artists used the camera, some of them adopting photography as their primary medium. Photographers joined avant-garde groups, and leading art critics wrote on photography. Art schools offered courses in photography, and museums began to collect photographs.

Fourth, as the avant-garde concepts and programs were absorbed, new institutions emerged and new boundaries between art and photography were established. This institutionalization gradually diminished the popularity of photography in art between 1930 and 1960. The medium of photography, however, was rediscovered by artists in the 1960s and 1970s, a period of great cross-fertilization and utopian vision, recalling the 1920s and to some extent the 1930s.

While these revolutionary periods emphasized the unity between art and society and the interchange between photography and art, the other decades tended to acknowledge the boundaries both between art and life and between photography, painting, and other art forms. The 1930s formed a period combining both trends—radical changes and increasing institutionalization. The Czech photography of the 1930s, which foreshadowed some developments after World War II, therefore may serve as a paradigm linking the periods between the two world wars and after World War II, between Modernism and Late Modernism or Postmodernism.[52]

• NOTES

1. Although the terms *Modernism* and *avant-garde* have been used as synonyms, most scholars now use the term *avant-garde* for those movements that questioned the institution of art. See Peter Burger, *The Theory of the Avant-Garde* (Minneapolis: Univ. of Minnesota Press, 1984).

2. See Graham Ovenden, *Alphonse Mucha: Photographs* (London and New York: Academy Editions and St. Martin's Press, 1974).

3. See František Kupka, *Creation in Fine Arts* (*Tvoření v umění výtvarném*, Prague: S.V.U. Mánes, 1923), pp. 44–48, 53–59, 95, 153–54, 179, 195–97. For a discussion of Kupka's work in relation to photography, see Margit Rowell, "Metaphysic of Abstraction," in *František Kupka 1871–1957: A Retrospective*, exh. cat. (New York: The Solomon R. Guggenheim Museum, 1975).

4. See Tomáš Vlček, "Preissig's Photography (Pressigovy fotografie)," *Fine Arts (Výtvarné umění)*, vol. 20 (1970), p. 269.

5. For instance, *Self-portrait* (1901), which uses double exposure, shows the artist slaying his alter ego.

6. Josef Váchal often poked fun at artists, including himself, in his books. He ridiculed artists and their self-conscious image in one of his early satirical manuscripts at the turn of the century.

7. The Pictorialist movement was represented by the ČKFA (Czech Club of Amateur Photographers) in Prague (founded in 1889) and by its organ, the monthly *Photographic Horizon (Fotografický obzor)*.

8. Vladimír Bufka also wrote on photography in *Veraikon*, the first Czech art magazine devoted exclusively to printmaking, which was founded by three members of the group Sursum in 1912.

9. He and his brother Karel Čapek wrote articles on film from 1910 on. For additional discussion, see the essays "Artists as Filmmakers" and "In Search of Redemption: Visions of Beginning and End" in this book.

10. The tendency to link both mediums culminated in the exhibition *Film und Foto* in Stuttgart in 1929.

11. For instance, Jindřich Štyrský, "Picture (Obraz)," *Disk 1* (1923), pp. 1–2; Karel Teige, "Painting and Poetry (Malířství a poesie)," *Disk 1* (1923), pp. 19–20; Karel Teige, "Poetismus," *Guest (Host)*, vol. 3, nos. 9–10 (1924), pp. 207–209; Karel Teige, "Pictures (Obrazy)," *Veraikon*, vol. 10, nos. 3–5 (1924), pp. 35–40.

12. Jaroslav Rössler had become a radio amateur in the 1910s, long before Devětsil artists expressed their interest in radio. See Karel Teige, "The Poetry for the Five Senses (Poesie pro pět smyslů)," *Zone (Pásmo)*, vol. 2, no. 2 (November 1925), pp. 23–24.

13. Although Jaromír Funke never became a member of Devětsil, he closely followed the group's activity. Otakar Štorch-Marien, Funke's close friend, was an important publisher of avant-garde books and periodicals.

14. See "Our Basis and Our Path: Constructivism and Poetism (Naše základna a naše cesta: Konstruktivismus a Poetismus)," *Zone (Pásmo)*, vol. 1, no. 3 (September 1924), pp. 1–2. In emphasizing the concepts of standard, function, and construction on the one hand and poetry on the other, he had indicated this dichotomy already in the essay "Foto Kino Film." Poetism gradually prevailed and for this reason has been more often identified with the Devětsil movement than Constructivism.

15. For a discussion of the Devětsil program and its impact on photography, see Jaroslav Anděl, "Construction and 'Poetism' in Czech Photography," *Photographies* (Paris), no. 7 (May 1985), pp. 121–25.

16. Besides his Modernist work, Jaromír Funke made a number of Pictorialist pictures from 1922 to 1924 that resulted from his contacts and involvement with the amateur photographers' movement. Funke's Pictorialist work is a telling example of the close link between institutional affiliations and stylistic idioms.

17. Josef Slánský, "New Goals (Nové cíle)," *Photographic Horizon* (*Fotografický obzor*), vol. 36 (1928), pp. 83–84.

18. Alexandr Rodchenko, "The Paths of Contemporary Photography (Puti sovremennoi fotografii)," *Novyi Lef*, vol. 2, no. 9 (1928), pp. 31–39.

19. The relationship between the Czech and the Russian avant-garde is similar in this respect. The first direct contacts date from the mid 1920s.

20. For instance, Karel Teige called for the "liquidation of art" in architecture. See Karel Teige, "Constructivism and the Liquidation of Art (Konstruktivismus a likvidace umění)," *Disk 2* (1925), pp. 4–8. At the end of the 1920s, he criticized Le Corbusier for compromising the principles of function and construction.

21. Hausenblas' *Eiffel Tower* (*Eiffelova věž*, 1928, cat. no. PH56) was included in the *FiFo* exhibition.

22. Hausenblas and Rossmann studied at the Bauhaus.

23. Prominent Czech architects and designers, including Jaroslav Fragner, Josef Havlíček, Karel Honzík, Jaromír Krejcar, and Zdeněk Rossmann, photographed and collaborated with leading photographers and filmmakers such as Jaromír Funke, Josef Sudek, and Jan Kučera.

24. See Jan Lauschmann, "Along the Stream (Po proudu)," *Photographic Horizon* (*Fotografický obzor*), vol. 36 (1928), p. 6.

25. "News photography, one of the oldest disciplines of professional photography, is indeed a prototype of functional photography. For this reason, it is becoming a more and more evident motto of the day. *Functionality is the motto of the photographic progress!* To be progressive in photography means to insist with an uncompromising and healthy attitude that photography is not art" (Jiří Jeníček, "News Photography [Reportážní fotografie]," *Typografia*, vol. 42 [1935], p. 27).

26. Aventinum published the periodicals *Gentlemen, The Aventinum Discourses* (*Rozpravy Aventina*), and *Studio*, in which a number of articles by Alexander Hackenschmied and Ladislav Berka appeared.

27. Among other things, they initiated regular film reviews in daily newspapers. Ladislav Berka became a co-editor and art director of the pictorial weekly *Ahoy* (*Ahoj*), Alexander Hackenschmied contributed regularly to the pictorial *Weekly Variety* (*Pestrý týden*) and directed its film section, and Jiří Lehovec was a co-editor and art director of the pictorial weekly *World and Home* (*Svět a domov*).

28. The Devětsil periodicals included documentary and scientific photographs. The magazine *ReD* (*Review of Devětsil*) often combined scientific, technical, and documentary photographs with reproductions of paintings, sculptures, and abstract photographs.

29. *Von Material zu Architektur* (1929, published in English under the title *The New Vision* in 1930) by László Moholy-Nagy, probably the most influential publication on modern art between the two World Wars, credited *Weekly Variety* (*Pestrý týden*) for more illustrations than any other source.

30. Although the term *Neue Sachlichkeit* was also associated with German typography, photography, and to some extent architecture, it originally referred to a movement of Realist figurative painting in the early 1920s.

31. See Karel Teige, "Photo-Typography. The Use of Photography in Modern Typography (Fototypografie. Užití fotografie v moderní typografii)," *Typografia*, vol. 40, no. 8 (1933), pp. 176–84. Moholy-Nagy coined the term *typofoto* in his *Painting, Photography, Film* (*Malerei, Fotografie, Film*, Munich: Albert Langen, 1925, 1927), pp. 36–38.

32. While the previous generation of photographers, including František Drtikol and Vladimír Bufka, made a living by making portraits, Josef Sudek, Jaroslav Rössler, and other leading photographers specialized in advertising photography and collaborated with publishing houses and pictorial weeklies.

33. See *Avant-Garde Photography in Moravia in the 1930s* (*Avantgardní fotografie 30. let na Moravě*), exh. cat. (Olomouc: Oblastní galerie výtvarného umění, 1981), essay by Antonín Dufek. Dufek's exhibition and articles rediscovered the group.

34. The association of the avant-garde movement with social radicalism had a long tradition. See Donald E. Egbert, *Social Radicalism and the Arts—Western Europe* (New York: Knopf, 1970).

35. See Karel Teige, *Economical Housing* (*Nejmenší byt*, Prague: Václav Petr, 1932).

36. Jiří Kroha, *The Sociological Fragment of Housing* (*Sociologický fragment bydlení*, Brno: Krajské středisko památkové péče, 1973).

37. Lubomír Linhart, *Social Photography* (*Sociální fotografie*, Prague: Jarmila Prokopová—Knihovna Levé fronty, 1934).

38. *Exhibition of Social Photography* (*Výstava sociální fotografie*), exh. cat. (Prague: Levá fronta, 1933), essay by Lubomír Linhart; *Second Exhibition of Social Photography* (*Druhá výstava sociální fotografie*), exh. cat. (Prague: Levá fronta, 1934).

39. The first major manifestation of Surrealism in Czechoslovakia was the exhibition *Poetry 1932* (*Poesie 1932*), organized by the S.V.U. Mánes in Prague in 1932.

40. See, for example, Jindřich Štyrský's and Toyen's collage and photomontage covers for Jan Bartoš, *The Haunted Mansion* (*Strašidelný dům*, Moravský Krumlov: Edice Forum, 1926) and Vítězslav Nezval, *Crooked Dice* (*Falešný mariáš*, Prague: Odeon, 1925) or Jaromír Funke's still lifes from the series *Glass and Ordinary Things* (1928). As another of Funke's series *Reflections* (1929) indicates, Funke was among the first photographers inspired by Eugène Atget's work.

41. See Karel Valter, *Linie* (České Budějovice: 1980). Fotolinie was rediscovered by the exhibition *Czech Photography 1918–1938* (*Česká fotografie 1918–1938*), organized by Moravská galerie and Antonín Dufek in Brno in 1981.

42. It has its antecedents in the ambiguities of Vojtěch Preissig's and Josef Váchal's photographs as well as in Jaromír Funke's optical puns from the 1920s.

43. For a discussion of the relationship between photography and Surrealism, see *L'Amour fou: Photography and Surrealism*, exh. cat. (Washington, D.C., and New York: The Corcoran Gallery of Art and Abbeville Press, 1985), essays by Rosalind Krauss and Jane Livingston.

44. See Pierre Naville, "Beaux-Arts," *La Révolution surréaliste*, vol. 1, no. 3, p. 27. For additional discussion of photography in the context of Surrealism in Czechoslovakia, see "Is Photography Art: Discussion (Anketa: Je fotografie uměním?)," *Worldview* (*Světozor*), vol. 35 (1936), pp. 480–88.

45. The most ambitious exhibition of Surrealist photography *L'Amour fou: Photography and Surrealism* (The Corcoran Gallery of Art, Washington, D.C., 1985) focused only on photographers associated with the French Surrealist group.

46. From the early 1930s on, most of the leading and young Czech photographers were influenced by Surrealism. A parallel development can be seen in the work of Henri Cartier-Bresson. See Peter Galassi, *Henri Cartier-Bresson: The Early Work*, exh. cat. (New York: The Museum of Modern Art, 1987).

47. See *Skupina Ra*, exh. cat. (Prague: Galerie hlavního města Prahy, 1988), essays by František Šmejkal, Antonín Dufek, Zdeněk Pešat, and Ludvík Kundera. For a discussion of the photographic activity of the group, see Dufek's essay "FotoRama," pp. 89–99.

48. Because the political developments in Germany, Austria, and the Soviet Union in the 1930s led to the end of the avant-garde movement, numerous artists found a temporary home or refuge in Czechoslovakia, including Adolf Loos, Oskar Kokoschka, John Heartfield, and Raoul Hausmann.

49. These were František Hudeček and Miroslav Hák of the Surrealist group that also included the painters František Gross, Václav Bartovský, and the critic Jindřich Chalupecký and that was the core of the later Skupina 42 (Group 42); Hugo Táborský and František Povolný of f5; and Ada Novák of Linie.

50. They called this activity *řádění*, a term that could be translated as "carrying-on."

51. See László Moholy-Nagy, *Painting, Photography, Film* (*Malerei, Fotografie, Film*, Munich: Albert Langen, 1925, 1927), p. 5.

52. The fact that both terms have been used to designate the development after World War II suggests that this period represents a transition rather than a rupture.

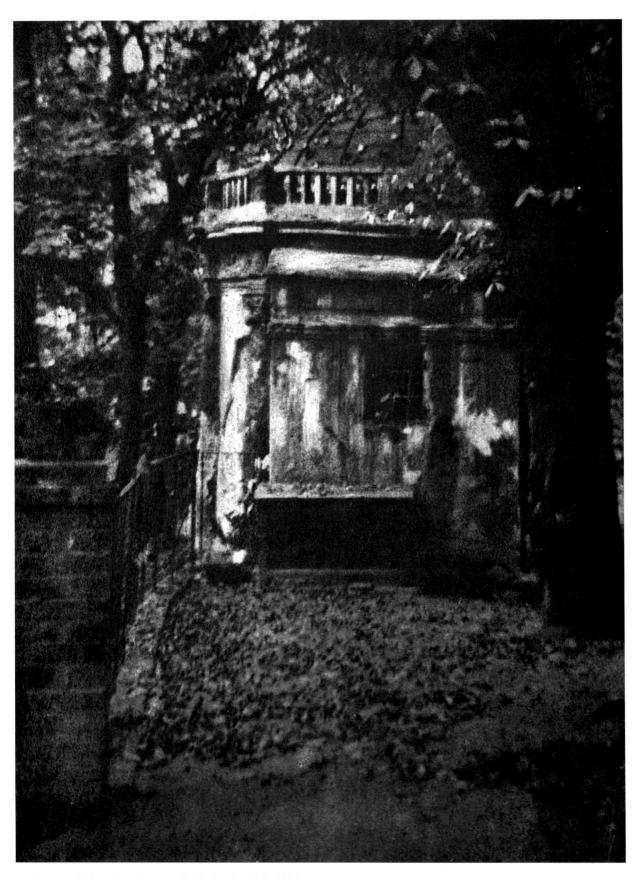

Vladimír Jindřich Bufka, *From the Košíře Garden (Z Košířské zahrady)*, 1914, Moravská galerie v Brně, cat. no. PH9.

Situation of Czech Modern Photography

ZDENĚK KIRSCHNER

Czech modern art, which since the 1890s had been showing distinct parallels to international movements in art, both by its will and by its character also incorporated national traits, frequently producing highly complex solutions to problems prompted by impulses of nineteenth-century European Romanticism. The creative freedom to turn to the independent expression of a unique national character had required that Czech artists first establish themselves in the cultural society of Europe. The literary movement calling itself in its 1895 manifesto Česká moderna was the expression of a generation of young artists of different aesthetic inclinations who shared the decision to be once again a part of that European society. Although language constraints normally prevented literary movements from easily disseminating across national boundaries, in the Czech regions historically called Bohemia and Moravia, the knowledge of languages commonly included Czech, German, in educated circles French, and often Russian. Czech artists therefore were aware of the most up-to-date European cultural themes. Also, again mainly in the literary and philosophical fields, the activity of translation was supported by Czech publishing projects systematically dedicated to individual national literatures.

Czech art of the twentieth century is firmly based in the efforts of nineteenth-century Czech society. After the scientific contributions of the Enlightenment, after the vertiginous beauty of the Romantic poetry of Karel Hynek Mácha, after Jan Neruda's opening up of Czech prose in the middle of the nineteenth century, followed by Jaroslav Vrchlický's brilliant demonstration that the Czech language knew no obstacles in interpreting foreign works or its own thoughts, the Česká moderna generation about 1900 could turn to art as an autonomous expression. The creative freedom to select thematic and formal standards allowed individual creators to return to the problems of national uniqueness and its expression.

The political environment was also shifting from the era of the Austro-Hungarian monarchy to that of the independent Czechoslovak state that emerged in 1918. The separation was fueled by the resentment in Czechoslovakia of the Austro-Hungarian Empire's unjustified and primitively contemptuous behavior toward Czechs, who nevertheless had provided the Austrian state with constantly renewed intellectual strength as well as substantial industrial and economic resources. With the liberation from the pressures of Viennese centralism came a consciousness that independence had been regained (a freedom based on the French Revolution, the American Constitution, and the Russian experience), that the Czech state proper was growing, and that after centuries of suppression, provincial Prague was once more a capital city.

Where did photography—a peripheral component of the fine arts still suffering from the indictment of being a technical servant unable to create a work of art—fit into these events?

The Czech press needed only a few weeks to acquaint the public with photography's invention after Daguerre made his announcement in 1839. Experimenters, and soon after them painters and chemists, quickly developed the first images breathed onto little metal plates. Although the evolution of photography in the Czech regions paralleled that of other countries, it also reflected national themes, both in the landscape and architectonic work made by Czech professional studios and in a great body of less commercial work of clearly Czech provenance. For example, Jindřich Eckert (1833–1905), who made studio portraits such as *Prague Dandy* (1868) or *Auguste Rodin* (1902) and photographed the Czech landscape, also made roentgenograms in 1896.

After the turn of the century, two Czech photographers with studios in Prague rivaled one another for preeminence in the Pictorial photography salons as well as in commercial portrait work: Vladimír Jindřich Bufka and František Drtikol. Few photographs by Bufka (see cat. nos. PH8, PH9), who died of tuberculosis in 1916, are preserved, but Drtikol, a prize-winning graduate of the Munich Photographic Institute, created a bridge between the photography of the pre-war era and that of the free Czechoslovak state. He eventually abandoned Art Nouveau Pictorialism, which he had mastered and about which he wrote specialized articles, to absorb elements of Cubism, Constructivism, Art Deco, and Expressionism. He was not, however, an unoriginal and unthinking eclectic, as this list of "isms" might imply. Even after the acceptance of a new canon, he was still able to return to older styles because the creation of each

Josef Sudek, *The Third Courtyard of the Castle, Prague (Třetí nádvoří Pražského hradu)*, 1936, Museum of Fine Arts, Boston, cat. no. PH144.

Jaromír Funke, *Composition: White Ball and Glass Cube (Kompozice. Bílý míč a skleněná krychle)*, 1923, collection family of the artist, cat. no. PH25.

Drahomír Josef Růžička, *The Struggle for Life, California (Boj o život)*, 1918, Kicken-Pauseback Galerie, Cologne, cat. no. PH116.

photograph was such a private and personal act; contemporary or fashionable considerations were unimportant. He demonstrated this in the first half of the 1930s when he turned away from photography at the moment that it ceased to give him the certainty that he was solving problems he considered important. His program from the beginning was to deal with basic human questions. For Drtikol, each photograph was a duel with the subject—with the model, with the woman or man, with the idea—as well as a struggle for expression. The psychological penetration of a person whose face he photographed or the attempt to interpret the human body by photographing the nude follows a long road from Symbolist photographs to works where the body is used in studies of shape as well as in poses echoing philosophical meditation (see cat. no. PH17). His work comprises an undoubtedly Central European expression from the first thirty years of the twentieth century.

Independent and modern Czech expression in photography, however, had to wait for the next generation, best characterized by such artists as Jaroslav Rössler, Josef Sudek, Jaromír Funke, Adolf Schneeberger, and Jan Lauschmann. The catalyst releasing them from the regime of contemporary amateur associations, where the "noble print" still ruled supreme as the expression of artistic photography, was provided by Drahomír Josef Růžička, a Czech physician living in the United States who periodically visited Czechoslovakia. Although he used soft lenses and other elements from the Pictorialist tradition, he still opened up the possibility of pure, straight photography (see cat. nos. PH116, PH117). The young photographers absorbed his lessons with gusto. Some of them were expelled from amateur photographers' clubs because of their vigorous fight for the new photography, going on to found the Czech Photographic Society (ČFS, Česká fotograficá společnost). Shy Rössler, who worked in Drtikol's studio as an apprentice and later an assistant, created in the after-work hours probably the first Czech photograph with clear Cubist stylistics. In 1924–28 Sudek produced *Saint Vitus*, a portfolio of original photo-

František Drtikol, Untitled: torso, c. 1925, Moravská galerie v Brně,
cat. no. PH17.

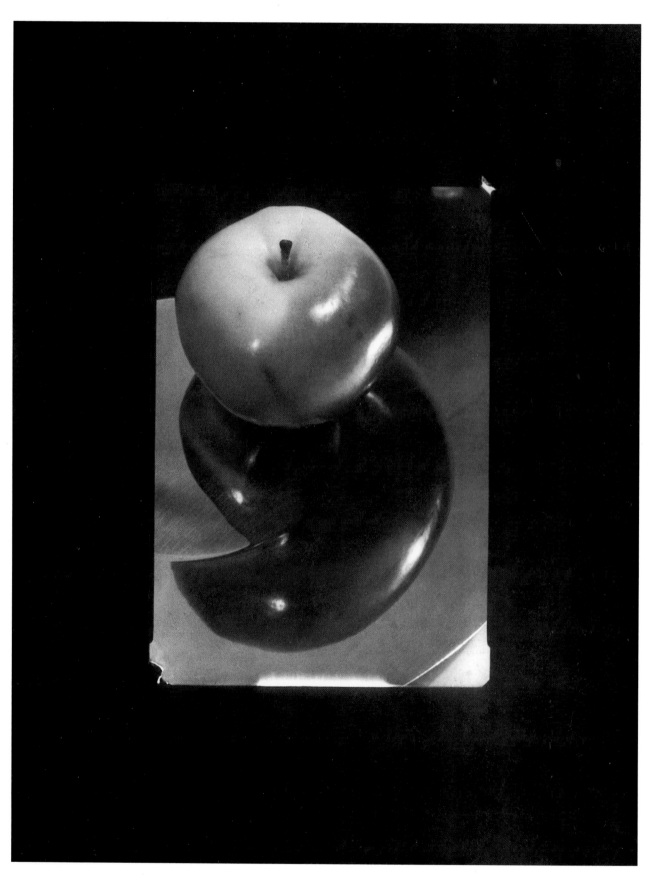

Josef Sudek, *Apple on Tray (Jablko no podnosu)*, 1932, Moravská
galerie v Brně, cat. no. PH141.

■ KIRSCHNER

graphs on the Prague cathedral, while collaborating with the publishing house Cooperative Work (Družstevní práce). Working with the designers of this publishing house, namely with Ladislav Sutnar, Sudek also made truly modern advertising photographs. In the 1920s he began as well to produce independently many modern views of Prague (see cat. no. PH144). Funke, who became a teacher at the Prague School of Graphic Arts in 1935 and who studied various theoretical disciplines at various universities, was a major influence both on peers and on students.

The activities of these young Czech photographers were drastically curbed during the five years of the Nazi occupation (1939–45). The magazine *Photographic Horizon* (*Fotografický obzor*), founded in 1893, ceased publication in 1941, as did a large number of other Czech newspapers and journals. In 1940 the editors Funke and Josef Ehm, however, published an important issue composed of modern photographs, risking their personal liberty and possibly their lives. Life became cruel for many artists. World War II marked for photography the ending of a glorious period.

The value of Funke's experiments from the twenties is not limited to the individual photographs and their artistic merit. Although he died before he was fifty and spent much of his life experimenting, Funke's seemingly short-lived series, while often failing to express fully his premises, remain a document of personal and aesthetic courage. He attempted—simultaneously with, and sometimes perhaps even earlier than, the photographers who gained world renown before him—to solve general photographic problems by working not only toward formal experiments but, above all, toward photography's independence from other art mediums. Funke made photograms (although he was later hostile to the form), and he experimented with light and shadow in photographs that were used for theatrical performances, but he did not live to collect his experiences; we do not know how he would have synthesized the ideas of his youth as a more mature artist. Sudek, on the other hand, who died when he was eighty, is best known for the work he made after he was sixty, including the series *Labyrinths, Remembrances, Vanished Statues*, and his panoramic landscapes.

Lauschmann, who also fought for modern photography with his pictures and articles, turned more to science and never revived his artistic creativity after 1939. Through his infatuation with white color, be it snow or white-washed walls, his modern bridges spanning old rivers, and the curves of architecture with cast shadows and the play of light in modern houses, he paid tribute to modern times and feelings. Finally, Rössler, who would not meet with strangers even when asked to portray famous people, ceased to photograph for many years. Only much later as an old man did he add new experiments to his early work and to the art he created in photographs for advertisements.

At the beginning of the 1920s Czech photography for the first time demonstrated that it was able to participate in the creative processes of its time on the same traditional level as Czech literature and other contemporary fine arts. This participation was without any sense of national pettiness or futility. The liberation and hope brought by the end of World War I allowed photographers a creative freedom from already stale forms and tasks.

The works by Funke, Sudek, Rössler, and others contributed to the development of fine art photography by simply and emphatically formulating arguments to justify photography against those who undervalued it by pointing to its technical dependence. Through their work they demonstrated the tenet of modern art that photography—like other mediums—best maintains creativity by preserving its unique properties and accepting its expressive and technical limitations. Then it is equally capable of interpreting human existence.

The brief span of twenty years given to Czechoslovakia between the two world wars was one constant explosion of new activity in all cultural areas, and the spectrum of photography in Czechoslovakia was broad. After World War II only two of the originating spirits in Czech photography could continue in their work—Sudek for another thirty years and Rössler after a creative lull of twenty years. However, another crop of young photographers appeared in the thirties and forties, and gifted young photographers continue to emerge with every generation.

Dr. Zdeněk Kirschner is chief curator of applied graphics and photography at the Museum of Decorative Arts, Prague (Uměleckoprůmyslové muzeum v Praze).

Translated by Jitka Salaquarda

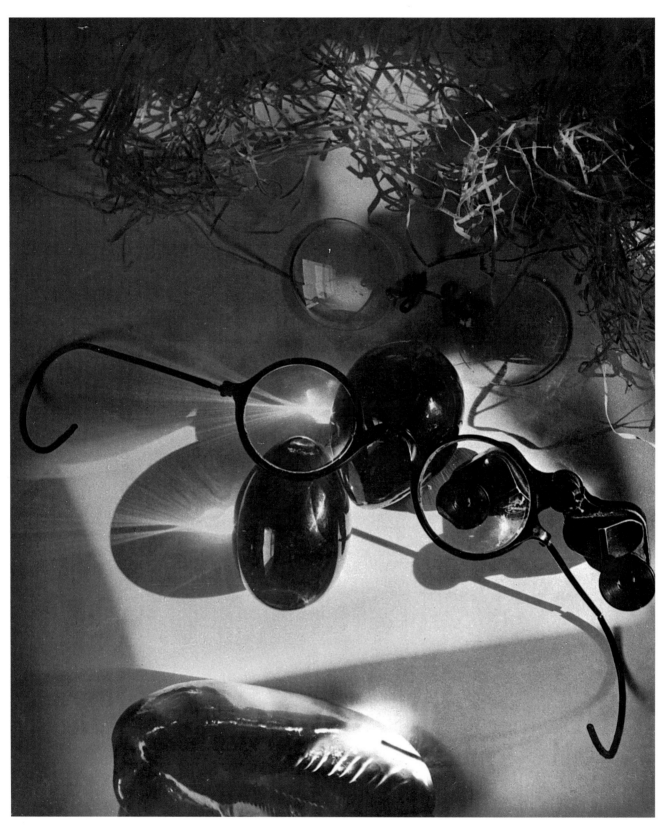

Jaromír Funke, *Face (Tvář)*, 1928, from the series *Glass and Ordinary Things (Věci skleněné a obyčejné)*, Moravská galerie v Brně, cat. no. PH37.

Imaginative Photography

ANTONÍN DUFEK

World War I and the establishment of the Czechoslovak Republic created a definite drift in the orientation of Czech photography as a new national freedom changed the cultural situation. It was no longer necessary to manifest "soulfulness" and to defend artistic stylization, as was characteristic of the starting phase of Modernism. After the war the older generation of amateur photographers continued working in the Art Nouveau style of Pictorialism, but the younger generation accepted the purist Pictorialism of Drahomír J. Růžička, the Czech-American pupil of Clarence H. White. In the second half of the 1920s, amateur photography began a rapprochement with the domestic and international avant-garde, and about 1930 the "new photography" was fully established. The ivory tower of the photographic salons had been subverted by the explosive growth of illustrated magazines, opening photography to a new and expanded social domain.

The Czech avant-garde of the 1920s, represented by the Devětsil association, was a genuine vanguard, and the dual Devětsil program—Constructivism and Poetism—included photography. Constructivism functioned as a link with the international avant-garde, but Poetism was a specifically Czech contribution to the postwar euphoria. Celebrating life values, it represented an irrational counterpart to Constructivism. In contrast to the Constructivist works of Devětsil photographer Jaroslav Rössler (see cat. no. PH103),[1] Man Ray's photograms and photographs (admired and published by Devětsil as early as 1922) were accepted as an expression of Poetism. If László Moholy-Nagy was revered as a teacher of Constructivism, with the further sanction of the Bauhaus, Man Ray was loved by the avant-garde and accepted as one of its own. In Czech culture of the 1920s, Poetism played a role similar to that of Surrealism in France, which was a reason why Surrealism was accepted in Czechoslovakia at a relatively late date, as František Šmejkal has discussed. The former creators of Poetism, Vítězslav Nezval and Karel Teige, eventually became strong proponents of Surrealism.

JAROMÍR FUNKE BETWEEN POETISM, SURREALISM, AND "EMOTIONAL" PHOTOGRAPHY[2]

The creative dialogue between the versatile Jaromír Funke and Man Ray apparently did not begin until 1926, when Funke created several photograms, one of which shows a face composed of "imprints" of different objects (cat. no. PH33).[3] In the following year Funke declared himself opposed to "photography" without a camera,[4] having moved logically from still lifes with the objects creating shadows toward nonfigurative shadow plays (1927–29; see cat. nos. PH35, PH36), which visually resembled photograms or frottages. These works (called *Abstract Photographs* [*Abstraktní fotografie*], *Compositions* [*Kompozice*], or *Black and White* [*Černá a bílá*]) were also used on stage to create the atmosphere of a primeval forest.[5] Many of these shadow plays have the oppressive feel of a dynamic labyrinth of all possible directions. Interweaving organic and geometric shapes evoke the creation or destruction of primeval matter. It is as if the experimenting photographer has been dragged into the underworld of shadows. Funke's work approaches the central principles of Surrealism, which would suppress conscious control over composition to give rein to unconscious associations. His photographs have a closer affinity with the mechanical or formal automatism of André Masson and the frottages of Max Ernst than with psychic automatism, which uses dream images and spaces in its associations. Therefore, although Funke's nonfigurative shadow plays sometimes are considered Constructivist,[6] their suggestive capacity undoubtedly points to Poetism.

Funke created another alternative to photograms by photographing the surface arrangements of objects rather than imprinting their shapes on light sensitive paper or a negative. These variations on then-fashionable tabletop still lifes remind today's viewers of assemblages, and it seems a pity Funke did not fix his models. (Similarly, some still lifes by Josef Dašek and Josef Slánský show elaborate objects that should be regarded as rare Constructivist sculptures.)[7] One of the photographed assemblages *Face* (*Tvář*, 1928, cat. no. PH37, from the series *Glass and Ordinary Things* [*Věci skleněné a obyčejné*]), which parallels the photogram of 1926, shows a face constructed from eyeglasses and other objects. Both the Arcimboldo principle[8] and the eyeglasses motif became a tradition in the following decades in works by Josef Sudek, Karel Kašpařík, Vilém Reichmann, and Karel Tichý, just to name a few.[9] Unlike those of Arcimboldo, however,

Funke's faces are depicted frontally: the objects watch the man. The ambiguity in animate/inanimate relations is a characteristic Surrealist theme.

Although other of Funke's photographed assemblages from the end of the 1920s resemble Man Ray's films, both in content (for example, starfish, shells, hummingbirds) and in concept, they also reflect Nezval's verses or Teige's sentences from the last Poetist manifesto *Conclusions* (*Závěry*), written by Nezval and Teige. Funke's compositions are the closest parallel to Poetism in Czech photography, remaining as distant from Surrealism as the majority of Man Ray's work in the 1920s. It is necessary to recall that at the time Funke himself was not talking about Poetism or Surrealism but considered himself to be the protagonist of a new direction—photogenism:

> This, a totally new direction here and perhaps also abroad (at least, we have no information to the contrary) not yet elaborated, has already reached a certain stage, and, of course, its future has a great potential. Our photogenism wishes to be the photographic counter-pole to the unphotographic but photogenic Man Ray, who proceeds much more from fine arts and painting than from photography.[10]

When Funke in 1940 described the logical development of his work, he wrote about his lyrical (Poetist) assemblages: "There is only a little step from this concept of photography to the search for fantastic elements in nature itself."[11] Once he had brought depiction of light and shadow to the very limit of possibility, Funke returned permanently to the objective world. In 1929 he produced the series *Reflections* (*Reflexy;* see cat. no. PH38), originally titled *Glass and Reflection* (*Sklo a odraz*), evidently inspired by Eugène Atget's work, which had been published since 1926 by the Paris Surrealists. In Atget's photographs, more than in their own photography circles, the Surrealists found confirmation of André Breton's fundamental thesis that a supra-reality is contained in reality itself rather than someplace above or outside of it. Atget's work was a revelation for many photographers, and Funke was one of the most important photographers to feel this influence. The series *Reflections* is probably the first Surrealist-oriented reaction to Atget's work. It consists of photographs of store windows, where the worlds in front of and behind the glass appear to meet in a miraculous and grotesque supra-reality. The principles of objective coincidence, convulsive beauty, and above all, chance encounter are operative, while the cycle foreshadows Pop Art's merchandise fetishism. The blending of incompatible realities in the store windows was especially important for Funke because it replaced the photomontage that, as an extreme purist, he had rejected.

Reflections, together with the series *Time Persists* (*Čas trvá*, 1930–34), *The Uncommon of the Common* (*Nevšednost všednosti*), and *The Unsated Land* (*Země nenasycená*, 1940–44), represents an outstanding manifestation of Surrealism in photography. Like the series *Reflections*, *Time Persists* depicts glass reflections and also utilizes chance confrontations of objects of unequal size and importance, grotesque names, and architectural details to establish its themes. (A shot of an optician's advertisement about 1932 [cat. no. PH41] recalls a famous photograph by Manuel Alvarez-Bravo from 1931.) Although the series is not uniform, its dominant works produce a subdued feeling, as does *The Unsated Land*, which takes its theme from cemeteries, a theme that had already appeared in photographs by Jindřich Štyrský. The most impressive picture of this series made during World War II, depicts an arm protruding through fallen leaves. The war updated the Surrealist theme of the power of biological life-forms, a theme that permeates *The Unsated Land* series.

Funke's photographs, closely linked to Surrealism, find Breton's supra-reality (magic, poetry, absurdity, the fantastic, the grotesque, convulsive beauty) directly in reality: Funke's shots were found, not constructed. While such photographs were the exception in France and elsewhere, even in later years, a number of important photographers in Czechoslovakia devoted themselves to the discovery of the fantastic in everyday reality. It was through photography that Czech art made its most substantial contribution to Surrealism.

Funke, however, saw his own work differently. He preferred to keep his distance from the "isms" of the day, creating his own "isms" instead. His depiction of the "uncommon in the common" was included in his own theory of emotional photography. He definitely was not an orthodox Surrealist, many of his images surpassing the framework of Surrealism and touching on visual jokes or rational metaphors.

IMAGINATIVE AND SURREALIST STRAIGHT PHOTOGRAPHY

Unlike Funke's work, the photography of the painter and creative spirit Štyrský, a member of the Surrealist Group since its foundation in Prague in 1934, formed an authentic component of Surrealism. Aside from the author's book jackets and the unique erotic photomontages that accompanied his published Surrealistic text *Emilie Comes to Me in a Dream* (*Emilie přichází ke mně ve snu*, 1933, see cat. no. PH128), all Štyrský's photographs are records of immediate reality. Most of them were made between 1934 and 1935 in Prague and Paris. Štyrský divided them into the series *Frog Man* (*Žabí muž*), *Man with Blinders* (*Muž s klapkami na očích;* see cat. no. PH129), and *Paris Afternoon* (*Pařížské odpoledne;* see cat. no. PH134), but he did not limit their inclusion to these cycles. A free selection of photographs was published with verses by Jindřich Heisler in *On the Needles of These Days* (*Na jehlách těchto dní*, 1941, see cat. nos. PH130–PH134). Štyrský's photographs received from the Surrealists a manifesto-like emphasis, seventy-four appearing in the *First Exhibition of the Surrealist Group in the Czechoslovak Republic* (*První výstava Skupina surrealistů v ČSR*) and a

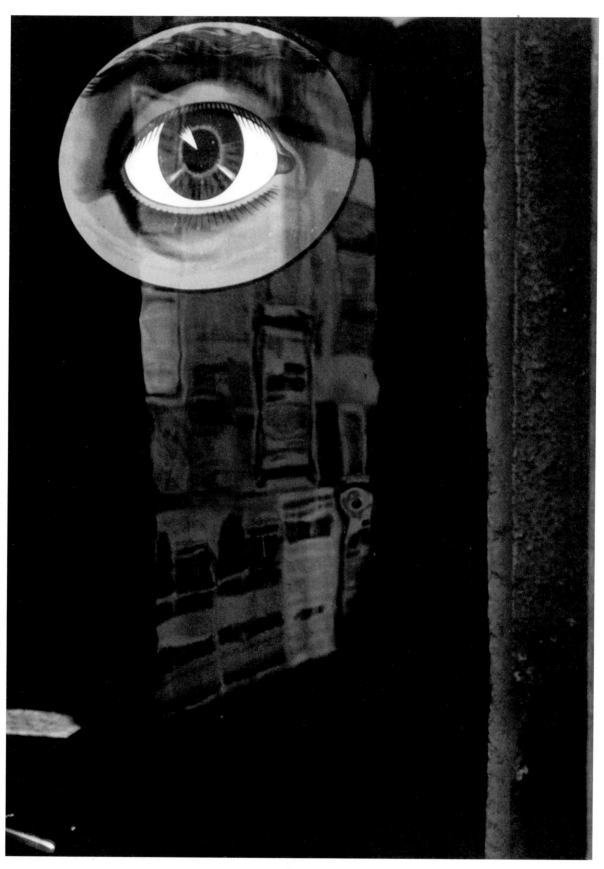

Jaromír Funke, Untitled, 1932, from the series *Time Persists (Čas trvá, 1930–34)*, The Museum of Fine Arts, Houston, cat. no. PH41.

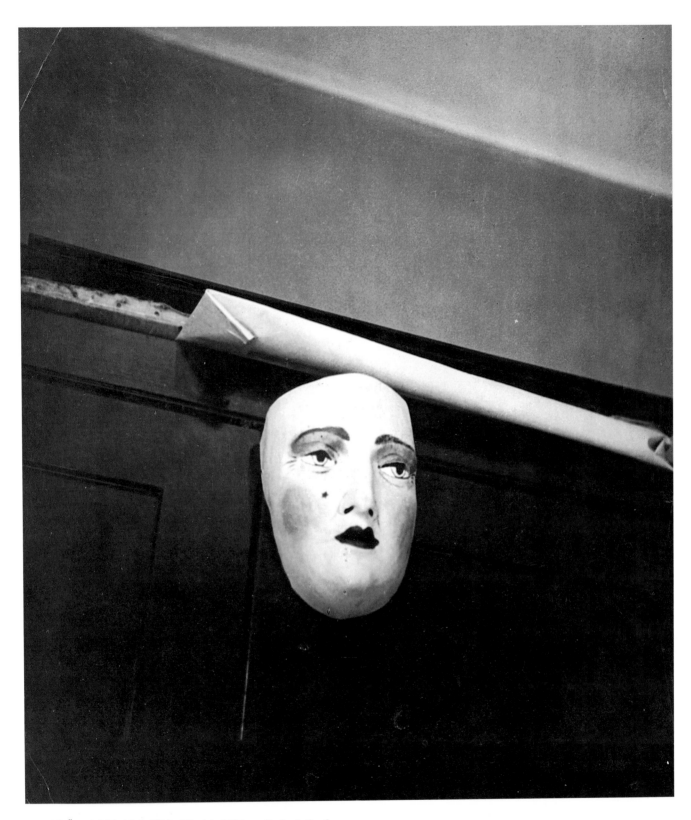

Jindřich Štyrský, Untitled, 1934–35, plate VII from the book *On the Needles of These Days (Na jehlách těchto dní),* published 1941, Uměleckoprůmyslové muzeum v Praze, cat. no. PH131.

strong representation being made in subsequent photographic exhibitions (including Štyrský's 1946 exhibition in Prague).

Like Funke, Štyrský continued in Atget's footsteps, intrigued by the "concrete irrationality" of objective reality as interpreted directly by photography. His point of departure was the objet trouvé or found object theory and Surrealist interpretations of the object in general. In Czech Surrealism special attention was devoted to the theory of the object. In the article "An Attempt to Understand the Irrationality of Photography (Pokus o poznání iracionality fotografie)" one of Štyrský's photographs is interpreted in the form of a questionnaire answered by Nezval and Štyrský.[12] These interpretations of objects and photographs published by the Surrealists aid the "reading" of their photographic works.

Štyrský's most interesting photographs are those images of the urban environment dominated by cultural products, be they store windows, posters, and still lifes from fairs and markets or graffiti found on walls and fences (see cat. nos. PH129–PH133). (Brassaï also began to document graffiti in the early 1930s.) Štyrský was fascinated by kitsch, primitive art, fashion and hairdressing salon mannequins, prostheses and other artificial simulations of human bodies, chance encounters of objects, symbolic objects, eroticism, obscurity, mystery, and culture reduced to the grotesque. His photographs are an expression of the principles in Breton's *Nadja* and similar texts, embodying the essence of Surrealism.[13]

In keeping with the principle of objet trouvé, Štyrský's images represent objects liberated from function and revitalized through contact with the observing eye. Categorized as Magic Realism, Štyrský's photographs, according to Teige, "capture commonplace and bizarre realities with documentary fidelity, doing so with merciless precision and unusual, quite impersonal technique, without any intentional or artificial arrangement of the theme, nor awaiting interesting light conditions."[14] Even Funke, the professional photographer, was unconcerned with the formal value of his "documentary" series, which most closely correspond to Surrealism. This lack of concern was intentional. In this context Surrealism was as important for photography as photography was for Surrealism. While creative photography had as one of its goals differentiation from a document, Surrealism sparked work whose documentary quality—in the sense of maximum preservation of the authenticity of the depicted object—was the fundamental condition. The less than brilliant execution of the prints and the taking of "banal" shots that failed to attract attention with their composition magnified the authenticity of photography. The immediate linkage of photography to the concrete reality of its subject, that capacity of the medium to preserve the "here and now," produced an exciting aesthetic contrast between unstylized reality and imagination, between the external and the internal model, between the reality "such as it is" and a fantasy of the perceived subject.

Štyrský's images generally are viewed in the context of books or exhibitions on Surrealism. With the passage of time, another context emerges. The photographs of this prominent Surrealist can also be seen as fascinating documents of a civilization now extinct, similar to the photographs of Walker Evans. Furthermore, from the viewpoint of post–World War II art, Štyrský can be considered one of the important forerunners of Pop Art.

Among Czech photographers, Štyrský found a faithful follower in Jiří Sever[15] who began making photographs about 1940 and was close to the Skupina 42 (Group 42). His photographs were first published in 1946 in the *Listy* magazine, edited by Jindřich Chalupecký. Until he died in 1968, Sever created some forty series, which he bound into portfolios with titles. Each series contains about twenty sequenced photographs. Sever, who was a friend of Zdeněk Lhoták and Richard Weiner, was also influenced by decadent literature, the writing of Pierre Mac Orlan and Paul Morand, French poetry, and last but not least, jazz—a musical taste he had acquired in the 1930s when he lived for many years in the United States. Sever used a wider range of motifs than Štyrský, and he accentuated the passage of time in his portfolios. Sever's contribution to photography was the creation of a context through the set sequence of images in a portfolio, the most frequent being an imaginary walk with an action subtext. Over the years his work became subject to aestheticism and started to lose its easy communicability.

The work of Reichmann, one of the great Czechoslovak photographers, crystallized during the 1930s. His photographs, including a number of his most famous images made about 1940 and just after World War II, were revealed to the public at the exhibitions of the Skupina Ra (Group Ra), of which he was a member. Although Reichmann started out fascinated by civilization's objects, he reacted to the new social situation with new visual metaphors. Orthodox Surrealism was only one of the sources of Reichmann's all-encompassing lyricism, expressed in images containing a powerful emotional charge rarely found in the work of other photographers.

Reichmann's series *Wounded City* (*Raněné město*, 1945–48) is a reaction to World War II. Although outside the framework of war documentary and photojournalism, the shots of damaged buildings and objects in postwar Brno are as effective as battlefield shots in expressing war's destructive force: the lifeless reality accuses the viewer. Also from the 1940s are the photographs later arranged into Reichmann's most important series *Metamorphoses* (*Metamorfózy*), *Abandoned One* (*Opuštěná*, see cat. nos. PH98, PH99), *Couples* (*Dvojice*), and *Magics* (*Kouzla*). He used the principles of convulsive beauty, miraculous encounters, and incompatible realities in these photographs, but instead of a libidinous motivation, Reichmann usually was interested in the use of metaphors to humanize the inanimate world. Although his work expresses the symbolic struggle between Eros and Thanatos actualized by the war, as well as the dominance of

Vilém Reichmann, *Abandoned One (Opuštěná)*, 1941, Moravská galerie
v Brně, cat. no. PH99.

■ DUFEK

biological forms of life (for example, *The Meshes* [*Osidla*, 1940]), many of the images convey anguish and absurdity in a uniquely existentialist way.

Miroslav Hák was a versatile experimental photographer (see cat. no. PH47–PH52) and member of Skupina 42 whose photographs taken during the war and liberation of Prague resound with the Magic Realism of Atget, Štyrský, Funke, and Reichmann. His few published photographs from the forties include some of the most effective works ever created in this genre. About 1950 Hák created the series *Nature the Magician* (*Divotvorná příroda*), in which he observed the anthropomorphic shapes of plants, following in the steps of Brassaï (Hák "repeated" his seeded potato) and Reichmann.

Isolated photographs of found objects in the Surrealist spirit were also created by František Povolný, Sudek, Eugen Wiškovský, Emila Medková, Jiří Linhart, Václav Zykmund, Josef Ehm, and others. The tradition remains a viable movement today. In photography influenced by Surrealism, the main intent was not to follow the formation of objects or to grasp their material character subject to natural laws and functions but to recognize the dependence of the object on the perceiving subject and to produce a new interpretation of reality that expressed an age in shock, an age that had lost its belief in optimistic rationalism. As photography began to grasp the "concrete irrationality," objects were partly dematerialized, perceived now as symbols or expressions of motivations whose character and meaning lacked absolute certainty. Photographs by Štyrský and others suggest that things created for a purpose are not exhausted by their function. Function merely protrudes above the surface of mystery, a mystery that triggers the memory, fantasy, and emotions of the spectator. Surrealist photography offers access to an interpretational freedom that allows individual acquisition and internalization of external reality. Should the spectator prove unable to engage in such acquisition, the depicted object remains a mysterious, even indifferent, fetish.

Surrealist photography can be considered the core of imaginative photography. Mystery is preferred to interpretation, which is nearly always abstract and relates to only a few life principles, mainly to Eros, Thanatos, and their struggle. The photographed concrete reality represents variations on this abstract symbolism. The photographs are effective, though viewed one after another can become monotonous. This is more applicable to Štyrský's photographs; Reichmann usually selected objects and situations that could activate both profound and superficial layers of the psyche. It is not easy to differentiate between Surrealism and imaginative photography, but it would be a disservice to Surrealism to consider every photograph appealing to fantasy as Surrealist.

THE PRINCIPLE OF ARRANGEMENT AND STAGING

Surrealist and imaginative photography depicts not only found objects but also constructed, arranged, and staged objects and situations, sometimes including people. It is interesting to note that by the mid 1930s even fashion photography for *Vogue* exploited the chance-encounter method. The Czech contribution to Surrealism expressed in staged arrangements should not pass unnoted. ▪

Aside from Funke's Poetist assemblages, the first Surrealist photographs of arranged objects emerged from the Photo Group of the Five (Fotoskupina pěti) or f5, which was formed at the School of Arts and Crafts in Brno. Composed primarily of students of the Functionalist graphic designer Emanuel Hrbek, the group was led by Povolný. His *Doll* (*Panenka*) and a self-portrait (1933–34, cat. no. PH91) were exhibited in 1934, and other untitled images (violin and eggs, mirror, masks) existed prior to 1936. Some of these works are extraordinary in the Czech environment because of their threatening symbolism, such as a mirror with a cushion and a fish hook: his photograph of a powerless doll was perhaps inspired by Moholy-Nagy. The remarkable shots of Surrealist objects by another f5 member, Jaroslav Nohel, although undated, were created between the years 1934 and 1939. One of Nohel's objects contains a planted potato (see cat. no. PH81), reminiscent of Brassaï's photograph on an identical theme published in *Minotaure* (no. 5, May 1934).

While the f5 members concentrated mostly on laboratory processes rather than on the actual creation of Surrealist objects, František Vobecký devoted himself in the years from 1935 to 1937 to the systematic photography of autonomous surface assemblages in which he combined details of his own photographs with objects and engravings. Following the example of Ernst's collages, he also created several series evoking mysterious tales of imaginary figures (see cat. no. PH177). Vobecký's photographic work is related not only to French Surrealism but also to Vobecký's painting and to the Czech imaginative art of the 1930s, as suggested by the title of the important Prague exhibition *Poetry 1932* (*Poesie 1932*). Vobecký created his photographs as pictorial poetry, where lyrical and epic components alternate and blend.

The painter, art historian, and theoretician Zykmund, member of the post–World War II Neo-Surrealist Skupina Ra (Group Ra), had been making photographs since the first half of the 1930s. His work includes remarkable direct photographs as well as photograms and experiments (for example, a 1936 enlargement made on crumpled cellophane instead of film). His perfectly executed studio nudes and portraits show an affinity both with Man Ray (masks) and with Brassaï, although the similarity in composition to the latter may be accidental. Of greatest importance, however, are Zykmund's symbolic stagings.

Zykmund made a few stagings in the early 1930s; for instance, the image of a pocket watch in a mirror goes back as far as 1933. A 1935 photograph shows a hand protruding from a drape—one of the more common Surrealist symbols. From the following year a series using playing cards and a fashion figurine has been preserved: a photograph of cards, combined with a photogram,[16] was used from the same negative in a photomontage with the figurine; the same figurine

František Povolný, Untitled: self-portrait, 1933–34, Moravská galerie
v Brně, cat. no. PH91.

Jindřich Hatlák, *Illusion (Iluse)*, c. 1934, private collection,
cat. no. PH53.

Miroslav Hák, *Mask—Beetle (Maska—Brouk)*, 1935, Moravská
galerie v Brně, cat. no. PH48.

Jaroslav Nohel, Untitled, c. 1935, Moravská galerie v Brně,
cat. no. PH81.

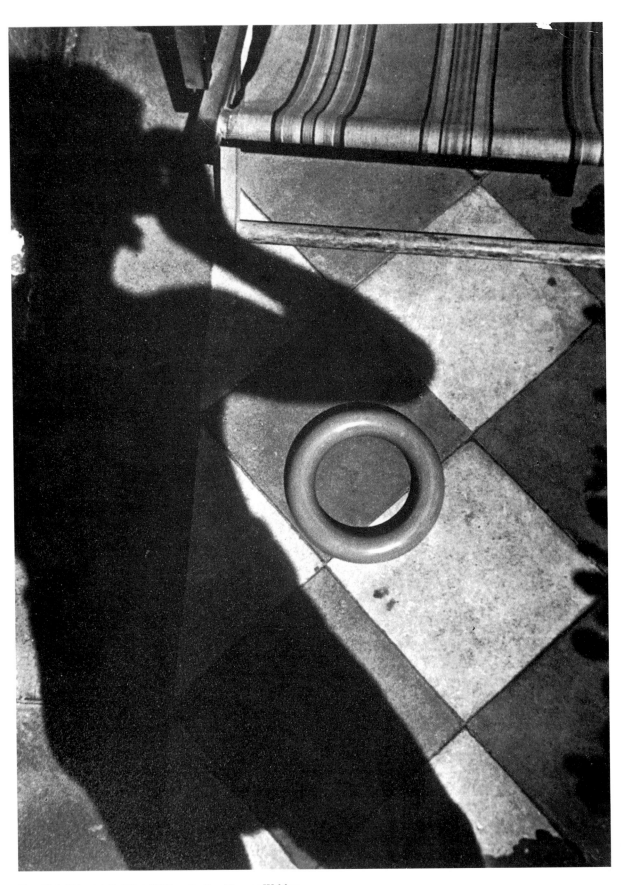

František Vobecký, Untitled, 1934, collection Thomas Walther,
New York, cat. no. PH172.

František Vobecký, *Phantom (Fantom)*, 1936, Sander Gallery,
New York, cat. no. PH177.

Václav Zykmund, *Self-portrait (Vlastní portrét)*, 1937, Moravská
galerie v Brně, cat. no. PH186.

Václav Zykmund and Ludvík Kundera, *The Menacing Compass*
(Výhružný kompas), 1944, Moravská galerie v Brně, cat. no. PH189.

was again photographed as a Surrealist object with a sepa-
rate bent hand in a glove thrown over its shoulder, pointing
toward the breasts. This series, together with a shot of a hat-
ter's store window showing mysterious mirror reflections, can
be ranked with other Surrealist works, although the figurine
also evokes a popular Poetist motif.[17]

Zykmund was assisted in 1937 by Bohdan Lacina in
making four images that symbolize time and the limitations
of human possibilities: Zykmund with a pendulum in his
teeth and a giant dial in front of him; a figure with a cape
over its head, holding a thermometer and various objects
wound in a cloth in its hands; Lacina with a pocket watch in
the palm of his hand, the shadow of a spindly plant on his
bare forearm (a motif suggesting decay that was also used by
Štyrský and other painters); and in perhaps the most expres-
sive image, Zykmund with his head in a bird's cage from
which a clock pendulum is hanging. The motif of the bird's
cage was used by René Magritte in the famous picture *Le
Thérapeute* (*The Therapeutist*, Galerie Urvater, Brussels)
from the same year, and as Šmejkal has pointed out, this
motif appeared the following year at the *International Exhi-
bition of Surrealism* in Paris, where Masson showed *Le Bâil-
lon vert à bouche de pensée* (1938, destroyed).[18] The
pendulum that appeared in Zykmund's and Lacina's pictures
later became a leitmotif for Lacina. Although the popularity
of Edgar Allan Poe might have influenced Lacina, he treated
the motif in a more abstract way. No less interesting is the
self-portrait of Zykmund, showing a profile of his head with a
light bulb in his mouth. This was a grotesque turn on the
meaning of the light bulb in modern photography. The sym-
bol of technical progress became a substitute for a breast and
an object of erotic play.[19]

With some members of the Skupina Ra, Zykmund staged
two events in 1944. For each event Zykmund arranged and
photographed objects as well as live actors on whom he had
drawn magical signs. Only Anna Korečková, later Zykmund's
wife, took part in the first event,[20] but the second event in-
volved her with Ludvík Kundera and another woman. Miloš
Koreček photographed Zykmund at work and also duplicated
several of Zykmund's shots on 35mm film with a medium
format camera. The first event resulted in the publication
The Menacing Compass (*Výhružný kompas*, cat. no. PH189)
in which Kundera's verses accompanied sixteen of Zyk-
mund's images. No book was made from the second event,
although several of Koreček's photographs were shown at the
1947 Skupina Ra exhibition. Both events, which originated
from Zykmund's ideas, can be seen as not only a development
of Surrealist games but also a precursor of Happenings,
action art, installations, Body Art, and environments.

The interpretation of the event draws on Surrealist
poetics. The two actions are connected by common symbols.
Woman is the central fetish. The dominant motif is two
female hands, one of them in a long black glove and the other
bare white skin, with drawings reminiscent of a compass.
Other common Surrealist props make repeated appearances:
cards, necklaces, eggs, veils. Some methods used to
combine objects and actors were typical of Surrealism, par-
ticularly the "short circuits" between incompatible realities
that produce an atmosphere of mystery and ambiguous
action. However, many of the realizations are inventive and
new. Wartime is evoked by the "corpse" of a half-naked man
first with a candle then with a light bulb in his mouth.
Faces are covered with drawings of signs, then with little
pieces of glass, and finally with glued-on newspapers. Hands

and various objects are "planted" in flower pots. (Other, similar creations are known from this time, for instance by Ladislav Zívr and Jaroslav Puchmertl [see PH196, PH197], as well as in contemporary sculpture.)[21]

Other effective compositions include several shots of a woman's head with objects in her loose hair and on her forehead, her closed eyes refuting associations with Medusa. (The motif of closed eyes changed its meaning in comparison to the Surrealist "period of sleep": it began to mean primarily an isolation from outer reality.) In these and similar arrangements, Zykmund's work approaches the late, mannerist phase of Surrealism, characterized by ostentatious luxury, formal refinement, and the selection of attractive motifs (e.g., Dorothea Tanning [American, b. 1913], Léonor Fini [Argentine/French, b. 1908], or Leonora Carrington [English, b. 1917] in the 1940s). Although at that juncture Surrealism was slowly reaching a prettiness bordering on kitsch, Zykmund was saved by his own inventiveness.

The mysterious labyrinth of Zykmund's making is not horrifying, even if it does contain the theme of annihilation. Zykmund's description of Czech Surrealism in general was characteristic of his photographs, as well:

> The need for a consequent poetization of reality (not only its external, sensually perceptible variety, but also the psychic one) excluded to a certain degree the so-called 'brutality' and consequent utilization of nonaesthetic moments of reality. A certain fineness, beauty of shapes, and gentleness of Poetism and Artificialism have endowed Czech Surrealism with unique traits, which have found expression even in artistic manifestations outside of painting, that is, also in photography.[22]

Staged actions similar to Zykmund's were arranged in 1938 in Amsterdam by Chris van Geel and the photographer Emile van Moerkerken. Edouard Jaguer has remarked that this activity foreshadowed the COBRA movement, New Realism, and Happenings.[23] The Skupina Ra eventually made contact with revolutionary Surrealists and future COBRA members.

Although Zykmund's photographic work represents the culmination of Czech staged Surrealist photography, isolated images, generally location staged using live actors, appear also in the 1930s work of Josef Bartuška and Kašpařík. Bartuška exploited Surrealist themes and techniques as early as the end of the 1920s, although the images of arranged objects and stagings in which his wife served as a model probably date from about 1935. Those images closest to Surrealism connect the female body with a tree and with a tailor's dummy. Kašpařík's work includes the filmlike image of a kiss (untitled, c. 1935), which, like the work of the French Surrealists, could have been inspired by Freudian theories as well as by Gustav Machatý's films.

Heisler with the assistance of Toyen (both members of the Prague and then of the Paris Surrealist groups) created in 1941 a series of "realized poems" titled *From the Dungeons of Sleep* (*Z kasemat spánku*, see cat. no. PH165). Published as a limited edition book, the text is surrounded by photographic montages (Heisler was able to follow Vobecký in this respect) that partly respond to images in the text. The double expression, by word and picture, prompts new associations, provoking a new interpretation of an already riddle-like text. The Surrealist contrast between the subjectivity of creative work and the objectivity of its realization is thereby increased. The reader-spectator is invited to participate in the interpretation, although the subject may remain impenetrable—a situation typical of Surrealism. The artist is more of an impersonal communicator of psychic apparitions. Surrealism is an impersonal art, just as much as Constructivism, Functionalism, or New Objectivity; it simply chooses irrationalism in place of rationalism.

Also in 1941 Heisler's verses interpreted the selection of Štyrský's images published in *On the Needles of These Days* (see cat. nos. PH129–PH133). Later Heisler made a substantial contribution to the creation of artists' books. His own photographs either exploit special photographic techniques or document the rarely original creation of Surrealist objects.[24]

Medková, whose photographs of found objects have already been mentioned, photographed Surrealist objects at the beginning of her creative career. Her work is usually classified as Magic Realism. Together with her husband Mikuláš Medek, an important post–World War II painter, Medková in 1951 joined the Prague group of Surrealists led by Teige and after his death by Vratislav Effenberger. At the beginning of her mature work (1948–49), she photographed Surrealist assemblages that occasionally included glass eyes (a prop that also appeared in the work of Sudek). Her best work includes the photograph *Double* (*Dvojník*, 1949), which she identified as "an attempt to illustrate a dream" related to Man Ray's stagings, and the original *Legs* (*Nohy*, 1953), one of the last arranged works. Medková concluded her career by concentrating on the photography of found imaginative objects. Her work occupies a central position in Czech postwar photography.

The consideration of whether the photograph is arranged or not arranged (direct) and the strict differentiation between the images of found objects and those created (composed) by the artist are important. In direct photography of found objects, the object is extracted—by photography or in fact—from its original place in reality and transferred into a new context without entirely losing its original place nor entirely adjusting to its new affiliation. It oscillates between the two contexts in an exciting encounter between *Wahrheit* and *Dichtung*, between reality and fiction, and in photography between the document and the vision. In arranged photography, either the object or the photograph of such an object obviously is created by the artist, and the *Dichtung* and *Wahrheit* encounter is cancelled; we do not encounter authentic reality in the context of a fiction but fiction itself. Tension

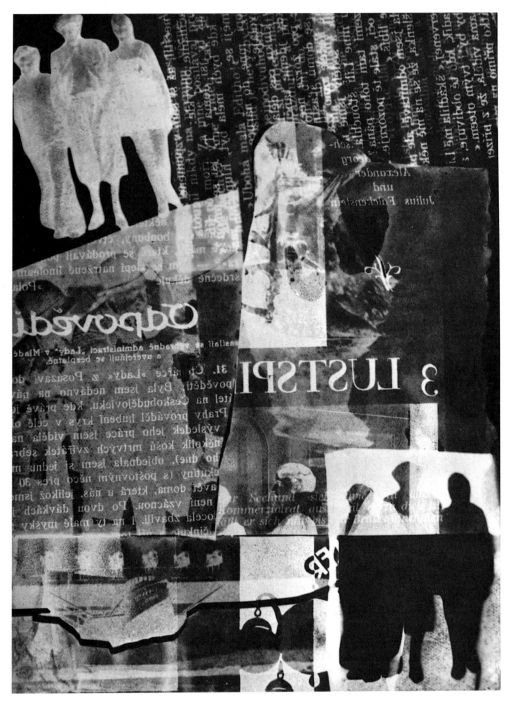

Hugo Táborský, *Answers (Odpovědi)*, 1935, Moravská galerie v Brně,
cat. no. PH151.

can be generated either by the object (for example, due to the heterogeneity of its components and the manifold significance of the whole) or by its relationship to another artificial context, such as literature. That is the case with Heisler's book *From the Dungeons of Sleep*, while his poetic accompaniment of Štyrský's direct photographs in *On the Needles of These Days* was perhaps intended to prevent their acceptance on a documentary level. Such a fear was, of course, inappropriate, and in fact verses appended to direct photographs tend to have a rather embarrassing effect; the photographs' publication in a book has already created a new context against the reality they depict, so the addition of yet another literary context disrupts the *Wahrheit* and *Dichtung* balance by the addition of another *Dichtung* weight.

SPECIAL TECHNIQUES IN THE SERVICE OF IMAGINATION

Imaginative photography also includes works that reflect the principles of montage and deformation (stylization) through the use of special photographic techniques, such as photomontage, Sabattier, photograms, glued collages of photographs, or their printed reproductions. Such techniques further loosen the binding of photography with the "here and now" of reality; the artist's vision conquers documentary tendencies and the medium becomes malleable.

Experimentation with the medium of photography developed particularly in the environment of f5 and its other variants (f3 and f4). Povolný made photograms, but he also "drew" with the developer and fixer directly on positives, as in his 1933–34 *Color Photogram* (*Barevný fotogram*). He used pictures within a picture, movement blur, deformed shadows, and the Sabattier effect, among other techniques (see cat. nos. PH191–PH193). His photographs *Apparition* (*Přízrak*) and *The Artificial Woman* (*Umělá žena*), both from c. 1933–35, are authentic Surrealist works combining photographs of faces with structures probably made by chemicals on the negative. From 1934 Povolný was a member— apparently the only photographer—of the Brno Surrealist group, which included the poets Ivan Blatný and Jan M. Tomeš. Little is known about this group, although its traces can be found even in the year 1939.[25]

The influence of Surrealism manifested itself somewhat later in the photographs of Nohel, whose work at first belonged among the purist manifestations of New Photography. Some of his montages and arranged images with poetic titles lie on the boundary between advertising and lyricism. His most interesting images are those of Surrealist objects.

Bohumil Němec's work first attracted attention with its pure poetry; later the tonality of his works darkened, and a symbolic undertone of threat began to dominate. Those images in closest proximity to Surrealism include the later arranged objects using optical deformations such as *Broken Mirror* (*Rozbité zrcadlo*) and *Paperweight* (*Těžítko*), both exhibited in 1939. Němec's experiments before 1935 recall Man Ray's work (see cat. no. PH176), but in addition to the

"relief" combinations of negatives and the symmetrical compositions around a vertical axis, Němec also made combinations of an original shot and its rotation by 180 degrees, deforming the image by inclining the surface under the enlarger. He also chemically induced color during the course of the development of the positive.

Hugo Táborský began to melt the negative to depict deformation as early as 1931. Two years later a series *Self-portrait* (*Autoportrét*), in which he gradually destroyed his image using photomontage and textural interventions, made a surprise appearance in his until then predominantly Constructivist work. His unique work *Answers* (*Odpovědi*, 1935, cat. no. PH151), a complex montage of photographs and a photogram, foreshadows Pop Art—even to the graphic qualities of the text. His photogram *Dream* (*Sen*, 1938) exemplifies the poetic and decorative repertory of Surrealism.

Similarly, a more poetic rather than Surrealist character predominates in most of the work of Otakar Lenhart. The influence of Man Ray is evident in Lenhart's frequent use of pseudo-relief or Sabattier effect in his portraits, nudes, and still lifes (see cat. no. PH169). Lenhart's experiments also extended the technique of combining photographs and photograms originated by Rössler about 1928. Lenhart's *Self-portrait* (*Autoportrét*, 1935, cat. no. PH68), which is the result of this combination of techniques, is one of the important works of Czech photography between the two world wars.

The versatile Kašpařík used photomontages in particular, among other special techniques. In addition to lyrical and Constructivist works influenced by avant-garde film, he created two Surrealistically grotesque *Anatomies of a Portrait* (*Anatomie portrétu*) and an exceptional realization *From the Depths* (*Z hlubiny*, cat. no. PH60), all about 1935. Surrealist inspiration (e.g., the motif of closed eyes) is encountered in his other works as well.

Like photographers in f3, f4, and f5, some Fotolinie (Photoline) members also used special photographic techniques in, for example, the erotically charged double exposures by Ada Novák or the photograms by Bartuška, who paid homage to Man Ray even in his writing. The contiguous series of photograms by Karel Valter from 1934–35 reflects the decorative style of the 1930s, which was strongly present in painting (the so-called lyrical or imaginative Cubism) as well as in applied art. The small body of photographic work by the theoretician and painter Oldřich Nouza documents the original contribution by this author to imaginative photography. His images from 1932 produce exceptionally effective optical illusions. Unfortunately, the photomontages and experiments of other Fotolinie members have not been preserved.

Although collages in Czech Surrealism usually were based on engravings, collages using photographic reproductions (for example, collages by Jaroslav Puchmertl, who belonged to the wider circle of the Skupina Ra, see cat. nos. PH96, PH97) also have been preserved. Teige systematically

■ DUFEK

Ada Novák, Untitled: portrait, 1932, private collection, cat. no. PH85a.

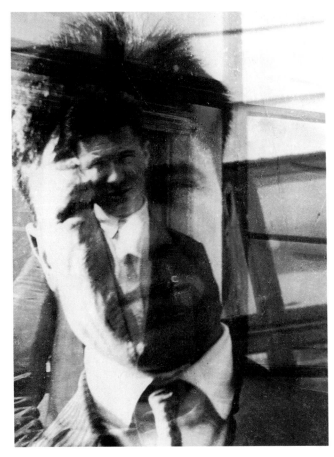

Oldřich Nouza, *Self-portrait (Autoportrét)*, c. 1932, collection Zuzana Kopecká, Prague, cat. no. PH83.

used printed photographs in his collages from 1935 until his death in 1951. (He used photographs for his book jacket designs as early as the 1920s as well as in the so-called image poems.) Teige's late collages are outstanding, comprising a private "Surrealist diary." It is notable that the collages contain photographs from the monographs of outstanding photographers (Moholy-Nagy [see cat. no. PH163], Bill Brandt, Hák, and Karel Ludwig, to name a few) and so provide Teige's interpretation of the images he used, sometimes reinterpreting the same image several times.[26]

Nonfigurative realizations are a subchapter of Surrealist photography that uses special techniques. In 1937 Hák created his "strucages" (a neologism pointing to the word structure) by applying chemicals directly on photographic papers. Other photographers also disrupted the emulsion of photographic plates. Among the first was probably Povolný, who exhibited two Photographics (the term used in 1933 by Moholy-Nagy for manually created work). The first one evidently was created only by melting the negative before printing it, while the other shows additional traces of scratching. The Skupina 42 member and painter František Hudeček worked in a similar manner when making his only known photographs. Hudeček's manipulation is much more evident: entire emulsion surfaces were ripped off and perhaps even

transposed, often creating strange Gothic coats-of-arms, while some furrowed sections resemble traces made by a comb. Josef Istler, also a member of Skupina Ra, treated melted plates with similar techniques of graphic arts, although the beginning of his work with melted emulsions in 1943 is not preserved. Another member of Skupina Ra, the photographer Koreček, whose first exhibited works date from 1944, remains systematically involved with this technique to this day. Koreček does not intrude in the melted emulsion, strictly limiting himself to the selection of effective details from the work of chance. In the 1940s, knowing no one else working in a similar fashion, he gave his technique the name *fokalk* (pho-calc), derived from "photographie" and "decalcomanie." (The works that originated before the 1936 publication of the Dominguez decals could have been inspired only by the Ernst frottages.) Fokalk is approximately the same as Raoul Ubac's *brulage* from the end of the 1930s or David Hare's *heatage* (1941?). Marcel Lefrancq's untitled fokalks published by Jaguer are from the 1960s.

CONCLUSION

This brief review of Czech imaginative photography is intended to offer a complete representation of the expressive spectrum of imaginative photography, not a complete listing of all the photographers; many photographers are unknown today who once regularly published in periodicals. For other reasons, some extremely limited expressions, such as the lyrical assemblages by Ladislav E. Berka or the Atget-like photographs of Jiří Lehovec from *Paris* (1932), have also been left out. Even so, it is clear that the realization of imaginative photography in Czechoslovakia belongs among the important movements of the medium. Funke is definitely a pioneer of imaginative photography, and in the field of direct photography Štyrský's and Reichmann's series are undoubtedly richer than Brassaï's work. While Man Ray and others (Boiffard, Paul Nougé, Roger Parry) have been the forerunners in arranged and staged work, the work by Vobecký and Zykmund can be considered the culmination of two main trends in this area. As far as is known, the work by many Bohemian and Moravian artists experimenting with special photographic techniques has very few parallels in world photography. The realizations of nonfigurative photography in Czechoslovakia are not only numerous but—as far as emulsion melting is concerned—also the first of their kind.

A specific characteristic of Czech imaginative photography seems to be an inclination toward harmony and aestheticism as well as a sense of teamwork even under supremely unfavorable conditions. An exception is represented by Štyrský and some "anti-aesthetic" realizations in the work of other photographers such as Povolný. However, the morbid eroticism and cruelty in work by Hans Bellmer or Boiffard are not to be found in Czechoslovakia.

The recent publication by Rosalind Krauss and Jane Livingston *L'Amour fou* (with the subtitle *Photography and Sur-*

Karel Kašpařík, *Why? (Proč?),* c. 1935, Moravská galerie v Brně,
cat. no. PH59.

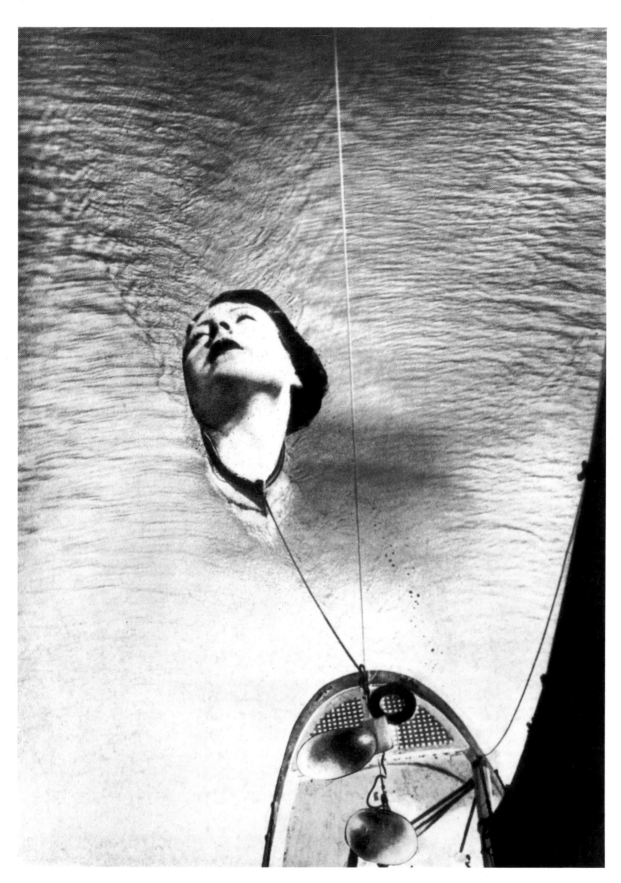

Karel Teige, Untitled, 1942, Památník národního písemnictví,
cat. no. PH163.

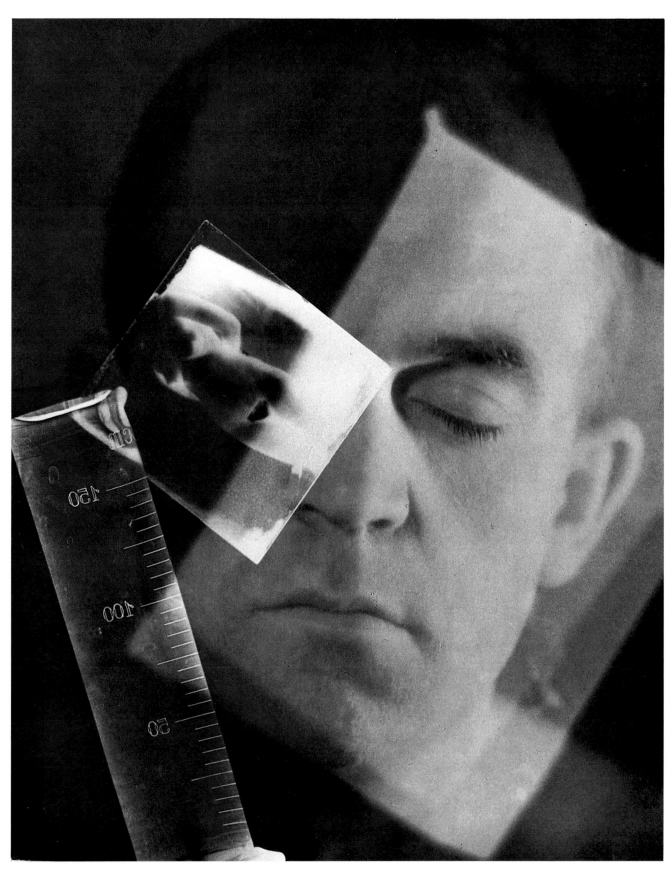

Otakar Lenhart, *Self-portrait (Autoportrét)*, 1935, Moravská galerie
v Brně, cat. no. PH68.

Jaroslav Puchmertl, *Robur, the Conqueror (Robur dobyvatel),* 1940,
The Museum of Fine Arts, Houston, cat. no. PH96.

realism)[27] concentrates only on the circle of the Parisian
Surrealist group. The paradox is that even the insignificant
works of Parisian provenance are well known, while impor-
tant and often unique manifestations of Surrealism outside
France are ignored. The theoretically oriented work by Amer-
ican critics represented by Krauss concludes erroneously that

> Surrealist photography is contrived to the highest
> degree, and that even when it is not involved in actual
> superimpositions, or colorizations, or double expo-
> sures, or what have you. Contrivance, we could say, is
> what ensures that a photograph will seem Surrealist;
> why Man Ray's "Anatomies"...is so, for example, in
> the absence of any darkroom manipulation. Surrealist
> photography does not admit of the natural, as opposed
> to the cultural or made, and so all of what it looks at
> is seen as if already, and always, constructed through a
> strange transposition of this thing into a different reg-
> ister. We see the object by means of an act of displace-

ment, defined through a gesture of substitution. The
object, 'straight' or manipulated, is always manipu-
lated and that always appears as a fetish. It is this
fetishization of reality that is the scandal (p. 91).

Although Krauss' thesis is not devoid of a rational core,
it is both too ample and too constricted. It is too ample
because manipulation and fetishization of the object existed
already, simultaneously with and also after Surrealism (we
may recall especially Dadaism, New Objectivity, and Pop
Art). Besides, every photograph is an interpretation of the
thing depicted, and only by emphasizing its "code" can a
relation to Surrealism be revealed. Krauss' thesis is also too
constricted because—as she underlined in many other pas-
sages of her text—the Bataille-like concept of Surrealism
emphasizes the variability, encodification, and "animality" of
reality (Bataille's term is *informe).* In Surrealist photography
the fokalks are most consonant with this concept. On the
other hand, Krauss suppresses Breton's fundamental thesis

on supra-reality as being contained directly in reality, drawing no conclusions about the "discovery" of Atget and the re-valuation of direct photography.

We should add that the importance of Czech Surrealism and imaginative work is indirectly confirmed in Czech post-war art and photography to this day. Every new generation resolves this heritage in its own way. At the present time, a new wave of staged and manipulated photography that has attracted attention even on an international level is exploiting the heritage of this imaginative art.

Dr. Antonín Dufek is curator of photography at the Moravian Gallery, Brno (Moravská galerie v Brně).

Translated by Jitka Salaquarda

• NOTES

1. František Šmejkal, "Czech Constructivism (Český konstruktivismus)," *Umění*, vol. 30 (1982), pp. 214ff.; Antonín Dufek, *Jaromír Funke and Jaroslav Rössler, 27 Contemporary Czechoslovak Photographers*, exh. cat. (London: The Photographers' Gallery, 1985).

2. "From Pictorialism to Emotional Photography (Od piktorialismu k emoční fotografii)," *Photographic Horizon (Fotografický obzor)*, vol. 44 (1936), pp. 148–49.

3. Janus, *Man Ray* (Milan, 1982), fig. 18, here dated "around 1926." The first photograms in Czechoslovakia were probably made by Rössler in 1925. Most of them have a Constructivist character, strikingly different from the Man Ray and Moholy-Nagy photograms. Man Ray had realized a similar idea probably in the same year.

4. Jaromír Funke, "Man Ray," *Photographic Horizon (Fotografický obzor)*, vol. 35 (1927), pp. 36–38.

5. Slide projection was involved in a production of John Millington Synge's *Riders to the Sea*, directed by E.F. Burian with stage design by Zdeněk Rossmann.

6. Šmejkal, "Czech Constructivism," note 1.

7. As far as is known, similar works by Walter Peterhans are not older. Ladislav Berka worked in a similar vein beginning in 1929.

8. Giuseppe Arcimboldo, the sixteenth-century Milanese painter of fantastic heads, was court painter at Prague in 1562–87.

9. We should also mention the other photograph of eyeglasses by Funke (1926), conceived in a fashion similar to the Ewald Hoinkis image (c. 1927, in Van Deren Coke, *Avant-garde Photography in Germany 1919–1939*, fig. 60) or Herbert List's famous work *Lake Lucerne* (1936).

10. From the foreword in the catalogue of the second exhibition of the Czech Photographic Society in Prague in 1929. Funke uses the term *photogenics* roughly according to Louis Delluc's concept. He does not mean by it his Poetist assemblages but works thematizing light and shadow. Funke's avant-garde stance is characteristic: he has no doubt whatsoever that he is on the way to solving the situation of photography with exemplary objectivity. Other photographers, therefore, must inevitably arrive at similar results; it is merely a question of time. It may well be that they have already attained them and Funke is merely not informed about it.

11. Jaromír Funke, "From the Photogram to Emotion (Od fotogramu k emoci)," *Photographic Horizon (Fotografický obzor)*, vol. 48 (1940), pp. 121–23.

12. *Surrealismus* (Prague, 1936), pp. 34, 48 (only issue of the periodical).

13. Similar to the role played by Boiffard's illustrations for *Nadja*, the documentary photographs of Štyrský, Nezval, and Jiří Honzl illustrated Nezval's trilogy *Invisible Moscow (Neviditelná Moskva*, 1935), *Rue Git-le-coeur (Ulice Git-le-coeur*, 1936), and *A Prague Pedestrian (Pražský chodec*, 1938).

14. Karel Teige, "The Paths of Czechoslovak Photography (Cesty československé fotografie)," *Blok*, no. 2 (1947), p. 81.

15. Jiří Sever was also known as George North, but his real name was Vojtěch Čech (1904–1968).

16. This combination is known also from the environment of the f5.

17. František Šmejkal, "The Story of the Hairdresser Virgin-Doll or From the Ready-made to the Surrealist Object (Příběh panny [kadeřnické] aneb od ready-made k surrealistickému objektu)," Festschrift for 50th birthday of Josef Krása, 1983.

18. *Skupina Ra*, exh. cat. (Prague: Galerie hlavního města Prahy, 1988), pp. 8, 12 (fig.). Šmejkal further notes that the unique Man Ray and Jacques-André Boiffard stagings with live actors apparently were not known in Czechoslovakia at that time.

19. Later a light bulb was connected to a "dead" body during a second event in 1944. The popular television series "The Addams Family," which derived black humor from Surrealist poetics, showed an uncle who was able to light a bulb in his mouth.

20. Other artists called such events *řádění* or "carrying on."

21. The magazine *Surrealism* (Prague, 1936) published Picasso's sculpture, which included a plant in a flower pot.

22. *Surrealismus und Fotografie*, exh. cat. (Essen: Museum Folkwang, 1966).

23. Edouard Jaguer, *Surrealistiche Fotographie* (Köln am Rhein: DuMont Verlag, 1984), pp. 115–16.

24. František Šmejkal, "Heisler," *Umění* (1965), p. 414ff. Contains also an analysis of the publications *On the Needles of These Days* and *From the Dungeons of Sleep*.

25. *Avant-garde Photography in Moravia*, exh. cat. (Olomouc: Fine Arts Gallery), 1981.

26. Franz Roh's photomontages from 1922–26 can be considered the precursors of Teige's collages, which also are similar to Alexander Krzywoblocki's or Pierre Boucher's montages from the 1930s.

27. Rosalind Krauss and Jane Livingston, *L'Amour fou: Photography and Surrealism*, exh. cat. (Washington, D.C., and New York: The Corcoran Gallery of Art and Abbeville Press, 1985).

František Drtikol, *The Wave (Vlna)*, 1927, collection Thomas Walther,
New York, cat. no. PH18.

Art/Commerce and the Avant-Garde

WILLIS HARTSHORN

The beauty of photography, just as the beauty...of modern technology, is given by [its] simple and complete...utility. The beauty of photography is of a kind with the beauty of an airplane or a trans-Atlantic vessel or an electric bulb; it is both the work of a machine and of human hands, human brain, and if you wish, of a human heart (Karel Teige, 1922).[1]

It is the strength of photography that it functions effectively in many, often contradictory, areas of culture simultaneously. Its usefulness to so many disciplines has led to confusion regarding its "appropriate" function. This confusion is most evident in the divergent goals of art and commerce. Yet in the 1920s and 1930s, avant-garde artists embraced photography for both its creative and its applied potential. Photography's ability to standardize and infinitely reproduce information complemented the avant-garde program, which based its redefinition of beauty on a machine aesthetic and saw technology as a source of spiritual and physical salvation.

The acceptance of photography by avant-garde artists in Europe and Russia came through their recognition of its practical applications and not through attempts by earlier photographers to be self-expressive or to follow the accepted styles of painting. The avant-garde disparaged the hand-manipulated painterly photograph as a lie and a betrayal of photographic truthfulness:

> Through the intervention of photography, painting could define its aesthetics for the future as anti-naturalistic....This merit of photography in curing painting of impressionism is enormous, but painting paid photography very badly. Painting infected photography with impressionism, turning it into artistic photography, something like artistic industry, a lie-art....[2]

As early as 1917 the painter Josef Čapek was championing the power of documentary photographs in the new illustrated weeklies to "confirm...and form...our opinions."[3] It was through the expanding mass media, not the rarified art world, that the avant-garde hoped to reach the new middle class. In the "humble" forms of applied photography and photomechanical reproduction, they found vehicles for creating and disseminating art.[4]

It was as the child of technology and commerce that photography gained acceptance from the avant-garde artists, who hoped to give new life not only to art but to graphic and industrial design as well. Their impulses were rooted in Modernist utopian ideals that looked to technology to reconstruct the old social order to meet more completely the needs of a growing industrialized society. The avant-garde saw in photography the perfect tool for bringing together art and modern life.

In Czechoslovakia the Modernist program was driven by Karel Teige, an artist and intellectual entrepreneur whose theories ran parallel to the ideas of the Bauhaus and the Constructivist avant-garde of the 1920s in Russia. Teige's 1922 essay "Foto Kino Film" is an early plea for Modernism and a hymn to popular culture. For Teige,

> modernity...is a privilege, discovery, progress and perfection, [it] is nothing ephemeral but contains the development tending to a more or less absolute perfection, to standardization, incessant vitality and eternity....[The] art born recently of scientific advances and the desire of the human heart, [is an] art that is not a studio aesthete affair, but an important world and life event of far-reaching public import.[5]

Teige cites the photographs of the American artist Man Ray, whose images of Dada constructions and Rayographs exemplify the revitalization of the medium, breaking with "routine studio quasi-artistic photography" to explore the inherent technical and abstract potentials of the medium. It was through such experiments that challenged the older Pictorialist forms that Teige saw the future of photography.

Teige's early appreciation of the Rayograph, as Man Ray called his photograms, made in Paris less than one year prior to Teige's essay, is evidence of the close relationship between Czech artists and the international avant-garde. Jaromír Funke understood as well as Teige the creative potentials of this "new form" and observed its rapid assimilation into advertising:

> Even if its beauty had consisted only in its magic and the photographic, self-serving black-white poetry, its heritage was claimed by purely practical advertising

František Drtikol, *Worker (Dělník*; Portrait of Jaroslav Rössler), 1924,
The Museum of Fine Arts, Houston, cat. no. PH15.

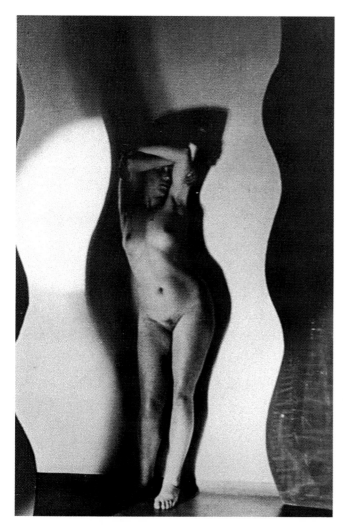

Fig. 1. František Drtikol, Untitled, 1927–28, gelatin silver bromide postcard, 8 ⅜ x 4 ½ inches, Kicken-Pauseback Galerie, Cologne.

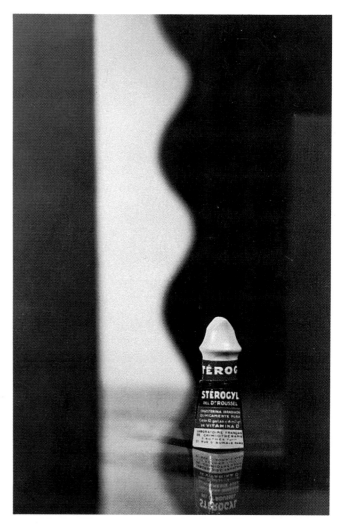

Fig. 2. Jaroslav Rössler, Untitled advertising photograph, 1931–32, gelatin silver bromide, 11¾ x 9⁷⁄₁₆ inches, Kicken-Pauseback Galerie, Cologne.

photography, which likes to exploit for [its] own ends the projected shadow-plays.... In the advertising montage this photogram is put to good use as a refreshing surprise for the spectator who often does not even notice what tricks have been used to give him pleasure and attract his attention.[6]

No sooner had Man Ray begun to experiment with the photogram than it was part of the new visual language shared by art and advertising alike.

The dichotomy between old and new attitudes toward art and photography in Czechoslovakia is particularly evident in the relationship between František Drtikol and his apprentice Jaroslav Rössler. Drtikol opened his Prague atelier in 1910 and rapidly became one of the main proponents of photographic Pictorialism in the country. Drtikol's style combined attributes of turn-of-the-century aesthetic movements such as Symbolism with his interest in occultism. The spiritual orientation of his work is suggested in a writing of 1924, which may prefigure his later photograph *The Wave* (*Vlna*, 1927, cat. no. PH18): "Life is like a wave. Its crests indicate joy,

happiness; its hollows show unhappiness, sadness."[7] Although the development of Drtikol's work brought many Modernist tendencies to Czech photography, the romanticism of this statement was clearly at odds with the younger generation's more utilitarian theories.

Rössler's early photographs, made in Drtikol's studio between 1917 and 1925, show a Cubo-expressionist style influenced by Drtikol (see cat. no. PH15). Yet as early as 1922 Rössler had been drawn to the principles of the avant-garde, making some of the first abstract photographs in Czechoslovakia. Although each influenced the other's work, Rössler was inspired more by technology, such as the radio set, than by Drtikol's classic studies. Although some of Rössler's photographs were printed using the same technique as Drtikol's nudes—the pigment process—their composition owes more to the Modernist "new vision" than to Drtikol's more elaborate style.[8] Rössler's interest in the complicated pigment technique of preparing emulsions and coating papers suggests that he saw the work as transitional. As the Functionalist concept "form follows function" advanced the appre-

ciation of photography's optical precision, Rössler, with many other photographers, began to prefer the clarity of the cold-toned, glossy-surfaced photographic papers that had been used commercially but disparaged by artists.

A source of tension between master and apprentice was Drtikol's rejection of the avant-garde program as turning photography into a non-art:

> One could never term art a photomontage—or any such object photographed from a bird's or a frog's eye perspective. Those who are chasing after sensations must always present something new at all costs. But, obviously, this has nothing to do with art. Art is something much, much more profound, something which gushes from the inside of the soul, or which touches God directly, and furthermore, this real art does not depend on the materials from which it is made.[9]

Rössler joined the avant-garde group Devětsil in 1923 and was the only member working solely in the medium of photography. Devětsil was principally a gathering of writers and painters, but their theories fit well with Rössler's inclinations and helped to propel his work beyond Drtikol's aesthetic. In keeping with the preferred methods of Devětsil, Rössler made his first works using collage and photomontage in 1923. Later in Paris from 1927 to 1935, he applied these techniques to work done in the commercial studios of Lorelle and Manuel Frères. Rössler also used photomontage and the more direct geometric style of the "new vision" in his advertising assignments. An ironic reference to Drtikol can be seen in an advertising photograph by Rössler that appropriates a decorative background from Drtikol to display a Vitamin D bottle (figs. 1, 2). Rössler used the sensual environment of Drtikol's image to heighten the sexuality implicit in the phallic packaging of the product. The structure of the photographs is almost identical; only the subject has changed to meet the advertising needs of Rössler's client. With a dexterity learned in Drtikol's studio, Rössler subverted the spirituality of the master's style by transforming it into a vehicle for commerce.

Photography's ability to be at once utilitarian and creative parallels the notions of "construction and poetry" that were at the heart of Devětsil and the uniquely Czech movement of Poetism. In Teige's words, Constructivism is an "art of utility," while Poetism "is the art of enjoyment."[10] Poetism was an attempt to combine image and text to "liquidate" the old forms of painting and poetry.[11] Using collage and photomontage, members of Devětsil combined photographs with words to produce image poems. By joining these forces, they produced an art that was both intellectual and visually compelling.

> Today there is not only spoken and written language: there is also the flag language, Morse alphabet, abbreviations, the jargon of journalism....If *word* has lost its ancient original power to become *a source of an idea*, then optical media are naturally more effective than acoustic ones. Besides, an optical poem becomes international.[12]

Recognition of the growing importance of visual language in an increasingly media-oriented modern world had many important lessons for both fine and applied art. Through the image poems of Teige and other members of Devětsil and, more pervasively, through the "humble" forms of advertising, the new illustrated weeklies, and the cinema, the public was being exposed to the development of a new sign/symbol system for communication. Poetism, in exemplifying the Modernist utopian program, intended to unify society and technology through these new forms of artistic imagination. Simultaneously, advertising began to absorb similar lessons, integrating photographs and text to reach the public with messages of commerce.

Devětsil formed further ties with commerce through its appreciation for the rotary press:

> Mechanical reproduction [will provide the] popularization of art safely and on a large scale. Print, not museums and exhibitions, is the middleman between artistic production and spectators.... Mechanical reproduction and print will ultimately make originals useless.[13]

Image poems appeared as book covers and illustrations in the group's publications as well as in early editions of the illustrated paper *Weekly Variety (Pestrý týden)*. These "poems," executed in a Constructivist manner, were in line with similar experiments of the time, particularly László Moholy-Nagy's concept of the *typofoto*, where words, images, and graphic elements were brought into new relationships on the printed page. Illustrated in his book *Painting, Photography, Film (Malerei, Fotografie, Film*, 1925), these experiments had a direct link to the work of graphic designers who were creating print advertising in mass market magazines using the same elements. As an instructor at the Dessau Bauhaus in 1926, Moholy-Nagy advocated the interaction between art and commerce when he encouraged outside advertising commissions as part of the school's curriculum. In 1927 Moholy-Nagy joined the Circle of New Advertising Designers (Ring Neuer Werbegestalter). Formed by the artist Kurt Schwitters, the group included Max Burchartz, Willi Baumeister, Jan Tschichold, Piet Zwart, and other artists who, under the influence of the Constructivist program, had begun actively to work in both fine and applied art.[14]

Some of the more ambitious publishing in Czechoslovakia came out of the collaborative Cooperative Work (Družstevní práce), which produced books and magazines to educate the public on the Modernist program. Its activities were similar to those of the international avant-garde, perhaps most closely aligned with the Bauhaus and Deutscher Werkbund in Germany. The guiding force at Cooperative Work was the designer Ladislav Sutnar, who used the magazines of the cooperative, *We Live (Žijeme)* and *Panorama*, to promote Functionalist design in the 1930s. Teige described

Josef Sudek, *Ladislav Sutnar China (Sutnarův porcelánový soubor)*,
c. 1930, made for Cooperative Work (Družstevní práce), collection
Robert Miller Gallery, New York, cat. no. PH139.

Sutnar's aesthetic as "the absence of decorative detail, the rectangular patterning of form and surface, asymmetry, simplicity of contour…[progressing] from art to science."[15] Sutnar applied his skills to the design of books, textiles, flatware, porcelain, and glassware, becoming Czechoslovakia's best representative of a new artist who emerged from the avant-garde program—the designer (see cat. no. PH139).

The Functionalist appreciation of "the thing itself" was most effective in commerce, its direct and powerfully graphic presentation appearing persuasively truthful to the public. Sutnar was attracted to photography's matter-of-fact representation and enlisted the talents of Josef Sudek to photograph objects he designed. Sudek's work appeared often in the magazines of Cooperative Work and provides some of the best examples of "new vision" aesthetics in applied photography between the two world wars (see cat. no. PH138). In Sudek's own words:

> My collaboration with Družstevní práce…was very important to me. The publishers…were really a combine that provided its members not only with an excellent choice of high-quality books, but also with articles.…It was all very exciting.…I worked with a group of friends, we had many similar ideas, and it would have been difficult to have found another circle in which I could have worked with such enthusiasm for so many years. My work with Družstevní práce brought me not only material gain but also intellectual recognition.[16]

Commercial assignments provided artists such as Sudek with needed income and often presented creative problems that artists would not have explored outside of the market environment. Collaboration with designers and other graphic artists provided the photographer with an intellectual and aesthetic stimulation lacking in the solitude of the studio. Although Sudek later abandoned these experiments in Functionalist photography for more romantic and Surrealist images, his commercial works, inspired by Sutnar, show a precision and exactitude that reflect the spirit of the age.

The influence of the avant-garde program on applied photography spread throughout Czechoslovakia, not only through the efforts of the artists but also by means of the educational system. Through the Bauhaus-based curricula of the School of Arts and Crafts in Bratislava and later the State Graphic School in Prague, students were instructed in the use of Functionalist and Constructivist principles. Funke's assignments at the State Graphic School reflected the innovative uses of applied photography. Funke asked the students to look in new ways at traditional subjects such as landscape, portraiture, still life, and architecture, while introducing them to the emerging areas of reportage and advertising. Some of the most successful examples of these exercises are found in the work of Jaroslava Hatláková. Done in 1936 for the assignment "Object in Space," they are highly developed explorations of abstract form, vantage point, and the reflec-

tivity of materials (see cat. no. PH55). The strong graphic quality of this assignment is also evident in advertising work Hatláková did during the same period, some of which was published in *Panorama* and other periodicals.

There was an active exchange between Bauhaus faculty members, such as Moholy-Nagy, and Czech artists, such as Teige, who was invited to the school as a guest lecturer. Similarly, Marie Rossmannová and her husband Zdeněk Rossmann, a prominent Functionalist designer, studied at the Bauhaus in 1930–31, where she began to photograph. When they returned to Czechoslovakia, she followed her husband to Bratislava, where he headed the graphic design department of the School of Arts and Crafts, and taught along with Funke who headed the photography department. Rossmann and Sutnar worked with many photographers, including Funke, to promote the use of photography and type in advanced design:[17]

> The employment of photography is almost universal in modern advertising. An impersonal documentary photograph suits today's "economical" man and woman more than an approximative drawing or an extensive article. This particular need causes the hunger for pictorial magazines. A clever and well-executed photograph, Grotesque, a sans serif typeface, and a compelling color represent inexhaustible means for any, even the most sophisticated, print advertisement.[18]

The economy of Czechoslovakia between the wars provided opportunities for photographers in industry. Tomáš Baťa, Czechoslovakia's largest manufacturer of shoes, understood the commercial potential of the avant-garde styles and offered work to Czech artists as well as to members of the international avant-garde, including Moholy-Nagy. Baťa had a sophisticated understanding of the value of advertising, commissioning photographs and films for presentation in stores carrying his products. He hired Alexander Hackenschmied in 1935 to organize a commercial studio to make advertising films. Hackenschmied had been in charge of *Weekly Variety*'s film section and was well known as a writer, filmmaker, and advertising photographer (see cat. no PH42). While at the Baťa Film Studio, Hackenschmied made a number of commercial films using the avant-garde sensibility. In addition to his commercial work, he used the facilities of the studio to complete the film *Crisis* (*Krise*, 1938), made in collaboration with Herbert Kline and Hans Burger. The alliance between Baťa and such avant-garde artists as Hackenschmied came from a mutual understanding of what could be gained through bringing together the businessman's capital and the artist's creative ideas.

Although members of the avant-garde tirelessly championed their own programs, it was largely through commercial and applied photography that the public came into contact with their styles. And though the world of high culture was slow to understand the avant-garde, the world of commerce saw in its graphic experiments the means to surprise and

Josef Sudek, *On the Table (Na stole)*, 1930, made for Cooperative Work
(Družstevní práce), Uměleckoprůmyslové muzeum v Praze, cat. no. PH138.

Jaroslava Hatláková, Untitled, 1936, Kicken-Pauseback Galerie,
Cologne, cat. no. PH55.

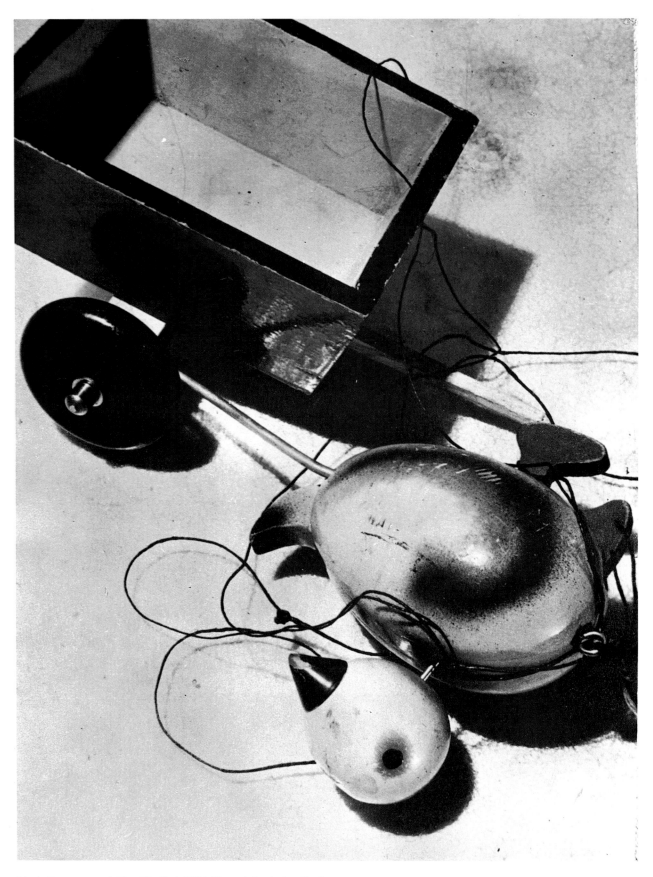

Marie Rossmannová, *Toy (Hračka)*, 1935, Moravská galerie v Brně,
cat. no. PH114.

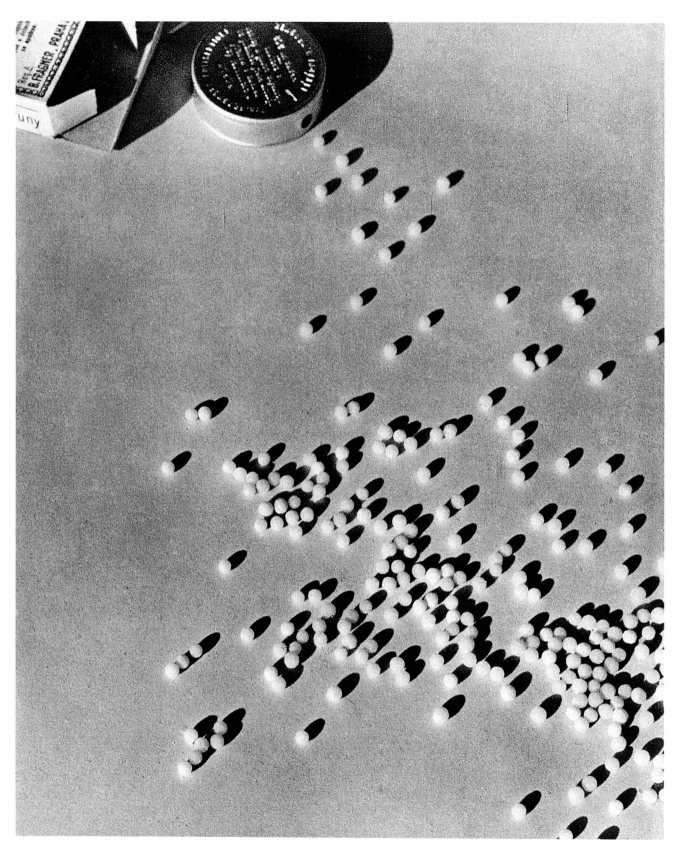

Alexander Hackenschmied, *Advertising Photograph (Reklamní fotografie)*, 1930, private collection, cat. no. PH42.

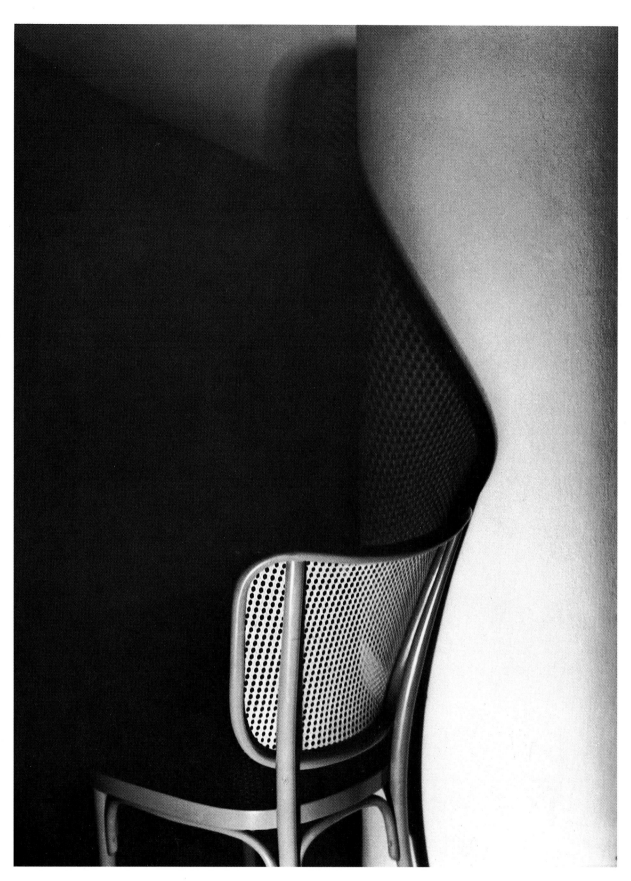

Bohumil Němec, *Advertising Photograph (Reklamní fotografie),* before
1940, Moravská galerie v Brně, cat. no. PH78.

Bohumil Šťastný, *Advertising Photograph of Safety Pins (Reklamní fotografie spínadel)*, 1934, Moravská galerie v Brně, cat. no. PH124.

attract the consumer. By the late 1930s the techniques of photomontage, collage, and multiple printing, as well as the styles of "new vision" and Surrealism, were an integral part of the growing advertising business and appeared in mass market publications throughout Europe and the United States.

It was at the point of first contact, when the avant-garde, the photographer, and the free market first met, that the power of mutual influence and discovery was most dynamic. The earliest applications of avant-garde styles in the marketplace naturally required the first generation artists to conceive and replicate their work with a convincing authority. Artists such as Rössler and Sudek brought the gift of invention to their applied photography, producing highly creative commercial works that also exemplified the vitality of the avant-garde. This cross-fertilization between art and commerce was cut short by the rise of Nazism and the advent of World War II. The political and personal upheaval of the war disrupted the opportunities for collaboration that were central to the avant-garde's work in applied art. The momentum of its activities was lost and its utopian ideals began to unravel.

Many of the artists were forced to relocate, as Sutnar, Hackenschmied, and Moholy-Nagy did to America. Rössler and Sudek remained in Czechoslovakia. Rössler maintained a commercial studio in the suburbs of Prague but gave up his personal work for almost twenty years. Sudek, on the other hand, no longer worked in applied photography during or after the war. Except for photographs commissioned for books and by artists of their paintings, Sudek devoted his attention to personal photography.

After the war a new generation of commercial photographers, occasionally joined by artists such as Rössler, continued to market the ideas of the avant-garde elite and to fashion them to the taste of the public. Quite naturally, after repeated use in commerce, these styles lost their surprising and at times scandalous edge. Rather than the coming together of artist and society that had been hoped for by the avant-garde, the cycle of interaction devolved into an appropriation of the artist's style without its substance for the commercial needs of the day. Because the avant-garde consciously sought to collaborate with mass culture, such absorption was inevitable. That an assimilation of its styles did not carry with it a realization of its ambition to reorder society attests to art's ambiguous ability to effect social change. Still, avant-garde experiments were responsible for a period of unrivaled innovation in commercial photography. The avant-garde introduced an aesthetic sophistication that fostered the visual awareness of the public and that represents one of the greatest revolutions in the appreciation and use of applied photography in Europe.

Willis Hartshorn is director of exhibitions at the International Center of Photography, New York.

• NOTES

1. Karel Teige, "Foto Kino Film," *Život* (Prague), vol. 2 (1922), pp. 153–68.

2. Teige, "Foto Kino Film," pp. 153–68.

3. Josef Čapek, *The Most Modest Art (Nejskromnější umění)*, 1918 (Prague: Aventinum, 1920).

4. Čapek, *The Most Modest Art*.

5. Teige, "Foto Kino Film," pp. 153–68.

6. Jaromír Funke, "From the Photogram to Emotion (Od fotogramu k emoci)," *Photographic Horizon (Fotografický obzor)*, vol. 44 (1936), pp. 148–49.

7. Quote from Drtikol letter, c. 1924, cited in Anna Fárová, *Drtikol* (Munich: Schirmer/Mosel).

8. Antonín Dufek, *Funke, Rössler and Modern European Photography* (London: The Photographers' Gallery, 1985), p. 4.

9. From a letter, c. 1927–29, cited in Fárová.

10. Karel Teige, "Painting and Poetry (Malířství a poesie)," *Disk* (Prague), vol. 1 (1923), pp. 19–20.

11. Teige, "Painting and Poetry," pp. 19–20.

12. Teige, "Painting and Poetry," pp. 19–20.

13. Teige, "Painting and Poetry," pp. 19–20.

14. Monica J. Strauss, "Captured Glance: The Avant-garde and Advertising," exh. cat. (New York: Helen Serger/La Boetie, Inc., 1978), p. 5.

15. Karel Teige, "Ladislav Sutnar and New Typography," *Panorama*, no. 1 (1934). As quoted in Jan Rous, "The Typography and Design of Czech Books between the Wars," *Fine Print*, vol. 13, no. 1 (January 1987), p. 20.

16. Sonia Bullaty, *Sudek* (New York: Clarkson N. Potter, 1978), p. 25.

17. Jaroslav Anděl, "The Czech Avant-Garde and the Book: 1900–1945," *Afterimage* (Rochester), vol. 12, no. 6 (January 1985), p. 13.

18. Zdeněk Rossmann, "Lettering and Photography in Advertising," *Index* (Olomouc, 1938), p. 19. As quoted in Anděl, p. 9.

FILM

Rhythm (Rytmus), 1941, directed by Jiří Lehovec.

The Light Penetrates the Dark (Světlo proniká tmou), 1930,
directed by Otakar Vávra and František Pilát.

Artists as Filmmakers

JAROSLAV ANDĚL

Film and its aesthetic are indebted to the artistic avant-garde, which advanced key concepts and decisively articulated the self-awareness of this new art form. Leading filmmakers, theoreticians, critics, and even historians have often been associated with the avant-garde movement.[1] Although the term *film avant-garde* emerged in the 1920s when numerous artists adopted film, permanently or temporarily, as their primary medium, this movement had its beginnings in the 1910s. Some of the medium's first explorers were Czech artists and critics who produced films and published essays between 1908 and 1918. Yet their work, including that produced in the period between the two world wars, still lacks recognition in the West.[2]

The first substantive outline of film theory and criticism originated in Bohemia rather than in France or Germany. It appeared under the title "Kinema" in the Czech literary magazine *Novina* in 1908.[3] In this penetrating study Václav Tille, a critic and scholar, called for recognition of the medium as a new art form and analyzed its characteristics, thus anticipating the development of film theory by more than a decade. Tille's analysis of the medium takes into account factors such as cinematic space and time as well as film's prehistory and a typology of its genres, and it offers one of the first examples of serious film criticism. It also outlines ideas that much later would dominate theoretical discourse, such as montage[4] and the comparison of cinematic apparatus to mental processes, specifically to dreams.[5]

Tille's interest in film was part of his exploration of popular art forms, including fairy tales, folk stories and legends, vaudeville, and so on.[6] In the first two decades of this century, young artists discovered in popular art an important source of inspiration. Members of Prague's bohemia, primarily disenchanted writers and artists having sympathies or affiliations with the Anarchist movement, favored cabaret, caricature, comic stories, and satirical sketches to high art forms. Years before the Dadaist performances in Zurich and other cities, they organized cabaret performances that reflected the absurdities of modern life. They not only performed their sketches in many of Prague's cabarets, restaurants, and pubs but often brought them out into the street. For example, in 1905 the writer Jaroslav Hašek founded the Party of the Modest Progress Within the Limits of the Law, which ran candidates in the general elections.[7]

Emil Artur Pitterman, a friend of Hašek's,[8] participated in the first painting exhibition of Osma (The Eight) in 1907, which has been regarded as the beginning of the Czech avant-garde movement. Pitterman also acted in numerous cabarets under the pseudonym E. A. Longen.[9] In 1911, in collaboration with the photographer and cinematographer Antonín Pech, he made three films produced by the company Kinofa.[10] These short films featured Longen as Rudi, a comic character from Longen's cabaret sketches. After the war Longen founded the avant-garde theater the Revolutionary Stage (Revoluční scéna) and worked as a screenwriter and actor.

The cabaret setting not only attracted vanguard artists such as Longen but also advanced what are now called multimedia productions, notably the fusion of film and theater. For instance, Karel Hašler, a popular cabaret artist, created the film *Czech Castles and Chateaux* (*České hrady a zámky*, 1914) for his performance *Man without an Apartment*. By juxtaposing the actor's appearance on the screen with his presence on the stage, this work presaged similar avant-garde experiments of the 1920s and 1930s.[11]

In 1911 several former members of Osma with other young artists founded the Skupina výtvarných umělců (Group of Fine Artists), which became a leading organization of vanguard artists and the center of the Cubist movement in Central Europe. Members of this group, which included painters, sculptors, architects, designers, writers, and musicians, contributed to the development of Czech filmmaking and film theory. In 1912 the husband and wife team of Max Urban, an architect and a member of the Skupina, and Anna Sedláčková, an actress associated with the National Theater, founded ASUM-Film, a leading Czech film company that specialized in narrative pictures before World War I. The couple not only produced films but, with a few friends, was also responsible for screenwriting, direction, cinematography, design, and acting. Urban often shared the role of the director and cameraman with Otakar Štáfl, a leading poster designer in the 1910s, who also designed sets.

Most of the ASUM films starred Sedláčková. Although this fact, as well as the name of the company, an acronym using their initials, suggests that Urban and Sedláčková

Rudi Fools Around (Rudi na záletech), 1911, directed by Emil
Artur Longen and Antonín Pech.

Rudi the Sportsman (Rudi sportsmanem), 1911, directed by Emil
Artur Longen and Antonín Pech.

sought to promote her theatrical acting career through the film company, ASUM artists did not attempt to emulate theater nor to follow the example of film d'art. As *The End of a Love Affair* (*Konec milování*, 1913), one of their few surviving titles, shows, they preferred dramatic action to costume spectacles.[12] They took advantage of the medium's capacity to move in space and time, although this movement still consisted more of sequenced scenes than of sequential shots. ASUM-Film may not have arrived fully at the notion of film as a juxtaposition of shots, but it moved in this direction during the two years of its existence.

The last ASUM production, *The Nightmare* (*Noční děs*, 1914), a farce with an Expressionist touch, is the most advanced in this respect. The author of the script was the writer František Langer, another member of the Skupina. In 1913 he wrote "Always Cinema (Stále kinema)," a perceptive essay on the relationship between cinema and literature.[13] Langer tried to define the roles of the director, actor, screenwriter, and spectator in relation to the nature of the medium, primarily to its democratic qualities. He also prized the new art form for its ability to celebrate and analyze the most ordinary things, a distinction much sought in contemporary art and literature.

The Czech avant-garde vision of the new medium appears most explicitly in the essays on film by the brothers Josef and Karel Čapek. As early as 1910 they published a short article that expresses a number of ideas anticipating a film avant-garde. It glorifies the unlimited artistic possibilities of the new medium, suggests techniques, strategies, and devices to be explored, and offers a program of new genres and forms.[14] The Čapeks' interest in film was part of their lifelong fascination with popular and primitive art, which inspired their novels, plays, art criticism, and Josef's paintings and drawings. Another influence on the Čapeks and other Czech artists was Cubism. Josef Čapek adopted the Cubist idiom in his paintings in 1912 and together with his brother tried to transpose its principles to literature.[15] Their interests in both Cubism and film amplified each other. While Cubism provided specific ideas about the significance of popular and primitive art for modern artists and thus intensified their effect on Josef's paintings and the brothers' writing,[16] film presented a new vision that seemed to justify the Cubist concept of space.

In 1913 Karel Čapek published "The Style of Cinema (Styl kinematografu),"[17] an essay that for the first time fully articulated the theory of film montage and sketched other principles advanced by the film avant-garde of the 1920s, including Sergei Eisenstein's concept of montage and Dziga Vertov's "kino-eye."[18] Čapek emphasized the visual nature of the medium and, consequently, its relationship with the visual arts. His theory of montage reflects the contemporary Cubist notion of a new vision of reality based on the juxtaposition of different views. Thus Čapek's interpretation of the inherent characteristics of the medium links film to contemporary art. This affinity is even more explicit in Čapek's 1917 essay "A.W.F. Co. (American World Film Company)" in which he confessed his deep admiration for the new medium and its inspiration for his writing.[19] The Czech vanguard artists and critics, who recognized in film a paradigm of modern art before other avant-garde groups, anticipated the film euphoria that would emerge in the art of the 1920s.

In 1922 the group Devětsil (founded in 1920) published two avant-garde anthologies celebrating film as the most modern of art forms. The essay "Foto Kino Film" by Karel Teige, a leading theoretician of the group, is the most significant manifesto of this trend.[20] It synthesized the various concepts and ideas that underlay the avant-garde's interest in the medium, including the notions of film as an integral, democratic, and international medium based on modern technology. Characteristically, Teige introduced his essay with a plea for the idea of progress in art. This idea was at the heart of the Devětsil program, where art was a function of the social and technological utopia, and film became a model for other art forms.

Thus the Devětsil interest in film and its ideological underpinnings was very different from the principles endorsed by the previous generation of artists. While in the 1910s the Čapeks and others discovered in film an inspiration for, and complement to, traditional art forms, Teige and other members of Devětsil saw in film (and other mediums based on mechanical reproduction) the art of the future, which would replace traditional mediums. Acclaiming the unity of the social, technological, and artistic revolution, the Devětsil artists promoted new art forms corresponding with the utopian concept of collectivism.

Inspired by film, they adopted and combined collage, photomontage, typographical design, and screenwriting into image poems and film poems. In his 1923 manifesto "Painting and Poetry (Malířství a poesie)," Teige defined image poems as "a solution of problems shared by painting and poetry" and predicted that "sooner or later this fusion will probably incite the liquidation, which may be slow, of the traditional modes of painting and poetry."[21]

These new art forms embodied the Devětsil program of Poetism, published in a manifesto several months later, which stated: "We have begun to seek possibilities in film, circus, sport, tourism and in life itself, the possibilities which paintings and poems failed to provide. Thus image poems, poetic riddles and anecdotes and lyrical films originated."[22] In fact, no films were made. Like other avant-garde writers, Teige blurred the distinction between poems (film scripts) and lyrical films to emphasize the priority of project over production, vision over reality. This utopian tendency was instrumental in articulating new film concepts and forms and stimulated the Devětsil interest in film theory.[23]

Most film poems were neither narrative nor abstract but attempted to reconcile both approaches. The concept of the so-called "nonteleological film"[24] as well as the two principal concepts of Devětsil—poetry and construction—contributed to this specific cinematic style. Believing that abstract (nonobjective or absolute) films did not satisfy the objectifying impulse of the spectator, Teige argued for a combination of

The Nightmare (Noční děs), 1914, directed by Jan Arnold Palouš.

Czech Castles and Chateaux (České hrady a zámky), 1914, directed by Karel Hašler.

abstract and naturalistic elements to generate lyrical associations.[25]

The Devětsil film poems prefigured or paralleled the advancements of avant-garde cinema through the 1920s, albeit not on celluloid but only on paper. As Teige remarked at the end of the decade, the film poems "anticipated various things that blossomed into the flowers of the film magic in the later pictures by Man Ray..., René Clair..., Hans Richter or by Léger and Ruttman."[26] For example, the film poems *Mr. Ulysses and Other News (Pan Odysseus a jiné zprávy*, 1924) by Teige and Jaroslav Seifert, *Rocket (Raketa*, 1924) by Vítězslav Nezval, *The Glass Poem (Skleněná báseň*, 1925) by Artuš Černík, *Nikotin* (1925) by Jiří Voskovec, and *Mixer* (1925) by František Halas employ a great variety of techniques, visual effects, and metaphors, including diagonal compositions, unusual perspectives and angles, large close-ups, abstract designs and signs, and colors.

The Devětsil members called documentary and narrative films, and sometimes even real objects or events, poems. These semantic stretches indicate the tendency of Poetism to transcend the boundaries between specific art forms and, ultimately, between art and life. As the term *film poem* itself

demonstrates, the Devětsil cinematic vision emphasized parallels between film and poetry, which were crucial for the rise and development of Poetism and decisively influenced Devětsil's literature and film aesthetic.

Despite all its enthusiasm, the Devětsil group did not produce a single film. The main reason was that the utopian overtones of the Devětsil program, which questioned the established institutions, categories, and genres, had created a wide gap between Devětsil and the Czech film industry. In his article on Czech film in October 1924, Teige stated: "In our country the film production will probably perish on its unforgivable sins. The poor quality is an ever-present cause of the box-office debacle. And yet there are a number of highly interesting and modern cinematographic works in Bohemia—alas, only on paper, in drawers of the desks of modern authors, or in the columns of modern reviews."[27]

Despite Teige's general condemnation of Czech film production, a number of films produced in the first half of the 1920s can be exempted from his criticism. While films such as *Visitor from Darkness (Příchozí z temnot*, 1921), directed by Jan S. Kolár, and *The Girl from Podskalí (Děvče z Podskalí*, 1922) by Václav Binovec did not satisfy the avant-

Tonka of the Gallows (Tonka Šibenice), 1930, directed by Karel Anton.

garde taste, they did enunciate the psychic and social themes that appeared later in more acclaimed films, including *The Kreutzer Sonata* (*Kreutzerova sonáta*, 1926) by Gustav Machatý, *Battalion* (*Batalion*, 1927) by Přemysl Pražský, and *Tonka of the Gallows* (*Tonka Šibenice*, 1930) by Karel Anton. These later films, which adopted some avant-garde elements, were viewed more favorably by vanguard critics and artists.

Nevertheless, the gap during the 1920s between the avant-garde and the film industry did not diminish. In 1927 the Devětsil artists and critics with other film enthusiasts founded the New Film Club (Klub za nový film) and in its program stated: "Our attitude towards Czech cinema is ruthlessly negative and uncompromising." Their goal was "to associate coworkers in the struggle for the creation of independent Czech film and to unite the formerly atomized attempts for a new filmic expression and for promotion of good films in general."[28] The club attempted to go into film production on its own and to establish an avant-garde film theater but failed.

Although the club remained only a debating platform that lasted one year, its agenda heralded things to come in the 1930s: festivals of avant-garde film, independent productions of experimental, documentary, and narrative feature films, professional film criticism, and Structuralist film theory. The club also brought together artists and writers who later played important roles in these developments. Among its members, Vladislav Vančura, Jindřich Honzl, Voskovec, and Jan Werich created influential narrative films in the 1930s. The chair of the club was Zdeněk Pešánek, a pioneer of kinetic sculpture, who saw film as the highest form of kinetic art. In 1926 Pešánek wrote a film poem interpreting his kinetic sculpture *Monument of Fallen Flyers* (*Pomník padlých letců*). This interplay between a kinetic art object and the most complex of kinetic mediums emerged again four years later in the film *The Light Penetrates the Dark* (*Světlo proniká tmou*, 1930) by František Pilát and Otakar Vávra, on which Pešánek collaborated. The film features his kinetic sculpture on the Edison Transformer Station in Prague or, more exactly, elaborates the theme that this sculpture represented.

The concept of independent film promoted by the club reappeared in the writings of Alexander Hackenschmied, a leading filmmaker and organizer of avant-garde film festivals and exhibitions of modern Czech photography in 1930 and 1931. Hackenschmied's program of independent film included scientific, advertising, and other functional pictures: "It is

The Earth Sings (Zem spievá), 1933, directed by Karel Plicka.

not necessary to place an attempt at pure film art elsewhere than in a perfect scientific film, a perfect travel film, or a perfect advertising film. If any of these films is treated with an understanding of the needs and possibilities of film technique and if using them has best complied with its purpose without limiting the creative intentions of its author, then it is a good film. The independent film movement wants and protects good films."[29]

This broader concept made it possible to see previously separate film productions as one movement[30] and helped to establish interchanges between different genres. For example, progressive critics praised films by Karel Plicka, such as *Along the Hills, Along the Dales* (*Po horách, po dolách*, 1929), which originated in the 1920s as ethnographic documentaries. Plicka's early work eventually led to the production of his internationally acclaimed film *The Earth Sings* (*Zem spievá*, 1933), created in collaboration with Hackenschmied. Another example of convergence and cooperation is the Czechoslovak Society for Scientific Cinematography, which organized screenings of experimental films with avant-garde groups in the 1930s. In the 1920s scientific films, such as *Plant Movements* (*Pohyby rostlin*, 1925–27) by Professor Vladimír Úlehla, *Carnivorous Plants* (*Masožravé rostliny*, 1928) by Professor Silvestr Prát, or *Movement—Expression*

of Life (*Pohyb—výraz života*, 1927) by Professor Bělohrádek and Karel Paspa, extended human vision and thus inspired the avant-garde's exploration of the medium.

One of the favorite genres of avant-garde cinema was the city film. In his 1933 seminal essay "Contribution to Film Aesthetic (K estetice filmu)," Jan Mukařovský referred to a classic of this genre, Vertov's *Man with the Movie Camera* (1929), while making a distinction between space and narrative in film.[31] Mukařovský noted that in Vertov's film the spatial sequence dominates the narrative sequence. Moreover, filmmaking itself and its apparatus became the story of Vertov's film and the man with a movie camera its hero. The film poem *Mr. Ulysses and Other News* by Teige and Seifert represents an interesting antecedent to Vertov's film. The poem's story highlights the cinematic fragmentation and synthesis of space, and the poem's protagonist becomes a personification of movement in space.

Some of Devětsil's ideas materialized in the film *Prague Shining in Lights* (*Praha v záři světel*, 1928), by Svatopluk Innemann and Václav Vích,[32] an important example of the city genre that shows parallels to Vertov's masterpiece. While Vertov juxtaposed the process of filmmaking with one day of city life, Innemann and Vích told a story of urban night life generated by electrical light. In both cases the central leit-

Prague Shining in Lights (Praha v záři světel), 1928, directed by Svatopluk Innemann.

motif of modern technology dominates the narrative structure and advances space over narration. Another city film, *Prague, City of Hundred Spires* (*Praha, město sta věží*, 1928), which contrasts historical and modern Prague, employs the same approach. Its author, the architect Josef Hesoun, was one of the protagonists of the International Style.

Aimless Walk (*Bezúčelná procházka*, 1930) by Hackenschmied, which was shown at the festival of avant-garde films in Prague in 1930, also relates to the city genre. But Hackenschmied's debut film is very different from previous city films: it avoids celebrating big city life and technology, and it leads the spectator from the inner city to its outskirts. Space again determines narration, but as the title indicates, the filmmaker has headed in the opposite direction from the Functionalism or Constructivism espoused by previous films. Contrary to Vertov's all-seeing and superhuman "kino-eye," Hackenschmied's vision is subjective and personal. As we identify with the protagonist, an anonymous young man, his walk becomes a metaphor for imagination or a mental trip, a meaning confirmed by the closing sequence in which the protagonist splits into two persons, one taking a streetcar back downtown, the other remaining on the city's outskirts.[33]

This bifurcation, achieved very simply by montage, is the most striking example of the internalization and subjectivization that emerged in the early 1930s and complemented the collectivist trend of the 1920s. Thus, the two opposing principles, construction/function and poetry, which were essential to Devětsil's program in the 1920s, grew into two separate movements: Functionalism (the European term for the International Style), with its growing social and political agenda, and Surrealism, with its emphasis on inner space.

The Levá fronta (Left Front), founded in 1929, an avant-garde organization of leftist intelligentsia and artists, was the most radical partisan of Functionalism. This organization had several sections devoted to specific art forms, including architecture, photography, and film. The Film and Photography Group (Filmová a fotografická skupina) of the Levá fronta in Prague, Brno, and Bratislava (formed in 1931)—an equivalent of the Film and Photo League in the United States—organized international exhibitions of "social photography" and screenings of independent and Soviet films. The leader of the group, Lubomír Linhart, and some of its members saw film and photography as mediums of the political or, in their words, class struggle. The group had a film production team consisting of Karel Kresl, Otto Vlk, and Václav Zelený that produced several documentaries. *Across Prague in Spring 1934* (*Napříč Prahou na jaře 1934*), the most important film of the group, shows big city life through the prism of the Marxist theory of class contradictions.

But even if most of the avant-garde artists and filmmakers more or less identified with the left political agenda, they were far from willing to reduce filmmaking to a duplication of ideological and political stereotypes. Moreover, in filmmaking the idea of function underlay a number of different concerns and developments, notably in documentary and

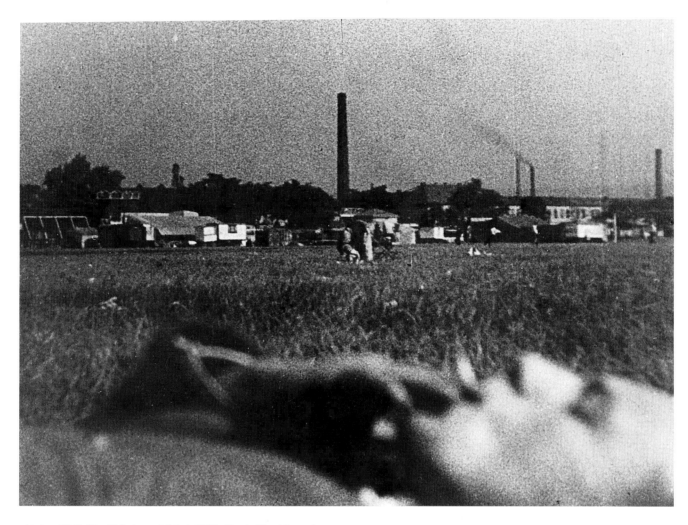

Aimless Walk (Bezúčelná procházka), 1930, directed by Alexander Hackenschmied.

advertising films, two genres most visibly representing the functional principle. By stimulating the interest of young artists and filmmakers in documentaries and advertising, Functionalism directly contributed to the development of these genres. The idea of function also fostered experimentation with the medium, a tendency traditionally associated with avant-garde film. Adhering to function, a filmmaker felt justified to use the most effective strategy available, even when that required the coexistence of different idioms and aesthetics, such as Surrealism and the International Style. The careers of the filmmakers Hackenschmied, Jan Kučera, and Jiří Lehovec are illustrative in this respect.

Like Hackenschmied, Lehovec started as a photographer. Although he was a member of the Film and Photo Group of the Levá fronta, his photographs manifested the principles of the so-called new vision rather than the class struggle. His series of photographs of the outskirts of Paris drew upon the work of Eugène Atget, then a recent Surrealist discovery, and his films reflect similar interests. In 1935 he made a Surrealist film *May (Máj)* in collaboration with the director Emil F. Burian for the avant-garde theater produc-

tion of the same title. (The 9.5mm film was remade in 16mm by Čeněk Zahradníček a year later.) Consisting mostly of large close-ups of various body parts with strong erotic overtones, the film was projected on a scrim to complement simultaneous action on the stage. In the same year Lehovec was working on his unproduced film *Botič—Creek of the Poor (Botič—potok chudých)*, a documentary to map the changing social and ecological environment around a stream in the suburbs of Prague. Despite the political crises and the German occupation, from 1938 to 1941 Lehovec made six documentary and educational films, recapitulating various cinematic procedures and devices. The most innovative pictures were *The Magic Eye (Divotvorné oko,* 1939) and *Rhythm (Rytmus,* 1941), which seek to correlate the processes of filmmaking and perception. Both are reminiscent of Vertov's films displaying the cinematic apparatus, but they also retain Surrealist elements from Lehovec's previous work. For instance, *The Magic Eye* demonstrates the camera's ability not only to capture unusual images of commonplace things but also to recover Freudian dreams in everyday life. Both films are crossovers of experimental and documentary film,

May (Máj), 1936, directed by Emil František Burian and Čeněk Zahradníček.

self-reflection and narration, Functionalism and Surrealism.

The work of other filmmakers demonstrated similar combinations of genres and idioms. For example, the film *Burlesque (Burleska*, 1932) by Kučera is a crossover of Vertov's "kino-eye" and Surrealism or, more specifically, oneiric film. It juxtaposes three incongruous elements: newsreel footage of a battlefront, close-ups of a card game, and images of a flower in the positive and negative print. By appropriating newsreel footage and combining it with two other incompatible motifs, the filmmaker questioned the concepts of fiction and nonfiction to reflect the stream of the subconscious. In his film reviews and essays, Kučera often emphasized the importance of the functional approach in cinema, promoting genres that highlight the concept of function, such as documentary and advertising films. His picture *The Construction (Stavba*, 1932), which has not been preserved, and his article "Film and Construction (Film a stavba)"[34] embody the Functionalist connection. The film documented the construction of the General Pensions Institute in Prague, one of the largest buildings of the International Style in Europe. Kučera, who collaborated on the film with the architects Josef Havlíček and Karel Honzík, was commissioned at the same time by Pierre Jeanneret to create another film on modern architecture in Czechoslovakia.[35]

Hackenschmied's career in the 1930s encompassed both the development of new genres and the transition from experimental and independent production to a modern film industry. After his first independent production, Hackenschmied made numerous advertising and documentary films. He worked for the Baťa Film Studio, which was formed by a shoe tycoon who hired young filmmakers and artists associated with the avant-garde movement to develop a modern film studio, primarily for advertising films. The Baťa Film Studio is representative of the significant contribution made by the artistic avant-garde to the development of modern advertising. In film perhaps more than in any other medium, advertising held a special attraction for the avant-garde. Kučera observed as early as 1928: "Advertising and film did not meet by chance. They were brought together by the century and by their very nature.... Film advertising, just like film newsreels (these two branches being rather similar), influence and impregnate cinematic art.... And freedom of handling of visual shapes of our world, so much desired by the true art, was first demonstrated in advertising. Directors of advertising films were not afraid to create absolute films, rapid montages, film without subtitles."[36]

As Kučera's observation indicates, it was often the opportunity to exercise creative freedom that attracted the

avant-garde to advertising. The best advertising films made by the Baťa Film Studio, such as *The Highway Sings* (*Silnice zpívá*, 1937), had a degree of youthful inventiveness and playfulness that matched any independent production. For some filmmakers advertising was the only way to produce their formal explorations. Moreover, this genre justified formal experiments and gave artists a sense of usefulness and social significance. Like political documentaries and agitprops, advertising appealed to them as an epitome of the functional approach and consequently an activity fitting into their vision of a utopian society. The development of these genres, however, revealed paradoxes inherent in the Functionalist ideology: the idea of function led to an unprecedented exploitation of the film medium for opposing political causes that had catastrophic consequences in Germany and the Soviet Union.

The history of cinema shows that the film industry co-opted a number of the avant-garde ideas along with numerous avant-garde artists and filmmakers. These artists were often recognized as major influences within the industry. For instance, the work of Hackenschmied, Plicka, and Lehovec generated a documentary film movement in Czechoslovakia and first articulated various documentary modes. Kučera and Čeněk Zahradníček earned credit for the development of the Czech newsreel industry. Karel Dodal initiated cartoon and animated film production, and his assistant Hermína Týrlová, working with several other artists at the Baťa Film Studio in Zlín, established the studio's ongoing practice of this genre. The composers Jaroslav Ježek and Burian set new professional standards for film scores, and the architect Bedřich Feuerstein did the same for set design. Otakar Vávra's career as a director of narrative features is probably the most graphic example of the transition from avant-garde and independent production to an established film industry.

Leading industry film directors were also quick to adopt concepts and procedures introduced by the avant-garde and to collaborate with vanguard artists. This union was most forceful in the work of Gustav Machatý, who emerged as a leading film director in the late 1920s. More than any other Czech film director, Machatý absorbed innovations of the film avant-garde, collaborating with vanguard artists that included the poet Nezval, the composer Ježek, the photographer and filmmaker Hackenschmied, and the poet Halas, whose poem "The Song of Work (Píseň práce)" inspired the epilogue of Machatý's best-known film, *Ecstasy* (*Extase*, 1933).

This film reflects the alliance of the collectivist vision with the introspective impulse, a polarity characteristic of the period between the two world wars in general and of the Czech avant-garde in particular. *Ecstasy* explores the inner world of a young woman who is married to an older, impotent man. The story, which ends in the wife's infidelity and the husband's suicide, has its counterpart in the epilogue celebrating the collective nature of work and society. While the story itself is told in sparse dialogue, long shots, and images disposed to psychoanalytic interpretations, the "song of

May (Máj), 1936, directed by Emil František Burian and Čeněk Zahradníček.

The Magic Eye (Divotvorné oko), 1939, directed by Jiří Lehovec.

work" consists of a rapid montage inspired by Soviet films of the 1920s.

The contribution of the Czech avant-garde to mainstream film production is most distinctly manifested in the work of many former Devětsil artists who in the 1930s ventured into narrative features: Honzl, Werich, Voskovec, and Vančura, as well as Nezval, Burian, Ježek, and Feuerstein, who often collaborated with filmmakers. Voskovec and Werich, the leaders of the Liberated Theater (Osvobozené divadlo), made four popular features between 1931 and 1936, the first two with the director Honzl, cofounder of the Liberated Theater, and the other two with the director Martin Frič.

Because film, especially slapstick comedy, had a formative influence on the development of the Liberated Theater, Voskovec and Werich's venture in the new medium was almost inevitable. Their films share similar concerns with their theatrical productions. By parodying artifices appropriated from film, theater, and life, their comedies had a liberating effect on both spectators and the film medium, particularly in their "nonobjective humor," which constantly challenged preconceptions of art and life. On the occasion of the tenth anniversary of their theater, Roman Jakobson pointed out that Voskovec and Werich's "non-objective and pure humor"[37] explored the same territory as the new science of semiology, notably in the relationship between the world of signs and the world of things, between language and object.[38]

The parallel between avant-garde activity and semiology found its most forceful expression in film, both in Structuralist film theory and in the collaboration between vanguard artists and scientists.[39] Jakobson, one of the founders of the Linguistic Circle of Prague (Pražský lingvistický kroužek) in 1926, was also a cofounder of the New Film Club in 1927. In 1931 Mukařovský, another leading member of the Linguistic Circle, published "An Attempt at Structural Analysis of an Acting Phenomenon (Pokus o strukturní rozbor hereckého zjevu)," which can be seen as the first Structuralist study in film theory.[40] Mukařovský argued that any work of art should be seen as a structure or as a hierarchy of signs, demonstrating this concept in an analysis of Chaplin's acting in *City Lights* (1931). Two years later Mukařovský published "Contribution to Film Aesthetic (K estetice filmu)," a seminal study of Structuralist film theory analyzing the structure of cinematic space. In the same year Jakobson's essay "Is the Cinema in Decline? (Úpadek filmu?)" appeared.[41] Jakobson questioned the notion that sound film brought about the decline of the medium and argued that both film image and sound function as signs.

Jakobson's interest in film sound reflects not only his important contribution to the articulation of the influential theory of phonology but also his interest and direct participation in the development of Czech cinema. In his essay Jakobson predicted that Czech sound film would flourish, citing Vančura and Innemman's *Before the Finals* (*Před maturitou*, 1932) and its inventive use of sound. Also at this time Jakobson collaborated on the script for Vančura's film

The Highway Sings (Silnice zpívá), 1937, directed by Elmar Klos.

Crisis (Krise), 1938, directed by Herbert Kline.

Black-and-White Rhapsody (Černobílá rapsodie), 1936, directed by Martin Frič.

Rhythm (Rytmus), 1941, directed by Jiří Lehovec.

The Play of Bubbles (Hra bublinek), 1936, directed by Karel Dodal
and Irena Dodalová.

On the Sunny Side (*Na sluneční straně*, 1933). Unlike
Before the Finals, this film was a commercial failure and
received mixed reviews.[42] Critics found the film contrived
and unconvincing both in the actors' performances and in its
narrative structure. A similar criticism had greeted Van-
čura's experimental novels, which combine different genres
and procedures and subvert psychological narrative. Like his
experimental novels, *On the Sunny Side* displays a rarely
achieved complexity of visual and sound syntax unappreci-
ated during Vančura's lifetime.

The film exposes contradictions in avant-garde utopian
vision. His belief in social utopia led Vančura to contrast
the chaotic world of the Great Depression with a collectivist
model of ideal society. In his film an institute for runaway
and homeless children represents the ideal. This questionable
metaphor for society can be seen as a projection of the
avant-garde's alienation and its desire to be rid of it. Thus,
On the Sunny Side and its institute for homeless children
are a reminder of the ambiguous status of the avant-garde in
society, poised between being rejected and being co-opted.

The history of Czech (or any other) film avant-garde
and the avant-garde's contribution to the development of the
medium has been a story of this ambiguity. It is also a
story of discovery and adventure. Although most of the
Devětsil artists experimented with the medium for several
years, their discoveries entered the mainstream and became
part of its fabric. Society absorbed the avant-garde provo-
cations and disruptions and turned the avant-garde itself into
an institution. This cycle of discovery and absorption, as
artists moved into filmmaking, has continued to the present
day and spread into new technologies, including video and
computer graphics.

A recurring question is whether the process of co-option
and institutionalization exhausts the avant-garde, wears
out society, or both. Whatever the answer, the characteristic
of this weariness is a crisis in the concept of progress, a
concept implicit in the very term *avant-garde*,[43] leading to
the need to redefine the terms *Modernism* and *avant-garde*
and their impact on the development of film aesthetic. The
period between the two world wars provides us with a para-
digm to help us tackle these current issues.

1. For instance, the Soviet directors Sergei Eisenstein, Alexander Dovzhenko, and Grigory Kozincev started as visual artists associated with the avant-garde movement. Georges Sadoul, the French historian of cinema, was associated with the Surrealist movement.

2. Probably the only public survey of Czech cinema including the period between the world wars was organized by the British Film Institute in London in 1988. This series, however, focused primarily on narrative features, particularly of the postwar period.

3. Václav Tille, "Kinema," *Novina*, vol. 1 (1908), nos. 21, 22, 23, pp. 647–51, 689–93, 716–20. Reprinted in Lubomír Linhart, *The First Film Aesthetician, Václav Tille (První estetik filmu Václav Tille)* (Prague: Československý filmový ústav, 1968).

4. "Compared to theater, cinema does have an advantage since it can put together scenes in the process of creation regardless of their successive evolution. Scenes which had to be prepared after pauses lasting several hours can be connected on the screen right after each other, regardless of set, terrain, costume changes, etc. A love story, which begins on a real London street and continues in a restaurant, then on a ship sailing to South Africa for several weeks and ends at the Boers battlefield, consists of shots taken at all these locations, where the same persons actually played it" (Tille, "Kinema," pp. 691–92). In describing this characteristic of the medium, Tille used the expression *skládání snímků* (editing or composing shots) and came close to the definition of montage.

5. "There is definitely something seductive in this new medium; in those silent, swift, nebulous and playfully swarming shadows there is something wonderfully attractive, something clearly evoking in the soul impressions of one's own dreams, those secrets, unfinished, bolting, and snuffed out images in the mind which ignite in the brain without our will, gaining grotesque forms and turning pale and colorful, prompted by unfathomable impulses — all that play of the ideas of inner life incessantly pursued by the intellect and consciousness trying to catch them, which then again falls back below the threshold of consciousness, be it in a whirling daze or in lazily dragging fogs of thoughts" (Tille, "Kinema," p. 720).

6. See Václav Tille, "Varieté," *Free Directions (Volné směry)*. With circus, sport, film, and photography, *varieté* (vaudeville) became one of the sources of inspiration for the Czech avant-garde of the 1920s.

7. See Jaroslav Hašek, *The History of the Party of the Modest Progress within the Limits of the Law (Dějiny strany mírného pokroku v mezích zákona*, Prague: Československý spisovatel, 1980). The book was written in 1913.

8. Emil A. Longen, *Jaroslav Hašek* (Prague: Synek, 1928). Longen also produced the first dramatization of Hašek's *The Good Soldier Švejk* in 1921.

9. Emil A. Longen, *Actress (Herečka*, Prague: Pokrok, 1929).

10. Two of them were shot at the cabaret U Lhotků in collaboration with the cabaret's actors. Kinofa was organized by Josef Kejř, the owner of Tůmkova, one of Prague's popular bohemian spots.

11. For a discussion of the early use of film in Czech theater, see Vladimír Birgus, "The Beginnings of the Use of Film on the Czech Stage (Počátky využití filmu na českém jevišti)," *Panorama*, no. 4 (1977), pp. 36–42.

12. Urban and Sedláčková rarely drew upon literary and theatrical sources, and their adaptations were set in a contemporary context only loosely related to the original sources.

13. František Langer, "Always Cinema (Stále kinema)," *Lidové noviny*, vol. 21, no. 234 (1913), pp. 1–2. With other Prague writers, including Max Brod and Franz Werfel, Langer also contributed to *Das Kinobuch (Film Book)*, edited by Kurt Pinthus (Leipzig, 1913), the first book of film scripts written by prominent writers, which anticipates the flourishing of this genre after World War I.

14. Bratři Čapkové, "Biograf (Biograph)," *Track (Stopa)*, vol. 1, no. 19 (1910), pp. 595–96.

15. Josef Čapek's three short stories "Walk (Procházka)," "Event (Událost)" and "Water Surface (Vodní hladina)," published in the *Almanac for 1914 (Almanach na rok 1914*, Prague, 1913), represent a literary parallel to his Cubist paintings of that time. For additional discussion see Jiří Opelík, *Josef Čapek* (Prague: Melantrich, 1980), pp. 89–92.

16. Stanislav K. Neumann pointed out this parallel between film and Čapek's fiction in his review of their books *Boží muka* and *Zářivé hlubiny*: "In both books, we often find the narrative and syntactic discontinuity of images, stories, and events which are not connected in their external relation but are comprised seemingly illogically and with cinematographic economy in one stream of different objects, places, and times. This method achieves a true poetical condensation of content, a rapid captivating succession, the intensity of effect and magic that on one hand regenerates the lost feeling of the relationship of all forms of life in our mind and, on the other, 'dematerializes' reality into images as if they were seen through children's eyes" ("The Two Really New Books [Dvě knihy skutečně nové]," *June [Červen]*, vol. 1, no. 2 [March 1918], p. 24).

17. Karel Čapek, "The Style of Cinema (Styl kinematografu)," *Style (Styl)*, vol. 5, no. 5 (1913), pp. 146–48.

18. Like Eisenstein, Čapek argued that the task of the new medium is "to organize reality and to extract from things sensations as forceful as possible" (Čapek, "The Style of Cinema," p. 158). Čapek anticipated Vertov in analyzing the cinematic apparatus and in emphasizing nonfiction over fiction: "This literary or theatrical reform of cinema is a great and unnecessary mistake; cinema will never become literature or even acting since a galloping horse or a dignitary is often as good an actor as the best mime.... First of all, its material is not a theatrical play, but reality, and this reality could be accessible to the cinematographic operation not only in an infinite variety of phenomena but also in many different degrees; a given action could be represented in a close-up or large view, more or less defined, reduced or enlarged, if necessary, seen under the microscope, i.e., in different degrees of visibility, urgency, and intensity" (Čapek, "The Style of Cinema," pp. 146, 147).

19. Karel Čapek, "A.W.F. Co. (American World Film Company)," *Narod*, vol. 1, no. 4 (1917), pp. 73–75.

20. Karel Teige, "Foto Kino Film," in *Life II: An Anthology of the New Beauty (Život II. Sborník nové kvásy*, Prague: Umělecká Beseda, 1922), pp. 153–68.

21. Karel Teige, "Painting and Poetry (Malířství a poesie)," *Disk 1* (1923), pp. 19–20.

22. Karel Teige, "Poetism (Poetismus)," *Guest (Host)*, vol. 3, nos. 9–10 (1924), p. 209.

23. For additional discussion, see Viktorie Hradská, *The Czech Avant-garde and Film (Česká avantgarda a film*, Prague: Československý filmový ústav, 1976).

24. This term appeared in the film script *Chocolate the Clown (Klaun Čokoláda)* by Jiří Mahen, *Zone (Pásmo)*, vol. 1, no. 3 (September 1924), pp. 3–4. The title of this Devětsil periodical represents another important concept that influenced the Devětsil poetry and film aesthetic. The term *pásmo* (zone) gained prominence with Apollinaire's famous poem "La Zone," which stimulated an appreciation for the film medium. No wonder that Zdeněk Rossmann designed the *Pásmo* cover logo in the form of a film strip.

25. See Karel Teige, "The Renewal of Film Art (Obroda filmového umění)," in Karel Teige, *Film* (Prague: Václav Petr, 1925), pp. 96–97.

26. Karel Teige, "On Film Aesthetic (K estetice filmu)," *Studio*, vol. 1 (1929), p. 293.

27. Karel Teige, "On Czech Cinema (O českém filmu)," in *Film*, p. 70.

28. "Proclamation of the New Film Club (Prohlášení Klubu za novy film)," *Czech Film World (Český filmový svět)*, vol. 1, no. 5 (1927), pp. 4–5.

29. Alexander Hackenschmied, "Independent Film — A World Movement (Nezávislý film — světové hnutí)," *Studio*, vol. 2 (1930), p. 70.

30. "Independent film wishes to be one of the forms of expression of the free spirit and in all the areas where activity can be recorded by film, together with those where film can be a direct means of creative expression. The concept of independent film thus contains much more than the concept of avant-garde which has been known as the youngest and freest branch of filmmaking" (Hackenschmied, "Independent Film," p. 70.)

31. Jan Mukařovský, "Contribution to Film Aesthetic (K estetice filmu)," *Newsletter for Art and Criticism (Listy pro umění a kritiku)*, vol. 1 (1933), p. 107.

32. Although most of Innemann's narrative features represent the mainstream Czech film industry during the 1920s and 1930s, in this documentary he and his cameraman adopted vanguard techniques and devices, including multiple exposures, high-speed film stock, and unusual views of urban life.

33. As Thomas E. Valasek has pointed out, this sequence anticipated *Meshes of the Afternoon* (1944) by Hackenschmied (Hammid) and Maya Deren. See Thomas Valasek, "Alexander Hammid: A Survey of His Film-Making Career," *Film Culture*, nos. 67, 68, 69 (1979), pp. 280–88.

34. Jan Kučera, "Film and Construction (Film a stavba)," *Free Directions (Volné směry)*, vol. 30, no. 2 (1933), pp. 41–42.

35. See Jan Svoboda, "Jan Kučera's Beginnings and the Avant-Garde Circle of the Devětsil (Začátky Jana Kučery a okruh devětsilské avantgardy)," *Umění*, vol. 35, no. 2 (1987), pp. 163–64.

36. Jan Kučera, "Advertising and the Art of Cinematography (Reklama a umění kinematografické)," *Filmový kurýr*, vol. 1, no. 25 (1928), p. 1.

37. According to Voskovec and Werich, nonobjective or pure humor was "capable of introducing the spectator into the most magic world of absurdity." See "Roman Jakobson's Letter to Jiří Voskovec and Jan Werich on the Noetic and Semantic of Fun (Dopis Romana Jakobsona Jiřímu Voskovcovi a Janu Werichovi o noetice a sémantice švandy)," *Ten Years of the Liberated Theater* (*10 let Osvobozeného divadla*, Prague: František Borový, 1937), p. 27.

38. "Roman Jakobson's Letter," p. 34.

39. *Word and Literature (Slovo a slovesnost)*, the organ of the Linguistic Circle of Prague, published a discussion on speech in film by two former members of Devětsil, the theater director Honzl and the writer Vančura, who ventured into feature film (vol. 1, no. 1 [1935], pp. 38–42).

40. Jan Mukařovský, "An Attempt at Structural Analysis of an Acting Phenomenon (Pokus o strukturní rozbor hereckého zjevu)," *Literary Newspaper (Literární noviny)*, vol. 5, no. 10 (1931).

41. Roman Jakobson, "Is the Cinema in Decline? (Úpadek filmu?)," *Newsletter for Art and Criticism (Listy pro umění a kritiku)*, vol. 1 (1933), pp. 15–19.

42. Film critics and historians have described it as controversial and flawed. The exception was Kučera who in his publication *The Progressive Tendencies in Czech Cinema from 1920–1938 (Pokrokové tendence v českém filmu v období 1920–1938*, Prague: Československý filmový ústav, 1971) argued that the presumed defects of the film were in fact a part of Vančura's deliberate strategy.

43. See Robert Nisbet, *History of the Idea of Progress* (New York: Basic Books, Inc., 1980).

Voskovec and Werich in *Greasepaint and Gasoline (Pudr a benzin,*
also released as *Powder and Gas)*, 1931, directed by Jindřich
Honzl.

The Theater and Films of Jiří Voskovec and Jan Werich

MICHAL SCHONBERG

In 1913, my friend, the late poet Apollinaire, took me to the Cirque Medrano. After what we'd seen that night, Apollinaire exclaimed: "These performers, using the means of the commedia dell'arte, are saving theatre for artists, actors and directors!" Since then, from time to time, I would return to the Medrano, hoping to intoxicate myself again with the hashish of improvised comedy. But Apollinaire was gone. Without him, I could no longer find the artists he had shown me. I looked for them with a longing heart but the Italian "lazzi" were no more. Only tonight, on October 30th, 1936, I saw the "zanni" again in the persons of the unforgettable duo of V & W, and was once more bewitched by performances rooted in the Italian commedia ex improviso. *Long live Commedia dell'Arte! Long live Voskovec and Werich![1]*

Thus wrote the great Russian director Vsevlod Meyerhold about the two young Czech actors and playwrights Jiří Voskovec and Jan Werich after seeing them perform at the Liberated Theater in Prague.

In the 1930s Voskovec and Werich were among the most celebrated and successful stage and screen artists in Czechoslovakia. By the middle of the decade, their reputation as satirists and comedians of the democratic and anti-Fascist movement had spread far beyond the borders of their small country. Today's historians of theater and cinema, especially in the West, are generally unaware of their work. This neglect is attributable in part to political circumstances and to the common misfortune of small nations that speak languages not universally used.

Voskovec and Werich were both born in 1905—the former into the family of a military band leader in the service of the Russian czar and the other, an only child, to an insurance company clerk. Their families lived close to each other in Prague and the two boys became friends. At the time of the formation of the first Czechoslovak Republic, they were thirteen. Shortly after the war Voskovec, who was fluent in French, received a scholarship to study at the Lycée Carnot in Dijon. There he became involved with the French avant-garde and began to write poetry. He was helped and encouraged in his early efforts by Josef Šíma, the Czech painter living in Paris, who later arranged for Voskovec's membership in the Czech avant-garde group Devětsil. Voskovec contributed poetry, collages, and theoretical articles to a variety of avant-garde publications.

Werich attended secondary school in Prague and grew into a robust and street-smart youngster with a keen interest in movies. Films, an important bond in Voskovec's and Werich's childhood friendship, were soon to play an even greater role in their lives.

Early in 1926 Voskovec was invited by the director Karel Anton to try out for a leading part in the movie *The Fairy Tale of May* (*Pohádka máje*), a romantic love story being shot in Prague. Voskovec, who was now a law student like his friend Werich and who had no professional acting experience, thought it might be an interesting diversion and accepted the director's offer; he performed in the film under the name of Jiří Dolan. Although Werich found his best friend's stardom amusing, the leaders of Devětsil were not pleased. Believing that a member's involvement in a "piece of commercial kitsch"[2] was a betrayal of the fundamental ideals of their movement, they expelled Voskovec from Devětsil. It didn't seem to worry him too much because, as Werich later wrote in his memoirs, "they all kept going to the same cafés, sitting at the same tables, talking to each other." Subsequently Voskovec accepted smaller parts in two other equally "debased" movies, *Kathy of the Egg Market* (*Katynka z Vaječného trhu*, 1926) and *In the Vampire's Claws* (*Ve spárech Upíra*, 1927).

In the early part of 1927, Voskovec and Werich wrote a theatrical entertainment called the *Vest Pocket Revue*. They produced it with a group of friends under the auspices of the avant-garde Liberated Theater (Osvobozené divadlo) and performed the leading parts of Publius Ruka and Sempronius Houska. The two characters they created were clowns whose virtuosity lay not in the physical but rather in the verbal realm.[3] The contemporary critic Franta Kocourek wrote about the *Vest Pocket Revue* that Voskovec and Werich "reach their greatest success when they are parodying conventional speech, as it is spoken in the society of both snobs and common people."[4] Other features, which were to figure prominently in Voskovec and Werich's subsequent work on stage and in film, included elements of Surrealism and of something they called "beastliness" (*hovadnost*). For Voskovec and Werich this term connoted objects or events

that were simultaneously beastly and beautiful. The concept comes very close to the practice of "camp" as Susan Sontag describes it in her "Notes on Camp." Both share "the love of the exaggerated, the 'off,' of things being-what-they-are-not." When Sontag talks about camp's "extraordinary feeling for artifice, for surface, for symmetry, its taste for the picturesque and the thrilling, its elegant conventions for representing instant feeling and the total presence of character—the epigram and the rhymed couplet (in words)...," she could be describing the practice Voskovec and Werich indulged in during the late twenties. The ultimate camp statement—"it's good because it's awful"— is analogous to Voskovec and Werich's "beastly but beautiful."[5]

Both camp and Voskovec and Werich's beastliness were "modes of enjoyment, of appreciation—not judgment...."[6] They generally operated on a dual level of meaning: one was for the initiates or the cognoscenti and the other for the general public. Voskovec and Werich also made beastliness the object of their comedy, sending up especially its pretentiousness and its mannered preciosity.

The staging of the *Vest Pocket Revue* began the first phase of Voskovec and Werich's work, which can be regarded as their theatrical apprenticeship. Initially they maintained a strong relationship with the Prague avant-garde, sharing the theater as well as the acting company. Soon, however, Voskovec and Werich outgrew the very limited facilities of the avant-garde theater as well as finding the artistic restrictions exacted by the aesthetic orthodoxy of the movement extremely constraining. They gradually separated from the avant-garde, moving into a larger modern theater and retaining only the name Liberated Theater. The first phase of their work as independent producers lasted until 1931. Besides producing, they wrote, performed, and directed several poetic comedies. During this period Voskovec and Werich refined their comic skills; they were influenced by the famous Italian circus clowns, the Fratellini Brothers, whom they saw in Paris at the Cirque Medrano, as well as by eccentric music hall artists and Charlie Chaplin. At the same time they were honing their personal improvisational skills. Their greatest success in this period came with the jazz fantasies *Fata Morgana* (1929) and *Dynamite Island* (*Ostrov Dynamit*, 1930). The latter was inspired both by W.S. Van Dyke's South Pacific film *White Shadows in the South Seas* (1928), whose locale and general mood they parodied, and by the slapstick film comedies of Laurel and Hardy like *Big Business* (1929).

Twice in 1930 Voskovec and Werich became involved directly with the United States. They were recommended by Paramount's representative in Prague to appear in the spectacular compilation film *Paramount on Parade*, which starred among others Maurice Chevalier, Gary Cooper, and Jean Arthur. It was indicative of the meteoric rise in popularity of these two young stars that not only were they hired to replace Jack Oakie, Skeet Gallagher, and Leon Errol in the comedy routines, but they were allowed to write their own material for the version of the film distributed in Czechoslovakia. The second incident occurred after the opening of

their new play *North against South* (*Sever proti jihu*, 1930), which, as the title indicates, concerned the American Civil War. It was Voskovec and Werich's first venture into a specific historical period and drew on an imaginary incident in the war involving a traitorous Union major who tries to sell a barge loaded with ammunition to both sides but is thwarted by the famous scout Buffalo Bill. Voskovec and Werich were inspired to write the play by, among other things, Woodrow Wilson's *A History of the American People*, which appeared in Czech translation in 1927.[7] The production entangled them in their first international incident: the Prague correspondent for *The New York Times*, Edward T. Heyn, who was much insulted by the play, especially by the irreverent treatment of Generals Grant and Lee, wrote that the play should have been censored. After the Czech newspapers rebuked him for causing "much ado about nothing" and lacking a sense of humor, Heyn complained to the U.S. Embassy in Prague. Barton Hall, the chargé d'affaires, reported in a memorandum to Washington that he found nothing wrong with the play, and the matter was allowed to rest.

By the summer of 1931 Voskovec and Werich were ready to embark on their own film-producing career. They started a new company called VaW, a variation on the acronym V&W by which they were now identified throughout Czechoslovakia. Their business manager announced ambitious long-range plans. These included cooperation with the firm Le Film Français, the Prague subsidiary of the French consortium Gaumont-Francofilm-Aubert. The first film, *Greasepaint and Gasoline* (*Pudr a benzin*, also released as *Powder and Gas*, 1931), starring Voscovec and Werich, was to be produced simultaneously in Czech and French versions, with the French company having exclusive worldwide distribution rights. The film's interior sequences were produced in Paris at the Gaumont Studios, and the exteriors were shot in and around Prague and in northern Bohemia. The involvement with Gaumont allowed the producers to use the most advanced Radiocinema sound system, marking the first time that live environmental sound was used in a Czech feature film.

Greasepaint and Gasoline suffered from the inexperience of the director Jindřich Honzl, who, although an accomplished theatrical director, had little experience working in film. On the other hand, precisely because of its theatrical nature, the film has become an invaluable documentary account of Voscovec and Werich's early acting style. The second half of the film contains complete scenes from *North Against South* and one of the earliest pieces of deliberate camp captured on film—a scene of comic ballet that originated in the *Smoking Revue* (1928). A "beastly and beautiful" scene in the woods shows Voskovec and Werich entertaining Martha in a quaint and comfortable parlor set of heavy white polished furniture. The scene might serve as an illustration to Sontag's statement that "Camp taste effaces nature, or else contradicts it outright."[8]

Greasepaint and Gasoline was released in Prague on Jan-

uary 15, 1932, but unfortunately was not a commercial success. In addition, the company's business manager, Josef Háša, had mismanaged the company's finances, and Voskovec and Werich as principal partners in VaW found themselves encumbered with heavy debts. Eventually the whole matter ended in litigation and Háša was fired. Instead of leaving the theater and turning to film as they had intended, Voskovec and Werich had to continue on stage to cover their financial liabilities. Two very successful plays, *Golem* (1931) and *Caesar* (1932), allowed them to do so. The former was the last of their politically disengaged poetic comedies, while the latter introduced Voskovec and Werich as political and social satirists.

In taking up the responsibilities of satirical commentators on domestic and international affairs, Voskovec and Werich allied themselves and their theater with the democratic and anti-Fascist forces in Czechoslovakia. By doing so, they brought upon themselves the wrath of the political right wing and, somewhat later, the full repressive power of the German Nazi propaganda machine. *Caesar*, set in Rome on March 14, 44 B.C., concerns the political and business machinations against Julius Caesar. Caesar's internal enemies are led by the corrupt senators Brutus and Cicero, while his external foes are represented by Cleopatra and her high priest. Voskovec and Werich played two plebians who represent the vox populi. One of the leading critics of the period, A.M. Píša, evaluated the play: "The authors' capricious derision hides a bitter veracity. Their revue does not resound with a singular political tendency, but is a direct and temperamental protest of today's youth against the current political and social lie and half-truth, against the role of platitude, militarism, and corrupt dirt, against improbity and ideological burlesquing of the powerful of this world."[9] The same attitudes reappeared in their next plays, *Robin Hood* (*Robin zbojník*, 1932) and *The World Behind Bars* (*Svět za mřížemi*, 1933).

Given the strong political content of their plays of this period, Voskovec and Werich's second venture into feature film was curiously apolitical. Unsuccessful as independent producers, they decided this time to make the film *Your Money or Your Life* (*Peníze nebo život*, 1932) with Lloyd Film and A.B. Company as producers and to limit their participation to writing the script and performing. The film was directed by Jindřich Honzl. The story concerns two boyhood friends who meet as grown men under peculiar circumstances. One of them, Tonda (played by Werich), a petty criminal, is accidentally given a stolen gem by fleeing robbers. While examining it in a park, he happens upon his old friend Pepík (Voskovec) who has married unhappily into a rich family and now is attempting suicide. Pepík takes Tonda to his house, where they get drunk and disrupt a dinner party given by Pepík's in-laws. The stolen jewel complicates the situation when Pepík's unfaithful wife, discovering it concealed in a bouquet, believes that a mysterious dinner guest has brought it for her. The rest of the film is spent in pursuit of the jewel. A magnificent battle scene between the real jewel

thieves and Voskovec and Werich is set in a closed museum. All the standard exhibits of a cluttered Central European museum are used in the action (which is somewhat reminiscent of the famous battle scene from the Marx Brothers' *Duck Soup*, 1933). Finally, Voskovec and Werich, accompanied by two pretty girls, give the jewel to charity and end up penniless but happy. The moral of the film is simple: money cannot buy freedom, happiness, love, or friendship. *Your Money or Your Life* forgoes many of the naive qualities of *Greasepaint and Gasoline* in favor of a greater cinematic and technical sophistication. This is seen in the much improved narrative continuity, editing, lighting, and sound techniques. *Your Money or Your Life* also provides an important document of Voskovec and Werich's finest work in the theater.

By the beginning of 1933 the political situation in Europe surpassed anything theatrical imagination could conceive, culminating in Hitler's ascendancy in Germany and the Reichstag fire. These events and the rise of Fascism in Czechoslovakia engendered a great satirical play *The Ass and the Shadow* (*Osel a stín*, 1933), based on Lucian's ancient Greek fable concerning an argument between a donkey's owner and its passenger as to who has the right to the animal's shadow. The trivial argument is taken up by opposing political sides, which eventually form a pernicious alliance of big money and demagogic populism. The play generated several formal diplomatic protests from Germany as well as a vicious campaign in the German National Socialist press. Denunciations by the Czech Fascist and ultrarightist media were not far behind.

In the summer of 1934 Voskovec and Werich wrote and acted in their third feature film, *Heave Ho!* (*Hej rup!*, 1934), produced by the Czech company Meissner Films and directed by Martin Frič. The film also starred the popular actress Helena Bušová. Voskovec plays Filip, an unemployed worker, while Werich is the industrialist Simonides. During a binge orchestrated by his scheming competitor, the dairy tycoon Worst, Simonides hears Filip on the bar radio delivering an impromptu condemnation of a system that puts people out of work. The drunken Simonides goes to the radio station to hire Filip as his assistant but soon discovers that he himself has been put out of business. The two end up on the breadline, with Filip acting as Simonides' teacher in the art of survival. When they discover that an unfinished building owned by Simonides has been overlooked by his creditors, they organize a cooperative with other unemployed workers, complete the building, and soon are competing against Worst. The latter tries to ruin them by having Simonides kidnapped, but all of his plots are foiled. In the end all the co-op workers buy shares in Worst's concern, "pack" the shareholders' meeting, and take control of Worst's empire.

The film director Frič brought to *Heave Ho!* a professionalism that Honzl lacked, and the results are cinematically more interesting. The film was faulted, however, by some Czech critics for having been substantially affected by American "crazy" comedies and by René Clair's parodies. The

movie contains a brilliant and noteworthy comic scene, the first in European film to parody successfully Sergei Eisenstein's style of montage. The scene in which a rattling old truck bought by the workers arrives at the co-op is a combination of extreme jump cuts and peculiarly angled close-ups of faces, intercut with shots of milking machinery at work. It is accompanied by music reminiscent of Soviet propaganda films and Voskovec and Werich speaking in Russian-sounding gibberish.

Also interesting is the thematic closeness between *Heave Ho!* and King Vidor's *Our Daily Bread* (1934), in which a cooperative farm venture is started by a property owner unable to manage on his own. Although (or possibly because) *Heave Ho!* delivered a utopian message that cooperation between working people of all classes could solve the problems of the Depression, the film was extremely successful with the public and at the box office. It was also the only one of Voskovec and Werich's films to receive popular and critical acclaim abroad. It had excellent runs in Vienna and London and was shown in the United States, both to American-Czech audiences and to the general public in New York. It was one of three films representing Czechoslovakia at the Venice Film Festival in 1935.

The attacks from Czech Fascists intensified when Voskovec and Werich in their next play, *The Hangman and the Fool* (*Kat a blázen*, 1934), focused their satire on the local scene. They were labeled Communist traitors and subjected to anti-Semitic invective—although neither of them was Jewish—and riots were organized by rightist students at the Liberated Theater. For a while Voskovec and Werich held their own by staging two lighthearted satirical revues, *Keep Smiling* (*Vždy s úsměvem*, 1935) and *Waxworks* (*Panoptikum*, 1935), both aimed at upholding freedom of expression and democracy. The unceasing attacks nonetheless disillusioned Voskovec and Werich so much that at the end of the 1935 season they decided to leave the stage altogether and to concentrate on making films. Besides the general fatigue of eight years of continuous work on stage and their unhappiness about the politics of the day, Voskovec and Werich's decision was also motivated by the prospect of turning their play *Golem* into a movie. The entrepreneur Miloš Havel, co-owner of the A.B. Company in Prague, was interested in producing *Golem* on an international scale and called in the prominent French director Jean Duvivier. After meetings between Havel, Voskovec and Werich, and Duvivier in Paris, antagonism developed between Voskovec and Werich and the Frenchman, and the Czech artists eventually were maneuvered out of the project.

With no immediate film prospects, Voskovec and Werich decided to return to the stage, and they established the Bound Theater (Spoutané divadlo) in a small, centrally located space. There they staged the charming and highly successful *Ballad Made of Rags* (*Balada z hadrů*, 1935), which was based on the life and works of the fifteenth-century French poet François Villon. The success of the stage work led to another attempt at a film, this time in collabora-

tion with the French director Bernard Deschamps. In an interview with a Czech magazine, Deschamps said, "It would be a historical satire, [in which] the French literary tradition would be better observed than in the American *The Vagabond King*."[10] Even the leading actor was announced: the part of Villon was to be played by René Lefèvre, well known from René Clair's films. Nonetheless, contractual and legal problems with A.B. Company eventually destroyed the project.

Encouraged by leading Czech intellectuals, Voskovec and Werich returned to the larger Liberated Theater and wrote their first and last completely contemporary play, *Obverse and Face* (*Rub a líc*, 1937). The play deals with the growing danger from an increasingly militant Fascist fifth column, which was especially active in the areas bordering Germany. Predictably the play was welcomed by democratic voices both at home and abroad, where it was widely reviewed, and condemned as Communist propaganda by the German and Czech right-wing press. The play engendered Voskovec and Werich's last feature film as a team, *The World Belongs to Us* (*Svět patří nám*, 1937), which was shot in the late spring of 1937 and released in Prague on July 30. The aggressive social and anti-Fascist comedy was their most serious and politically committed work to date. Although based on *Obverse and Face*, it was not simply an adaptation of the play. The script, which was written by Voskovec and Werich, the director Martin Frič, and Karel Steklý, included scenes from the play *Waxworks* as well as new material.

The film opens with a scene in a decrepit wax museum, where Drexler, a carnival barker, is exhibiting Lionel, "half-man, half-beast." When the customers find out that in reality the creature is Forman, a normal young man, they demolish the booth. Some years later during the Depression, Drexler is back in business, this time as a propaganda chief to the leader of the local Fascist party. Forman, who encounters his former employer in a flophouse where Drexler is recruiting the down-and-outs to join his party, becomes a strike leader in a large factory. Voskovec and Werich are hired by the two opposing sides, the workers and the strike-breakers, to paint slogans on the factory walls. After interfering with each other's work and getting beaten up, they join forces, pool their money, and in pursuit of a dropped coin, end up in the basement of the factory, where they join the striking workers. The strike becomes violent, leading one of Drexler's captains to inform the workers about the Fascists' plan to overthrow the government using weapons stockpiled somewhere in the factory. On a home-built transmitter, the workers broadcast a message to the nation, while others try to locate the weapons. Voskovec and Werich, looking for something to eat, find grenades marked "Krupp Essen," and mistaking them for cans of food, accidentally detonate one of them. This attracts Drexler and his henchmen, who are ambushed by Voskovec and Werich and handed over to the police. In the end Voskovec and Werich, who are thought to have perished in the explosion of the arsenal, attend the memorial service in their honor.

Greasepaint and Gasoline (Pudr a benzin, also released as *Powder and Gas),* 1931, directed by Jindřich Honzl.

The World Belongs to Us (Svět patří nám), 1937, directed by
Martin Frič.

The World Belongs to Us (Svět patří nám), 1937, directed by
Martin Frič.

The film contains several brilliant comic scenes, the best and most controversial involving the attempt by Voskovec to remove some window bars from Werich's neck by sending him on a conveyor belt toward a giant circular saw. Some critics accused them of taking the idea from Chaplin's *Modern Times* (1935), a charge that the comics vehemently denied. (Paradoxically, Chaplin faced similar charges regarding the relationship of the factory scenes in *Modern Times* to those in René Clair's *À nous la liberté* [1931]). In retrospect such arguments seem irrelevant, given the fact that the original contribution of the comics, be they Chaplin or Voskovec and Werich, is such as to render their own works unique.

The cast of the film included the popular Czech star Adina Mandlová and practically the whole ensemble of the Liberated Theater, as well as two of the finest actors from the National Theater, Jaroslav Průcha and Zdeněk Štěpánek. The film was immensely successful when released, serving as a morale booster to the resistance-minded supporters of Czechoslovak democracy. During the Nazi occupation of Czechoslovakia, the negative of the film was destroyed. The film was reconstructed from fragments after the war, but no complete copy survives.

In the deteriorating political situation of Central Europe, Voskovec and Werich produced two final plays in the 1937–38 season. *Heavy Barbara* (*Těžká Barbora*, 1937), set in the mythical seventeenth-century country of Eidam, deals with the resistance of ordinary people against invaders from the neighboring warlike country of Yberland. With the help of Voskovec and Werich, who play two deserting mercenaries in possession of a large cannon called Barbara, the people of Eidam defeat the enemy and rid their country of internal traitors. The second production was a revue called *Fist in the Eye, or Caesar's Finale* (*Pěst na oko aneb Caesarovo finále*, 1938), which contains several allegorical pieces concerning the confrontation between beauty and ugliness, excellence and mediocrity, and good and evil. Although its political purpose remains unambiguously democratic, the play is more philosophical in approach than its predecessors.

With the loss of democracy in Czechoslovakia after the country's betrayal at Munich in the fall of 1938, the Liberated Theater came to an end. Regarded as a political liability just prior to the German occupation of the country, it was closed down by order of the police prefect for being dangerous to the public safety. Voskovec and Werich, together with their principal collaborator, the composer Jaroslav Ježek, escaped to the United States.

In the United States Voskovec and Werich resumed their acting careers, first entertaining compatriots at Czech-American clubs in New York, Cleveland, Baltimore, and Chicago. Later, when they learned English, they staged translations of *Heavy Barbara* and *The Ass and the Shadow*. Between 1942 and 1945 they were engaged by the U.S. Office of War Information, preparing more than two thousand radio programs broadcast into Czechoslovakia. In January 1945 Voskovec and Werich made their Broadway debut, appearing as Trinculo and Stephano in Margaret Webster's production of *The Tempest* at the Alvin Theater.

After the war both Voskovec and Werich returned to Czechoslovakia, appearing together in George Kaufman and Moss Hart's *The Man Who Came to Dinner* (*Přišel na večeři*) in 1946 and then in an updated revival of *Fist in the Eye*. Their last collaboration was a Czech version of Fred Saidy and E.Y. Harburg's *Finian's Rainbow* (*Divotvorný hrnec*), with Werich performing an added part of the water sprite Cochtan and Voskovec directing.

After the Communist takeover in February 1948, Voskovec left Czechoslovakia. He returned eventually to the United States, where he had a distinguished acting career on Broadway and in Hollywood. Werich remained in Czechoslovakia, where he continued to work on stage and in film. His never-ending battle against censorship and the obtuseness of political authorities made him one of the leaders of the Czech intellectual opposition.

In its eleven-year history the Liberated Theater developed from a small student- and intellectual-oriented amateur enterprise with Dadaist and Surrealist roots into a large-scale theater of a popularity unequaled until the present day. Throughout the Nazi occupation and during the periods of political oppression under the Stalinist rule of the late forties and the fifties, the Liberated Theater and the films of Voskovec and Werich remained associated in the consciousness of the Czech people with the highest ideals of liberty and democracy. They remain so today. Indeed the recent generation of Czech artists and intellectuals who were principally responsible for the renaissance of Czechoslovak film and theater in the sixties freely admits its debt to Voskovec and Werich.

The success of Voskovec and Werich came from their ability to offer highly intelligent comedy while maintaining popular appeal. The lasting quality of their best work shows them as comic-humanists, tirelessly examining people and events around them, looking at history to find parallels for the vagaries of their contemporaries, occasionally despairing over the state of affairs but never giving up hope that fairness, justice, and common sense will at some point prevail. The four films of Voskovec and Werich allowed them to overcome the transient nature of live theater and to preserve some of this for posterity.

Michal Schonberg is associate professor of drama at the University of Toronto, Scarborough Campus.

1. V.E. Meyerhold, "On a Performance of Prague's Liberated Theater (O spekt-akle prazhskogo Osvobozhdennogo teatra)," *Letters, Speeches, Discussions (Stat'i, Pis'ma, Rechi, Besedy)*, second part, 1917–1939 (Moscow: Izdatel'stvo Iskusstvo, 1968), p. 371. "V&W" became established as the popular acronym for Voskovec and Werich.

2. *Dialogues with Voskovec (Dialogy s Voskovcem)*, series 2, tape 10, transcript p. 116.

3. The distinguished linguist Roman Jakobson referred to Voskovec and Werich's work from the *Vest Pocket Revue* as "semantic clowning" in an article inspired by them. See "Roman Jakobson's Letter to Jiří Voskovec and Jan Werich on the Noetic and Semantic of Fun (Dopis Romana Jakobsona Jiřímu Voskovcovi a Janu Werichovi o noetice a sémantice švandy)," in *Ten Years of the Liberated Theater (10 let Osvobozeného divadla)*, ed. Josef Träger (Prague: [published for the Liberated Theater by] František Borový, 1937), pp. 27–34.

4. Franta Kocourek, "What is Voskovec's and Werich's Contribution? (Co přinesli Voskovec a Werich)," *Přítomnost*, vol. 6, no. 8 (February 28, 1929), p. 121.

5. Susan Sontag, *Against Interpretation and Other Essays* (New York: Dell Publishing Co., 1966), p. 292.

6. Sontag, p. 291.

7. *Dějiny amerického lidu* (Prague: Kvasnička a Hampl, 1927).

8. Sontag.

9. A.M.P. [A.M. Píša], "The New Revue of the Liberated Theater (Nová revue Osvobozeného divadla)," *Právo lidu* (March 10, 1932), p. 6.

10. Reported by S. Ježek in his article "Our Film Collaboration with France (Naše filmová spolupráce s Francií)," *Groš* (March 2, 1936). A version of *The Vagabond King*, starring Dennis King, was made in 1930 in Hollywood by the German director Ludwig Berger. According to *Halliwell's Film Guide*, it is now lost.

On the Sunny Side (Na sluneční straně), 1933, directed by
Vladislav Vančura.

On the Sunny Side of Film

PAVEL TAUSSIG

The cinema of Czechoslovakia is among the oldest in the world: the first projections of "photographs come to life" took place in 1896 in Bohemia and Moravia, only a few months after the world premiere of the Lumière Brothers in Paris. The first Czech feature and documentary films, which were also first in the Austro-Hungarian Empire, were made by Jan Kříženecký in 1898.

Among the pioneers who contributed to the development of cinema was Jan Evangelista Purkyně, a Czech physiologist of worldwide importance. In the mid nineteenth century Purkyně replaced the drawings on a stroboscopic disk with photographs and used his "kinesiskop" or "forolyte" in lectures to demonstrate, for example, blood circulation.

In the 1910s the first Prague film companies came into being and with them the tradition of Czech film comedy. Film also began to attract famous actors and representatives of official culture, particularly writers, who were intrigued by the artistic potential of the new technical invention. Following the establishment of the independent Czechoslovak Republic on October 28, 1918, the national cinema experienced a production boom. Although intellectuals and artists wrote articles on film, some of them with considerable theoretical content, the majority of films actually produced were directed and written by former crafts and trades persons. Their ambition was not art but an entertainment for the masses. This had a detrimental effect on the selection of themes and problems to depict. The Czech film industry was rejected by art critics, who admired American films. A depression throughout the industry that began in 1924 was overcome a year later by the increased production of films based on "popular" literature. The writer and painter Josef Čapek aptly warned that "garbage is garbaging garbage."

Following the proclamation of state and national independence, films whose themes attempted to capture the national character began to be produced; films celebrating the courageous feats of the independent Czechoslovak Legion in World War I helped to create a legionnaire myth. The film *Jánošík*, shot in Slovakia thanks to the initiative of Slovak-Americans, became the cornerstone of Slovak national cinematography.

Several silent films made at the end of the 1920s are genuine works of art, particularly *Battalion* (*Batalion*, 1927) by the director Přemysl Pražský and *Such Is Life* (*Takový je život*, 1929), made in Prague by the German director Karl Junghans. Prague locations figure prominently in both films. The films emphasize social determination (the main characters are members of the lower classes, even, as in *Battalion*, of the "lumpenproletariat"). Recognizable real-life conditions and the chiaroscuro side streets of Prague's outskirts intensify the photogenic quality of the shots. The subjects of the films are similar, too: *Battalion* follows the social downfall of an esteemed society lawyer (Uher, a deputy in the Imperial Diet and an historical figure), and in *Such Is Life* a laundress, married to an alcoholic, becomes the victim of tragic fate. (The laundress was one of three roles in Czech films played by the Russian actress Vera Baranovskaia, who had also played the title role in Vsevold I. Pudovkin's drama *Mother* [*Mat,* 1926].[1]) Baranovskaia and Karel Hašler, who played Uher in *Battalion*, were remarkable for their realistic depictions of even the inner depressions of their characters. The psyche of Uher, including an attack of delirium, was also "depicted" by the cameraman Jaroslav Blažek through the use of a "subjective" camera that shows the beer-hall surroundings as if through the eyes of the main character: the view is foggy, the furniture and the walls are moving. The symbolic "speech" of objects was also used in an original manner; Uher's torment is evoked by a shot of violin strings being cut by a knife.

Hašler, Pražský, and the actor Theodor Pištěk, who initiated *Such Is Life*, were among the pioneers of Czech cinema. Along with other actors and directors, especially Josef Rovenský, they represented a group of filmmakers whose films surpassed the level of most commercial productions. Later, in the era of sound, Rovenský created an original realistic style characterized by an expressive lyricism, frequently with outdoor landscape settings. These filmmakers (the list includes the directors Jan Stanislav Kolár, Karel Anton, and Karel Lamač) made their films spontaneously, without any artistic theoretical agenda.

From 1930 to 1933, following the entry of sound, eighty-four feature-length films were made in Czech studios, many of them successful abroad. Audiences favored comedies, especially those featuring Vlasta Burian, the "king of the comedians." His first film, *The Imperial and Royal Field Marshal*

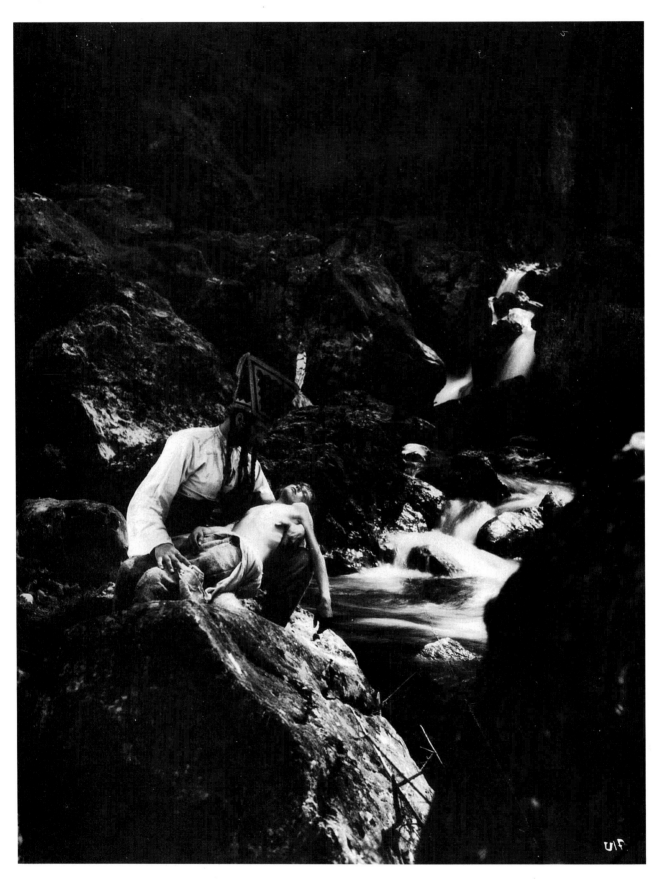

Jánošík, 1936, directed by Martin Frič.

■ TAUSSIG

Battalion (Batalion), 1927, directed by Přemysl Pražský.

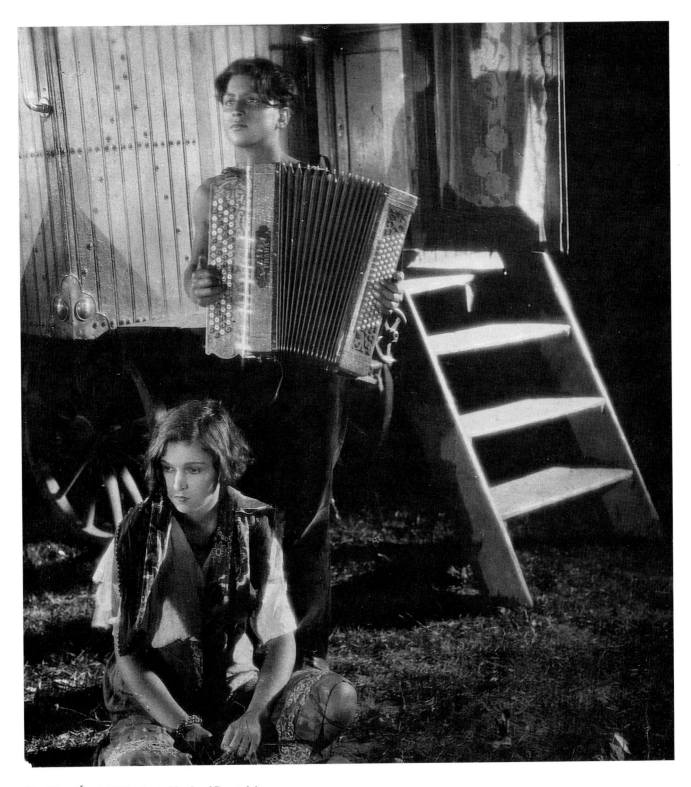

The River (Řeka), 1933, directed by Josef Rovenský.

From Saturday to Sunday (Ze soboty na neděli), 1931, directed by
Gustav Machatý.

(*C.a.k. polní maršálek*, 1930), sustained a twenty-four week
run in two of Prague's largest cinemas.

Emerging sound film frequently exploited literary and
theatrical scenarios, and writers and playwrights increasingly
were invited to collaborate in film production. Some writers
(for example, the humorist Karel Poláček) worked for short
periods as screenplay writers. During this period Jiří
Voskovec and Jan Werich, together with other actors and
artists of the Liberated Theater (Osvobozené divadlo), made
their first comedies. (The studio scenes of their feature-length
debut *Greasepaint and Gasoline* [*Pudr a benzin*, also released
as *Powder and Gas*, 1931] were shot in Paris, however, since
sound apparatus was not yet available in Prague.) Domestic
film writers even delved into the world theater repertory:
Vlasta Burian conjured up a disciplined interpretation of
Khlestakov in the film adaptation of Gogol's *The Inspector
General* by director Martin Frič. The new and modern Bar-
randov studios, built on a hill on the outskirts of Prague, fur-
thered the development of Czech film.

Two avant-garde writers penetrated into the world of
actual filmmaking on the cusp of the arrival of sound tech-
nology in Czech cinema: the poet Vítězslav Nezval and the
writer Vladislav Vančura. Both previously had published
critical analyses of films and film scripts; it is not surprising

that they wrote about the products of domestic commercial
cinema using a vocabulary that abounded in condemnation.[2]

Although the existing production system suffered from
provincialism in the sound era of the thirties, its conventions
could be disrupted by producers, who did not hesitate to
finance the creative attempts of true artists. Two leaders in
the effort to make films of greater artistic merit were Julius
Schmitt and Ladislav Kolda. It is certainly no coincidence
that both supported the early film experiments of Vančura
and Nezval.

Nezval wrote or collaborated on the scripts of the silent
films *The Native of Podskalí* (*Podskalák,* 1928), directed by
Pražský, *Organist at the Saint Vitus Cathedral* (*Varhaník u
svatého Víta*, 1929), made by Frič, and *Erotikon* (1929),
signed by director Gustav Machatý. Nezval continued to col-
laborate with Machatý on some of his "talking" films.

The films Nezval made in collaboration with Machatý
are the pinnacles of his film work. Machatý, who had
acquired a command of nearly all the filmmaking skills (he
even acted in several films), managed to make films with a
simple plot but an exciting external expression that reflected
the internationalism of film, especially during the silent era.
The erotic source of his films is suggested by their titles: *Ero-
tikon, Ecstasy* (*Extase*, 1933), and an unrealized silent film

Erotikon, 1929, directed by Gustav Machatý.

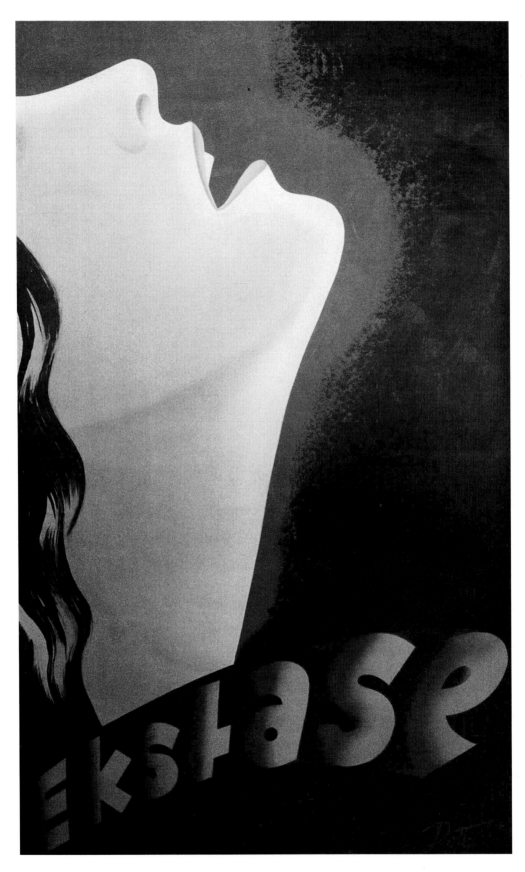

Poster by Rotter for *Ecstasy (Extase)*, 1933, Uměleckoprůmyslové
muzeum v Praze.

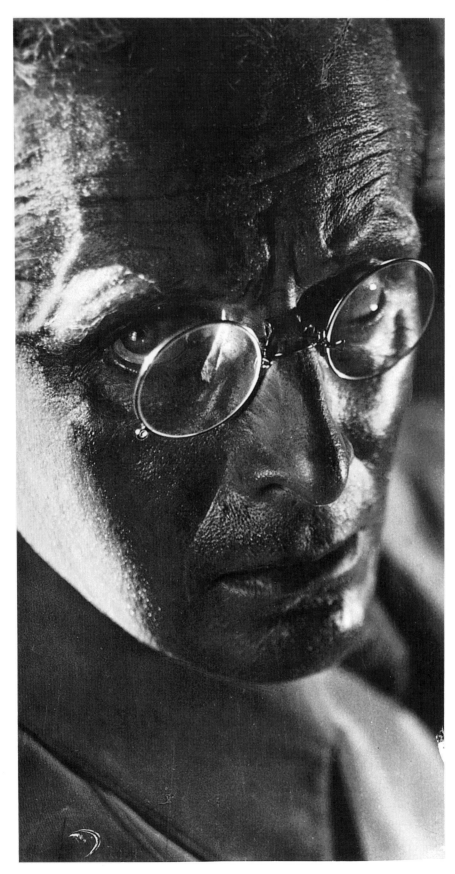

Ecstasy (Extase), 1933, directed by Gustav Machatý.

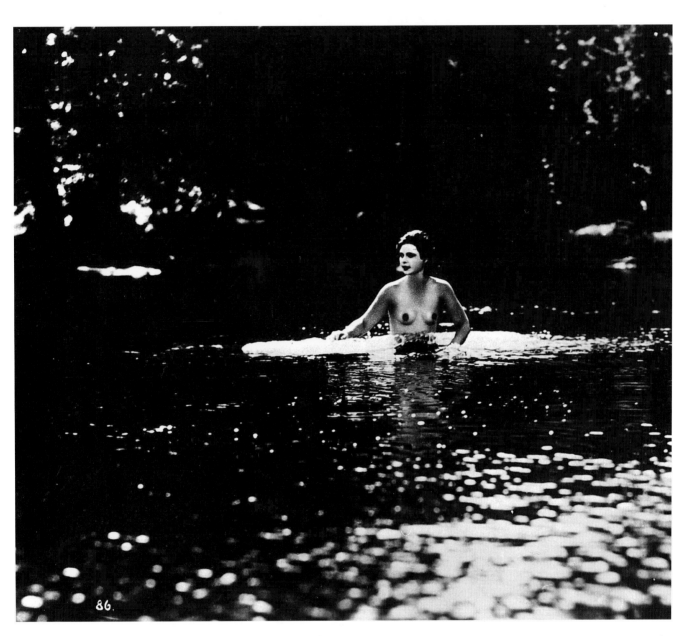

Ecstasy (Extase), 1933, directed by Gustav Machatý.

Poster by an anonymous artist for *From Saturday to Sunday (Ze soboty na neděli)*, 1931, Československý filmový ústav–Filmový archiv.

■ TAUSSIG

From Saturday to Sunday (Ze soboty na neděli), 1931, directed by
Gustav Machatý.

Before the Finals (Před maturitou), 1932, directed by Svatopluk Innemann and Vladislav Vančura.

script *Lust* (*Chtíč*). The sweet melodramatic pain of these simple, often sentimental, stories was elevated to the artistic level of the film poem thanks to Machatý's invention. Naturally, the cameramen also shared in the films' realization, turning many script banalities into effective film images.

After the success of *Erotikon* (it remains a mystery why Nezval's name is missing from the credits of this internationally famous film), Nezval and Machatý wrote a script for another silent film, *Lust*. Because this was at the very end of the silent era, scholars have hypothesized that Machatý used an altered version of the *Lust* script to shoot his sound film *Ecstasy*. This, however, was not the case. With the discovery of the previously lost script, it has been determined that *Lust* was a model for Machatý's first sound film, *From Saturday to Sunday* (*Ze soboty na neděli*, 1931), also made in collaboration with Nezval. Original music for this film was composed by Jaroslav Ježek, who was sympathetic to Devětsil members. The chamber melodrama, taking place over one weekend, effectively evokes the atmosphere of a luxury nightclub, a

small pub frequented for morning coffee and soup by those ending the night shift, and the meager tenement flat of a young woman.

The films *Erotikon*, *From Saturday to Sunday*, and *Ecstasy*, made in the brief period from 1929 to 1932, form a free trilogy. All three films portray conflicting love relations. Only in *From Saturday to Sunday* are all signs of catastrophe straightened out: the conflict caused by the unjust suspicions of a jealous boyfriend, which led his partner to attempt suicide, is deflected, and harmony is restored. This film is also the only one of the three to feature protagonists of the same age and similar social origin: she is a typist and he works as a typesetter. In *Erotikon* a country girl is seduced by an experienced playboy, while the husband in *Ecstasy* differs from his youthful wife by age. His impotence is manifest not only in limited sex appeal but in "flaccid activity" that characterizes his entire behavior, resulting in a negative attitude to any expression of passion and sensuality. The differences between youth and age are highlighted, for example, by the

appearance of a bee. The husband kills a bee when it bothers him during his siesta. The wife's young lover, on the other hand, is overjoyed by the presence of a bee in a meadow full of flowers.

Both *From Saturday to Sunday* and *Ecstasy* emphasize the visual-pictorial component; having little dialogue, the films use music, whose modernism represented a life-style characteristic of the young generation. Machatý also tried to find in each shot some object with an intrinsic symbolic meaning. He frequently used associative montage, linking phenomena and situations through some external similarity. That is why the scripts of these films are remarkable for their metaphorical character. Close-ups predominate, and as words search for the visual significance of the objects, they acquire an additional meaning.

Following this period of collaboration, Nezval had less success as a scriptwriter. Although he wrote thirteen or more scripts for feature-length films—during World War II he even wrote a film version of Bedřich Smetana's national opera *The Bartered Bride* (*Prodaná nevěsta*)—only one came to fruition. *In the Still Nights* (*Za tichých nocí*, 1940), directed by Zdeněk Gina Hašler, deservedly was designated by critics as bittersweet kitsch. The film was the sentimental story of a young musician, distantly inspired by the life of Rudolf Friml, uncle of the aspiring director.

Nezval was unable to film his other scripts, even after liberation at the end of World War II, when he headed the film section of the Ministry of Information as one of the top officials of the nationalized Czech cinema, although he tried to direct his own film version of Dostoyevsky's *Gentle* (*Něžná*). Nezval is best remembered for his youthful avantgarde art offensives. While intoxicated by the perfume of celluloid, he wrote, "Behold this trembling small leaf lost forever in space which can be brought to life on the movie screen at any time!"

Vančura was a passionate film lover, often attending the cinema several times a day.[3] Because he did not wish to participate in commercial production, he did not negotiate with any official film company, although by the end of the 1920s he had written several film scripts (according to contemporary press reports, their book publication was being contemplated). Only in 1932 was he asked to collaborate on a film about high school students, titled *Before the Finals* (*Před maturitou*). Although the director, Svatopluk Innemann, had considerable practical experience, those who took part in the making of the film said that Vančura independently directed several sequences and that he had considerable influence over the final outcome of the work.[4]

The film is a psychological drama—although some scenes have a lyric and comic tone—on the life of high school students. As they solve not only academic problems but also the more complex matters of personal life, their naive romanticism often clashes with real life. Professor Donát, a modern man and pedagogue, admonishes the students: "Life is not an adventure; life is work and order." These words express Vančura's aesthetic and life credo.

Vančura's influence on the film is also evident in the way interiors are modeled by means of illumination that frequently breaks through various objects and creates fantastic shadows on the walls. These images of the environment correspond to the moods and psychological states of the characters. Dazzling and intrusive light suddenly penetrating the dusty and crowded room of a fossilized and soured professor symbolizes modern art, its youth and hope.

Thus, it was not Innemann, the routine practitioner, who influenced Vančura, the film novice, but vice versa: in the next film that Innemann directed, the thriller *The Ostrovní Street Murder* (*Vražda v Ostrovní ulici*, 1933), he used many cinematic solutions incorporated by Vančura in *Before the Finals*. These artistic and unconventional initiatives enjoyed a success that led to their immediate exploitation in commercial production. The kindred character of the two films is further demonstrated by the fact that the "Vančurian" actor Jindřich Plachta plays in both of them: as the professor in *Before the Finals* and as a detective in *The Ostrovní Street Murder*.

Vančura independently directed two feature-length films (it is interesting to note that the films Vančura directed or later codirected were based on scripts by other authors; Vančura did not direct his own scripts). He also kept fighting against the existing production system, which usurped other creative artists. Vančura was not only thrilled by the possibilities of film as a new dramatic art but also enchanted by the collective character of filmmaking: "Artists join a film work to solve time and space according to the same order and to make poetry in images." That is why he gathered coauthors and fellow workers for the making of the film *On the Sunny Side* (*Na sluneční straně*, 1933). The script is the collective work of Nezval, the pedagogue Miloslav Disman, and the linguistic structuralist Roman Jakobson; the contribution of the modern architect Bedřich Feuerstein was also of importance in making this film.

The film's theme—the problem of educating runaway children and new educational methods coming into use— offered an even greater opportunity than *Before the Finals* for Vančura to experiment with film "language." The original film was rejected by the producers, but for reasons that remain unclear, a revised version came into being and later played in the cinemas. Because of this delay, Vančura had already started to shoot a new film, *Faithless Marijka* (*Marijka nevěrnice*, 1934), when *On the Sunny Side* finally opened. To free himself and his collaborators from the constraining influence of the commercial producers, Vančura initiated the Film Cooperative (Filmové družstvo), and *Faithless Marijka*, an exceptional film, was made under its auspices.[5]

It was shot in authentic mountain settings in Ruthenia, until 1945 the easternmost part of Czechoslovakia. With the exception of episodic figures, all characters were played by non-actors, Ruthenians and Jews living in the confines of this extremely poor region. The script was written by Karel Nový and Ivan Olbracht, who was familiar with the place (the material for his best novel *Nikola Šuhaj, the Highway Robber*

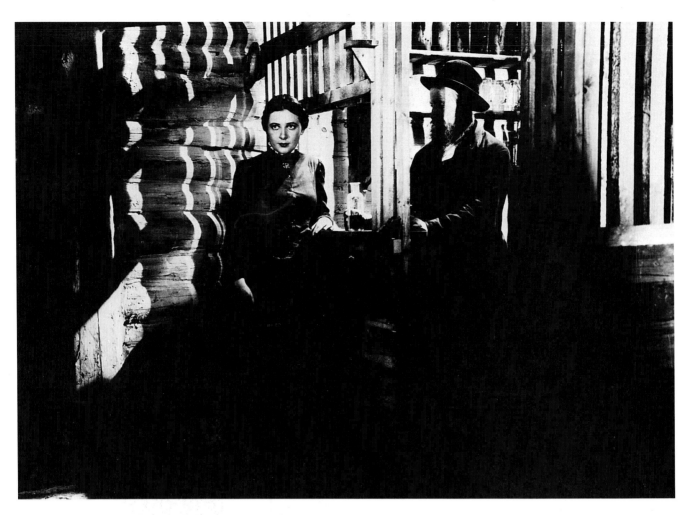

Faithless Marijka (Marijka nevěrnice), 1934, directed by Vladislav Vančura.

[*Nikola Šuhaj, loupežník*] was gathered here). Vančura also tried to involve Nezval in the collaboration, but Nezval refused, unwilling to pay the cooperative membership fee. Music for the film was composed by Bohumil Martinů—his only work for a feature-length film. At that time already living and working in Paris, Martinů did not stay with the filmmakers in Ruthenia but composed the music in Prague.

The balladic *Faithless Marijka* could not be expected to appeal to the mass public due to its unusual depiction of the raw reality of peasant life in Ruthenia. Unfortunately, most critics did not like the film either, paradoxically reproaching the filmmakers, especially Vančura, for their ignorance of film craft and their insufficient experience. Nevertheless, Vančura had succeeded in applying Sergei Eisenstein's editing principles to a full-length feature film. It was precisely the brisk editing, consciously disrupting the flow of storytelling contrary to general practice at the beginning of the sound age, that bothered the critics.[6]

Before shooting, Vančura had said: "This is a free film, that is clear; otherwise it would not be poor, but then—it would be not free." After the financial failure of *Faithless Marijka*, the Film Cooperative broke up. Olbracht resigned and began to collaborate with official production companies.

Vančura, however, kept up his fight. Unable to convince the commercial film producers to finance his films and discovering that even the Film Cooperative was unrealistic, he decided to finance his films himself. Luboš Bartošek mentions that according to Vančura's wife, the writer intended to turn an unused Zbraslav granary into a studio, for which he had commissioned a large spotlight. In this studio Vančura intended to make a film cartoon *Walls Have Ears* (*Stěny mají uši*), later titled *Misunderstanding* (*Nedorozumění*).

Vančura's correspondence with his distant relative, the writer and playwright Jiří Mahen, testifies to his plan to film the *Misunderstanding* script, a story about the life of a touring theatrical company:

> Dear Mahen, received your letter right at the moment when I was deciding about the film. It came out like this: I found (for a very low fee) an engineer, who is going to make 15 bulb lights. These lights will be quite sufficient to light a smaller scene and will not cost too much. I wrote a film story which maintains the unity of place, involving very few persons. I have been thinking about an ambiance that would be interesting even if it would be poor and I opted for a variety show. A

theatrical road show. I shall therefore put up (in Košíře, on a lot that I have already reserved), a tent with roughly four internal spaces and I will shoot a silent film. Maybe later I shall synchronize it. It is a situation comedy about people who get rid of their principal and turn their old dream of playing theater into reality.—Maybe this entire enterprise is foolish, but, as they say, the die is cast.—I believe, dear friend, that you have experience and the nose. I would like to ask your advice and would be very glad to show you this thing. Will you be coming to Prague some day? Realization will begin sometime in April, but construction must be done immediately once the freezing weather is over. Before that I would like to show you the plans and send you the libretto. And one more thing. Wouldn't you like to shoot another film yourself? It could be very easily arranged. The possible themes are naturally given by the meagerness of the inventory. A barrack colony, etc.[7]

Neither Mahen nor Vančura filmed in the improvised studio. Vančura's dream of absolute artistic freedom, totally unique in the contemporary film world, which he tried so persistently to realize, came to nothing. Vančura did not listen to Mahen, who had warned him back in 1928: "You have slid somewhere to film, but Nezval already knows that the people there are not enterprising and are too calculating. Not enterprising mentally. I am afraid that both of you shall drink from a pretty muddy source and that it could produce bitterness for a very long time."[8]

In 1937 when Vančura realized it would be impossible to produce his own films, he returned to the official movie industry. With another practitioner, Václav Kubásek, he made his last two films: an updated version of the classic Ladislav Stroupežnický drama *Our Swells* (*Naši furianti*) and a psychological drama set in the auto racing milieu *Love and People* (*Láska a lidé*).

Vančura was given less than ten years to realize some of his creative intentions in film. In the entire art world of the 1930s, it is difficult to find another personality who devoted as much creative and organizational energy to the rise of film art. Vančura attempted to show that the creative and moral greatness of an artist cannot succumb to the pressure of a system that does not favor the development of artistic creation. When the Gestapo came to arrest Vančura, a principal member of the Resistance, they took away the hand camera that he had received as part of his royalties for the film *Before the Finals* and had used to shoot some takes for the film *Faithless Marijka* as well. At that time a group of filmmakers led by Vančura were already thinking of nationalizing Czech cinematography.

Earlier, when he was pondering aloud the problems of the art film, Vančura stated: "It has already been mentioned to what considerable extent filmmaking depends on craft, technology and scientific knowledge. When we become aware of all these linkages, then the problem of filmmaking acquires for us nearly monstrous dimensions. Happily enough, the film light brushes are infinitely more perfect than the brushes of the old arts."[9]

Dr. Pavel Taussig is a film historian and a programmer at the Czechoslovak Film Institute—Film Archive (Československý filmový ústav—Filmový archiv), Prague.

Translated by Jitka Salaquarda

• NOTES

1. Věra Baranovskaia also played Princess Ludmila in the Czech historical blockbuster *Saint Wenceslas* (*Svatý Václav*, 1929), made with silent technology, as well as the role of the prostitute Tonka's mother in *Tonka of the Gallows* (*Tonka Šibenice*, 1930), a partially sound-endowed work.

2. The domestic film industry was criticized by other artists as well. Josef Čapek wrote in the article "Film" (*Road* [*Cesta*], vol. 1, no. 18 [October 4, 1918], pp. 447–48]): "In this respect, practically nothing at all has been done in Bohemia to date. If those few experiments that had taken place are the start of further work, the question arises as to how our domestic production could possibly compete with its foreign counterparts."

3. Vančura's wife, Ludmila, wrote in her memoirs *Twenty-Six Beautiful Years* (*Dvacet šest krásných let*, Prague, 1967), p. 76, that Vančura was fascinated with Pudovkin's film *Storm over Asia*: "And when we later talked about the 'Storm' at home, Vladislav said that the 'Storm' is proof positive that film can be and is art."

4. Vančura cast the main student characters, many of whom later became professional filmmakers: directors Elmar Klos, František Čáp, Vladimír Čech, and Miloš Makovec, cameraman Vladimír Novotný, and animated filmmaker Eduard Hoffman.

5. The Melantrich publishing house, which published the works of all three writers, participated in financing the film. Dr. Bedřich Fučík took part as a producer, shooting on location on behalf of Melantrich.

6. The literary script of *Faithless Marijka*, together with film stills, a selection of critical responses, and other documentary material, was published in 1982 by the Prague publishing house Odeon, thanks to the efforts of the editors Rudolf Havel and Pavel Taussig.

7. In *Addressed to Jiří Mahen* (*Adresát Jiří Mahen*, Prague, 1964), p. 98.

8. *Addressed to Jiří Mahen*, pp. 96–97.

9. Vladislav Vančura, "On Art Film," lecture deposited in the artist's estate. In *New Creation Order* (*Řád nové tvorby*, Prague, 1972), p. 154.

Crisis (Krise), 1938, directed by Herbert Kline.

The Distant Journey (Daleká cesta), 1948, directed by Alfred Radok.

Chronology: Painting, Sculpture, Drawings, Prints

JAROSLAV ANDĚL AND
ALISON DE LIMA GREENE

• 1900

Third exhibition of the Spolek výtvarných umělců Mánes (Mánes Union of Fine Artists; named after the prominent nineteenth-century Czech artist Josef Mánes) is held in Prague. The S.V.U. Mánes is the most prominent artistic organization at the turn of the century in Prague.

The architect Jan Kotěra publishes the essay "New Art (Nové umění)" in the journal *Free Directions (Volné směry)* published by the S.V.U. Mánes.

František Kupka begins the series of prints *The Voices of Silence (Hlasy ticha)* that includes the print *The Beginning of Life (Počátek života)*. Living in Paris since 1894, he also works as an illustrator. Among other Czech artists living in Paris are Alfons Mucha and Vojtěch Preissig.

Josef Váchal apprentices bookbinding and makes his early series of drawings and handwritten satirical pamphlets.

• 1901

A special issue of *Free Directions* is devoted to Auguste Rodin.

• 1902

Guillaume Apollinaire visits Prague in May; the visit inspires several verses in his famous poem "Zone."

A retrospective exhibition of Auguste Rodin is sponsored by the S.V.U. Mánes from May to July. It is held at a new pavilion designed by Jan Kotěra.

Modern French Art (Moderní francouzské umění), an exhibition concentrating on Impressionism sponsored by the S.V.U. Mánes from September to October, includes Edgar Degas, Claude Monet, Auguste Renoir, and Alfred Sisley among others.

František Kupka makes a series of satirical drawings *Money (Peníze)* and the painting *Ballade—Les Joies de la vie (Balada—Radosti života)*.

Josef Váchal illustrates his copy of *After Us, Deluge (Po nás ať přijde potopa)* by František Gelner.

• 1903

František Šalda, a leading critic, becomes co-editor of *Free Directions* and publishes the essay "The New Beauty: Its Genesis and Character (Nová krása: její geneze a charakter)."

Worpswede, an exhibition organized by S.V.U. Mánes in Prague, features the association of German artists who promoted a lyrical interpretation of nature.

Bohumil Kubišta begins studying at the School of Decorative Arts in Prague.

Emil Filla begins studying at the Academy of Fine Arts in Prague.

Vojtěch Preissig returns from Paris to Prague. The book *Fireflies (Broučci)* by Jan Karafiát, illustrated and designed by Preissig, is published in Prague.

Josef Váchal becomes a member of the Theosophical Society of Prague.

• 1904

František Kupka's painting *Ballade—Les Joies de la vie* is awarded the gold medal at the St. Louis World's Fair in Missouri.

Josef Váchal makes his first paintings.

• 1905

Exhibition of Edvard Munch is sponsored by S.V.U. Mánes from February to March. František Šalda's penetrating essay "The Oppressor of Dream (Násilník snu)" appears in *Free Directions*. The exhibition has a great impact on young artists.

Exhibition of František Kupka travels in Bohemia and Moravia.

Vojtěch Preissig opens a studio in Prague and publishes an edition of etchings titled *Czech Prints (Česká grafika)*.

• 1906

František Kupka moves to Puteaux, a Paris suburb.

Vojtěch Preissig publishes the English edition of the portfolio *Colored Etchings*.

Bohumil Kubišta goes to Florence and studies at the Reale Instituto delle Belle Arti.

Josef Váchal begins numerous primitivist carvings.

• 1907

Emil Filla paints *Reader of Dostoyevsky (Čtenář Dostojevského)* and *The Night of Love (Milostná noc)*.

The Osma (The Eight) association of artists is formed in Prague. Their first exhibition is held in Prague from April to May; it presents Friedrich Feigl, Emil Filla, Max Horb, Bohumil Kubišta, Otakar Kubín, Willy Nowak, and Antonín Procházka.

Exhibition of Vojtěch Preissig is held at the Topič Salon in Prague and in Vienna.

French Impressionists (Francouzští impressionisté), an exhibition sponsored by the S.V.U. Mánes from September to November, presents leading Impressionist and Post-Impressionist painters, including Paul Cézanne, Paul Gauguin, and Vincent van Gogh.

Free Directions devotes a special issue to Vincent van Gogh.

František Kupka studies Michel Chevreul's ideas on color and other scientific theories. He begins to write his book *Creation in Plastic Arts (Tvoření v umění výtvarném),* which will not be published until 1923.

Josef Váchal makes his first important woodcuts.

• 1908

Second Osma exhibition is held at the Topič Salon from June to July.

The artists' cooperative Artěl is founded in Prague. Inspired by the Wiener Werkstätte, it concentrates on the applied arts. The founding members include Jaroslav Benda, Vratislav Brunner, Pavel Janák, Helena Johnová, Jan Konůpek, and Marie Teinitzerová.

First issue of the journal *Style (Styl)* devoted to architecture and decorative arts is published by S.V.U. Mánes in Prague.

The journal *Meditation (Meditace)* is founded in Prague; it is a forum for writers and artists interested in religion and mysticism. Josef Váchal makes woodcut illustrations for the magazine.

• 1909

Exhibition of Emile-Antoine Bourdelle is sponsored by S.V.U. Mánes from February to March.

Exhibition of Emile Bernard is sponsored by S.V.U. Mánes.

Vojtěch Preissig publishes the book *Color Etchings and Color Engravings (Barevný lept a barevná rytina)* and illustrates and designs *Silesian Songs (Slezské písně)* by Petr Bezruč.

Bohumil Kubišta visits Paris for two months and meets Henri Matisse and other artists of the Fauvist circle.

Otto Gutfreund spends a year in Paris in order to study with Emile-Antoine Bourdelle.

František Kupka begins a series of drawings that reflects the artist's interest in the depiction of movement and in the theories of color.

• 1910

Bohumil Kubišta goes to Paris for six months and co-organizes an exhibition of Les Indépendants

for S.V.U. Mánes. He makes his first Cubo-expressionist paintings.

Exhibition of Les Indépendants sponsored by S.V.U. Mánes, from February to March, includes Pierre Bonnard, Georges Braque, André Derain, Aristide Maillol, and Henri Matisse among others.

The group Sursum, an association of Symbolist artists and writers, is founded in Prague. The first exhibition of the group is held in Brno and includes Emil Pacovský, František Kobliha, Jan Konůpek, and Josef Váchal.

Josef Váchal publishes his first book, *Vision of the Seven Days and Planets* (*Vidění sedmera dnů a planet*).

Among other Czech artists staying in Paris, Emil Filla, Otto Gutfreund, and Josef Čapek are influenced by Cubism. Čapek begins studying primitive art at the Musée d'Ethnographie du Trocadéro and writes a book on this topic.

The Czech art historian Vincenc Kramář begins a three-year sojourn in Paris and forms a significant collection of Cubist paintings.

Vojtěch Preissig goes to the United States.

• 1911

A group of young artists secedes from the S.V.U. Mánes and founds the Skupina výtvarných umělců (Group of Fine Artists), which becomes the most important proponent of Cubism in Central Europe. The Skupina publishes the journal *Artistic Monthly* (*Umělecký měsíčník*) in which numerous important texts appear. Among the members are painters, sculptors, architects, writers, art critics, and musicians, including Vincenc Beneš, Emil Filla, Josef Gočár, Otto Gutfreund, Vlastislav Hofman, Josef Chochol, Pavel Janák, Antonín Procházka, Václav Špála, Josef Čapek, and Karel Čapek.

Ernst Ludwig Kirchner and Otto Müller visit Prague to establish contact with young Czech artists and to invite them to take part in the exhibition of the Neue Secession in Berlin. Kirchner and Müller meet and befriend Bohumil Kubišta, who participates in the Neue Secession exhibition and who is later listed as a member of Die Brücke for 1911–12.

Bohumil Kubišta publishes the essay "The Prerequisites of Style (Předpoklady slohu)."

František Kupka begins studies for his important abstract paintings, including *Cosmic Spring* (*Kosmické jaro*) and *Creation* (*Tvoření* [*Stvoření*]).

Otto Gutfreund makes the sculpture *Anxiety* (*Úzkost*).

• 1912

First exhibition of the Skupina is held at the Municipal Building (Obecní dům) in Prague in January and February. Only Czech artists are represented.

Second exhibition of the Skupina is held at the Obecní dům in September and October. It also features artists from abroad, including Emil-Othon Friesz, Ernst Heckel, Ernst Ludwig

Kirchner, Pablo Picasso, and Karl Schmidt-Rottluff.

Second exhibition of Sursum held at the Municipal Building in September and October includes Rudolf Adámek, Jaroslav Horejc, Jan Konůpek, Miroslav Sylla, Josef Váchal, and Jan Zrzavý.

Section d'Or exhibition at Galerie La Boétie in Paris in October includes František Kupka. He also shows at the Salon des Indépendants *Planes by Colors I, II, III* (*Plans par couleurs I, II, III*) and the important abstract paintings *Amorpha, Warm Chromatics* (*Amorpha, Chromatique chaude*) and *Amorpha, Fugue in Two Colors* (*Amorpha, Fugue à deux couleurs*) at the Salon d'Automne.

Neue Secession exhibition in Berlin in March includes Czech artists Vincenc Beneš, Friedrich Feigl, Emil Filla, and Bohumil Kubišta.

Sonderbund exhibition in Cologne from May to September includes Emil Filla, Bohumil Kubišta, and Antonín Procházka.

Josef Gočár and Pavel Janák found the Prague Art Workshops (Pražské umělecké dílny) that produce Cubist furniture.

Josef Čapek extensively refers to Futurism in *Artistic Monthly*; he also reviews Wassily Kandinsky's book *On the Spiritual in Art.*

Several artists including Josef and Karel Čapek, Václav Špála, and Vlastislav Hofman secede from the Skupina.

• 1913

The third exhibition of the Skupina is held at the Municipal Building in May and June. Among the artists included are Georges Braque, Pablo Picasso, André Derain, and Juan Gris.

Exhibition of Italian Futurists is held at the Havel Gallery in Prague in December; it presents Umberto Boccioni, Carlo Carrà, Luigi Russolo, and Gino Severini.

Exhibition of Skupina artists is held at the Goltz Salon in Munich in April.

The Erster deutscher Herbstsalon exhibition organized by Herwarth Walden in Berlin includes Emil Filla, Otto Gutfreund, Bohumil Kubišta, and Antonín Procházka. Walden also exhibits Filla, Josef Čapek, Gutfreund, and Vlastislav Hofman at Galerie Der Sturm.

Almanac for 1914 (Almanach na rok 1914) is published in Prague; it contains contributions by Josef Čapek, Karel Čapek, Vlastislav Hofman, Václav Špála, Stanislav Kostka Neumann, and others.

S. K. Neumann publishes the essay "Open Windows (Otevřená okna)," considered the Czech Futurist manifesto.

Bohumil Kubišta enters military service.

• 1914

The 45th exhibition of the S.V.U. Mánes, from February to March, is organized by the French critic Alexandre Mercereau. The exhibition contains an international survey of contemporary art includ-

ing works by Alexander Archipenko, Robert Delaunay, Raymond Duchamp-Villon, Albert Gleizes, Roger de la Fresnaye, Louis Marcoussis, Jean Metzinger, Piet Mondrian, Constantin Brancusi, Jacques Villon, Raoul Dufy, Bohumil Kubišta, and Josef Čapek.

Fourth exhibition of the Skupina held at the Municipal Building from February to March includes work by Edvard Munch, Georges Braque, André Derain, Juan Gris, and Pablo Picasso, as well as Emil Filla and Otto Gutfreund among others.

Werkbund exhibition in Cologne includes artists from the Czech Design and Industries Association (Svaz českého díla).

Bohumil Kubišta publishes the essay "On the Spiritual Essence of the Modern Age (O duchovní podstatě moderní doby)."

After the outbreak of World War I, Emil Filla takes refuge in Holland, Otto Gutfreund joins the Foreign Legion, and František Kupka enlists in the French army as a volunteer.

• 1915

Bohumil Kubišta paints *Meditation (Meditace)* and *The Hanged Man (Oběšený)*.

Jan Zrzavý paints *Meditation (Meditace)*.

• 1916

Josef and Karel Čapek publish the book *Luminous Depths (Zářivé hlubiny)*, illustrated by Vlastislav Hofman, in Prague.

• 1917

Josef Čapek publishes the book *Lelio* in Prague.

Josef Čapek's drawings and linocuts appear in the Berlin journal *Die Aktion*.

• 1918

The artists' association of the Tvrdošíjní (Stubborn Ones) is formed. Among its members are Josef Čapek, Vlastislav Hofman, Rudolf Kremlička, Otakar Marvánek, Václav Špála, and Jan Zrzavý. First exhibition of the Tvrdošíjní is held at the Weinert Gallery in Prague in March and April.

First issue of the journal *June (Červen)* is published in Prague on March 7 and features the work of the Tvrdošíjní.

Josef Čapek publishes in *June* the essay "Negro Sculpture (Černošská plastika)," based on his notes from his visit to Paris in 1910–11.

Bohumil Kubišta dies from the flu epidemic in Prague on November 27.

• 1919

Josef Váchal makes the series of drawings *The Dictionary of Colors and Lines in a Spiritualist's Mind (Slovníček barev a linií v myšlenkách spiritualisty)*.

Josef Čapek illustrates Guillaume Apollinaire's poem "Zone," which appears in a Czech translation by Karel Čapek.

• 1920

Second exhibition of the Tvrdošíjní is held in Prague in January. It travels to Dresden and Hanover.

Raoul Hausmann and Richard Huelsenbeck give Dada presentations at the Commodities Exchange and the Mozarteum in Prague on March 1 and 2.

Jan Zrzavý organizes a memorial exhibition of Bohumil Kubišta's work.

The Art Union Devětsil (Umělecký svaz Devětsil) is founded in Prague on October 5. It becomes a leading organization of the Czech avant-garde in the 1920s, uniting artists, architects, writers, actors, and musicians. It includes Karel Teige, Vítězslav Nezval, Jaroslav Seifert, Jaromír Krejcar, Jindřich Štyrský, Toyen (Marie Čermínová), Jindřich Honzl, Jiří Voskovec, Jan Werich, Vladislav Vančura, Josef Šíma, Evžen Markalous, and others.

The book Long Live Life! (Ať žije život!) by S. K. Neumann, illustrated by Josef Čapek, is published in Prague.

Josef Čapek publishes the book The Most Modest Art (Nejskromnější umění), which consists of essays on various forms of primitive and naive art.

Josef Váchal publishes the book The Mysticism of Smell (Mystika čichu).

First issue of Musaion is published by Aventinum in Prague; it contains important texts by members of the Tvrdošíjní.

• 1921

The Tvrodošíjní exhibit at the Richter Gallery in Dresden in February. The exhibition includes Václav Špála, Josef Čapek, Vlastislav Hofman, and Jan Zrzavý and travels to Berlin, Hanover, Vienna, and Geneva.

Devětsil Matiné is held on February 6 at the Revolutionary Stage (Revoluční scéna).

Third exhibition of the Tvrdošíjní in Prague in March includes as guests Paul Klee, Otto Dix, Zdeněk Rykr, Josef Šíma, and Jiří Kroha and travels to Brno in April and to Košice in May.

Raoul Hausmann and Kurt Schwitters lecture on September 6 on "Presentism, World Propagation, Antidada" at the Commodities Exchange in Prague.

An exhibition of modern Italian art, organized by Enrico Prampolini, is sponsored by the Artists Emporium (Krasoumná jednota) at the Rudolfinum in Prague from October to November.

Filippo Tommaso Marinetti visits Prague in December. The Futurist Theatrical Syntheses is performed at the Švanda Theater in Prague.

Vincenc Kramář publishes the book Cubism (Kubismus) in Brno.

The play R.U.R. by Karel Čapek is produced by the National Theater in Prague with stage design by Bedřich Feuerstein. A German production is organized by Friedrich Kiesler and Erwin Piscator in Berlin. In March 1924 R.U.R. premieres in Paris at the Comédie des Champs-Elysées.

The Literární skupina (Literary Group) is founded in Přerov; among its members are Lev Blatný, Čestmír Jeřabek, Jiří Wolker, and others.

A number of art journals devote special issues to Devětsil: in Prague, June (Červen), no. 12, and Veraikon, nos. 5–6, and in Belgrade, Zenit, no. 7.

Josef Šíma settles in Paris.

• 1922

Devětsil exhibition is held at the Artists Emporium in April and May.

Pablo Picasso exhibition organized by Vincenc Kramář is sponsored by S.V.U. Mánes in September.

Karel Teige visits Paris and meets leading proponents of the avant-garde, including Amédée Ozenfant, Le Corbusier, Tristan Tzara, Man Ray, and others.

Revolutionary Anthology Devětsil (Revoluční sborník Devětsil), edited by Karel Teige and Jaroslav Seifert, is published in Prague by V. Vortel.

Life II: An Anthology of the New Beauty (Život II. Sborník nové krásy), edited by Jaromír Krejcar, is published in Prague. It contains a number of important essays and manifestos, including "Purism" by Amédée Ozenfant and Le Corbusier, statements from Ilja Ehrenburg's "And Yet the World Goes Round," and "Foto Kino Film" by Karel Teige.

A group of artists advocating the concept of Magic Realism secedes from the Devětsil and founds the Nová skupina (New Group). The group includes František Muzika, Bedřich Piskač, Bedřich Stefan, and Alois Wachsman.

Josef Váchal publishes Josef Váchal's Perfect Magic of the Future (Josefa Váchala dokonalá Magie Budoucnosti).

Jindřich Štyrský meets Toyen while on vacation in Yugoslavia, beginning a twenty-year association.

• 1923

Last group exhibition organized by the Tvrdošíjní in Prague in March and April features guests from abroad, including Raoul Dufy, Le Corbusier, Amédée Ozenfant, Jan Matulka, and Léopold Survage. Czech artists included are Josef Šíma, Bedřich Feuerstein, and Alfred Justitz.

Bauhaus exhibition from August to September includes Bedřich Feuerstein, Jaromír Krejcar, Karel Honzík, and other Czech architects.

Bazaar of Modern Art (Bazar moderního umění), organized by Devětsil, is held at the Artists Emporium from November to December. It contains paintings, drawings, architectural projects, stage designs, photographs, collages, Dada objects, and non-art material. Among the artists included are Josef Šíma, Jindřich Štyrský, Toyen, and Karel Teige.

First issue of the journal Disk is published by Devětsil; it contains the manifesto "Picture (Obraz)" by Jindřich Štyrský and "Painting and Poetry (Malířství a poesie)" by Karel Teige, which introduces the concept "image poem (obrazová báseň)," a form of collage and photomontage.

Exhibition of Alexander Archipenko, organized by Devětsil, is held in Prague.

Josef Váchal publishes the book In Memoriam Marie Váchalové.

František Kupka publishes the book Creation in Plastic Arts in Prague.

• 1924

First issue of the journal Zone (Pásmo) is published by Devětsil in Brno.

Karel Teige publishes the manifestos "Poetism (Poetismus)" in the journal Guest (Host) and "Our Basis and Our Path: Constructivism and Poetism (Naše základna a naše cesta. Konstruktivismus a Poetismus)" in Zone.

Architects Club in Prague organizes a lecture series by leading architects, including Jacobus Johannes Pieter Oud, Walter Gropius, Le Corbusier, and Adolf Loos.

First solo exhibition of Josef Čapek, organized by Tvrdošíjní, is held at the Rudolfinum in Prague.

Josef Čapek publishes the book The Artificial Man (Umělý člověk).

Czech Modern Art (Československé moderní umění), an exhibition organized by Maurice Raynal at John Levy Galleries, Paris, includes Bohumil Kubišta, Josef Čapek, Emil Filla, Otto Gutfreund, Rudolf Kremlička, Josef Šíma, Václav Špála, and Jan Zrzavý.

Josef Váchal publishes the book The Devil's Garden (Ďáblova zahrádka).

• 1925

The publishing house Odeon in Prague is founded by Jan Fromek, who closely collaborates with Devětsil.

Zdeněk Pešánek completes his first color piano.

The Liberated Theater (Osvobozené divadlo) is founded by the Theatrical Section of Devětsil. Among the artists to design sets and costumes are Karel Teige and Jindřich Štyrský. First production is held on January 9, 1926.

Exhibition of Josef Šíma is held at the Topič Salon.

Jindřich Štyrský and Toyen settle in Paris for three years.

Art d'aujourd'hui exhibition is held in Paris. Among the artists exhibited are Jindřich Štyrský, Josef Šíma, and Toyen.

Karel Teige and Jindřich Honzl visit the Soviet Union.

• 1926

Katherine Dreier visits Prague with Lucia Moholy-Nagy in April to select pictures for *An International Exhibition of Modern Art Assembled by the Société Anonyme* at The Brooklyn Museum. In December Emil Filla and Otto Gutfreund participate.

Third Devětsil exhibition is held at the Artists Emporium in May and includes numerous photomontages and typographical designs. Among the artists exhibited are Man Ray, Amédée Ozenfant, and Le Corbusier.

The Prague Linguistic Circle is founded on May 6. Its members include Petr Bogatyrev, Jan Mukařovský, Vilém Mathesius, Roman Jakobson, and Nikolai Trubetskoy. Out of this association grows the school of Structuralist theory.

Exhibition of Jindřich Štyrský and Toyen is held at the Galerie d'Art Contemporain in Paris in December. The artists coin the term Artificialism for their new style.

Kurt Schwitters exhibits at the Artists Emporium from December to January.

The portfolio *Four Stories in White and Black (Quatre histoires de blanc et noir)* by František Kupka is published in Paris.

• 1927

Otto Gutfreund dies in Prague on June 2.

Exhibition of Jindřich Štyrský and Toyen is held at the Galerie Vavin in Paris in December. Preface in catalogue is written by Philippe Soupault.

The journal *ReD (Review of Devětsil)* is published in Prague; it is the most prominent periodical of the avant-garde in Czechoslovakia.

Front: International Anthology of Current Activity (Fronta. Mezinárodní sborník soudobé aktivity) is published in Brno.

Jaromír Krejcar and Jiří Kroha participate in the *First International Exhibition of Contemporary Architecture* organized by O.S.A. at the Vkhutemas in Moscow.

The Dada Theater is founded by Emil František Burian and Jiří Frejka in Prague.

Karel Teige publishes *Construction and Poem (Stavba a báseň)* in Prague.

Josef Šíma, Roger Gilbert-Lecomte, Roger Vailland, and René Daumal found the group Le Grand Jeu in Paris.

• 1928

Exhibition of Josef Šíma opens at the Aventinum Garret (Aventinská mansarda) in Prague on March 19.

Erwin Schulhoff plays a composition by Alexander Scriabin on Zdeněk Pešánek's color piano in Smetana Hall in Prague on April 13.

Exhibition of Jindřich Štyrský and Toyen opens at the Aventinum Garret on June 2. Karel Teige writes introduction to the catalogue.

Exhibition of Contemporary Culture (Výstava soudobé kultury) takes place in Brno, celebrating the tenth anniversary of the Czechoslovak Republic.

Vítězslav Nezval publishes *The Jewish Cemetery (Židovský hřbitov)*, illustrated with lithographs by Jindřich Štyrský, in Prague.

Karel Teige publishes the essay "Abstractivism, Surrealism and Artificialism."

• 1929

International Exhibition of New Architecture (Výstava mezinárodní nové architektury) is organized by the Architects' Club in Prague in May.

The Levá fronta (Left Front) is founded in Prague.

Film und Foto exhibition in Stuttgart includes the Czech artists and architects Bohuslav Fuchs, Josef Hausenblas, Evžen Markalous, Zdeněk Rossmann, and Karel Teige.

• 1930

Zdeněk Pešánek completes a kinetic sculpture for the Edison Transformer Station in Prague.

Karel Teige lectures on the sociology of architecture at Bauhaus in Dessau.

Vítězslav Nezval publishes the magazine *Zodiac (Zvěrokruh)* that promotes Surrealism.

Jindřich Štyrský co-edits the magazine *Erotic Review (Erotická revue)*, published in Prague.

• 1931

The journal *ReD* ceases publication.

František Kupka becomes a founding member of the group Abstraction-Création in Paris.

Vojtěch Preissig returns to Prague from the United States.

Vítězslav Nezval publishes *Sexual Nocturne (Sexuální nokturno)*, illustrated with erotic collages by Jindřich Štyrský.

• 1932

Poetry 1932 (Poesie 1932), an international survey of Surrealism and related trends sponsored by S.V.U. Mánes, opens on October 27. Among the artists exhibited are Jean Arp, Salvador Dali, Max Ernst, Giorgio de Chirico, André Masson, Joan Miró, and Yves Tanguy. Czech artists include Emil Filla, Josef Šíma, Jindřich Štyrský, and Toyen.

• 1933

Vítězslav Nezval and Jindřich Honzl establish contact with André Breton and the Surrealists in Paris.

Exhibition of Vojtěch Preissig is held at the Hollar Gallery in Prague.

• 1934

Vítězslav Nezval, Jindřich Štyrský, Toyen, Vincenc Makovský, Jindřich Honzl, and others found the

Surrealist Group in Prague on March 21. Another group practicing Surrealism includes František Gross, František Hudeček, Ladislav Zívr, Miroslav Hák, and Jindřich Chalupecký.

Jindřich Štyrský makes his first series of photographs.

Exhibition of Hannah Höch's photomontages is held in Brno.

• 1935

First *Exhibition of the Surrealist Group in the Czechoslovak Republic* opens at the S.V.U. Mánes on January 15.

André Breton and Paul Eluard visit Prague from March 27 to April 10 to meet the Czech Surrealists. They publish the first volume of the *Bulletin international du surréalisme* in Prague.

Exhibition of László Moholy-Nagy opens in Bratislava on May 2 and in Brno on June 1.

• 1936

František Kalivoda founds the international magazine *Telehor: Review of Visual Culture*. The first and only issue is devoted to László Moholy-Nagy. It is also the first retrospective publication on Moholy-Nagy.

The Surrealist anthology *Neither Swan nor Moon (Ani labuť, ani Lůna)* is published in Prague by Otto Jirsák.

Vítězslav Nezval publishes the book *A Woman in the Plural Number (Žena v množném čísle)*, illustrated and designed by Karel Teige.

Exhibition of František Kupka and Alfons Mucha is held at the Musée du Jeu de Paume in Paris.

• 1937

Emil František Burian and his D 37 Theater begin to sponsor exhibitions of young artists. First exhibition held at D 37 opens on May 8 and features František Gross, Miroslav Hák, František Hudeček, Bohdan Lacina, Ladislav Zívr, Josef Šíma, Jindřich Štyrský, Toyen, and Václav Zykmund. The more prestigious *Exhibition of the Czechoslovak Avant-garde (Výstava československé avantgardy)* held at the Czech Design and Industries Association (Svaz českého díla) also includes these artists.

Raoul Hausmann exhibition at The Museum of Decorative Arts (Uměleckoprůmyslové muzeum) runs from May 27 to June 13.

Salon des Surindépendantes exhibition in Paris includes Zdeněk Rykr. Rykr also collaborates with the journal *Volontés*.

Exhibition of Czechoslovak modern art is held at the Galerie Charpentier in Paris.

Czechoslovak Pavilion at Paris World's Fair features Zdeněk Pešánek's kinetic and light sculptures.

• 1938

Karel Čapek dies on December 25 in Prague.

Retrospective exhibition of Jindřich Štyrský and Toyen is held in Prague at Topič Salon in January, Brno in April, and Bratislava. The extensive monograph *Štyrský and Toyen* by Vítězslav Nezval and Karel Teige is published by František Borový in Prague.

Josef Čapek publishes the book *The Art of Tribal Peoples (Umění přírodních národu)*.

Following the signing of the Munich agreement on September 30, Czechoslovak territories are truncated. Vojtěch Preissig, among others, begins to publish anti-German propaganda.

• 1939

Germany invades Czechoslovakia on March 15, curtailing almost all activity in the visual arts.

Josef Čapek is arrested on September 1 and sent to the first of several concentration camps. Emil Filla is also arrested and detained until the end of World War II.

Jindřich Heisler and Toyen publish the book *The Spectres of the Desert (Les Spectres du désert)* in Prague.

Zdeněk Rykr and Milada Součková publish the books *The Talking Zone (Mluvící pásmo)* and *Kaladý*.

• 1940

Jindřich Štyrský completes the book *Dreams (Sny)* but publishes only a small fragment.

Retrospective exhibition of Jan Zrzavý is held at the Municipal Building in Prague.

The manifesto "The World We Live In (Svět ve kterém žijeme)" by Jindřich Chalupecký appears in the journal *Program D 40* in Prague.

Zdeněk Rykr commits suicide in Prague on January 15.

• 1941

Jindřich Heisler and Toyen publish *From the Dungeons of Sleep (Z kasemat spánku)* in a clandestine edition.

Jindřich Heisler and Jindřich Štyrský publish the album *On the Needles of These Days (Na jehlách těchto dní)*.

Vojtěch Preissig is arrested in September by the German authorities.

• 1942

Jindřich Štyrský dies from a heart attack in Prague on March 21.

The Skupina 42 (Group 42) is founded in Prague; it includes František Gross, Miroslav Hák, František Hudeček, Kamil Lhoták, Karel Souček, Jan Kotík, Ladislav Zívr, Jiří Kolář, Jindřich Chalupecký, and Jiří Kotalík.

The book *The Dismembered Dolls (Roztrhané panenky)* is published in a clandestine edition by a group that evolves later into the Skupina Ra; the group includes Josef Istler, Miloš Koreček, Ludvík

Kundera, Zdeněk Lorenc, Vilém Reichmann, Václav Tikal, and Václav Zykmund.

• 1943

Exhibition of Skupina 42 is held at the Topič Salon.

• 1944

Václav Zykmund and other members of the Skupina Ra perform several events; they call their activity *řádění* ("carrying on").

Vojtěch Preissig dies at the Dachau concentration camp about June 11.

• 1945

Josef Čapek dies at the Bergen Belsen concentration camp about April 15.

Exhibition of Toyen is held at the Topič Salon.

Exhibition of Emil Filla is held at the S.V.U. Mánes.

Memorial exhibition of Vojtěch Preissig is held at the Hollar Gallery in Prague in July–August.

Retrospective exhibition of S.V.U. Mánes members, 1907–1938, is held at the S.V.U. Mánes.

Chronology: Photography

ANTONÍN DUFEK

• 1900

Seven Czech amateur photographers exhibit at the World Exhibition in Paris. A silver medal goes to the Prague Club of Amateur Photographers (Klub fotografů amatérů, or KFA). Two professional gold medals and a silver medal are awarded to photographers from Prague.

The *Photographic Horizon (Fotografický obzor)* magazine (published by KFA, 1893–1944) acquaints the Czech community with new views on photography and with the works of C. Puyo, Robert Demachy, and others. Also published is the extensive five-part series by Antonín Stifter, "Instructions for Art Photography (Pokyny k fotografii umělecké)."

A gum print is reproduced for the first time, a work by Otto Šetele that aroused attention at the 1899 exhibition.

• 1901

Photographic Horizon publishes articles on motif, modern amateur photography, and artistic practices, as well as reproductions of the work of the first generation of Czech art photographers: Otto Šetele, Ludvík Pinka, and in later years Rudolf Špillar, Karel Dvořák, Jindřich Imlauf, Adolf Vyšata, Ludvík Komrs, and Julie Jirečková, the only woman member.

František Drtikol studies in Munich, a center of Jugendstil activity. The spirit of Art Nouveau is increasingly evident in his work until World War I.

• 1902

The Prague KFA changes its name to Czech Club of Amateur Photographers in Prague (Český klub fotografů amatérů v Praze) or ČKFA. Until the Union of Czech Clubs of Amateur Photographers is established in 1919, the ČKFA plays a central role, especially by publishing *Photographic Horizon* and other publications on photographic practice.

• 1903

Gum prints by Otto Šetele and Rudolf Špillar, pigment works by Šetele and Ludvík Pinka, and silver gelatin enlargements by Karel Dvořák, Pinka, Špillar, and others are exhibited at the ČKFA exhibition in Prague. Diapositives (projected transparencies) are also presented. ČKFA frequently sponsors lectures accompanied by diapositives.

Large format photographs dominate the 1903 exhibition. The publication of a portfolio of reproductions from the exhibition is the first publication of Czech art photography. Articles on technical novelties and their practical uses dominate issues of *Photographic Horizon*, including information on ozotypes, cyanotypes, color photography, and stereophotography.

• 1905

Four KFAs are operative outside Prague: Plzeň (Pilsen), established 1894; Vyškov, 1904; Kladno, 1905; and Vysoké Mýto, 1905.

• 1906

ČKFA holds its exhibition in Prague.

KFAs are established in Strakonice and Chrudim.

The growing self-confidence of photographers is evident in the article by Jindřich Imlauf in *Photographic Horizon* accusing the daily press of ignorance regarding photography.

• 1907

A survey in *Photographic Horizon* reveals a new self-awareness among photographers: "Who are we? Sportsmen, or artists, or . . . (Kdo jsme? Sportovci, nebo umělci, nebo . . .)." Vladimír Fanderlík reports on the book *Art and the Camera* by A. Guest.

In the Christmas ČKFA exhibition some thirty artists show about 300 works including autochromes. Fanderlík in his *Photographic Horizon* review writes that Czech photographers cannot yet "stand our ground in international competition."

A KFA is established in Brno.

The Prague Club of German Amateurs (Klub deutscher Amateure) exhibits in Graz (Austria) with other German clubs of Austria-Hungary. Works from Prague evoke a negative reaction.

• 1908

The Jubilee Exhibition of the Chambers of Commerce and Trade includes a photography pavilion. Amateurs are not allowed to participate. Exhibits include Vladimír J. Bufka's series *Beautiful Prague (Krásná Praha)*.

František Drtikol's and Bufka's works are published in *Photographic Horizon*.

At an exhibition that intentionally confronts photography with painting, held in Vysoké Mýto, 171 photographs are exhibited.

• 1909

Photographic Horizon publishes an extensive report on the Dresden World Exhibition of Photography.

• 1910

With Augustin Škarda, František Drtikol opens his studio in Prague. (Partnership with Škarda ends in 1921.) Drtikol has his first exhibition in ČKFA galleries.

An exhibition of the Association of Photographers (Společenstvo fotografů), a group of professional photographers, is held in Brno.

Jaroslav Petrák publishes the book *The Harvest of Light and Shadow: The Problem of Art Photography in Theory and Practice (Žeň světla a stínu)*.

• 1911

František Drtikol and Augustín Škarda publish the portfolio *From the Courtyards of Old Prague (Z dvorů a dvorečků staré Prahy)*.

An exhibition of photographs and etchings organized by the artists' cooperative Artěl includes pictures by Drtikol and Vladimír J. Bufka.

The first exhibition of the KFA at Královské Vinohrady, established in 1908, is held at the Rudolfinum in Prague with 300 photographs by twenty-eight artists.

With four other amateur photographers' clubs, the ČKFA exhibits 327 photographs in Prague. ČKFA publishes the *Almanac for the Year 1911*.

Bufka opens his studio in Prague. It becomes a place of artistic meetings and discussions.

• 1912

Vladimír J. Bufka publishes the essay "On the Development of Modern Photography (O vývoji moderní fotografie)" in *Veraikon*.

• 1914

An exhibition celebrating seventy-five years of photography is organized by the Decorative Arts Museum (Uměleckoprůmyslové muzeum) in Prague.

Václav V. Štech gives the lecture "The Aesthetics of Photography (Estetika fotografie)," published later in *Photographic Horizon* (1922).

• 1915

The second exhibition of the KFA at Královské Vinohrady is held in Prague.

• 1916

Vladimír J. Bufka dies of tuberculosis.

• 1917

After a six-year hiatus an exhibition of the ČKFA is held in Prague with 200 photographs by nineteen artists.

Jaroslav Rössler begins an apprenticeship with František Drtikol that lasts until 1920. Rössler continues to work with Drtikol until 1925 and is influenced in particular by Drtikol's command of printing processes and his interest in compositions of light and shadow. Rössler makes his Constructivist *Opus 1* during the last year of his apprenticeship.

• 1918

Josef Čapek publishes the essay "Photography (Fotografie)" reflecting on the relationship between photography and modern art.

A ČKFA exhibition is held in Prague.

• 1919

The State Graphic School is established in Prague. Beginning in 1920, photography is taught by Karel Novák.

The ČKFA exhibition in Prague celebrates the thirtieth anniversary of the club.

The Union of Czech Clubs of Amateur Photographers (Svaz Československých klubů fotografů amatéru, SČKFA) is established in Prague from foundations laid as early as 1914.

Adolf Schneeberger becomes a member of the ČKFA.

• 1920

The avant-garde group Art Union Devětsil (Umělecký svaz Devětsil) is established in Prague.

The book *The Most Modest Art (Nejskromnější umění)* by Josef Čapek is published in Prague. It includes "In Praise of Photography (Chvála fotografie)," an essay on photography and film.

Josef Sudek becomes a member of the ČKFA.

• 1921

The twelfth Prague exhibition of the ČKFA shows numerous pictures by young photographers. A Josef Sudek landscape photograph wins first prize, his first public recognition.

Drahomír J. Růžička visits Prague, bringing magazines and photographs by American Pictorialists. He has his first of four one-person exhibitions at the ČKFA. Funke reviews Růžička's 1925 exhibition in *Photographic Horizon*.

Photographic Horizon appears with a new format and cover.

The magazine *Review of an Amateur Photographer (Rozhledy fotografa amatéra)* is published in Prague. In 1929 it merges with *Photographic Horizon*.

• 1922

In *Life (Život)* Karel Teige publishes the avant-garde manifesto "Foto Kino Film," which emphasizes the central position of photography and film in twentieth-century art. He also publicizes the Man Ray portfolio *Les Champs délicieux*.

The first photomontages are made by members of Devětsil.

Jaroslav Rössler makes Cubo-expressionist and semi-abstract photographs.

Jan Purkyně, J. Diviš, Adolf Schneeberger, and Josef Sudek are expelled from ČKFA and establish the Photo Club Prague (Foto klubu Praha).

Jaromír Funke begins a series of still lifes and shadow plays.

Sudek begins his studies with Karel Novák at the State Graphic School.

The Association of Photographers celebrates its fortieth anniversary.

• 1923

The Bazaar of Modern Art (Bazar moderního umění), organized by Devětsil in Prague, includes non-art objects, image poems, photographs from films, photographs of technical objects, and Rayographs by Man Ray.

The first issue of the magazine *Disk (Disc)*, published by Devětsil, contains the manifestos "Picture (Obraz)" by Jindřich Štyrský and "Painting and Poetry (Malířství a poesie)" by Karel Teige. The photograph of a wheel bearing by Paul Strand is reproduced from the publication *Broom*.

Jaroslav Rössler becomes a member of Devětsil.

Jaromír Funke and Rössler make abstract photographs.

The first exhibition of the Union of Czech Clubs of Amateur Photographers is held in Prague. Photo Club Prague is clearly the most successful.

Drahomír Růžička exhibits photographs by Edward Weston and Clarence White at ČKFA, encouraging an aesthetic shift from Pictorialist to straight photography.

• 1924

Jaromír Funke, Adolf Schneeberger, Josef Sudek, and Josef Šroubek are expelled from the Union of Czech Clubs of Amateur Photographers. They establish the Czech Photographic Society (Česká fotografická společnost, ČFS) for both professionals and amateurs.

The first issue of the magazine *Zone (Pásmo)* is published by Devětsil in Brno.

An exhibition of works by Drahomír Růžička and other American photographers selected by Růžička is held at the ČKFA in Prague.

Funke makes *After the Carnival (Po karnevalů)*, the first modern diagonal composition in Czech photography.

• 1925

Vilém Santholzer publishes the essay "The Victorious Beauty of Photography (Vitězná krása fotografie)" demonstrating the significance of documentary and scientific photography for modern art.

Jaroslav Rössler visits Paris, works in Manuel Frères' studio, and takes numerous pictures of and from the Eiffel Tower.

František Drtikol participates in the International Exhibition of Decorative and Industrial Art in Paris, from which comes the term *Art Deco*, a style that characterizes Drtikol's photographs of nudes in the twenties. Throughout the twenties Drtikol's work is regularly included in exhibitions in the United States and Europe.

• 1926

The first issue of the pictorial weekly *Weekly Variety (Pestrý týden)* is published. Photographs by Alexander Hackenschmied, Jaroslav Rössler, and Josef Sudek are among those reproduced by its high-quality rotogravures.

The Alphabet (Abeceda), a book combining poems by Vítězslav Nezval with reproductions of Karel Teige's photomontages and of choreographic compositions by Milča Majerová, is published in Prague.

The first exhibition of the Czech Photographic Society and the second exhibition of the Union of Czech Clubs of Amateur Photographers are held in Prague.

The third Devětsil exhibition is held at Krasoumná jednota at the Rudolfinum in Prague. It contains numerous photographs, photomontages, and photograms, including work by Man Ray and Rössler.

An exhibition of the work of Jan Lauschmann is held at the ČKFA in Prague.

Rössler works as a photographer for the Liberated Theater (Osvobozené divadlo) and for the magazine *Weekly Variety*.

• 1927

Front: An International Anthology of Current Activity (Fronta: Mezinárodní sborník soudobé aktivity) is published in Brno.

The first issue of the monthly magazine *ReD (Review of Devětsil)* is published in Prague. This leading magazine of the Czech avant-garde pays much attention to photography and film.

Jaroslav Rössler goes to Paris and lives there for eight years. He works for the Lucien Lorelle Studio and other commercial studios. On his own he photographs Parisian street life.

The magazine *Photographic Horizon* features polemics about modern photography, which culminate in Jan Lauschmann's article "Along the Stream (Po proudu)" in 1928.

Jaromír Funke publishes "Man Ray," in which he admires the artist while rejecting the artistic authenticity of photograms.

Josef Sudek opens a studio where he lives and works until his death.

Karel Teige publishes *Construction and Poem (Stavba a báseň)*, a collection of essays which discusses Rössler's photographs, in Prague.

• 1928

The International Salon of Photography is held in Prague, the first of a series of exhibitions influenced by Constructivism and New Objectivity. Succeeding salons are held in 1933 and 1935.

The exhibition of *Independent Photography* is held in Mladá Boleslav. The articles "New Goals (Nové cíle)" by Josef Slánský and "For Our Goals (O naše cíle)" by Josef Dašek, manifestos of new photography, are published.

Josef Sudek joins Cooperative Work (Družstevní práce), which publishes books and magazines promoting Functionalist designs such as furniture and Sutnar china. He works there until 1936.

A portfolio of fifteen photographs by Sudek, *St. Vitus (Svatý Vít)*, is published by Cooperative Work with a preface by the writer Jaroslav Durych. This work done between 1924 and 1928 earns Sudek the title of Official Photographer of the City of Prague.

• 1929

The second and last exhibition of the Czech Photographic Society is held in Prague.

The second and last exhibition of *Independent Photography* takes place in Mladá Boleslav.

The book *The Nudes of Drtikol (Les Nus de Drtikol)* is published in Paris.

Alexander Hackenschmied reviews the exhibition *Film und Foto* in the magazine *Photographic Horizon*. This international show in Stuttgart includes photomontages by the Czech artists and architects Bohuslav Fuchs, Josef Hausenblas, Evžen Markalous, Zdeněk Rossmann, and Karel Teige.

Jaromír Funke makes *Reflections (Reflexy)*, a series of photographs inspired by Eugène Atget.

The Levá fronta (Left Front) is founded in Prague.

• 1930

In response to the *Film und Foto* exhibition in Stuttgart, the exhibition *New Photography (Nová fotografie)*, organized by Alexander Hackenschmied with Ladislav Berka and Jiří Lehovec, is held at the Aventinum Garret (Aventinská mansarda) in Prague. The second exhibition is held the following year. These exhibitions are the meeting place of photographers of different generations, both professional and amateur, and members of photographic and nonphotographic organizations.

The exhibition *Das Lichtbild* in Munich includes pictures by Berka, Hackenschmied, Josef Sudek, and Karel Teige.

Teige publishes the essay "Modern Photography (Moderní fotografie)," championing "honest work devoid of artistic tricks" as manifest throughout the history of photography, most recently in the *Film und Foto* exhibition in Stuttgart.

• 1931

The Film and Photo Group of the Levá fronta is founded in Prague and Brno.

The avant-garde group Line (Linie) is founded in České Budějovice in South Bohemia. The group publishes the magazine *Line (Linie)*.

The Exhibition of Working Class Housing (Výstava proletářského bydlení) is organized by A.S.F.L. (Architecture Section of the Left Front).

The yearbook *Czechoslovak Photography 1931 (Československá fotografie 1931)* is published by *Photographic Horizon* in Prague, continuing through 1940 and resuming publication after the war.

Jaromír Funke starts to teach photography at the School of Arts and Crafts in Bratislava.

• 1932

The exhibition *New Photography: Photo, Photogram, Typo-Photography, Photomontage (Výstava nové fotografie/foto, fotogram, typofoto, fotomontáž)* is organized by Linie in České Budějovice. Including twenty photographers, it is the first of six exhibitions organized by Linie.

The national exhibition of Professional Photographers is held in Brno.

The first one-man exhibition of Josef Sudek's work is held at the Cooperative Work gallery Krásná jizba in Prague.

Karel Teige publishes the essay "On Photomontage (O fotomontáži)."

• 1933

The Sociological Fragment of Housing (Sociologický fragment bydlení), a series of panels by Jiří Kroha and his students combining photomontage with statistics and diagrams, is shown at the Exhibition of Building Industries and Housing in Brno. It is shown the following year in Prague.

The exhibition *Social Photography (Sociální fotografie)* is organized by the Film and Photo Group of the Levá fronta in Prague, led by Lubomír Linhart, and Brno, led by František Kalivoda. It includes an extensive representation of French and Russian photographers and work by progressive photographers as well as political photographers.

Linie begins to exhibit photographs under the name Fotolinie (Photoline) in České Budějovice. Led by Josef Bartuška, members of the group collaborate with progressive amateurs. An exhibition in Plzeň (Pilsen) includes the work of eighteen photographers including Bartuška, Oldřich Nouza, Karel Valter, and Ada Novák.

An exhibition of the Union of Czech Clubs of Amateur Photographers is held in Prague.

The book *Photography in Advertising and Neubert's Photogravure (Fotografie v reklamě a Neubertův hlubotisk)* edited by Miloš Bloch is published in Prague.

The first issues of the magazine *Photography (Fotografie)* and the pictorial weekly *Sunday Ahoy*

(Ahoj na neděli) are published in Prague.

Jindřich Štyrský makes erotic photomontages for his publication *Emilie Comes to Me in a Dream (Emilie přichází ke mně ve snu)*.

In Brno Jiří Kamenický, Bohumil Němec, Jaroslav Nohel, František Povolný, and Hugo Táborský establish the Photo Group of the Five (Fotoskupina pěti, or f5), an avant-garde group promoting experimental photography influenced by principles of Surrealism.

Cooperative Work issues postcards and a calendar of Josef Sudek's photographs.

• 1934

Exhibitions of the f5 are held at the Cooperative Work gallery (Krásná jizba) in Prague and at the Museum of Decorative Arts in Brno.

The exhibition of the Fotolinie is held in České Budějovice. It includes work by František Drtikol, Karel Hájek, and Josef Sudek, as well as by Fotolinie members.

Fotolinie and f5 exhibit together with local amateurs in Znojmo. Josef Bartuška and František Povolný write the catalogue.

The *Second International Exhibition of Social Photography (Druhá výstava sociální mezinárodní fotografie)* is held in Prague. It includes photographers from Austria, Belgium, France, Germany, Holland, Hungary, Latvia, and the Soviet Union. The installation is designed by Povolný.

Lubomír Linhart, a leading theorist of the social documentary movement, publishes the book *Social Photography (Sociální fotografie)*, one of the first publications on this subject. Karel Teige writes on social photography in *The World of Work (Svět práce)* magazine.

Jindřich Štyrský makes the series of photographs *Frog Man (Žabí muž)* and *Man with Blinders (Muž s klapkami na očích)*.

The first and only issue of the international magazine *Ekran*, devoted to film and photography, is published by František Kalivoda in Brno.

The German Dadaist Hannah Höch shows photomontages at her first one-person exhibition in Brno.

• 1935

The exhibition of the f5 is held in Hradec Králové with a catalogue text by Ivan Blatný and Vítězslav Nezval.

Jaromír Funke is appointed professor at the State Graphic School in Prague. He and Ladislav Sutnar edit the book *Photography Sees the Surface (Fotografie vidí povrch)*, published by the State Graphic School with a preface by Václav V. Štech.

A retrospective exhibition of Funke's work is held at the Cooperative Work gallery (Krásná jizba) in Prague then, in 1936, in Bratislava.

The *First Exhibition of the Surrealist Group in the Czechoslovak Republic (První výstava skupiný surrealistů v ČSR*, established the year before), is held at the S.V.U. Mánes in Prague. Jindřich Štyr-

ský exhibits paintings and collages and is represented by the seventy-four photographs in the series *Frog Man* and *Man with Blinders*.

The Photo Exhibition of the Three: Experiments, Photomontages, Photograms, Photographs, Advertising Photographs (Fotovýstava tří: fotoexperimenty, fotomantáže, fotogramy, fota, reklamní fota) is held in Olomouc. Karel Kašpařík, Otakar Lenhart, and Jaroslav Nohel are represented.

The magazine *Typografia* devotes a special issue to photography.

An exhibition of work by László Moholy-Nagy is held in Brno and Bratislava.

František Dritkol stops photographing to paint and study Oriental teachings.

• 1936

S.V.U. Mánes organizes the *International Exhibition of Photography (Mezinárodní výstava fotografie),* one of the most comprehensive presentations of avant-garde photography in the 1920s and 1930s. It includes work by László Moholy-Nagy, John Heartfield, Brett Weston, Man Ray, Alexandr Rodchenko, and other Europeans as well as Czech photographers Josef Sudek, Jaromír Funke, and others. This is one of the last events of the collective avant-garde in Czech photography.

The Photographic Section of S.V.U. Mánes is established.

The exhibition of the Fotolinie in České Budějovice includes works by Moholy-Nagy, by Jindřich Štyrský, and by the f5 members.

An exhibition of work by Karel Hájek is held at the Public Library (Městská knihovna) in Prague.

An exhibition of work by Josef Voříšek is organized by the KFA at Vinohrady and presented in Prague.

František Kalivoda publishes the first and only issue of *Telehor: Review of Visual Culture* in Brno. It is the first retrospective publication on Moholy-Nagy.

• 1937

The first exhibition of the D 37 Theater, *Third Salon in a Corridor (Třetí salon na chodbě),* organized by Emil F. Burian, includes the work of young artists and photographers. The exhibition *Czechoslovak Avant-garde (Výstava československé avantgardy)* is held at the Czech Design and Industries Association (Svaz českého díla).

The exhibition *Photo-Typography-Line (foto-typo-linie)* is organized by Linie in České Budějovice with the State Graphic School, Ladislav Sutnar, and others.

The International Exhibition of Professional Photographers is held at S.V.U. Mánes in Prague, sponsored by Kodak.

• 1938

The exhibition *Photography (Fotografie),* organized by the Photographic Section of S.V.U. Mánes, represents its six members: Jaromír

Funke, Jiří Lehovec, František Pekař, Josef Sudek, Jindřich Štyrský, and František Vobecký.

An exhibition of work by Miroslav Hák is held at the D 38 Theater.

The book *Lettering and Photography in Advertising (Písmo a fotografie v reklamě)* by Zdeněk Rossmann is published by Index in Olomouc.

The book *Woman in Light (Žena ve světle)* by František Drtikol is published in Prague.

• 1939

The exhibition of the Photo Group of the Four (Fotoskupina čtyř, or f4) is held in Prague. Among the artists exhibited are Karel Kašpařík, Otakar Lenhart, Bohumil Němec, and Jaroslav Nohel.

An exhibition of the group Seven in October (Sedm v říjnu) is held in Prague. Among the members are two photographers, Jan Lukas and Věra Gabrielová.

The exhibition *One Hundred Years of Photography (100 let fotografie)* is held at the Museum of Decorative Arts (Uměleckoprůmyslové muzeum) in Prague. More than 1,000 pictures are shown. This is the last pre-war exhibition in Prague.

• 1940

The editor of *Photographic Horizon,* Josef Ehm (1939–41), collaborates with Jaromír Funke, Eugen Wiškovský, and others on an issue of the magazine devoted to avant-garde photography. Wiškovský publishes the essay "Figure and Motif (Tvar a motiv)," elaborating gestalt theory in art and photography criticism. He proposes that "the meaning of every photograph…is to see in a novel way, to have new visual impressions" but "with a guarantee of reality."

The first edition of the book *Prague (Praha)* by Karel Plicka is published. Focusing on the Gothic and Baroque heritage of Prague, it is popular in occupied Prague.

Josef Sudek begins the series *From the Window of My Studio (Z okna mého ateliéru).* He also decides to use large format cameras almost exclusively and to make only contact prints.

• 1941

The album *On the Needles of These Days (Na jehlách těchto dní),* consisting of photographs by Jindřich Štyrský and poems by Jindřich Heisler, is published in a clandestine edition in Prague. A second edition is published in 1945 by František Borový in Prague.

Toyen and Heisler publish photomontages and assemblages in the book *From the Dungeons of Sleep (Z kasemat spánku),* which is published clandestinely in Prague.

Eugen Wiškovský publishes in *Photographic Horizon* the essay "Representation, Expression, Information (Zobrazení, projev, sdělení)," anticipating the later interest of art critics and theorists in linguistic theory and information theory.

• 1942

The Skupina 42 (Group 42) is established in Prague, evolving from the group of artists associated with E.F. Burian's theater. The group includes poets, the painters František Gross and František Hudeček, the sculptor Ladislav Zívr, the photographer Miroslav Hák, and the critic Jindřich Chalupecký. The Skupina 42 influences a number of other photographers including Karel Ludwig, Václav Chochola, Jiří Sever, and Tibor Honty.

The anthology *The Dismembered Dolls (Roztrhané panenky)* is published in a clandestine edition by a group that evolves later into the Skupina Ra. It includes the photographers Vilém Reichmann, Jaroslav Puchmertl, Miloš Koreček, and Václav Zykmund.

• 1943

The exhibition of the Skupina 42 is held at the Topič Salon in Prague.

The portfolio *Modern Czech Photography (Česká moderní fotografie)* with an introduction by Karel Teige is published in Prague.

Zdeněk Tmej, a photojournalist since 1937, starts the series *Totaleinsatz* in Breslau/Wroclaw. It was later published in 1946 in Prague as the book *The Alphabet of a Mental Emptiness (Abeceda duševního prázdna)* with a preface by Alena Urbanová.

• 1944

Ludvík Kundera and Václav Zykmund publish the book *The Menacing Compass (Výhružný kompas)* in a private edition in Brno. It contains poems by Kundera and sixteen photographs of assemblages and performances organized by Zykmund and other members of Skupina Ra. They call their happenings *řádění* ("carrying-on"). Miloš Koreček photographed the second *řádění* and constructed a book that remains unpublished.

Koreček, already having experimented with heated negatives for some time, makes the first successful nonfigurative photographs and later coins the term *fokalk (phocalque,* after Dominguez' *decalcomanie)* for them. Before him, similar and identical techniques were used by František Povolný (1933–34) and František Hudeček (c. 1935).

• 1945

Jaromír Funke dies.

Vilém Reichmann starts his Surrealist series *The Wounded City (Raněné město),* dealing with the experience of World War II.

The Prague insurrection and liberation are photographed by Karel Ludwig, Svatopluk Sova, and others. Warsaw, Berlin, Dresden, and other towns are photographed by Jindřich Marco, a member of The Black Star Agency.

Translated by Jitka Salaquarda

Chronology: Film

ZDENĚK ŠTÁBLA

WITH ADDITIONS REGARDING AVANT-GARDE FILM BY JAROSLAV ANDĚL

• 1896

In July the first film projection in what is now Czechoslovakia takes place in Karlovy Vary (Carlsbad) at the Lumière Brothers cinema.

In October itinerant cinemas are initiated.

• 1897

In August the American cameraman Walter W. "Doc" Freeman shoots a Passion Play performed exclusively for film by the local German amateur theatrical company Böhmerwaldbund in Horice, in the Sumava (Böhmerwald) mountains. The filming is financed by Klaw and Erlanger, a New York theatrical company.

• 1898

From June to October the first Czech "live photographs" shot by Jan Kříženecký with a Lumière camera are shown at the Architecture and Engineering Exhibition in Prague. Titles include *The Rendezvous at the Mill (Dostaveníčko ve mlýnici), Crying and Laughing (Pláč a smích),* and *The Fairground Sausage Vendor and the Poster Hanger (Výstavní párkař a lepič plakátů).* Until 1910 Kříženecký is the only active native filmmaker.

• 1902

In October Jan Kubík, a theatrical director, stages the farce *That Best Number (To nejlepší číslo)* in the Smíchov theater Arena and commissions Jan Kříženecký to make a film that is incorporated into this theater presentation. Czech theater, as far as we know today, is among the first in Europe to begin using film as a theatrical medium.

• 1907

In June the first permanent Czech cinema opens in Brno. Called The Empire Bio Co., it is the property of Dominik Morgenstern, owner of an advertising agency. Ponrepo's Theater of Live Photographs (Divadlo živých fotografií) opens in Prague in September. Between 1907 and 1910 permanent cinema houses progressively replace the itinerant cinemas.

In September the first Czech film periodical begins publication in Brno. Printed in German, its name is *Anzeiger für die gesamte Kinematographen-Industrie.*

• 1908

In November the *Novina* magazine publishes "Kinema," the first aesthetic study of film, by Václav Tille, a university lecturer.

• 1910

In March the photographer Antonín Pech establishes the First Prague Cinematographic Image Factory (Pruví pražska výrobna kinematografických obrazů), which makes newsreel, advertising, and scientific films.

In October the *Track (Stopa)* periodical publishes "Biograph (Biograf)," an essay by Josef and Karel Čapek on the artistic potential of the new medium.

• 1911

In January František Tichý begins to publish, at his own expense, *Czech Cinematograph (Český kinematograf),* the first Czech-language film periodical. Alois Jalovec is co-publisher.

In May Kinofa, the first Czech film company, is established at the urging of Josef Kejř, owner of the Prague coffeehouse Tůmovka. Antonín Pech is entrusted with the technical, artistic, and commercial management of the company. The first Kinofa films are three slapsticks featuring the character Rudi, a creation and embodiment of Emil Artur Longen (E.A. Pitterman), a painter, actor, author, and later, theatrical director. Titles include *Rudi Fools Around (Rudi na záletech)* and *Rudi the Sportsman (Rudi sportsmanem).*

• 1912

In June Václav Havel, an entrepreneur and the owner of the Lucerna Building, and Richard Baláš, the Lucerna cinema director, establish the Lucerna Film company. Lucerna Film starts to produce newsreels in September 1914 and feature films in 1915.

In July the architect Max Urban, husband of the famous Prague theater actress Anna Sedláčková and a member of Skupina, establishes the ASUM-Film production unit together with Sedláčková. In the next two years they make sixteen comedies and dramas in which famous Prague actors appear with Sedláčková. ASUM-Film is the first in present-day Czechoslovakia to adapt famous literary and dramatic themes (Paul Bourget, Shakespeare, Sabina) for film, thus associating itself with the artistic film trend born in France.

• 1913

Paul Wegener makes *The Student from Prague (Der Student von Prag)* in Prague.

In November *Das Kinobuch,* the first compendium of film scripts, edited by Reinhardt's literary director Kurt Pinthus, is published in Leipzig. It contains fifteen film scripts by beginning playwrights and writers of the time, including three scripts by Prague authors: František Langer, Max Brod, and Otto Pick.

The film company Illusion Film is founded by Alois Jalovec and František Tichý.

Karel Čapek publishes the essay "The Style of Cinema (Styl kinematografu)," a pioneering analysis of the cinematic syntax.

František Langer, a member of Skupina, publishes the essay "Always Cinema (Stále kinema)," which examines the writer's role in filmmaking.

• 1914

In March *Kinematografie,* the first Czech book on film, is published by Jaroslav Petrák and Jan Srp.

In December the Czech two-reel comedy *The Nightmare (Noční děs)* opens in Prague. It was made by Jan Arnold Palouš from the first original Czech screenplay by František Langer, based on a story by Jaroslav Hašek, who later wrote the famous *The Good Soldier Švejk (Dobrý voják Švejk).*

Karel Hašler makes the film *Czech Castles and Chateaux (České hrady a zámky)* for his multimedia performance at the Prague Varieté.

• 1915

In May the two-reel comedy *Ahasver* has its premiere in Prague. Story and direction were both by Jaroslav Kvapil, a leading director of the National Theater in Prague. Kvapil followed the example of the German theatrical director Max Reinhardt.

• 1916

Karel Čapek publishes the essay "A.W.F. Co. (American World Film Company)," which suggests parallels between film and modern art.

In October the three-act Lucerna Film comedy *The Little Golden Heart (Zlaté srdéčko),* made by Antonín Fencl, a theatrical director, opens in Prague. The film is exceptionally successful and revives systematic production of Czech feature films, which had been in stagnation since the outbreak of World War I.

• 1917

In September the Praga-film company, a subsidiary of Czech Bank (Česká banka), is established in Prague with Antonín Fencl as its artistic manager. Praga-film had a small film studio with artificial light equipment. The Excelsiorfilm company is also established, with Weteb-Film following in 1918.

In October the first Czech full-length feature film, *The Prague Adamites (Pražští Adamité),* made by Antonín Fencl for Lucerna Film, is introduced within the framework of the Czech Film Week in the Lucerna cinema.

In October Josef Čapek's study "Film," later included in his book *The Most Modest Art (Nejskromnější umění*, 1920), is published in the journal *Path (Cesta)*. Čapek ponders the contemporary status of film and expresses his highest appreciation for American films distributed by the American World Film Co., which were being screened in Czech cinemas during the second half of World War I.

•1919

In May the magazine *June (Červen)* publishes "Kino," a study by the writer Stanislav Kostka Neumann, who sides with film against its detractors. He advocates that the state take the biographs out of the hands of private speculators, proposing instead that the movie industry be turned into a cooperative.

In June Václav Binovec's film *The Grey-Eyed Demon (Sivooký démon)*, a free adaptation of Jakub Arbes' novel, has its premiere in Prague. In keeping with contemporary fashion, Binovec chose to adapt domestic and foreign literary works including those of Růžena Svobodová, Aleksandr Pushkin, Knut Hamsun, and George Bernard Shaw.

In November S.K. Neumann, Františka Zeminová, František Houser, and other members of the National Assembly present a bill proposing that cinema be exclusively under the Ministry of Education and Culture and not be controlled by police or trade criteria.

•1920

In March Antonín Novotný and Karel Degl's *The Builder of the Cathedral (Stavitel chrámu)*, based on local legend, opens in Prague. The film technically and artistically challenges all previous productions.

Also in March American Film Co. and Biografia, the two major Prague film distributors, establish the A.B. Film Factory Inc., the largest Czech production company formed to date.

In April the Czechoslovak Film League (Filmová liga československá) is formed with the aim of defending and economically supporting Czech film against the interventions of foreign capital and of elevating the artistic level of Czech film.

In September the painter Ferdinand Fiala and the cameraman Svatopluk Innemann make the first Czech animated film, *Adventures in Africa (Dobrodružství v Africe)*, a Pojafilm production.

In October Devětsil, an artistic association of Czech leftist avant-garde artists, is established. At first Devětsil members regard American movies and the names of Chaplin and Fairbanks as being synonymous with film. In the following years they articulate their own filmic vision in a number of film scripts and essays.

•1921

In February Karel Čapek completes the film script *The Little Golden Key (Zlatý klíček)*, which is directed by Jaroslav Kvapil as an A.B. Company production. The film has censor problems and is a commercial failure. Čapek also begins work on the script for a fairy-tale film *Water Nymph (Rusalka)*, which is never realized.

In June the Prague cinema Na Slovanech presents Imrich Daranyi's *Siciliána*, a Slovak "kinema-sketch." "Kinema-sketch" is a combined theater-film form, a precursor of Prague's Laterna magika.

In July A.B. Company opens a provisional film studio in Prague's Vinohrady borough. Smaller than most contemporary foreign film studios, it is Prague's largest facility and efficiently concentrates the entire film production from shooting to editing.

In October the supernatural film of Jan Stanislav Kolár, *Visitor from Darkness (Příchozí z temnot)*, starring Anny Ondráková and Karel Lamač, opens in Prague.

In November Jaroslav Siakel and František Horlivý's Slovak-American film *Jánošík* has its premiere in Prague.

•1922

In May Czechoslovak Society for Scientific Cinematography (Československá společnost pro vědeckou kinematografii) is established in Prague, consolidating the activity of individual scientists using film as a research tool.

In September Karel Teige writes "Foto Kino Film," an essay declaring that photography and film are the art forms of the future. Rejecting traditional arts, he celebrates film as a popular and universal medium.

In October *The Devětsil Revolutionary Almanac (Revoluční sborník Devětsil)* is published. Of its twenty-five articles, seven are devoted to film (Vítězslav Nezval, Jindřich Honzl, Artuš Černík, Jaroslav B. Svrček, Jaroslav Seifert, Ilia Ehrenburg, and Karel Teige).

Also in October *Sršatec* magazine publishes Nezval's script *Charlie at the Bar (Charlie před soudem)*, an improvised two-act "Chapliniad." Nezval's film script precedes similar efforts of his peers to write film poems and poetical film scripts. None is ever produced on film.

•1924

In March Karel Teige writes the paper "Film and Cinema Aesthetics (Estetika filmu a kinografie)," attempting to outline film aesthetic.

In September *Czech Film World (Český filmový svět)* resumes publication in a new form and with new contents, becoming for a short time one of the most valuable film periodicals as well as the theoretical tribune for Devětsil members.

In December the first issue of *Mass (Dav)*, a magazine of young Slovak intellectuals and students, is published in Prague. The magazine devotes attention to film and publishes critical evaluations of important domestic and foreign productions.

•1925

In April Karel Teige's anthology *Film* is published. The collected articles outline in full the development of the Devětsil film theory.

In May an exhibition of artifacts from the beginnings of cinematography opens at the Schwarzenberg Palace in Prague. It was selected by Jindřich Brichta from the collection of Prague's Technological Museum. Subsequent exhibitions add to the collection, which soon ranks among the most remarkable in the world.

•1926

Vítězslav Nezval writes his study "Film" in an attempt to explain the various stages in making a film, to characterize its specific genres, and to outline the mission and function of film in contemporary life.

In February Karel Lamač's film *The Good Soldier Švejk (Dobrý voják Švejk)*, based on the satirical novel by Jaroslav Hašek, with Karel Noll in the title role, opens in Prague.

In April a second film studio, Kavalírka, opens in Prague, breaking the monopoly of the A.B. Company studio.

In November Karel Lamač's film *Camel Through the Eye of a Needle (Velbloud uchem jehly)*, based on František Langer's play, has its premiere in Prague.

In December Karel Anton's film *The Fairy Tale of May (Pohádka máje)*, based on a novel by Vilém Mrštík, has its premiere in Prague.

•1927

In January the program statement of the New Film Club (Klub za nový film) is published in *Czech Film World*. The club, founded in association with Devětsil, unites filmmakers and film journalists in the struggle to make independent Czech films and to promote avant-garde ideas in filmmaking.

In March Gustav Machatý's film *The Kreutzer Sonata (Kreutzerova sonáta)*, based on a story by Leo Tolstoy, opens in Prague. Machatý draws the characters' psychology with a depth as yet unseen in Czech film and expresses dramatic structure through purely filmic means. Despite the framework of Czech domestic production, Machatý, like Karel Anton and Karel Lamač, aspired to reach international as well as domestic audiences.

In August Dr. Vladimír Úlehla, a professor at the Masaryk University in Brno, works on the film *Plant Movements (Pohyby rostlin)*, a feature-length work of scientific cinematography created for the 1928 Contemporary Culture Exhibition in Brno.

In November the Prague cinema Adria programs a fortnight of short sound films, including Lee de Forest's "phonofilms," calling attention to the great variety of sound in film.

In December Přemysl Pražský's film *Battalion (Batalion)* has its premiere in Prague. It is the first purely Czech film tragedy based on a true event.

In September the mid length documentary film by Svatopluk Innemann and Václav Vích *Prague Shining in Lights (Praha v záři světel)* is presented in Prague. It represents the first use in Czechoslovakia of the newly developed high-speed panchromatic film material.

In October *Studio*, an independent critical monthly for film art, begins publication in Prague. Its contents and graphic design place it among the best film magazines of the period.

In November, Karel Plicka's ethnographic film *In Search of the Slovak People (Za slovenským l'udom)* is presented in Prague.

Also in November the first Czech talking picture, a short, opens at Adria cinema. It includes Otakar Mařák and Mary Cavanová singing an aria from *Romeo and Juliet*. The film was made in Prague when Fox sound engineers visited with the Movieton recording system.

• 1929

In May *Studio* begins installments of Karel Teige's "On Film Aesthetic (K estetice filmu)." In this work Teige developed further the theories outlined in his 1925 book *Film*.

In July Gustav Machatý's film *Erotikon* has its premiere in Karlovy Vary. Plot is secondary to the overall film conception; more important is the depiction of the inner states of characters, their feelings and their passions.

In August Prague's Lucerna cinema screens the first feature-length sound film shown in Czechoslovakia, the American production *Show Boat*, accompanied by a Fox talking newsreel. The theater is equipped with a Western Electric sound system.

In October Levá fronta (Left Front) is founded in Prague. Its orientation is Marxist, anti-Fascist, and anti-Nazi. Levá fronta is led at first by Karel Teige; after its 1930 reorganization S.K. Neumann becomes the leader. The Film and Photography Group (Filmová a fotografická skupina), founded in 1931 by Lubomír Linhart, a film journalist and Soviet film propagator, is one of Levá fronta's "work groups."

In December the Czechoslovak Ethnographic Society (Národopisná společnost československská), together with the Masaryk Institute for Popular Education (Masarykuv lidovýchovný ústav), present in Prague Karel Plicka's Slovak documentary film *Along the Hills, Along the Dales (Po horách, po dolách)*. In 1932 this film is awarded the Gold Medal at the Venice International Film Festival.

• 1930

Futurm-Film company of Brno produces *The Light Penetrates the Dark (Světlo proniká tmou)*, a short experimental film by Otakar Vávra and František Pilát, inspired by Zdeněk Pešánek's kinetic light sculpture on the Edison Transformer Station in Prague.

In February Lubomír Linhart's book *The Small Film Alphabet (Malá abeceda filmu)* is published.

Linhart attempts to synthesize the demand of tendentiousness with the demand of filmic specificity.

Also in February the Film Journalists and Writers Club (Klub filmových novinářů a publicistů) is founded in Prague. It provides a much-needed common platform for the growing number of film journalists.

Also in February the first Czech feature-length sound film, *Tonka of the Gallows (Tonka Šibenice)*, directed by Karel Anton and based on a story by Egon Erwin Kisch, opens in Prague. Several sound track sequences had been made in Paris.

In May a Tobis-Klangfilm sound system is installed and tested in the Vinohrady studio of the A.B. Company.

Also in May Karl Junghan's Czech/German production *Such Is Life (Takový je život/So ist das Leben)* with Vera Baranovskaia premieres in Prague. At this time, at the cusp of the sound era, this supreme work of Czech silent film is a complete failure with audiences.

In October Karel Lamač's film *The Imperial and Royal Field Marshal (C.a.k. polní maršálek)* with Vlasta Burian, based on Emil Artur Longen's play, has its premiere in Prague. Its commercial success proves Czech sound films to be a realistic and profitable possibility.

In November Kotva cinema stages the First Week of Avant-garde Film in Prague. Wishing to compensate for the shortage of independent filmmaking in Czechoslovakia, the organizers Alexander Hackenschmied and Ladislav Kolda screen films by Henri Chomette, Jean Vigo, Jean Painlevé, and René Clair as well as Hackenschmied's *Aimless Walk (Bezúčelná procházka)*. In January and February 1931 two more Weeks of Avant-garde Film are held at the Kotva cinema. The third week includes Otakar Vávra and František Pilát's *The Light Penetrates the Dark*.

In December Josef Háša, the director of the Liberated Theater (Osvobozené divadlo), together with Jiří Voskovec and Jan Werich, establishes the film company VaW, which enters into collaboration with the French production and distribution company Gaumont-Francofilm-Aubert. *Greasepaint and Gasoline (Pudr a benzín*, also released as *Powder and Gas)* with Voskovec and Werich, directed by Jindřich Honzl, is their first production.

• 1931

In January the Czech-language version of the American film *The Doctor's Secret (Tajemství lékařovo)* has its premiere in Prague. Made in Paris by a Czech director with Czech actors, it is one of three Czech versions of American films made in Paris. None is commercially successful.

In February the sound puppet film *Špejbl's Film Intoxication (Špejblovo filmové opojení)*, directed by Josef Skupa, the creator of the Špejbl and Hurvínek puppet theater, is made at the A.B. Company Studios in Vinohrady.

In April the theater director Josef Kodíček begins shooting the film *The Bandit (Loupežník)*, based on Karel Čapek's play. Kodíček is the first theater artist working at the beginning of the sound era in

feature filmmaking. He is followed by other experienced artists: Jindřich Honzl, Jiří Voskovec, Jan Werich, Vladislav Vančura, Ivan Olbracht, Karel Poláček, Emil František Burian, Hugo Haas, et al.

In May Gustav Machatý's film *From Saturday to Sunday (Ze soboty na neděli)*, based on Vítězslav Nezval's idea and script, with music by the Czech jazz genius Jaroslav Ježek, has its premiere in Prague.

In June Jan Mukařovský's study "An Attempt at the Structural Analysis of an Acting Phenomenon (Pokus o strukturní rozbor hereckého zjevu)," using Chaplin's acting in *City Lights* (1931) as its subject matter, is published in *Literary Newspaper (Literární noviny)*.

In November ground is broken for the Barrandov film studios to supplement the inadequate Vinohrady studios. Initiated by Max Urban, Barrandov studios begins operating in February 1933 as the most advanced in Central Europe, attracting many foreign productions and coproductions to this day. The first film made there is *The Ostrovní Street Murder (Vražda v Ostrovní ulici)*, based on Emil Vachek's novel.

• 1932

The Ministry of Commerce and Industry issues new directives, effective January 1, known as the Contingent, for foreign film imports. In principle foreign films could be imported only by someone who had made at least one feature domestically. Such producers then had priority listing for the import of seven (later six and five) foreign features. Because this import privilege could be transferred to another importer, a Czech filmmaker who did not import films could obtain state subsidy to produce a Czech film by selling seven import licenses. The shortcoming of the Contingent system was that any Czech film could receive state support regardless of its quality, which lowered the overall quality of Czech films.

In March the publishing house Cooperative Work (Družstevní práce) begins issuing installments of Karel Smrž's *History of Cinema (Dějiny filmu)*, up to this time the most important work of Czech film literature and one of the first comprehensive books on cinema. The series is completed before Christmas 1933.

In June the Antonín Fencl studio AFES in Radlice, adapted from a former industrial plant, begins operation, but only one film is made before production stops. Jaroslav Foist, the Smíchov paper and office machinery wholesaler, reopens the studio after renovations, equipped with the Visaton-Marconi sound system. Production resumes in March 1937.

In September Vladislav Vančura and Svatopluk Innemann's film *Before the Finals (Před maturitou)*, with music by E. F. Burian, opens in Prague.

In October Jindřich Honzl's film *Your Money or Your Life (Peníze nebo život)*, starring Jiří Voskovec and Jan Werich with music by Jaroslav Ježek, has its premiere in Prague.

In December Host Film company begins construction of studios in Hostivař. Production begins in the fall of 1933 but is soon interrupted by technical difficulties. Work resumes in 1934, when six

marginally successful films are made before another shutdown. Reopened in 1937, the studios are leased in 1938 for three years to Baťa Auxiliary Plants or BAPOZ (Baťovy pomocné závody) for feature filmmaking.

• 1933

In January Gustav Machatý's film *Ecstasy (Extase)* with Hedy Kiessler (Hedy Lamarr), which attracts extraordinary attention internationally thanks to its daring theme and unconventional approach, has its premiere in Prague. Representing Czech cinematography at the 1934 Venice International Film Festival, it wins the Cup of the City of Venice for best direction.

In March Roman Jakobson, member of the Prague Linguistic Circle, publishes "Is the Cinema in Decline? (Úpadek filmu?)," a chapter from a proposed but never finished book on the potentials of cinema, in *Newsletter for Art and Criticism (Listy pro umění a kritiku)*.

In April *Newsletter for Art and Criticism* publishes Jan Mukařovský's study "Contribution to Film Aesthetic (K estetice filmu)" a thorough analysis of filmic space.

In October Karel Plicka and Alexander Hackenschmied's film *The Earth Sings (Zem spievá)* with music by František Škvor opens in Prague.

Also in October Josef Rovenský's film *The River (Řeka)*, one of the most widely seen films of the early thirties, has its premiere in Prague.

Also in October, at Barrandov studios, the French director Victor Tourjansky begins shooting in French *Volga in Flames (Volha v plamenech)*, based on a work by Aleksandr Pushkin. Two other elaborate French-Czech coproductions are made: Julien Duvivier's *Golem* and Nicolas Farkas' *Port Arthur*. The A.B. Company makes these blockbuster movies with international participation to demonstrate the technologically advanced standards of the Prague studios and their personnel.

In December Vladislav Vančura's film *On the Sunny Side (Na sluneční straně)* has its premiere in Prague. The script is written by Vítězslav Nezval, Roman Jakobson, and Miroslav Disman.

• 1934

In March Vladislav Vančura, Ivan Olbracht, and Karel Nový's film *Faithless Marijka (Marijka nevěrnice)*, made on location in former Ruthenia primarily with non-actors, has its premiere in Prague. The music is composed by Bohuslav Martinů.

In August the first foreign-language film is dubbed in Czech—the French film *Amok* by Fedor Ocep. At this time Czech dubbing does not become popular, and most foreign films in Czechoslovakia are still projected with Czech subtitles.

In October the first Czech color film, a short documentary titled *Prague in Autumn (Podzimní Praha)*, is made in Prague by Jiří Dušek and Karel Melíšek.

Also in October Martin Frič's film *Heave Ho! (Hej rup!)*, with Jiří Voskovec and Jan Werich and music by Jaroslav Ježek, has its premiere in Prague.

In November the Contingent is replaced by the Registration system. This again brings about voluntary production of Czech films and, instead of Contingent lists, institutes a uniform Contingent fee allocated to a central fund for support of domestic film production.

• 1935

The Cultural Department of A.B. Company (Kulturní oddělení společnosti A.B.) becomes the first center of progressive documentary filmmaking in Czechoslovakia. Conditions attract new young people who are offered a chance to demonstrate their talent in film work. The director Jiří Weiss and the cameraman Václav Hanuš begin working in the Cultural Department at this time.

At the beginning of the year Film Advisory Group (Filmový poradní sbor) is established in Prague to allocate grants from the Registration fund and decide on imports of foreign films. The progressive segment of the group, for which Vladislav Vančura has the decisive word, takes an intransigent stand against grants to purely commercial films and recommends augmentation of grants to films attempting in whatever way to rise above the regular commercial aspect. The group's activity has an indisputable influence on the increased quality of Czech filmmaking.

In April E.F. Burian uses a film by Jiří Lehovec in the 9.5mm format for his theatrical staging of *May (Máj)*, a poem by Karel Hynek Mácha, in the D 35 Theater. Replacing classical props, the film is also linked to the dramatic plot, thus expanding the stage action.

In autumn Baťa Company breaks ground for production studios at Kudlov in the city of Zlín (presently Gottwaldov). Advertising films and, later, educational films are also made there. Capable young people such as Elmar Klos, Alexander Hackenschmied, František Pilát, and Ladislav Kolda are engaged by the Baťa Film Studios, resulting in the Zlín facility's becoming the second center of progressive documentary film in Czechoslovakia.

In November Josef Rovenský's film *Maryša*, based on the play by Alois and Vilém Mrštík, has its premiere in Prague. It is the first Czech feature film to include color sequences and wins the Medal of Venice at the 1936 Venice International Film Festival.

• 1936

In January Martin Frič's film *Jánošík* with Palo Bielik has its premiere in Prague. The film is one of the most popular films of the decade at home and abroad.

In March E.F. Burian and his stage designer, Miroslav Kouřil, combine theater and film, termed "theatergraph," for the staging of Frank Wedekind's *Spring's Awakening (Procitnutí jara/ Fruehlings Erwachen)*. The film segment was shot in 16mm by Čeněk Zahradníček.

In October Czechoslovak Film Society (Československá filmová společnost) is founded as an association for workers active in Czech film. Vladislav Vančura is elected as head of the Society. The members of its committee are Jan Mukařovský, Jan Kučera, Jindřich Elbl, Otakar Jeremiáš, Josef Kopta, Marie Pujmanová, Jindřich Honzl, Otakar Vávra, and Lubomír Linhart.

• 1937

In May Elmar Klos, with Alexander Hackenschmied and Jan Lukas, makes a film advertising Baťa tires, *The Highway Sings (Silnice zpívá)*, which contains avant-garde elements. The film wins first prize at the 1937 Paris exhibition.

Also in May, on the occasion of E.F. Burian's D 37 Spring Festival, seven Czech avant-garde films are presented at the Lucerna cinema: *Prague Castle (Na Pražském hradě*, 1932) by Alexander Hackenschmied, *Black-and-White Rhapsody (Černobílá rapsodie*, 1937) by Martin Frič, *Autumn (Listopad*, 1934) by Otakar Vávra, *Burlesque (Burleska*, 1933) by Jan Kučera, and *Hands on Tuesday (Ruce v úterý*, 1935), *The Story of a Soldier (Příběh vojáka*, 1936), and *The Atom of Eternity (Atom věčnosti*, 1934) by Čeněk Zahradníček.

In June Karel Dodal and Irena Dodalová's color cartoon *The Play of Bubbles (Hra bublinek)* is completed.

In July Martin Frič's anti-Fascist film *The World Belongs To Us (Svět patří nám)*, with Jiří Voskovec and Jan Werich and music by Jaroslav Ježek, has its premiere in Prague. Clearly anti-Fascist, it is the most important of the Voskovec and Werich films.

In November Otakar Vávra's film *Virginity (Panenství)*, based on Marie Majerová's novel and featuring Lída Baarová in the title role, has its premiere in Prague. It marks Vávra's feature debut. Vávra is one of a new generation of filmmakers entering film from literature and theater. Others include Jiří Slavíček, Jan Alfred Holman, František Čáp, and Václav Krška.

In December Hugo Haas's film *White Sickness (Bílá nemoc)*, based on Karel Čapek's play, opens in Prague. Like the play, the film warns against the threat of Fascism.

• 1938

Karel Dodal and Irena Dodalová make the abstract cartoon *The Idea Seeking Light (Myšlenka hledající světlo)*.

In May the American producer and director Herbert Kline of Frontier Film comes to Czechoslovakia to film the internal political crisis preceding the Munich agreement. Alexander Hackenschmied and Hans Burger collaborate with Kline on the film *Crisis (Krise)*. Its premiere takes place in New York two days before the remainder of Czechoslovakia is occupied by Hitler's Germany.

In September a film department under the direction of Karel Plicka is established at the School of Arts and Crafts in Bratislava. It is the first film school in Czechoslovakia.

Also in September Otakar Vávra's film *Guild of the Maidens of Kutná Hora (Cech panen kutnohorských)* has its premiere in Prague. Outstanding in its direction and acting performances, the film takes a political tone in a politically critical

period. It is awarded the Golden Cup LUCE at the 1938 Venice International Film Festival.

• 1939

Following the Nazi occupation of Czechoslovakia, which began on March 15, Hans Burger immigrates to the United States and Jiří Weiss to England. Alexander Hackenschmied, who is in Paris, does not return to Czechoslovakia but immigrates to the United States.

In March and April the Czech film censors ban a number of Czech and foreign films (including all Soviet films) to avoid irritating the occupation authorities.

In April the Office of the Reichsprotektor, or German governor, establishes a cultural-political department in charge of press, theater, film, broadcasting, music, literature, and the fine arts under the Berlin Ministry of Enlightenment and Propaganda directed by Joseph Goebbels.

In June the Reichsprotektor issues an edict concerning Jewish property that defines the Nazi concept of "Jew," initiating a wave of reprisals against the Jewish population. As a result the Barrandov film studio of the A.B. Company and the Hostivař studio are confiscated as Jewish property. A third studio, Radlice, is purchased by the Germans in 1942, putting all three Prague studios where feature films are made in Nazi hands. The studio in Radlice, technically the least satisfactory, is placed at the disposal of Czech filmmakers; Czechs can use the other two studios only when Germans are not working.

In August domestic and foreign films in which Jews and Freemasons act or participate are openly banned.

In August Jiří Lehovec's short film *The Magic Eye (Divotvorné oko)* opens in Prague.

In September, when war breaks out and the Reichsprotektor cultural-political department assumes film censorship, all English and French films and many American films are banned. The remaining American films, together with the rare new films for which import permits were given, continue in circulation for another year and a half before a complete ban on American films is declared.

In September E.F. Burian's film of Božena Benešová's novel *Věra Lukášová* is presented. The vacation story of a twelve-year-old schoolgirl addresses disquieting issues of good and evil.

In November the Nástup company is established in Slovakia and authorized to obtain exclusive rights for production, import, export, and distribution of 35mm films, thus creating a Slovak film industry.

In November Otakar Vávra's film *Magical House (Kouzelný dům)*, based on the novel by Karel Josef Beneš dedicated to the German actress Elisabeth Bergner, is released. The story of a girl who loses her memory, and with it any idea about her future, offers an escape from the reality of the occupation to the world of "unconsciousness" and dreams.

• 1940

In July Film Harvest (Filmové žně), a festival of feature and short films produced during the previous year, is organized in Zlín (today Gottwaldov). Repeated the following year, the festival is then banned by the Germans for its emphatic demonstration of the Czech character.

In October Otakar Vávra's film *The Fairy Tale of May (Pohádka máje)*, based on Vilém Mrštík's novel, premieres. Vávra's version emphasizes the lyrical and poetic qualities of this classic novel.

In December the Institute for School and Educational Film (Ústav pro školní a osvětový film; Školfilm) is created in Bratislava. During its existence Školfilm equips some 400 schools with film projectors and produces 65 short 16mm films.

• 1941

In February the Czecho-Moravian Film Central (Českomoravské filmové ústředí), the supreme public corporation of the film industry, is established on the model of the Berlin Reichsfilmkammer. The Central is in charge—under German supervision—of overseeing and organizing all Czech cinema activity. It also becomes a union in which membership was obligatory.

In April work begins in the Baťa Film Studio (Filmové ateliery Baťa; FAB) in Zlín on *Ferdie the Ant (Ferda mravenec)*, a puppet film, directed by Hermína Týrlová.

In July Jiří Lehovec's documentary film *Rhythm (Rytmus)*, made in the Zlín studio, is released.

In the autumn the illegal National Revolutionary Intelligentsia Committee (Národně revoluční výbor inteligence) is established by members of the resistance. Coordinated, through Lubomír Linhart, by the illegal central committee of the Communist Party of Czechoslovakia, its task is to prepare plans for the future organization and activity of the individual cultural fields after the liberation of the Czechoslovak Republic. Vladislav Vančura is president of the entire committee as well as of its literary group. The film group, led by Jindřich Elbl and including František Papoušek, Vladimír Kabelík, and Emil Sirotek, maintains communication with the Zlín group (Ladislav Kolda, Elmar Klos, and František Pilát).

In October František Čáp's costume melodrama *Night Butterfly (Noční motýl)* is released.

In November the A.B. Company is turned into a purely German enterprise called Pragfilm, Aktiengesellschaft, and becomes part of the UFA conglomerate. Pragfilm is established to replace Czech filmmaking in the Protectorate with German production as part of the effort to liquidate the Czech nation by Germanization of its territory and population. Pragfilm produces only German films, some with the collaboration of Czech directors, cameramen, and actors, most of whom are coerced to cooperate. Czech film production is reduced from 41 films in 1939 to 8 in 1944.

• 1942

In January, after Prime Minister Alois Eliáš is executed, the Protectorate government is reorganized. Film is removed from the Ministry of Industry, Commerce, and Trade and becomes the concern of the infamous collaborator Emanuel Moravec in his Ministry of Education and Enlightenment.

In February the Zlín film studio is taken over by the German company Böhmisch-mährische Schmallfilmgesellschaft. The Czech management remains in place, but the production of documentary and advertising films is reduced and the studio concentrates on puppet and cartoon films.

In June Vladislav Vančura is executed during the repression that followed the assassination of the Deputy Reichsprotektor Reinhard Heydrich.

• 1943

In January the production of Czech films is concentrated in the two largest Czech production companies, Lucernafilm and Nationalfilm, while film distribution is concentrated in Kosmosfilm.

In January Martin Frič's film *Barbora Hlavsová*, based on an original screenplay by the writer Jaroslav Havlíček, is released. The film's powerful moral conclusion underlines the humanistic qualities of national culture and demands the right to their continued existence.

In July the film group led by Jindřich Elbl resumes its illegal activity, continuing the plans for postwar Czech cinema as a nationalized enterprise.

In December Otakar Vávra's film *Bon Voyage (Šťastnou cestu)*, the story of salesgirls in a large Prague department store, is released. The film's effect of dramatic reportage counters the standard of contemporary Czech films. Vávra's dramatic approach and his attempt to obtain a documentary veracity mark the search for a new style, which is to find its purest form after World War II in Italian Neo-realism.

In March Otakar Vávra begins to shoot the historical film *Rozina the Foundling (Rozina sebranec)*, based on Zikmund Winter's tragic historical novel of passion and disappointed love. The most expensive film made under the Protectorate, it is set in seventeenth-century Prague before the Battle of Bílá-Hora (White Mountain), which marked the beginning of complete Hapsburg domination over the previously independent kingdom of Bohemia. The film is released only after World War II.

In July a Czech filmmakers' collaborative in the Prague Cartoon Film Studio (Pražské studio kresleného filmu) attached to Pragfilm finishes the color cartoon *Wedding in the Coral Sea (Svatba v korálovém moři)*. After the war the collective forms the base for Czech postwar animated film.

In August, when the uprising of the Slovak nation against Tiso begins, a film group is formed in rebel territory that makes documentaries about the Slovak National Uprising.

• 1945

In February, after Eastern Slovakia is liberated, cinemas begin to be nationalized by means of the National Committees.

On May 5 Czech cameramen participate in the Prague Uprising, preserving on film these critical days.

Following the liberation of Prague by the Red Army on May 9, the Czech National Council (Česká národní rada) in Prague commissions František Papoušek, president of the National Committee of Film Workers (Národní výbor filmových pracovníků), and Jindřich Elbl to take over and secure all German film enterprises and institutions in the name of the National Committee of Film Workers and to organize their further operations—including all other film enterprises in Bohemia and Moravia—in keeping with the needs and instructions of the Czech National Council.

Dr. Zdeněk Štábla is a film historian at the Czechoslovak Film Institute—Film Archive (Československý filmový ústav–Filmový archiv), Prague.

Translated by Jitka Salaquarda

Checklist of the Exhibition: Painting, Sculpture, Drawings, and Prints

Each entry begins with the catalogue number for that object within the painting and sculpture section. All artists are Czechoslovak. Titles and dates are given as specified by the lender; English translations precede Czech and/or French. All dimensions are given in inches followed by centimeters, with height preceding width and depth. English translations are given for Czech institution names. Numbers following the lenders' names are those lenders' identification numbers.

The following list cross-references works in the exhibition with some of the major themes of the period. Works are identified by the artist's last name and the checklist number.

From Symbolism to Abstract Art
Kupka: PS36–PS46; Preissig: PS51–PS67

Expressionism and Cubism
Váchal: PS107–PS119; Filla, PS11–PS17; Gutfreund; PS18–PS26; Kubišta: PS26–PS35; Čapek: PS1–PS10; Zrzavý: PS120–PS131

Surrealism and Imaginative Art
Rykr: PS68–PS76; Šíma: PS77–PS84; Pešánek: PS47–PS50; Toyen: PS98–PS106; Štyrský: PS85–PS97

PS1
Josef Čapek
Figure (Postava), 1914
Etching on rice paper
Image: 13½ x 8⅞ (34.2 x 22.5)
Sheet: 21⅞ x 16½ (55.5 x 42)
Signed lower right: Josef Čapek 1914
Národní galerie v Praze (National Gallery, Prague)
R 145491

PS2
Josef Čapek
Head (Hlava), c. 1914
Oil on canvas
18⁵⁄₁₆ x 14⁹⁄₁₆ (46.5 x 37)
Národní galerie v Praze (National Gallery, Prague)
O 11667

PS3
Josef Čapek
Head (Hlava), c. 1914
Watercolor and collage
18⅞ x 13⁹⁄₁₆ (48 x 34.5)
Collection Dr. Jaroslav Dostál, Prague

PS4
Josef Čapek
Woman with a Headdress (Žena s čelenkou), 1914
Charcoal on pink paper
17¹¹⁄₁₆ x 12³⁄₁₆ (45 x 31)
Signed upper left: Josef Čapek 1914
Collection Dr. Jaroslav Dostál, Prague

PS5
Josef Čapek
Man with a Top Hat (Hlava muže v cylindru), 1915
Linocut on newsprint
11 x 9¹³⁄₁₆ (28 x 25)
Collection Dr. Jaroslav Dostál, Prague

PS6
Josef Čapek
Man with a Bowler Hat (Hlava muže v tvrdém kloubouku), c. 1916
Oil on canvas
16¾ x 11¹⁵⁄₁₆ (42.5 x 30.3)
Krajská galerie v Hradci Králové (Regional Gallery Hradec Králové)
O 824

PS7
Josef Čapek
Resemblance from a Movie Theater (Podoba z biografu), c. 1918
Hand-colored linocut with blue, red, and yellow washes
Image: 8½ x 6¹⁄₁₆ (21.5 x 15.4)
Sheet: 10 x 9⁷⁄₁₆ (25.5 x 24)
Moravská galerie v Brně (Moravian Gallery, Brno)
C 30014-II

PS8
Josef Čapek
Beggar and Child (Žebračka s dítětem), 1918
Oil on canvas
20¹⁄₁₆ x 14⅜ (51 x 36.5)
Signed upper right: J.C. 1918
Collection Dr. Jaroslav Dostál, Prague

PS9
Josef Čapek
Woman over the City (Žena nad městem), c. 1917–20
Oil on canvas
31¹¹⁄₁₆ x 17½ (80.5 x 44.5)
Signed lower right: J.Č.
Oblastní galerie Liberec (Regional Gallery, Liberec)
O 999

PS10
Josef Čapek
Illustrations to Guillaume Apollinaire's "Zone (Pásmo)" from *June (Červen)*, 6 February 1919 (volume 1, issues 21–22)
Woodcut
Images: 3⅞ x 3⁹⁄₁₆, 3⅛ x 2 (9.8 x 9.1, 8.9 x 5.1)
Sheets: 10¼ x 8¼ (26 x 21) each
Moravská galerie v Brně (Moravian Gallery, Brno)
C 12588a&b

PS11
Emil Filla
Mask (Maska), 1904
Watercolor on paper
5⁷⁄₁₆ x 7⁵⁄₁₆ (13.8 x 18.6)
Signed lower right: Emil Filla 1904
Moravská galerie v Brně (Moravian Gallery, Brno)
B1834

PS12
Emil Filla
Self-portrait with Cigarette (Autoportrét s cigaretou), 1908
Oil on board
26 x 19⅜ (66 x 49)
Národní galerie v Praze (National Gallery, Prague)
O 8042

PS13
Emil Filla
The Night of Love (Milostná noc), c. 1907–1908
Oil on canvas
28¾ x 43⅜ (73 x 110)
Signed lower left: Emil Filla
Národní galerie v Praze (National Gallery, Prague)
O 3849

PS14
Emil Filla
The Dance of Salome (Tanec Salome), c. 1912
Oil on canvas
54 x 32⅜ (137 x 82)
Signed upper right and lower left: Emil Filla
Krajská galerie v Hradci Králové (Regional Gallery Hradec Králové)
O 743

PS15
Emil Filla
Study of African Mask, Diary No. 4, 1912
Notebook (98 pages including cover)
6⁵⁄₁₆ x 3¹⁵⁄₁₆ (16 x 10)
Collection F. Krejčí, Prague

PS16
Emil Filla
Studies of African Sculptures from Trocadéro, Diary No. 6, 1913
Notebook (40 pages including cover)
6⁵⁄₁₆ x 3¹⁵⁄₁₆ (16 x 10)
Collection F. Krejčí, Prague

PS17
Emil Filla
Mask (Maska), c. 1935
Plaster
15¹⁄₁₆ x 7¹¹⁄₁₆ (38.2 x 19.5)
Collection F. Krejčí, Prague

PS18
Otto Gutfreund
Lovers (Milenci), c. 1910
Ink on paper
9 x 6 (22.9 x 15.1)
Národní galerie v Praze (National Gallery,
Prague)
K 39215

PS19
Otto Gutfreund
*Study: Four Figures in Motion (Čtyři pohybové
studie)*, c. 1911
Ink on paper
9¹⁄₁₆ x 5¹³⁄₁₆ (23 x 14.8)
Národní galerie v Praze (National Gallery,
Prague)
K 42698

PS20
Otto Gutfreund
Anxiety (Úzkost), 1911
Bronze
58¼ x 22½ x 19¹⁵⁄₁₆ (148 x 57.2 x 50.6)
Hirshhorn Museum and Sculpture Garden,
Smithsonian Institution
Joseph H. Hirshhorn Purchase Fund and Partial
Gift of Mr. and Mrs. Jan V. Mladek

PS21
Otto Gutfreund
Figures (Postavy), c. 1911
Ink on paper
6⁷⁄₁₆ x 8¼ (16.4 x 20.9)
Národní galerie v Praze (National Gallery,
Prague)
K 39186

PS22
Otto Gutfreund
Figures (Postavy), c. 1911
Ink on paper
11¼ x 8¹¹⁄₁₆ (28.5 x 22.1)
Národní galerie v Praze (National Gallery,
Prague)
K 39194

PS23
Otto Gutfreund
Cubist Figure (Kubistická postava), 1911–13
Sepia ink on paper
13½ x 8⅜ (34.2 x 21.2)
Severomoravská galerie výtvarného umění v
Ostravě (North Moravian Gallery of Fine Art,
Ostrava)
G 1408

PS24
Otto Gutfreund
Embracing Figures (Objímající se postavy),
1912–13
Plaster with blue pigment
25⅜ x 12⅝ x 9⅜ (64.5 x 32 x 23.8)
The Solomon R. Guggenheim Museum, New York

PS25
Otto Gutfreund
Cubist Bust (Kubistické poprsí), 1912–13
Bronze
24½ x 23¼ x 17¾ (62.2 x 58.9 x 45)
Hirshhorn Museum and Sculpture Garden,
Smithsonian Institution
Joseph H. Hirshhorn Purchase Fund and Partial
Gift of Mr. and Mrs. Jan V. Mladek, 1987

PS26
Otto Gutfreund
Head (Hlava), 1919
Bronze relief
10⅝ x 7⅛ (27 x 18)
Národní galerie v Praze (National Gallery,
Prague)
P 5106

PS27
Bohumil Kubišta
*Self-portrait with Overcoat (Vlastní podobizna v
haveloku)*, c. 1908
Oil on canvas
36¼ x 26 x 1⅝ (92 x 66 x 4)
Oblastní galerie výtvarného umění Gottwaldov
(Regional Gallery of Fine Arts, Gottwaldov)
O-412

PS28
Bohumil Kubišta
Self-portrait (Autoportrét), 17 March 1910
Ink on paper
12⁷⁄₁₆ x 9⅝ (31.5 x 24.5)
Národní galerie v Praze (National Gallery,
Prague)
K 54357

PS29
Bohumil Kubišta
Saint Sebastian (Svatý Šebestián), c. 1912
Graphite on paper
37⅜ x 29 (94.8 x 73.7)
Národní galerie v Praze (National Gallery,
Prague)
K 39176

PS30
Bohumil Kubišta
Hypnotist (Hypnotizér), 1912
Oil on canvas
23⅞ x 22⅞ (60.5 x 58)
Signed upper right: KUBIŠTA B. 1912
Severomoravská galerie výtvarného umění v
Ostravě (North Moravian Gallery of Fine Art,
Ostrava)
O 396

PS31
Bohumil Kubišta
Murder (Vražda), 1912
Oil on canvas
35⅛ x 37 x 1⅝ (89 x 94 x 4)
Signed upper right: B. Kubišta 1912
Oblastní galerie výtvarného umění Gottwaldov
(Regional Gallery of Fine Arts, Gottwaldov)
O 68

PS32
Bohumil Kubišta
Plea (Prosba), 1913–14
Woodcut
Image: 9⁹⁄₁₆ x 6⅛ (24.3 x 15.6)
Sheet: 12⅝ x 9⁷⁄₁₆ (32 x 24)
Národní galerie v Praze (National Gallery,
Prague)
R 179746

PS33
Bohumil Kubišta
Study for Head (Studie k plastice Hlava),
before 1914–15
Ink and graphite on paper
8 x 6 (20.2 x 15)
Národní galerie v Praze (National Gallery,
Prague)
K 39076

PS34
Bohumil Kubišta
Head (Hlava), 1915
Istria marble
14⅝ (37) high
Národní galerie v Praze (National Gallery,
Prague)
P 5071

PS35
Bohumil Kubišta
The Hanged Man (Oběšený), 1915
Oil on canvas
19¾ x 11¹⁵⁄₁₆ (50 x 30.3)
Moravská galerie v Brně (Moravian Gallery, Brno)
A 1044

PS36
František Kupka
The Beginning of Life (Počátek života),
from the series *The Voices of Silence (Hlasy ticha,
1900–1903)*, 1900
Colored aquatint
13⅝ x 13⅝ (34.7 x 34.7)
Signed lower right: Kupka
Národní galerie v Praze (National Gallery,
Prague)
R11447

PS37
František Kupka
The First Step (První krok), 1910–13(?);
dated on painting 1909
Oil on canvas
32¾ x 51 (83.2 x 129.6)
Signed lower right: Kupka 1909
The Museum of Modern Art, New York
Hillman Periodicals Fund, 1956

PS38
František Kupka
Study for Around the Point, 1910–12
Gouache on paper
7⅞ x 8¼ (20 x 21)
Signed lower right: Kupka
Collection Mladek, Washington, D.C.

PS39
František Kupka
*Irregular Forms: Creation (Formes irrégulières:
Création)*, 1911
Oil on canvas
42½ x 42½ (108 x 108)
Signed lower right: Kupka
Inscribed lower left: FORMES IRRÉGULIÈRES/
CRÉATION
Los Angeles County Museum of Art, David E.
Bright Bequest
M.67.25.10

PS40
František Kupka
Red and Blue Disks (Červené a modré kotouče),
1911(?); dated on painting 1911–12
Oil on canvas
39⅜ x 28¾ (100 x 73)
Signed lower right: Kupka 1911–12
The Museum of Modern Art, New York,
Purchase, 1951
141.51

PS41
František Kupka
Study for Cosmic Spring, 1911(?)
Ink and gouache on paper
15⅜ x 17⁵⁄₁₆ (39 x 44)
Collection Mladek, Washington, D.C.

PS42
František Kupka
Disks of Newton (Newtonovy kotouče), 1911–12
Oil on canvas
39½ x 29 (77.5 x 73.6)
Signed lower left: Kupka
Philadelphia Museum of Art, The Louise and
Walter Arensberg Collection
50-134-122

PS43
František Kupka
Study for Around the Point, 1911–12
Gouache, watercolor, and pencil on paper
7½ x 8½ (19 x 21.6)
Signed lower right: Kupka
Collection Mladek, Washington, D.C.

PS44
František Kupka
Cosmic Spring I (Kosmické jaro I), 1911–20(?);
dated on painting 1913–14
Oil on canvas
43¹¹⁄₁₆ x 49¼ (111 x 125)
Signed lower left: Kupka 1913–14
Národní galerie v Praze (National Gallery,
Prague)
O 1827

PS45
František Kupka
Study for Around the Point, 1919
Gouache, watercolor, and pencil on paper
7⅞ x 8⅞ (20 x 22.5)
Signed lower left: Kupka
Collection Mladek, Washington, D.C.

PS46
František Kupka
*Four Stories in White and Black (Čtyři příběhy
bílé a černé; Quatre histoires de blanc et noir)*,
1926
Book with woodcuts (title page and 25 prints)
13 x 10 (33.2 x 25.4)
The Museum of Modern Art, New York
Gift of Mr. and Mrs. Alfred H. Barr, Jr.
840.66.1-52

PS47
Zdeněk Pešánek
Amper's Law (Ampérovo pravidlo), 1930–31
Mixed media framed in a shadow box
46¹⁄₁₆ x 17⅝ x 3 (117 x 44.8 x 7.7)
Národní galerie v Praze (National Gallery,
Prague)
P 5247

PS48
Zdeněk Pešánek
*Model of the Color-Kinetic Sculpture I (Kontrola
jednotlivých fází barevné kinetické plastiky I)*,
1930–31
Mixed media framed in a shadow box
21¹⁄₁₆ x 6⅛ x 3³⁄₁₆ (53.5 x 15.5 x 8)
Národní galerie v Praze (National Gallery,
Prague)
P 5250

PS49
Zdeněk Pešánek
*Model of the Color-Kinetic Sculpture II (Kontrola
jednotlivých fází barevné kinetické plastiky II)*,
1930–31
Mixed media framed in a shadow box
6⅛ x 21⅛ x 3⅛ (15.5 x 53.6 x 8)
Národní galerie v Praze (National Gallery,
Prague)
P 5249

PS50
Zdeněk Pešánek
Torso (Torzo), c. 1936
Glass, neon, and mixed media
19¾ (50) high
Collection Charlotta and Petr Kotik, New York

PS51
Vojtěch Preissig
Two Tobacco Leaves (Dva tabákové listy), c. 1900
Transfer print
Image: 31⅞ x 22⅝ (81 x 57.5)
Sheet: 39 x 29 (99 x 73.5)
Private collection, Prague

PS52
Vojtěch Preissig
Tobacco Leaf (Tabákový list), c. 1900
Transfer print
Image: 31⅞ x 22⅝ (81 x 57.5)
Sheet: 39 x 29 (99 x 73.5)
Private collection, Prague

PS53
Vojtěch Preissig
Evening (Večer), c. 1900
Ink and gouache on board
9⅝ x 5¹⁄₁₆ (24.5 x 13)
Památník národního písemnictví (The National
Museum of Literature), Prague
9/68-91

PS54
Vojtěch Preissig
Ornamental Drawing (Ornamentální kresba),
c. 1903
Ink on paper
13¾ x 9⅞ (35 x 25)
Signed lower right: PV
Památník národního písemnictví (The National
Museum of Literature), Prague
9/68-508

PS55
Vojtěch Preissig
Evening (Večer), 1905
Colored aquatint
Image: 14⅛ x 10¹⁵⁄₁₆ (36 x 27.8)
Signed lower right: Vojt Preissig
Národní galerie v Praze (National Gallery,
Prague)
R 29465

PS56
Vojtěch Preissig
Landscape (Krajina), 1908–1909
Etching
Image: 31⅛ x 25¾ (79.2 x 65.5)
Sheet: 35½ x 25¾ (90 x 65.5)
Signed lower left: V. Preissig
Národní galerie v Praze (National Gallery,
Prague)
R 163608

PS57
Vojtěch Preissig
*Invention: Art Fundamental (Invence—Art
Fundamental)*, c. 1915–25
Graphite, watercolor, and yellow crayon on paper
7¹³⁄₁₆ x 10¹⁵⁄₁₆ (19.8 x 27.8)
Signed lower left: PV
Národní galerie v Praze (National Gallery,
Prague)
K 6283

PS58
Vojtěch Preissig
Composition (Kompozice), c. 1915–25
Collage with pine needles, string, and paper
5¹¹⁄₁₆ x 5¹⁵⁄₁₆ (14.5 x 15.0)
Private collection, Prague

PS59
Vojtěch Preissig
Composition with Squares (Kompozice se čtverci),
c. 1915–25
Collage
5½ x 5 (14 x 12.7)
Private collection, Prague

PS60
Vojtěch Preissig
Geometric Drawing (Geometrická kresba),
c. 1925–35
Black and orange ink and graphite on paper
12³⁄₁₆ x 17⁵⁄₁₆ (31 x 44) ·
Památník národního písemnictví (The National
Museum of Literature), Prague
9/68-1

PS61
Vojtěch Preissig
*Matrix of Elemental Print of Nine Curves
(Matrice elementární grafiky o devíti křivkách)*,
c. 1932–34
Mixed media on sandpaper
11 x 8⅞ (28 x 22.5)
Památník národního písemnictví (The National
Museum of Literature), Prague
9/68-99

PS62
Vojtěch Preissig
*Elemental Print of Nine Curves (Elementární
grafika o devíti křivkách)*, c. 1932–34
Transfer print on paper
Image: 10¹³⁄₁₆ x 9¹⁄₁₆ (27.5 x 23)
Sheet: 15⅜ x 9⅞ (39 x 25)
Památník národního písemnictví (The National
Museum of Literature), Prague
9/68-53

PS63
Vojtěch Preissig
*Matrix of Elemental Print of Two Lines and Blots
(Matrice elementární grafiky o dvou liniích a
skvrnách)*, c. 1932–34
Mixed media on sandpaper
6⅛ x 5⅞ (15.5 x 15)
Památník národního písemnictví (The National
Museum of Literature), Prague
9/68-85

PS64
Vojtěch Preissig
*Elemental Print of Two Lines and Blots (Elemen-
tární grafika o dvou liniích a skvrnách)*,
c. 1932–34
Transfer print on paper
Irregular image: 6⅛ x 5⅞ (15.5 x 15)
Sheet: 10 x 7¹¹⁄₁₆ (25.5 x 19.5)
Památník národního písemnictví (The National
Museum of Literature), Prague
9/68-77

PS65
Vojtěch Preissig
Birth of the World (Zrození země), c. 1936
Oil on masonite
23⅞ x 28⅜ (60.5 x 72)
Signed lower left: PV
Národní galerie v Praze (National Gallery,
Prague)
O 9537

PS66
Vojtěch Preissig
Birth of the World (Zrození země), 1936
Oil on masonite
23⅞ x 28⅜ (60.5 x 72)
Signed lower left: PV
Private collection, Prague

PS67
Vojtěch Preissig
*Composition with Squares, Stars, and Arabesques
(Kompozice se čtverci, hvězdicemi a vlnovkami)*,
c. 1936–37
Oil on masonite
22¼ x 24 (56.5 x 61)
Signed lower right: PV
Národní galerie v Praze (National Gallery,
Prague)
O 9539

PS68
Zdeněk Rykr
Orient I , 1935
Mixed media in glazed shadow box
13⅜ x 9⅝ (34 x 24.5)
Národní galerie v Praze (National Gallery,
Prague)
O 13146

PS69
Zdeněk Rykr
Orient II, 1935
Mixed media in glazed shadow box
13⅜ x 9⅝ (34 x 24.5)
Národní galerie v Praze (National Gallery,
Prague)
O 13149

PS70
Zdeněk Rykr
Countryside (Venkov), from the series *Czech
Village*, 1936
Mixed media between 2 sheets of glass
17⁵⁄₁₆ x 13 (44 x 33)
Národní galerie v Praze (National Gallery,
Prague)
O 13143

PS71
Zdeněk Rykr
Composition (Kompozice), 1937
Oil on canvas
26⅜ x 32⁵⁄₁₆ (67 x 82)
Signed upper right: RYKR 37
Městské muzeum a galerie Jindřicha Průchy,
Chotěboř (City Museum and Gallery of Jindřich
Průcha, Chotěboř)
P 1955/143

PS72
Zdeněk Rykr
Composition with Teeth (Kompozice se zuby), 1938
Ink and watercolor over graphite on paper
7⅛ x 9⅞ (18 x 25)
Signed lower right: Rykr/38
Collection Alain and Nicole Faure, Paris

PS73
Zdeněk Rykr
Composition: Landscape (Kompozice—Krajina),
c. 1938–39
Watercolor on paper
5½ x 8¹⁄₁₆ (14 x 20.5)
Národní galerie v Praze (National Gallery,
Prague)
K 61940

PS74
Zdeněk Rykr
Composition: Landscape (Kompozice—Krajina),
c. 1938–39
Watercolor on paper
5¾ x 8½ (14.6 x 21.5)
Národní galerie v Praze (National Gallery,
Prague)
K 61941

PS75
Zdeněk Rykr
*Kaladý or The Refuge of Language (Kaladý aneb
Útočiště řeči)*, Prague, 1939
Book by Milada Součková with 4 lithographs
(unpaginated)
7½ x 5¼ (19 x 13.3)
By permission of the Houghton Library, Harvard
University

PS76
Zdeněk Rykr
The Talking Zone (Mluvící pásmo), Prague, 1939
Book by Milada Součková with 6 color linocuts
(32 pages)
Images: 11¹³⁄₁₆ x 9⁷⁄₁₆ (30 x 24)
Uměleckoprůmyslové muzeum v Praze (Museum
of Decorative Arts, Prague)
GK-8757-C

PS77
Josef Šíma
*Double Landscape: Thunderstorm (Double Pay-
sage: Tempête électrique; Dvojitá krajina—
bouřka)*, 1927
Oil on canvas
26⅜ x 53¹⁵⁄₁₆ (67 x 137)
Signed lower right: Šíma/1927
Musée National d'Art Moderne, Centre Georges
Pompidou, Paris
AM 1978-320 P

PS78
Josef Šíma
*Illustrations for Pierre Jean Jouve's "Paradise Lost
(Le Paradis perdu; Ztracený ráj),"* 1928
Portfolio of 12 etchings
14⅞ x 10¹⁵⁄₁₆ (37.8 x 27.7)
Národní galerie v Praze (National Gallery,
Prague)
R 205355-R 205367

PS79
Josef Šíma
Landscape (Krajina), 1929
Ink, charcoal, and pastel on paper
16¾ x 24¼ (42.5 x 61.5)
Signed lower right: Šíma 1929
Národní galerie v Praze (National Gallery,
Prague)
K 43416

PS80
Josef Šíma
Landscape with Straw (Krajina se stébly), 1930
Oil on canvas
19¹¹⁄₁₆ x 23⅝ (50 x 60)
Signed lower right: Šíma 30
Krajská galerie v Hradci Králové (Regional Gal-
lery Hradec Králové)
O 764

PS81
Josef Šíma
Island I (Ostrov I), 1931
Oil on canvas
23⅝ x 28¾ (60 x 73)
Signed lower right: ŠÍMA 1931
Národní galerie v Praze (National Gallery,
Prague)
O 12788

PS82
Josef Šíma
*Landscape with Crystal and Torso (Krajina
s krystalem a torzem)*, c. 1932
Graphite on paper
10¹¹⁄₁₆ x 9⅝ (27.2 x 24.5)
Národní galerie v Praze (National Gallery,
Prague)
K 43420

PS83
Josef Šíma
Cover for André Breton's "Nadja" (Prague: F.J.
Müller, 1935), 1935
Book
8⅜ x 5⅞ (21.3 x 15)
Uměleckoprůmyslové muzeum v Praze (Museum
of Decorative Arts, Prague)

PS84
Josef Šíma
Landscape (Krajina), 1939
Ink and charcoal on paper
13⅜ x 17⅜ (34 x 44)
Signed lower right: Šíma 1939
Oblastní galerie Benedikta Rejta v Lounech
(Regional Gallery of Benedikt Rejt, Louny)
KG 371

PS85
Jindřich Štyrský
The Cemetery of Suicides (Hřbitov sebevrahů),
1925
Mixed media on paper board
15⅜ x 9⁷⁄₁₆ (39 x 24)
Signed lower right: Štyrský/1925
Collection Bernard Galateau, Paris

PS86
Jindřich Štyrský
Deluge (Povodeň), 1927
Oil with sand on canvas
43⁵⁄₁₆ x 21⅝ (110 x 55)
Signed lower right: ŠTYRSKÝ 1927
Moravská galerie v Brně (Moravian Gallery, Brno)
A 1346

PS87
Jindřich Štyrský
*Illustrations for Vítězslav Nezval's "Jewish Ceme-
tery (Židovský hřbitov)"* (Prague: Odeon, 1928),
1928
Book with 6 lithographs (34 pages)
11¹³⁄₁₆ x 9⁷⁄₁₆ (30 x 24)
Národní galerie v Praze (National Gallery,
Prague)
B 571

PS88
Jindřich Štyrský
*Illustrations for Lautréamont's "The Songs of
Maldoror (Les Chants de Maldoror; Zpěvy
Maldororovy),"* 1928
Ink and airbrush on paper
Four drawings: 5⅝ x 8⅜ (14.3 x 21.2)
Signed lower right: Štyrský 1928
Národní galerie v Praze (National Gallery,
Prague)
K 36290-K 36293

PS89
Jindřich Štyrský
November (Listopad), 1930
Graphite, watercolor, and metallic paint on paper
11¼ x 15¼ (28.6 x 38.8)
Signed lower right: Toyen/Jindřich Štyrský/
November 1930
Inscribed lower left: 1930
Collection Radovan Ivsic and Annie Le Brun,
Paris

PS90
Jindřich Štyrský
Man-Cuttlefish (Člověk-sepie), 1934
Oil on canvas
39⅜ x 28¾ (100 x 73)
Signed lower right: ŠTYRSKÝ 1934
Collection Bernard Galateau, Paris

PS91
Jindřich Štyrský
Omnipresent Eye (Všudypřítomné oko), 1936
Charcoal and frottage on paper
19¹¹⁄₁₆ x 15 (50 x 38)
Signed lower right: ŠTYRSKÝ/1936
Collection Bernard Galateau, Paris

PS92
Jindřich Štyrský
The Trauma of Birth (Trauma zrození), 1936
Oil on canvas
39¾ x 100⅜ (101 x 255)
Signed lower right: ŠTYRSKÝ/1936
Collection Maître Binoche, Paris

PS93
Jindřich Štyrský
Dream of the Mother Earth (Sen o matce zemi),
1940
Graphite and watercolor on paper
11¹³⁄₁₆ x 15¾ (30 x 40)
Signed lower right: ŠTYRSKÝ/1940
Musée National d'Art Moderne, Centre Georges
Pompidou, Paris
AM 1982.366

PS94
Jindřich Štyrský
Hands (Ruce), 1940
Collage, frottage, and graphite on paper
11¹³⁄₁₆ x 17⅜ (30 x 44)
Signed lower right: ŠTYRSKÝ 1940
Národní galerie v Praze (National Gallery,
Prague)
K 40717

PS95
Jindřich Štyrský
Dream of the Fish I (Sen o rybách I), 1940
Ink on paper
8¹³⁄₁₆ x 13½ (22.4 x 34.4)
Signed lower left: ŠTYRSKÝ 1940
Collection Radovan Ivsic and Annie Le Brun,
Paris

PS96
Jindřich Štyrský
Dream of the Serpents I (Sen o hadech I), 1940
Ink on paper
11 x 14¹⁵⁄₁₆ (28 x 38)
Signed lower right: ŠTYRSKÝ /1940
Collection Marcel Fleiss, Gallery 1900-2000, Paris

PS97
Jindřich Štyrský
Dream of the Serpents II (Sen o hadech II), 1940
Charcoal and frottage on paper
11¹³⁄₁₆ x 16¹⁄₁₆ (30 x 40.9)
Signed lower right: ŠTYRSKÝ/1940
Musée National d'Art Moderne, Centre Georges
Pompidou, Paris
AM 1982.365 D

PS98
Toyen
Summer Day (Letní den), 1930
Oil and sand on canvas
21¼ x 28⅜ (54 x 72)
Signed lower right: TOYEN/30
Středočeská galerie, Praha (Gallery of Central
Bohemia, Prague)
O 16

PS99
Toyen
Dawn (Jitro), 1931
Oil and sand on canvas
35¹⁄₁₆ x 45½ (89 x 115.6)
Signed lower right: TOYEN 31
Moravská galerie v Brně (Moravian Gallery, Brno)
A 1612

PS100
Toyen
Surrealist Composition (Surrealistická kompozice),
1933
Watercolor and airbrush on paper
12¾ x 17⅜ (32.3 x 44)
Signed lower right: Toyen 33
Národní galerie v Praze (National Gallery,
Prague)
K 39275

PS101
Toyen
Composition (Kompozice), 1933
Watercolor on paper
15 x 10¼ (38 x 26)
Signed lower left: Toyen/33
Collection Alain and Nicole Faure, Paris

PS102
Toyen
In the Fog (V mlze), 1933
Oil and sand on canvas
50¾ x 37¹³⁄₁₆ (129 x 96)
Signed lower right: TOYEN 33
Galerie hlavního města Prahy (Gallery of the City
of Prague)
M 2596

PS103
Toyen
*The Voice of the Forest (Voix de la Forêt; Hlas
lesa)*, 1934
Oil on canvas
39⅜ x 28½ (100 x 72.5)
Signed lower right: TOYEN/34
Collection Bernard Galateau, Paris

PS104
Toyen
The Handshake (Stisk ruky), 1934
Oil on canvas
19¼ x 28¾ (49 x 73)
Signed lower left: TOYEN 34
Národní galerie v Praze (National Gallery,
Prague)
O 11563

PS105
Toyen
Hide! War! (Cache-toi guerre!; Schovej se, válko!),
1944
Portfolio of 10 intagliotypes, 1946 edition
12⅝ x 17⁵⁄₁₆ (32 x 44)
Signed lower right: Toyen 44
Uměleckoprůmyslové muzeum v Praze (Museum
of Decorative Arts, Prague)
GK-6730-B/1-11

PS106
Toyen
Before the Spring (L'avant printemps; Předjaří),
1945
Oil on canvas
35⅛₆ x 57½ (89 x 146)
Signed lower right: Toyen/45
Musée National d'Art Moderne, Centre Georges
Pompidou, Paris
AM 1982-364P

PS107
Josef Váchal
After Us, Deluge (Po nás ať přijde potopa), 1902
Ink and watercolor on printed book
7½ x 4⅞ (19 x 12.5)
Signed center: Jožka Váchal
Památník národního písemnictví, Prague (The
National Museum of Literature, Prague)
53/71-40

PS108
Josef Váchal
*Illustration for Josef Šimánek's "Gothic Song (Píseň
gotiky),"* 1907
Etching
Image: 7¹³⁄₁₆ x 6¹⁄₁₆ (19.8 x 15.3)
Sheet: 9¾ x 7¾ (24.7 x 19.6)
Signed lower right: J. Váchal 07
Inscribed lower left: Píseň gotiky
Památník národního písemnictví, Prague (The
National Museum of Literature, Prague)
15-67-3786

PS109
Josef Váchal
Mystic in Nature (Mystik v přírodě), c. 1908
Etching and aquatint
Image: 8 x 5⅞ (20.1 x 14.8)
Sheet: 9¼ x 6⅝ (23.5 x 16.8)
Signed lower right: J. Váchal
Památník národního písemnictví, Prague (The
National Museum of Literature, Prague)
97/61-1163

PS110
Josef Váchal
Seance (Seance), 1909
Etching
Image: 7⁷⁄₁₆ x 5⅞ (18.9 x 14.9)
Sheet: 10½ x 8½ (26.5 x 21.5)
Signed lower right: J. Váchal
Inscribed lower left: Seance 1909
Památník národního písemnictví, Prague (The
National Museum of Literature, Prague)
97/61-1147

PS111
Josef Váchal
Satanic Invocation (Vzývači ďábla), c. 1909
Oil on canvas, carved wood frame
Image: 26⅜ x 26 (67 x 66)
Frame: 37⅜ x 37 (95 x 94)
Signed lower left on the frame: VJ
Krajská galerie v Hradci Králové (Regional Gal-
lery Hradec Králové)
O 806

PS112
Josef Váchal
*Vision of the Seven Days and Planets (Vidění sed-
mera dnů a planet),* 1910
Block book with 33 woodcuts (34 pages)
7⁵⁄₁₆ x 5¹¹⁄₁₆ x ½ (18.5 x 14.5 x 1.3)
Private collection, Prague

PS113
Josef Váchal
Three Columnar Figures (Tři figurální sloupy),
c. 1910–11
Wood, varnished and gilded
Two figures: 35½ x 2¾ (90 x 7)
One figure: 22⅛ x 2⅜ (56 x 6)
Private collection, Prague

PS114
Josef Váchal
*Josef Váchal's Mystical Fortune Telling Cards
(Josefa Váchala vykládací mystické karty),* c. 1914
Hand-colored wood engravings (deck of 32 cards,
4 suits)
3¹⁵⁄₁₆ x 2⅜ (10 x 6) each
Uměleckoprůmyslové muzeum v Praze (Museum
of Decorative Arts, Prague)
GS-4554/1-33

PS115
Josef Váchal
*The Dictionary of Colors and Lines in a Spiritual-
ist's Mind (Slovníček barev a linií v myšlenkách
spiritualisty),* 1919–20
Series of 47 ink and watercolor drawings
13¼ x 10¼ (33.7 x 26)
Uměleckoprůmyslové muzeum v Praze (Museum
of Decorative Arts, Prague)
GK 7860-B

PS116
Josef Váchal
Mysticism of Smell (Mystika čichu), 1920
Wood engraving
12½ x 19⅛ (31.8 x 48.5)
Signed lower right: J. Váchal 1920
Okresní galerie, Jičín (Municipal Gallery, Jičín)
G 331

PS117
Josef Váchal
Magic (Magie), c. 1922
Woodcut; frontispiece
Image: 7⅛ x 5⅜ (18 x 13.6)
Sheet: 10¹⁄₁₆ x 8⅛ (25.5 x 20.6)
Moravská galerie v Brně (Moravian Gallery, Brno)
C 9811

PS118
Josef Váchal
Ex Libris Josefa Váchala, n.d.
Etching and aquatint
Image: 6¹⁄₁₆ x 4⁵⁄₁₆ (15.4 x 11)
Sheet: 8⅜ x 6⅞ (21.3 x 17.5)
Signed lower right: Váchal
Moravská galerie v Brně (Moravian Gallery, Brno)
C 13844

PS119
Josef Váchal
In Memoriam Marie Váchalové, 1923
Book with 48 color wood engravings, 11 mono-
chrome engravings, and 1 etching (78 pages;
unbound version)
9¼ x 8½ (23.5 x 21.5)
Private collection, Prague

PS120
Jan Zrzavý
Passion-Delight (Rozkoš), c. 1907
Colored ink and gold
Image: 2¾ x 5¹³⁄₁₆ (7 x 14.8)
Matted on handmade paper: 6⅝ x 9⅝
(16.8 x 24.5)
Národní galerie v Praze (National Gallery,
Prague)
K 53160

PS121
Jan Zrzavý
Mountain of God (Boží hora), c. 1907
Pastel on paper
Image: 3¾ x 3¹⁄₁₆ (9.5 x 7.8)
Sheet: 7⅞ x 7⅛ (20 x 18)
Národní galerie v Praze (National Gallery,
Prague)
K 53139

PS122
Jan Zrzavý
*Self-portrait with Straw Hat (Autoportrét se
slaměným kloboukem),* 1907
Oil on canvas
8⁹⁄₁₆ x 12¹¹⁄₁₆ (21.8 x 32.2)
Moravská galerie v Brně (Moravian Gallery, Brno)
A 1657

PS123
Jan Zrzavý
Self-portrait I (Autoportrét I), c. 1908
Tempera and embossed bronze on plywood
14¾ x 11 (37.5 x 28)
Národní galerie v Praze (National Gallery,
Prague)
O 14380

PS124
Jan Zrzavý
The Palm of Paradise (Rajská palma), c. 1908
Colored ink on paper
4 x 3¹¹⁄₁₆ (10.2 x 9.4)
Národní galerie v Praze (National Gallery,
Prague)
K 53159

PS125
Jan Zrzavý
Fantastic Landscape (Fantastická krajina),
c. 1908
Sepia ink on paper
8⅜ x 6¹¹⁄₁₆ (21.3 x 17)
Signed lower right: Jan Zrzavý
Moravská galerie v Brně (Moravian Gallery, Brno)
B 5181

PS126
Jan Zrzavý
Spirit of the Forest: Siren (Divoženka), 1908
Oil on paper
11¹¹⁄₁₆ x 10 (29.7 x 25.3)
Národní galerie v Praze (National Gallery,
Prague)
K 53169

PS127
Jan Zrzavý
Sermon on the Mountain (Kázání na hoře),
c. 1911–13
Graphite on paper
21¼ x 14¹⁵⁄₁₆ (54 x 38)
Národní galerie v Praze (National Gallery,
Prague)
K 13444

PS128
Jan Zrzavý
The Magdalen (Magdaléna), c. 1914
Oil on canvas
21¼ x 16½ (54 x 42)
Národní galerie v Praze (National Gallery,
Prague)
O 9601

PS129
Jan Zrzavý
Obsession: Lovers (Posedlost—Milenci), 1914
Charcoal on paper
15⁹⁄₁₆ x 11½ (39.5 x 29)
Signed upper right: Jan Zrzavý 1914
Verso: "Portrait of Štefa Heřmanová from
Okrouhlice"
Alšova jihočeská galerie, Hluboká nad Vltavou
(Aleš's Gallery of South Bohemia, Hluboká nad
Vltavou)
O 1244

PS130
Jan Zrzavý
The Good Samaritan (Milosrdný Samaritán),
c. 1914–15
Oil on canvas
18⅞ x 13⅜ (48 x 34)
Národní galerie v Praze (National Gallery,
Prague)
O 7664

PS131
Jan Zrzavý
Madman (Šílenec), c. 1918
Charcoal on paper
16⅝ x 13⅞ (42.1 x 35.2)
Signed lower left: J. Zrzavý
Moravská galerie v Brně (Moravian Gallery, Brno)
B 4445

Checklist of the Exhibition: Photography

Each entry begins with the catalogue number for that object within the photography section. All artists are Czechoslovak unless otherwise noted. Titles and dates are given as specified by the lender; English translations precede Czech and/or other language titles. The date of the negative follows the title. If the print is not approximately contemporary with the negative, the date of the print is also given. All prints are gelatin silver unless otherwise noted. All dimensions are given in inches followed centimeters, with height preceding width. English translations are given for Czech institution names. Numbers following the lenders' names are those lenders' identification numbers.

The following list cross-references major schools, styles, and artists' groups represented in the exhibition and book with works in the exhibition. Works are identified by the artist's last name and the checklist number.

Early Modernism

 I. Artists as Photographers
 Mucha: PH74, PH75; Pressig: PH94, PH95; Váchal: PH166, PH167.
 II. Pictorialism
 Drtikol: PH11–PH14; Bufka: PH8, PH9; Růžička: PH116, PH117; Schneeberger: PH118; Sudek: PH135; Funke: PH27.
 III. Drtikol: PH15–PH22.

Constructivism and Functionalism

 IV. Devětsil
 Teige: PH152–PH157; Štyrský: PH126, PH127; Markalous: PH73; Hausenblas: PH56; Rössler: PH100–PH113.
 V. Dašek: PH10; Funke: PH23–PH26, PH28–PH37, PH39, PH40; Lauschman: PH64, PH65; K. Novak (students): PH88, PH89; Schneeberger: PH119–PH123; Sudek: PH136–PH140, PH143, PH144; Wiškovský: PH181–PH185.
 VI. Berka: PH5, PH6, PH7; Lehovec: PH66.
 VII. Levá fronta
 Kroha: PH61, PH62, PH63; Lehovec: PH67.
 VIII. Hatláková: PH54, PH55; Rossmannová: PH114, PH115.
 IX. Applied: Advertising and Magazine Photography
 Hájek: PH44–PH46; Hackenschmied: PH42; Jírů: PH57, PH58; Lukas: PH71, PH72; Šťastný: PH124, PH125; Voříšek: PH178–PH180.

Imaginative Photography and Surrealism

 X. Line Group
 A. Novák: PH84ab, PH85ab, PH86, PH87; Bartuška: PH1–PH4; Valter: PH168ab, PH169–PH171; Nouza: PH82, PH83.

 XI. Group f5 and f4
 Táborský: PH147–PH151; Povolný: PH91–PH93; Nohel: PH79–PH81; Némec: PH76–PH78; Kašpařík: PH59, PH60; Lenhart: PH68–PH70.
 XII. Sudek: PH141, PH142, PH145, PH146.
 XIII. Funke: PH38, PH41; Hatlák: PH53; Hackenschmied: PH43; Vobecký: PH172–PH177.
 XIV. Surrealist Group
 Teige: PH158–PH164; Toyen: PH165; Štyrský: PH128–PH134.
 XV. Skupina 42 and Skupina Ra
 Reichmann: PH98, PH99; Hák: PH47–PH52; Zykmund: PH186–PH190.

PH1
Josef Bartuška
Photogram (Fotogram), 1932
9⅜ x 7 (23.8 x 17.8)
Private collection

PH2
Josef Bartuška
Photogram (Fotogram), 1932
9⅜ x 7 (23.8 x 17.8)
Private collection

PH3
Josef Bartuška
Shadow Play (Stínohra), 1930s
7 x 5 (17.8 x 12.7)
Private collection

PH4
Josef Bartuška
Shadow Play (Stínohra), 1930s
7 x 5 (17.8 x 12.7)
Private collection

PH5
Ladislav Emil Berka
Drier (Sušák desek), 1927–28
6⅝ x 9 (16.8 x 22.9)
Private collection

PH6
Ladislav Emil Berka
Close-Up of Plant (Detail květiny), 1929
11 x 8⅝ (28.0 x 21.8)
Moravská galerie v Brně (Moravian Gallery, Brno)
9260

PH7
Ladislav Emil Berka
Construction (Novostavba), c. 1929
11⅝ x 9¼ (29.5 x 23.5)
Private collection

PH8
Vladimír Jindřich Bufka
In the Chuchle Cemetery (Na Chuchelském hřbitově), 1912
Gum bichromate with slight hand-coloring
14⅜ x 10⅛ (36.5 x 25.7)
Moravská galerie v Brně (Moravian Gallery, Brno)
6810

PH9
Vladimír Jindřich Bufka
From the Košíře Garden (Z Košířské zahrady), 1914
Color gum bichromate
11⅛ x 8¼ (28.3 x 21.0)
Moravská galerie v Brně (Moravian Gallery, Brno)
6811

PH10
Josef Dašek
Cube and Egg (Krychle a vejce), 1927–28
Rotogravure
5¼ x 5⅞ (13.4 x 14.9)
Private collection

PH11
František Drtikol
Still Life (Zátiší), 1901–1907
Bromoil(?)
2⅞ x 4⅛ (7.3 x 10.5)
The Museum of Fine Arts, Houston, museum purchase with funds provided by an anonymous donor
86.390.1

PH12
Drtikol & Spol
(František Drtikol and Augustín Škarda)
Untitled, plate 15 from the portfolio *From the Courtyards of Old Prague (Z dvorů a dvorečků staré Prahy XV)*, 1911
Bromoil
8⅝ x 5⅛ (22.0 x 13.0)
Uměleckoprůmyslové muzeum v Praze (Museum of Decorative Arts, Prague)
G-1886 A/15

PH13
Drtikol & Spol
(František Drtikol and Augustín Škarda)
Untitled, plate 25 from the portfolio *From the Courtyards of Old Prague (Z dvorů a dvorečků staré Prahy XXV)*, 1911
Bromoil
8⅝ x 5⅞ (22.0 x 15.0)
Uměleckoprůmyslové muzeum v Praze (Museum of Decorative Arts, Prague)
G-1886 A/25

PH14
Drtikol & Spol
(František Drtikol and Augustín Škarda)
Self-portrait as Christ (Autoportrét jako Kristus), 1914
Bromoil
9¹¹⁄₁₆ x 11⅞ (24.5 x 30.3)
The Museum of Fine Arts, Houston, museum purchase with funds provided by the Photography Accessions Sub-Committee in honor of the wedding of Anne Tucker and Joe Wheeler
85.305

PH15
František Drtikol
Worker (*Dělník*; Portrait of Jaroslav Rössler),
1924
Pigment
11⁷⁄₁₆ x 9¼ (29.1 x 23.5)
The Museum of Fine Arts, Houston, the Sonia and
Kaye Marvins Portrait Collection
85.219

PH16
František Drtikol
Still Life (*Zátiší; La Nature morte*), 1925
Pigment
9⅜ x 8¹³⁄₁₆ (23.8 x 22.4)
Société Française de Photographie, Paris
698.26

PH17
František Drtikol
Untitled: torso, c. 1925
10½ x 8⅛ (26.7 x 20.8)
Moravská galerie v Brně (Moravian Gallery, Brno)
6960

PH18
František Drtikol
The Wave (*Vlna*), 1927
5⅝ x 11⁷⁄₁₆ (14.3 x 29.0)
Collection Thomas Walther, New York

PH19
František Drtikol
Composition (*Kompozice*), 1928
10⅞ x 8⅞ (27.6 x 22.7)
Collection Thomas Walther, New York

PH20
František Drtikol
Prayer (*Modlitba; La Prière*), 1928
Pigment
11³⁄₁₆ x 8¹¹⁄₁₆ (28.4 x 22.1)
International Museum of Photography at
George Eastman House
72:046:2

PH21
František Drtikol
Luminous Nude (*Světelný akt*), c. 1928
11¹³⁄₁₆ x 9⅜ (30.0 x 23.8)
Uměleckoprůmyslové muzeum v Praze (Museum
of Decorative Arts, Prague)
30/7

PH22
František Drtikol
Untitled, c. 1930
Pigment
8⅝ x 11⅛ (22.0 x 28.3)
Private collection

PH23
Jaromír Funke
Kolín: Page from an Album (*Kolín:
Stránka z alba*), 1921
1⁹⁄₁₆ x 2³⁄₁₆ (4.0 x 5.5) each; 8⅝ x 12⅜ (22.0 x
31.5) overall
Collection family of the artist

PH24
Jaromír Funke
Composition (*Kompozice*), 1923
8⅝ x 11⁹⁄₁₆ (21.1 x 29.4)
The Museum of Fine Arts, Houston, museum pur-
chase with funds provided by the Bernstein Devel-
opment Foundation
84.95

PH25
Jaromír Funke
Composition: White Ball and Glass Cube (*Kom-
pozice. Bílý míč a skleněná krychle*), 1923
9³⁄₁₆ x 11⅝ (23.3 x 29.5)
Collection family of the artist

PH26
Jaromír Funke
Untitled, c. 1923–24
8½ x 11⁷⁄₁₆ (21.5 x 29.0)
Collection Thomas Walther, New York

PH27
Jaromír Funke
Staircase of Old Prague (*Na staropražském
schodišti*), 1924
9 x 8¼ (22.8 x 21)
The Museum of Fine Arts, Houston, museum pur-
chase with funds provided by Isabell and Max
Herzstein
84.94

PH28
Jaromír Funke
Composition (*Kompozice*), 1924
8½ x 11⅝ (21.5 x 29.5)
Collection Thomas Walther, New York

PH29
Jaromír Funke
Portrait: After the Carnival (*Portrét. Po
karnevalu*), 1924
9⁵⁄₁₆ x 7¹¹⁄₁₆ (23.7 x 19.5)
Collection Kicken-Pauseback Galerie, Cologne

PH30
Jaromír Funke
Spiral (*Spirála*), 1924
9 x 10⅜ (22.8 x 26.4)
Moravská galerie v Brně (Moravian Gallery, Brno)
9306

PH31
Jaromír Funke
Scrap Iron (*Staré železo*), 1925
13 x 11¾ (33.0 x 29.8)
Moravská galerie v Brně (Moravian Gallery, Brno)
5222

PH32
Jaromír Funke
Photogram (*Fotogram*), 1926
15¾ x 11¾ (40.0 x 29.8)
Moravská galerie v Brně (Moravian Gallery, Brno)
9397

PH33
Jaromír Funke
Photogram (*Fotogram*), 1926
15⅝ x 11⁹⁄₁₆ (39.5 x 29.4)
Moravská galerie v Brně (Moravian Gallery, Brno)
5239

PH34
Jaromír Funke
Nude (*Akt*), 1927
15⁹⁄₁₆ x 11¹¹⁄₁₆ (39.5 x 29.7)
Moravská galerie v Brně (Moravian Gallery, Brno)
3607

PH35
Jaromír Funke
Composition (*Kompozice*), c. 1927–29
8⁹⁄₁₆ x 11⁷⁄₁₆ (21.8 x 29.0)
Collection family of the artist

PH36
Jaromír Funke
Composition (*Kompozice*), 1927–29
11⁹⁄₁₆ x 14⅝ (29.3 x 37.2)
Uměleckoprůmyslové muzeum v Praze (Museum
of Decorative Arts, Prague)
GF-1770

PH37
Jaromír Funke
Face (*Tvář*), from the series *Glass and Ordinary
Things* (*Věci skleněné a obyčejné*), 1928
14³⁄₁₆ x 11⅝ (36.0 x 29.6)
Moravská galerie v Brně (Moravian Gallery, Brno)
9305

PH38
Jaromír Funke
Reflections (*Reflexy*), from the series *Glass and
Reflection* (*Sklo a odraz*), c. 1929
11⅜ x 15³⁄₁₆ (28.9 x 38.5)
Moravská galerie v Brně (Moravian Gallery, Brno)
2051

PH39
Jaromír Funke
Untitled, c. 1930
19³⁄₁₆ x 15⅝ (48.7 x 39.7)
Moravská galerie v Brně (Moravian Gallery, Brno)
2050

PH40
Jaromír Funke
Factory (*Fabrika*), from the series *My Kolín*
(*Můj Kolín*), 1932
11 x 10⅞ (28.0 x 27.7)
San Francisco Museum of Modern Art, Mrs. Ferdi-
nand C. Smith Fund purchase
80.7

PH41
Jaromír Funke
Untitled, from the series *Time Persists* (*Čas trvá,
1930–34*), 1932
15¼ x 11³⁄₁₆ (38.8 x 28.4)
The Museum of Fine Arts, Houston, museum pur-
chase with funds provided by an anonymous
donor
83.121

PH42
Alexander Hackenschmied
American, born Czechoslovakia
Advertising Photograph (*Reklamní fotografie*),
1930
Photogravure
6⅞ x 5¹¹⁄₁₆ (17.5 x 14.4); published in *Photographic
Horizon* (*Fotografický obzor*), January 1931
Private collection

PH43
Alexander Hackenschmied
American, born Czechoslovakia
La Madeleine, 1939
8⅜ x 6¹¹⁄₁₆ (21.2 x 17.0)
Museum Folkwang, Essen
204 / 1 (Houston only)

PH44
Karel Hájek
Untitled, 1927
6½ x 4¾ (16.5 x 12.1)
San Francisco Museum of Modern Art, Fund of
the 80s Purchase
85.118

PH45
Karel Hájek
Untitled, 1930s
9½ x 3⅝ (24.2 x 9.2)
Private collection

PH46
Karel Hájek
Students Demonstrating Against Fascism (*Studenti demonstrující proti fašismu*), 1936
11¹³⁄₁₆ x 15¾ (30.0 x 40.0)
Private collection

PH47
Miroslav Hák
Mask (*Maska*), 1933
11¹³⁄₁₆ x 9⁷⁄₁₆ (30.0 x 24.0)
Bibliothèque Nationale, Paris
18876

PH48
Miroslav Hák
Mask—Beetle (*Maska—Brouk*), 1935
15³⁄₁₆ x 11⅜ (38.5 x 28.9), printed c. 1970
Moravská galerie v Brně (Moravian Gallery, Brno)
5715

PH49
Miroslav Hák
Day and Night (*Den a noc*), 1935
11¼ x 8¹⁵⁄₁₆ (28.6 x 22.7)
Moravská galerie v Brně (Moravian Gallery, Brno)
5730

PH50
Miroslav Hák
A Rainy Day (*Deštivý den*), 1936
11¹³⁄₁₆ x 9⁷⁄₁₆ (30.0 x 24.0)
Bibliothèque Nationale, Paris
18876

PH51
Miroslav Hák
Strukáž, I, 1936
7 x 9¹⁵⁄₁₆ (17.7 x 25.2)
Bibliothèque Nationale, Paris
18876

PH52
Miroslav Hák
Billboard (*Vývěsní tabule*), 1938
11⅝ x 15⁹⁄₁₆ (29.5 x 39.6)
Moravská galerie v Brně (Moravian Gallery, Brno)
5709

PH53
Jindřich Hatlák
Illusion (*Iluse*), c. 1934
13¾ x 6⅞ (35 x 17.5)
Private collection

PH54
Jaroslava Hatláková
Untitled, 1935
4⅜ x 3¼ (11.2 x 8.2)
Kicken-Pauseback Galerie, Cologne

PH55
Jaroslava Hatláková
Untitled, 1936
9¼ x 7 (23.5 x 17.8)
Kicken-Pauseback Galerie, Cologne

PH56
Josef Hausenblas
Eiffel Tower (*Eiffelova věž*), 1928
Photomontage: photogravure and ink
15⁹⁄₁₆ x 6⅞ (39.5 x 17.5); published in *ReD*, no. 9,
1929
Private collection

PH57
Václav Jírů
Self-portrait (*Autoportrét*, as a woman), 1926
5⅛ x 9¹⁄₁₆ (13.0 x 23.0)
Private collection

PH58
Václav Jírů
Untitled, c. 1935
6⅝ x 9⅛ (16.9 x 23.2)
The Museum of Fine Arts, Houston, museum purchase with funds provided by Mr. and Mrs. Harry
B. Gordon
81.111

PH59
Karel Kašpařík
Why? (*Proč?*), c. 1935
15³⁄₁₆ x 11⅜ (38.5 x 28.9)
Moravská galerie v Brně (Moravian Gallery, Brno)
9584

PH60
Karel Kašpařík
From the Depths (*Z hlubiny*), before 1936
14⅜ x 10⅞ (36.6 x 27.6)
Moravská galerie v Brně (Moravian Gallery, Brno)
9588

PH61
Jiří Kroha
Senses (*Smysly*), from *Sociological Fragment of
Housing* (*Sociologický fragment bydlení*), 1932–33
Collage
27⁹⁄₁₆ x 39 (70.0 x 99.0)
Muzeum města Brna (Museum of City of Brno,
Špilberk)
I.C.261.889

PH62
Jiří Kroha
Clothes without People (*Šaty bez lidí*), from *Sociological Fragment of Housing* (*Sociologický fragment bydlení*), 1932–33
Collage
27⁹⁄₁₆ x 39 (70.0 x 99.0)
Muzeum města Brna (Museum of City of Brno,
Špilberk)
I.C.261.887

PH63
Jiří Kroha
Diseases and their Environment (*Nemoce a jejich
prostředí*), from *Sociological Fragment of Housing*
(*Sociologický fragment bydlení*), 1932–33
Collage
27⁹⁄₁₆ x 39 (70.0 x 99.0)
Muzeum města Brna (Museum of City of Brno,
Špilberk)
I.C.261.893

PH64
Jan Lauschmann
Castle Staircase (*Hradní schůdky*), 1927
11¹¹⁄₁₆ x 11⅝ (29.7 x 29.5)
Uměleckoprůmyslové muzeum v Praze (Museum
of Decorative Arts, Prague)
GF-296

PH65
Jan Lauschmann
Holiday Evening: At Barrandov (*Sváteční večer.
Na Barrandově*), 1932
13⁷⁄₁₆ x 12⅛ (34.2 x 30.8)
Uměleckoprůmyslové muzeum v Praze (Museum
of Decorative Arts, Prague)
GF-1214

PH66
Jiří Lehovec
Façade, Paris (*Průčelí, Paříž*, also called *Luxe à
louer* [*Luxury for Rent*], *Paris*), 1932
8¾ x 11 (22.2 x 28.0)
Uměleckoprůmyslové muzeum v Praze (Museum
of Decorative Arts, Prague)
GF-2619

PH67
Jiří Lehovec
Untitled, 1933
Collage of gelatin silver, halftone, and graphite
8⅞ x 5¾ (22.5 x 14.6); design for cover of *Exhibition of Social Photography* (*Výstava sociální
fotografie*) catalogue
Private collection

PH68
Otakar Lenhart
Self-portrait (*Autoportrét*), 1935
Photo-photogram
11¹³⁄₁₆ x 9⅜ (30.0 x 23.9)
Moravská galerie v Brně (Moravian Gallery, Brno)
9556

PH69
Otakar Lenhart
Nude (*Akt*), 1936
15½ x 11⅛ (39.3 x 28.3)
Moravská galerie v Brně (Moravian Gallery, Brno)
9558

PH70
Otakar Lenhart
Print (*Tisk*), 1939
Photogram
14⅝ x 11 (37.1 x 28.0)
Moravská galerie v Brně (Moravian Gallery, Brno)
9551

PH71
Jan Lukas
American, born Czechoslovakia
Untitled, 1936
6⅜ x 5¼ (18.0 x 13.0)
Private collection

PH72
Jan Lukas
American, born Czechoslovakia
Before the Transport (*Před transportem*), 1942
10⁷⁄₁₆ x 8¹⁵⁄₁₆ (26.5 x 22.6)
Collection Debbie Friedman

PH73
Evžen Markalous
Untitled, c. 1928
Photomontage
17¾ x 12⅞ (45.0 x 32.7)
Museum Folkwang, Essen
96a/2 (Houston only)

PH74
Alfons Mucha
Untitled: man and woman, c. 1900
4¾ x 3⁵⁄₁₆ (12.0 x 8.5)
Uměleckoprůmyslové muzeum v Praze (Museum
of Decorative Arts, Prague)
GF-1196

PH75
Alfons Mucha
Seated Model (*Sedící model*), c. 1900
4½ x 3⅜ (11.5 x 8.5)
Uměleckoprůmyslové muzeum v Praze (Museum
of Decorative Arts, Prague)
GF-1191

PH76
Bohumil Němec
Torso II (*Torzo II*), 1933–34
Photomontage
11¹¹⁄₁₆ x 7⅞ (29.7 x 20.0)
Moravská galerie v Brně (Moravian Gallery, Brno)
8911

PH77
Bohumil Němec
Experiment, 1936
Solarized and chemically altered
5⅛ x 4½ (13.0 x 11.5)
Private collection

PH78
Bohumil Němec
Advertising Photograph (*Reklamní fotografie*),
before 1940
15³⁄₁₆ x 11⁷⁄₁₆ (38.5 x 29.0)
Moravská galerie v Brně (Moravian Gallery, Brno)
8913

PH79
Jaroslav Nohel
Grapes (*Hrozny*), 1934
9 x 11³⁄₁₆ (22.9 x 28.5)
Moravská galerie v Brně (Moravian Gallery, Brno)
9531

PH80
Jaroslav Nohel
Self-portrait (*Autoportrét*), 1935
Solarized "photorelief" process
10⁷⁄₁₆ x 7½ (26.5 x 19.0)
Moravská galerie v Brně (Moravian Gallery, Brno)
9529

PH81
Jaroslav Nohel
Untitled, c. 1935
12⅝ x 9⅛ (32.1 x 23.1)
Moravská galerie v Brně (Moravian Gallery, Brno)
9539

PH82
Oldřich Nouza
Untitled, 1932
1⅝ x 2 (4.1 x 5.0), 2¾ x 2⅛ (7.0 x 5.4), 2¾ x 2
(7.0 x 5.1), and 2¾ x 1⅝ (6.9 x 4.1)
Moravská galerie v Brně (Moravian Gallery, Brno)
A2084, A2087, A2085, and A2086

PH83
Oldřich Nouza
Self-portrait (*Autoportrét*), c. 1932
2¾ x 2 (7.0 x 5.0)
Collection Zuzana Kopecká, Prague

PH84ab
Ada Novák
The Painter Jakub Bauerfreund (*Malíř Jakub
Bauerfreund*), 1932
Diptych; 11½ x 8¼ (29.2 x 21.0) each
Private collection

PH85ab
Ada Novák
Untitled: portrait, 1932
Diptych; 11⅜ x 8½ (29.0 x 21.6) each
Private collection

PH86
Ada Novák
Nude (*Akt*), 1933
15⁹⁄₁₆ x 11⅝ (39.6 x 29.5)
Moravská galerie v Brně (Moravian Gallery, Brno)
9935

PH87
Ada Novák
Photo, 1934
15⅝ x 11⁵⁄₁₆ (39.7 x 28.7), printed 1970s
Moravská galerie v Brně (Moravian Gallery, Brno)
9941

PH88
Students of Karel Novák (Státní grafická škola)
Untitled, c. 1930
14⅜ x 12⁵⁄₁₆ (36.4 x 31.2)
Uměleckoprůmyslové muzeum v Praze (Museum
of Decorative Arts, Prague)
GF-123/3

PH89
Students of Karel Novák (Státní grafická škola)
Untitled, c. 1930
10⅞ x 7¼ (27.5 x 18.4)
Uměleckoprůmyslové muzeum v Praze (Museum
of Decorative Arts, Prague)
GF-123/2

PH90
Josef Podrábský
Untitled, 1936
Collage: rotogravure and map
17⅜ x 11⅞ (44.2 x 30.1)
Private collection

PH91
František Povolný
Untitled: self-portrait, 1933–34
11⅛ x 13¾ (28.2 x 35.0)
Moravská galerie v Brně (Moravian Gallery, Brno)
8864

PH92
František Povolný
Shadow (*Stín*), 1933–34
14¹³⁄₁₆ x 10¹⁵⁄₁₆ (37.6 x 27.8)
Moravská galerie v Brně (Moravian Gallery, Brno)
8868

PH93
František Povolný
Photography (*Fotografika*), 1933–34
11 x 14¹⁵⁄₁₆ (27.9 x 37.9)
Moravská galerie v Brně (Moravian Gallery, Brno)
8877

PH94
Vojtěch Preissig
Untitled, c. 1900
Printing-out paper
6¹⁵⁄₁₆ x 5⅛ (17.7 x 13.0)
Private collection, Prague

PH95
Vojtěch Preissig
Untitled, c. 1900
Printing-out paper
5⅛ x 7 (13.0 x 17.8)
Private collection, Prague

PH96
Jaroslav Puchmertl
Robur, the Conqueror (*Robur dobyvatel*), 1940
Rephotographed collage
12 x 8⁹⁄₁₆ (30.5 x 21.8), modern print
The Museum of Fine Arts, Houston, museum pur-
chase with funds provided by Anne W. Tucker in
honor of František Šmejkal
89.26

PH97
Jaroslav Puchmertl
Such an End (*Takový konec*), 1944
Rephotographed collage
12 x 15¾ (30.5 x 40); modern print
The Museum of Fine Arts, Houston, museum pur-
chase with funds provided by Alison de Lima
Greene in honor of František Šmejkal
88.327

PH98
Vilém Reichmann
From the Workshop of Adolf Loos senior (*Z dílny
Adolfa Loosa sen.*), from the series *Abandoned
One* (*Opuštěná*), 1938
15⅜ x 10¹³⁄₁₆ (39.0 x 27.5), printed 1960s
Moravská galerie v Brně (Moravian Gallery, Brno)
2114

PH99
Vilém Reichmann
Abandoned One (*Opuštěná*), 1941
15⅜ x 11¹³⁄₁₆ (39.1 x 30.0), printed 1970s
Moravská galerie v Brně (Moravian Gallery, Brno)
9855

PH100
Jaroslav Rössler
Untitled: skylight, 1922
15¾ x 11⅛ (40.0 x 28.3)
Uměleckoprůmyslové muzeum v Praze (Museum
of Decorative Arts, Prague)
GF-142

PH101
Jaroslav Rössler
Untitled: composition with radio tube, 1922
Pigment
8½ x 8⁷⁄₁₆ (21.5 x 21.8)
Uměleckoprůmyslové muzeum v Praze (Museum
of Decorative Arts, Prague)
GF-143

PH102
Jaroslav Rössler
Untitled, 1922
8⅞ x 9½ (23.1 x 24.1)
Collection Marjorie and Leonard Vernon
R-1

PH103
Jaroslav Rössler
Untitled: abstraction, 1922
15¼ x 11⁷⁄₁₆ (38.7 x 29.0), modern print
Bibliothèque Nationale, Paris
D 21426

PH104
Jaroslav Rössler
Petřín Tower (*Petřínská věž*), 1922–23
9 x 9¼ (22.9 x 23.5)
Collection Marjorie and Leonard Vernon
R-4

PH105
Jaroslav Rössler
Photograph I (Fotografie I), 1923
Collage: gelatin silver and black paper
11⁵⁄₁₆ x 9⅝ (28.8 x 24.4), printed and assembled
1925
Uměleckoprůmyslové muzeum v Praze (Museum
of Decorative Arts, Prague)
GF-4459

PH106
Jaroslav Rössler
Untitled, 1923
8⅛ x 8 (20.7 x 20.4)
Collection Marjorie and Leonard Vernon
R-15

PH107
Jaroslav Rössler
Radio, 1923–24
Photomontage
9⅛ x 8 (23.2 x 20.4)
Prakapas Gallery, New York

PH108
Jaroslav Rössler
Untitled, c. 1924
Photomontage rephotographed with pencil
drawing
9½ x 8¹⁵⁄₁₆ (24.2 x 22.7)
Collection Thomas Walther, New York

PH109
Jaroslav Rössler
Paris: Marconi Radio, 1926
Collage: halftone, letterpress, and black paper
7⅞ x 6½ (20.0 x 16.5)
Uměleckoprůmyslové muzeum v Praze (Museum
of Decorative Arts, Prague)
GF-4468

PH110
Jaroslav Rössler
Unlife, 1926
Collage, halftone and ink
8⅜ x 8¼ (21.7 x 21.0)
Private collection

PH111
Jaroslav Rössler
Untitled: abstraction, 1926(?)
Stencil print
5 x 4 (12.7 x 10.2)
The J. Paul Getty Museum
84.GG.1613.1

PH112
Jaroslav Rössler
Self-portrait, Paris (Autoportrét), 1931
8⅝ x 8⁵⁄₁₆ (21.8 x 21.1)
New Orleans Museum of Art, museum purchase
79.148

PH113
Jaroslav Rössler
Paris, 1932
11 x 9 (28.4 x 23.0)
Collection Marjorie and Leonard Vernon
R-8

PH114
Marie Rossmannová
Toy (Hračka), 1935
15⅜ x 11³⁄₁₆ (39.0 x 28.4), printed 1978 by
K. Čejka
Moravská galerie v Brně (Moravian Gallery, Brno)
8640

PH115
Marie Rossmannová
Untitled, c. 1935
15⁹⁄₁₆ x 11⅝ (39.5 x 29.5)
Private collection

PH116
Drahomír Josef Růžička
American, born Bohemia
The Struggle for Life, California (Boj o život), 1918
11½ x 13½ (29.2 x 34.3)
Kicken-Pauseback Galerie, Cologne

PH117
Drahomír Josef Růžička
American, born Bohemia
Penn Station (Pensylvánské nádraží), before 1932
11⅞ x 9⅞ (30.1 x 25.0)
Moravská galerie v Brně (Moravian Gallery, Brno)
7992

PH118
Adolf Schneeberger
Close-up of Tree (Detail stromu—Udine), 1926
9 x 10¹⁵⁄₁₆ (22.9 x 27.7)
Moravská galerie v Brně (Moravian Gallery, Brno)
7607

PH119
Adolf Schneeberger
*Photographic Ornament: Portrait of L. Pikart
(Fotografický ornament. Portrét L. Pikarta)*, 1926
10¹⁵⁄₁₆ x 8⅝ (27.8 x 22.0)
Moravská galerie v Brně (Moravian Gallery, Brno)
6842

PH120
Adolf Schneeberger
*Compositional Study: Legs (Kompoziční studie.
Nohy)*, 1927
11⅜ x 8⅞ (28.9 x 22.6)
San Francisco Museum of Modern Art, Mrs. Ferdi-
nand C. Smith Fund purchase
80.2

PH121
Adolf Schneeberger
Spool Composition (Kompozice s cívkami), c. 1930
9½ x 8¾ (24.1 x 22.2)
The Saint Louis Art Museum, purchase, Museum
Shop Fund
102:1982

PH122
Adolf Schneeberger
*Poster for ČKFA exhibition in Prague (Plakát
výstavy ČKFA v Praze)*, 1931
Gelatin silver with stenciled airbrush lettering
11¹¹⁄₁₆ x 9⁵⁄₁₆ (29.6 x 23.6)
Moravská galerie v Brně (Moravian Gallery, Brno)
7605

PH123
Adolf Schneeberger
Untitled: amusement park, c. 1934
7⁵⁄₁₆ x 5 (18.6 x 12.7)
San Francisco Museum of Modern Art, purchase
84.53

PH124
Bohumil Šťastný
*Advertising Photograph of Safety Pins (Reklamní
fotografie spínadel)*, 1934
11⅝ x 15½ (29.5 x 39.3)
Moravská galerie v Brně (Moravian Gallery, Brno)
9975

PH125
Bohumil Šťastný
*Advertising Photograph: Drawing Pins, Scissors
(Reklamní fotografie. Připínáčky, nůžky)*, c. 1934
15⅝ x 11⁷⁄₁₆ (39.6 x 29.0)
Moravská galerie v Brně (Moravian Gallery, Brno)
9977

PH126
Jindřich Štyrský
Souvenir, 1924
Collage: halftone, letterpress, watercolor, and ink
9⁷⁄₁₆ x 11¹³⁄₁₆ (24.0 x 30.0)
Národní galerie v Praze (National Gallery,
Prague)
K-40718

PH127
Jindřich Štyrský
Toyen
*How I Did Find Livingston (Jak jsem našel
Livingstona)*, 1925
Collage
11¹³⁄₁₆ x 15¾ (30.0 x 40.0)
Collection Jan Halas, Prague

PH128
Jindřich Štyrský
Untitled, 1930
Ten photomontages in loose bound book format
for *Emilie Comes to Me in a Dream* (*Emilie
přichází ke mně ve snu*), 1933
7⅞ x 5⅛ (20.0 x 13.0) overall
Prakapas Gallery, New York

PH129
Jindřich Štyrský
Man with Blinders (*Muž s klapkami na očích*),
plate XVII from the book *On the Needles of These
Days* (*Na jehlách těchto dní*), published 1941,
1934
12½ x 11¼ (31.8 x 28.6)
Uměleckoprůmyslové muzeum v Praze (Museum
of Decorative Arts, Prague)
GF-1715

PH130
Jindřich Štyrský
Untitled, 1934–35
Seven contact prints on one sheet
2⅜ x 2⅜ (6.0 x 6.0) each; five reproduced in *On
the Needles of These Days* (*Na jehlách těchto dní*)
Uměleckoprůmyslové muzeum v Praze (Museum
of Decorative Arts, Prague)
1633-39

PH131
Jindřich Štyrský
Untitled, plate VII from the book *On the Needles
of These Days* (*Na jehlách těchto dní*), published
1941, 1934–35
12½ x 11¹³⁄₁₆ (31.8 x 28.4)
Uměleckoprůmyslové muzeum v Praze (Museum
of Decorative Arts, Prague)
GF-4709

PH132
Jindřich Štyrský
Untitled, plate XV from the book *On the Needles
of These Days* (*Na jehlách těchto dní*), published
1941, 1934–35
9³⁄₁₆ x 9½ (23.3 x 24.2)
Museum Folkwang, Essen
2859/84

PH133
Jindřich Štyrský
Untitled, plate XI from the book *On the Needles of
These Days* (*Na jehlách těchto dní*), published
1941, 1934–35
11¾ x 11³⁄₁₆ (29.8 x 28.4)
Uměleckoprůmyslové muzeum v Praze (Museum
of Decorative Arts, Prague)
GF-4704

PH134
Jindřich Štyrský
Paris Afternoon (*Pařížské odpoledne*), 1935
15¾ x 11¹³⁄₁₆ (40.0 x 30.0)
Národní galerie v Praze (National Gallery,
Prague)
K-56890

PH135
Josef Sudek
Untitled: man in a quarry, c. 1918–22
Gum bichromate/pigment
4 x 5 (10.2 x 12.7)
Gilman Paper Company Collection
PH81.739

PH136
Josef Sudek
Architectural Detail (*Architektonický detail*),
1924–28
10⅞ x 9³⁄₁₆ (27.7 x 23.3)
Moravská galerie v Brně (Moravian Gallery, Brno)
7679

PH137
Josef Sudek
From Hlávka's Bridge (*Z Hlávkova mostu*),
1924–29
10⅞ x 9⁵⁄₁₆ (27.7 x 23.6)
Moravská galerie v Brně (Moravian Gallery, Brno)
5688

PH138
Josef Sudek
On the Table (*Na stole*) for Cooperative Work
(*Družstevní práce*), 1930
15⅜ x 10¼ (39.0 x 26.0)
Uměleckoprůmyslové muzeum v Praze (Museum
of Decorative Arts, Prague)
GF-1549

PH139
Josef Sudek
Ladislav Sutnar China (*Sutnarův porcelánový
soubor*) for Cooperative Work (*Družstevní práce*),
c. 1930
6¾ x 9 (17.2 x 22.9)
Collection Robert Miller Gallery, New York
1180.36

PH140
Josef Sudek
Steel and Glass (*Kov a sklo*), 1930
11⁷⁄₁₆ x 9¼ (29.0 x 23.5), published in *Studio*
(Prague), 1930–31, p. 254
Uměleckoprůmyslové muzeum v Praze (Museum
of Decorative Arts, Prague)
p.p.1467

PH141
Josef Sudek
Apple on Tray (*Jablko na podnosu*), 1932
11¹¹⁄₁₆ x 9⅜ (29.7 x 23.8), printed before 1976
Moravská galerie v Brně (Moravian Gallery, Brno)
8423

PH142
Josef Sudek
The Coming of Autumn (*Vzpomínka podzimní*),
1932
9⅜ x 6½ (23.8 x 16.5)
Collection Sonja Bullaty and Angelo Lomeo

PH143
Josef Sudek
Gramophone discs (*Gramofonové desky*), 1934
15⁷⁄₁₆ x 11¼ (39.2 x 28.6)
International Museum of Photography at George
Eastman House
73:124:7

PH144
Josef Sudek
The Third Courtyard of the Castle, Prague (*Třetí
nádvoří Pražského hradu*), 1936
15¹⁄₁₆ x 11⅝ (38.3 x 29.5)
Museum of Fine Arts, Boston, Sophie M. Fried-
man Fund, 1984.90 (New York only)

PH145
Josef Sudek
Hydrangea Leaves (*Listy hortenzie*), 1940
Transfer pigment
6¼ x 4½ (15.9 x 11.5)
The J. Paul Getty Museum
84.XM.149.53

PH146
Josef Sudek
From the Window of My Studio (*Z okna mého
ateliéru*), 1940–45
9⅜ x 6¼ (23.3 x 16)
Collection Sonja Bullaty and Angelo Lomeo

PH147
Hugo Táborský
Self-portrait I (*Autoportrét I*), 1933
5¼ x 3⁵⁄₁₆ (13.4 x 8.4)
Moravská galerie v Brně (Moravian Gallery, Brno)
9609

PH148
Hugo Táborský
Self-portrait II (*Autoportrét II*), 1933
5¼ x 3⁵⁄₁₆ (13.4 x 8.4)
Moravská galerie v Brně (Moravian Gallery, Brno)
9610

PH149
Hugo Táborský
Self-portrait III (*Autoportrét III*), 1933
5¼ x 3⅜ (13.4 x 8.5)
Moravská galerie v Brně (Moravian Gallery, Brno)
9611

PH150
Hugo Táborský
Double Self-portrait (*Dvojportrét*), 1935
5¼ x 3⁵⁄₁₆ (13.4 x 8.4)
Moravská galerie v Brně (Moravian Gallery, Brno)
9608

PH151
Hugo Táborský
Answers (*Odpovědi*), 1935
Photogram and montage
7¹⁄₁₆ x 5¹⁄₁₆ (17.9 x 12.9)
Moravská galerie v Brně (Moravian Gallery, Brno)
9606

PH152
Karel Teige
Life: An Anthology of the New Beauty (*Život.
Sborník nové krásy*), 1922
Letterpress book with halftone reproductions
(photomontage book cover by K. Teige, J. Krejcar,
J. Šíma, and B. Feurstein; edited by J. Krejcar)
(Prague: Umělecká Beseda, vol. 2, 1922; 214 pp.)
10¹⁄₁₆ x 7¼ (25.5 x 18.5)
From the Collection of the J. Paul Getty Center for
the History of the Arts and the Humanities

PH153
Karel Teige
The Departure for Cythera (*Odjezd na Cytheru*),
1923
Collage: halftone, watercolor, ink, and graphite
10½ x 8¾ (26.7 x 22.2)
Galerie hlavního města Prahy (Gallery of the City
of Prague)
K-2516

PH154
Karel Teige
Travel Postcard (*Pozdrav z cesty*), 1923
Collage: halftone, letterpress, tempera, and ink
12¹³⁄₁₆ x 9⅝ (32.5 x 24.5)
Galerie hlavního města Prahy (Gallery of the City of Prague)
K-2515

PH155
Karel Teige
Film, 1925
Letterpress book with halftone reproductions, Prague: Václav Petr
7½ x 5½ (19.0 x 14.0); 132 pp.
Private collection

PH156
Karel Teige
Karel Paspa
Vítězslav Nezval
The Alphabet: Choreographic compositions by Milča Majerová (*Abeceda. Taneční komposice; Milča Majerová*), 1926
Letterpress book (designed by Teige, halftone reproductions of photographs by Paspa, poems by Vítězslav Nezval; Prague: Česká grafická unie
11¹³⁄₁₆ x 9³⁄₁₆ [30.0 x 23.3]; 60 pp.)
Private collection

PH157
Karel Teige
Jaroslav Rössler
Review of Devětsil: Monthly of Modern Culture (*ReD. Měsíčník pro moderní kulturu*), 1928
Letterpress magazine (designed by Teige, photographs, photomontages by Rössler; Prague: Odeon, vol. 1, no. 1)
9¼ x 7¼ (23.5 x 18.4); 32 pp.
Ex Libris Books, New York

PH158
Karel Teige
Untitled, 1936
Collage: halftone
9⁷⁄₁₆ x 7⁵⁄₁₆ (24.0 x 18.5)
Památník národního písemnictví (The National Museum of Literature), Prague
77/72-225

PH159
Karel Teige
Untitled, 1937
Collage: halftone, letterpress, and rotogravure
16½ x 11¼ (42.0 x 28.5)
Památník národního písemnictví (The National Museum of Literature), Prague
77/72-212

PH160
Karel Teige
Untitled, 1939
Collage: halftone, letterpress, and rotogravure with slight hand-coloring
9¹⁄₁₆ x 7¹⁄₁₆ (23.0 x 18.0)
Památník národního písemnictví (The National Museum of Literature), Prague
77/72-276

PH161
Karel Teige
Untitled, 1940
Collage: halftone, letterpress, and rotogravure
10⁷⁄₁₆ x 9³⁄₁₆ (26.5 x 23.4)
Památník národního písemnictví (The National Museum of Literature), Prague
77/72-320

PH162
Karel Teige
Untitled, 1942
Collage: rotogravure
6⅝ x 5 (16.8 x 12.8)
Památník národního písemnictví (The National Museum of Literature), Prague
77/72-379

PH163
Karel Teige
Untitled, 1942
Collage: halftone and rotogravure
8³⁄₁₆ x 6¹⁄₁₆ (20.8 x 15.4)
Památník národního písemnictví (The National Museum of Literature), Prague
77/72-384

PH164
Karel Teige
Untitled, 1943
Collage: halftone, letterpress, ink, and graphite
11¼ x 7½ (28.5 x 19.0)
Památník národního písemnictví (The National Museum of Literature), Prague
77/72-415

PH165
Toyen
Jindřich Heisler
From the Dungeons of Sleep (*Z kasemat spánku*), 1941
Book, with slipcase; eight gelatin silver prints
6⅛ x 5⁵⁄₁₆ (15.5 x 13.5) overall
Collection Radovan Ivsic and Annie Le Brun, Paris

PH166
Josef Váchal
Self-portrait with Palette (*Autoportrét s paletou*), c. 1905
4⅝ x 3½ (11.8 x 9), printed 1984 by Miloš Šejn
Moravská galerie v Brně (Moravian Gallery, Brno)
11.994

PH167
Josef Váchal
Self-portrait as Christ Crucified (*Autoportrét jako Kristus. Ukřižovaný*), c. 1906
6¹⁵⁄₁₆ x 9⅜ (17.6 x 23.9), printed 1980 by Miloš Šejn
Moravská galerie v Brně (Moravian Gallery, Brno)
11.984

PH168ab
Karel Valter
Double Image—Forms (*Dvojobraz—tvary*), 1931
Diptych; 6⅝ x 4⅝ (16.8 x 11.8) and 6⅞ x 4¹⁵⁄₁₆ (17.5 x 12.5)
Moravská galerie v Brně (Moravian Gallery, Brno)
10.281 and private collection

PH169
Karel Valter
Dissolve—Sportsman (*Prolínání—sportovec*), 1931
5¹⁄₁₆ x 7 (12.9 x 17.7)
Moravská galerie v Brně (Moravian Gallery, Brno)
10.276

PH170
Karel Valter
Dissolve—Schoolboy (*Prolínání—školák*), 1931
5¹⁄₁₆ x 7¹⁄₁₆ (12.9 x 17.9)
Moravská galerie v Brně (Moravian Gallery, Brno)
10.277

PH171
Karel Valter
Double Image—Snow (*Dvojobraz—sníh*), 1931
6⁵⁄₁₆ x 5 (16.1 x 12.8) each, printed 1980
Moravská galerie v Brně (Moravian Gallery, Brno)
10.912

PH172
František Vobecký
Untitled, 1934
9¼ x 6⅞ (23.5 x 17.4)
Collection Thomas Walther, New York

PH173
František Vobecký
Untitled: abstraction, 1934
5½ x 7¾ (14.0 x 19.7)
The J. Paul Getty Museum
84.XM.150.10

PH174
František Vobecký
Hand (*Ruka*), 1935
15⁹⁄₁₆ x 11⅜ (39.6 x 28.9)
Moravská galerie v Brně (Moravian Gallery, Brno)
6331

PH175
František Vobecký
Recollections (*Vzpomínky*), 1935
15½ x 11 (39.4 x 28.0)
Moravská galerie v Brně (Moravian Gallery, Brno)
6332

PH176
František Vobecký
Composition (*Kompozice*), 1935
15¹¹⁄₁₆ x 11¾ (39.8 x 29.8)
Sander Gallery, New York

PH177
František Vobecký
Phantom (*Fantom*), 1936
16¹⁵⁄₁₆ x 11¾ (43.0 x 30.0)
Sander Gallery, New York

PH178
Josef Voříšek
Premiere (*Premiéra*), 1935
13³⁄₁₆ x 11⁷⁄₁₆ (33.4 x 29.1)
Moravská galerie v Brně (Moravian Gallery, Brno)
9293

PH179
Josef Voříšek
In a Bar (*V baru*), 1934
11¼ x 12⁹⁄₁₆ (28.6 x 31.9)
Moravská galerie v Brně (Moravian Gallery, Brno)
9286

PH180
Josef Voříšek
Untitled, c. 1935
12¾ x 11¾ (32.4 x 29.9)
Private collection

PH181
Eugen Wiškovský
Collars: Lunar Landscape (*Límce. Měsíční krajina*), 1929
11⁵⁄₁₆ x 8⅝ (29.0 x 22.0)
Uměleckoprůmyslové muzeum v Praze (Museum of Decorative Arts, Prague)
GF-54

PH182
Eugen Wiškovský
Dump (*Haldy*), 1932
5⁹⁄₁₆ x 3½ (14.1 x 8.8)
Moravská galerie v Brně (Moravian Gallery, Brno)
6616

PH183
Eugen Wiškovský
The Chimney (*Komín*), 1932
14⅜ x 10⁷⁄₁₆ (36.5 x 26.5)
Uměleckoprůmyslové muzeum v Praze (Museum of Decorative Arts, Prague)
GF-62

PH184
Eugen Wiškovský
Insulator (*Izolátor*), 1933
15⁹⁄₁₆ x 10⁵⁄₁₆ (39.5 x 26.2)
Uměleckoprůmyslové muzeum v Praze (Museum of Decorative Arts, Prague)
GF-63

PH185
Eugen Wiškovský
Insulator II (*Izolátor II*), 1935
11¼ x 9¼ (28.5 x 23.4)
Uměleckoprůmyslové muzeum v Praze (Museum of Decorative Arts, Prague)
GF-65

PH186
Václav Zykmund
Self-portrait (*Vlastní portrét*), 1937
7¹⁄₁₆ x 5⅛ (18.0 x 13.0)
Moravská galerie v Brně (Moravian Gallery, Brno)
10.806

PH187
Václav Zykmund
Action (*Akce*), 1944
Reticulated negative process
5¹⁄₁₆ x 7 (12.9 x 17.8)
Moravská galerie v Brně (Moravian Gallery, Brno)
10.807

PH188
Václav Zykmund
Action (*Akce*), 1944
Reticulated negative process
5¹⁄₁₆ x 6¹⁵⁄₁₆ (12.9 x 17.7)
Moravská galerie v Brně (Moravian Gallery, Brno)
10.808

PH189
Václav Zykmund
Ludvík Kundera
The Menacing Compass (*Výhružný kompas*), 1944
Sixteen photographs with typewritten copy and one photographic reproduction in accordion book format, edition one of 20
3⁹⁄₁₆ x 2⅜ (9.0 x 6.0) each photograph; 6³⁄₁₆ x 4⁷⁄₁₆ x ¹¹⁄₁₆ (15.7 x 11.2 x 1.8) closed
Moravská galerie v Brně (Moravian Gallery, Brno)
11.145

PH190
Václav Zykmund
Miloš Koreček
Carrying-On II (*Řádění II*), 1944
Forty-three photographs in accordion book format, "fokalk" cover by Koreček
3⁹⁄₁₆ x 2⅜ (9.0 x 6.0) each photograph; 3⅛ x 4⅛ x ⅞ (7.9 x 10.4 x 2.2) closed, assembled 1982
Moravská galerie v Brně (Moravian Gallery, Brno)
A3607

Annotated Checklist of Films

All films are 35mm, black and white, with a soundtrack unless otherwise indicated; running times are at 24 frames per second (fps) unless noted differently. Except for those films identified as "loan only," all films are new prints struck from the original negatives at ČSFÚ-FA; these prints will remain in the collection of Anthology Film Archives after the exhibition as part of an archival exchange. Film titles are listed in Czech with English translation following.

• EARLY NARRATIVE

Dostavníčko ve mlýnici (The Rendezvous at the Mill), 1898
Director and camera: Jan Kříženecký
180 feet (54 m.), silent, 2 minutes at 18 fps

Pláč a smích (Crying and Laughing), 1898
Director and camera: Jan Kříženecký
180 feet (54 m.), silent, 2 minutes at 18 fps

Výstavní párkař a lepič plakátů (The Fairground Sausage Vendor and the Poster Hanger), 1898
Director and camera: Jan Kříženecký
180 feet (54 m.), silent, 2 minutes at 18 fps

These short Lumière-inspired sketches, known at the time as "live photographs," are the first Czech films. Kříženecký was a photographer and self-styled architect.

Rudi na záletech (Rudi Fools Around), 1911
Directors: Emil Artur Longen and Antonín Pech
Camera: Antonín Pech
338 feet (103 m.), silent, 5 minutes at 18 fps

Rudi sportsmanem (Rudi the Sportsman), 1911
Directors: Emil Artur Longen and Antonín Pech
Camera: Antonín Pech
473 feet (144 m.), silent, 7 minutes at 18 fps

Two slapstick spoofs were shot with spontaneity on location amid the recreational facilities of contemporary Prague. Rudi is the cabaret invention and embodiment of Emil A. Longen.

Konec milování (The End of a Love Affair), 1913
Directors: Otakar Štáfl and Max Urban
Camera: Max Urban
2,054 feet (626 m.), color tinted, silent, 31 minutes at 18 fps

In this domestic melodrama dressed in the secessionist trappings of the late Austro-Hungarian Empire, scandal, propelled by the modernity of telephones and touring cars, spreads from the boudoir to the drawing room, the office place, and the highway with fatal speed.

Noční děs (The Nightmare), 1914
Director: Jan Arnold Palouš
Screenplay: František Langer
Camera: Max Urban
3,478 feet (1,060 m.), color tinted, silent, 40 minutes at 18 fps

In a two-reel farce with an Expressionist touch, domestic squabbles over infidelity lead to a who-dunit akin to Hitchcock's *The Trouble with Harry*, where there are no victims or accusers, only guilt-ridden innocents.

České hrady a zámky (Czech Castles and Chateaux), 1914
Director: Karel Hašler
Camera: Josef Brabec
666 feet (203 m.), color tinted, silent, 9 minutes at 18 fps

Made as a prelude to the stage production *Man without an Apartment*, the film consists of an actor's chase from a countryside castle to the Variété stage, where the play awaits his entrance. Hitching rides, hijacking conveyances from speedboats to trains, and managing a change to top hat and tails, the tardy thespian, in his final stretch over the rooftops and chimneys of Prague, evokes the image of *Fantomas*.

Ahasver, 1915
Director: Jaroslav Kvapil
Camera: Josef Brabec
1,210 feet (369 m.), silent, 17 minutes at 18 fps

This comic story, rich with character studies from the bohemian fabric of Prague, centers on a liberated woman painter seeking a model for *Ahasver*, her painting on the theme of the Wandering Jew. Pressed into the casting call, her shrimp of a husband unearths a burly worker who applies himself to a make-over that fits his preconception of the artist's ideal.

• EXPERIMENTAL AND DOCUMENTARY

Praha v záři světel (Prague Shining in Lights), 1928
Director: Svatopluk Innemann
Camera: Václav Vích
2,063 feet (629 m.), silent, 26 minutes

This teeming, mid length document of Prague's night life at the height of the roaring twenties is an important example of the city genre with parallels to Ruttman's *Berlin, the Symphony of a Great City (Berlin, die Sinfonie der Grosstadt, 1927)* and Vertov's *Man with the Movie Camera (Chelovek s kinoapparotom, 1929)*. A celebration of urbanity powered by electrical light, this was the first Czech film to exploit the newly developed, extremely sensitive panchromatic film stock.

Bezúčelná procházka (Aimless Walk), 1930
Director and camera: Alexander Hackenschmied
538 feet (164 m.), silent, 10 minutes

Hackenschmied's first film, a first-person study of a young man who sets out for a distant Prague suburb, associates the spectator with the anonymous protagonist by means of a subjective camera. This unconventional vision evokes a lyrical melancholy in everyday reality while the walk becomes a metaphor for imagination or a mental trip. The closing sequence (in which the man splits into two persons) links thematically to the director's later work in *Meshes of the Afternoon* (1943).

Světlo proniká tmou (The Light Penetrates the Dark), 1930
Directors: Otakar Vávra and František Pilát
Camera: František Pilát
Sculpture: Zdeněk Pešánek
371 feet (113 m.), silent, 8 minutes

Sculptor and designer Pešánek's kinetic sculpture projected rays of light for eight years from the façade of the Edison Transformer Station of the Prague Electric Company. Made before the sculpture's destruction in 1938 during the Nazi occupation, this short abstract film—contemporary to Moholy-Nagy's *Lightplay: Black White Gray (Ein Lichtspiel: Schwarz Weiss Grau, 1930)*—encompasses the sculpture's Modernist theme. Only this complex film document and still photographs survive.

Na Pražském hradě (Prague Castle), 1932
Director and camera: Alexander Hackenschmied
1,102 feet (336 m.), 12 minutes

In his second film, a mobile, hand-held essay, Hackenschmied tried "to find the relationship between architectonic form and music." Hackenschmied had studied architecture, photography, and set design before he turned to film. Impressions of the soaring Gothic forms of St. Vitus Cathedral are framed from both pedestrian and bird's-eye views, matched to František Bartoš' musical composition through the fluid rhythm of the editing.

Burleska (Burlesque), 1932
Director and camera: Jan Kučera
302 feet (153 m.), silent, 3 minutes

The young journalist and film critic Kučera concocted a playful mixture of Surrealist trick shots and newsreel material to express his pacifist sentiments through a spectrum of hidden poetic associations.

Zem spievá (The Earth Sings), 1933
Director and camera: Karel Plicka
Editor: Alexander Hackenschmied
5,980 feet (1,823 m.), 67 minutes, loan only

The Czech photographer Plicka, inspired by years of collecting Slovak folk material and by Flaherty's *Nanook of the North* (1922), filmed this lyric record of a vanishing culture on location in the mountains of Slovakia. Hackenschmied's editing of the film to František Škvor's original score transforms this ethnographic work into a compelling visual and aural symphony.

Žijeme v Praze (We Live in Prague), 1934
Director: Otakar Vávra
Camera: Jaroslav Tuzar
1,187 feet (362 m.), 13 minutes

On-the-street vignettes mixing social documentary with dramatic interludes fix Prague's landmarks and denizens with acrid observations. Woven into this poetic reportage on the beauty, banality, vulgarity, and optimism of Prague's irrepressible urbanity is a romantic encounter that progresses from stolen kisses in the shadow of St. Vitus to a breathtaking suicide leap from the Charles Bridge.

Atom věčnosti (The Atom of Eternity), 1934
Director and camera: Čeněk Zahradníček
545 feet (166 m.), silent, 6 minutes

The course of spring passion and its volatile consummation are telegraphed with great style and fluency using the lexicon of avant-garde iconography. Exaggerated sexual metaphor (the train rushes into, pulls out of, and thrusts back into the tunnel) takes this "art" film into the realm of self-parody.

Ruce v úterý (Hands on Tuesday), 1935
Director and camera: Čeněk Zahradníček
984 feet (300 m.), silent, 11 minutes

A stellar cast of hands is caught in the personal acts of one day: playing, loving, communicating, and resting. Extremely inventive scenarios, lifted from the pages of cheap detective novels or noticed in under-the-table, café flirtations, distinguish this "amateur" film.

Listopad (Autumn), 1934
Director: Otakar Vávra
Camera: Alexander Hackenschmied
Music: Emil František Burian
1,837 feet (560 m.), 20 minutes

In one of Vávra's first films, a man meets a past lover on a streetcar and remembers their earlier romance. A brilliant, understated city sequence cuts to flashbacks of couples rowing on a river in a lyrically filmed pastorale.

Máj (May), 1936
Directors: Emil František Burian and
Čeněk Zahradníček
Camera: Čeněk Zahradníček
2,054 feet (626 m.), silent, 16 minutes, 16mm

This evocative short film was integrated into Burian's avant-garde stage dramatization of Karel Hynek Mácha's nineteenth-century Romantic poem. Distorted close-ups of female body parts were enlarged almost to abstraction and projected on a scrim to complement simultaneous action on stage.

Černobílá rapsodie (Black-and-White Rhapsody), 1936
Director: Martin Frič
Camera: Ferdinand Pečenka
233 feet (71 m.), 3 minutes

With slick, kaleidoscopic camera effects, the prolific director Frič filmed this quick outdoor frolic involving pairs of women in duotone costumes. The film, backed by a sophisticated swing rhythm and hovering amusingly between a gymnastic celebration and a brilliant lingerie commercial, was in reality promotion for Frič's daughter's dance company.

Hra bublinek (The Play of Bubbles, 1936, also released as *Fantaisie érotique [Erotic Fantasy]*, 1937)
Director and camera: Karel Dodal and
Irena Dodalová
171 feet (52 m.), color tinted, 2 minutes

This animated advertisement for Saponia products features a jazz jingle, storks making deliveries to points across Czechoslovakia, playful abstract designs, and the two-strip Gaspar-color process.

Silnice zpívá (The Highway Sings), 1937
Director: Elmar Klos
Camera: Alexander Hackenschmied and
Jan Lukas
354 feet (108 m.), 4 minutes

The youthful ingenuity and playfulness brought to advertising by the avant-garde are evident in the low-budget special effects and photographic style of this Baťa tire commercial. It was awarded first prize at the 1937 Paris Exhibition.

Myšlenka hledající světlo (The Idea Seeking Light), 1938
Directors: Irena Dodalová and Karel Dodal
Camera: Karel Dodal
899 feet (274 m.), 10 minutes

A precursor to computer-animated graphics, this imaginative abstract film combines various patterns of light with a message for universal brotherhood.

Krise (Crisis), 1938
Director: Herbert Kline
Camera: Alexander Hackenschmied
Producer: Hans Burger
Music: H.W. Süsskind
Commentary: Vincent Sheean
6,390 feet (1,936 m.), 71 minutes

Kline, an American producer/director and one-time leftist magazine editor, in a joint effort with Hackenschmied and Burger, made this remarkable film on the Fascist threat. *Crisis* documents the political crisis in Czechoslovakia about the time of the Munich agreement.

Divotvorné oko (The Magic Eye), 1939
Director: Jiří Lehovec
Camera: Václav Hanuš
902 feet (275 m.), 10 minutes

A crossover between Functionalism and Surrealism, Lehovec's extreme close-ups allow his Freudian vision to unveil hidden connections between commonplace objects. Reviving the appeal of Dziga Vertov's pioneer "kino-eye" manifesto, the film seduces the viewer into a world inaccessible to the naked eye.

Rytmus (Rhythm), 1941
Director: Jiří Lehovec
Camera: Pavel Hrdlička
1,115 feet (340 m.), 12 minutes

Divided into four parts, *Rhythm* explores, illustrates, and harmonizes in a dynamic conclusion the oldest as well as the most contemporary methods of visually representing musical perception. In Lehovec's last work before the nationalization of Czech cinema, sequences move from a science lab with *noir* lighting, to a recording studio, to the animator's table, and finally to the projection room of a movie theater.

Příchozí z temnot (Visitor from Darkness), 1921
Director: Jan Stanislav Kolár
Camera: Otto Heller
5,609 feet (1,710 m.), silent, 83 minutes at 18 fps

A supernatural ménage à trois is invoked when a malevolent visitor leaves an alchemical manuscript with a young couple living in opulent isolation and a somnambulant chevalier is awakened by the husband. The film is shot on location among the lush precipices and eccentric ruins of a storybook castle. (The best of a series of popular mystery films pairing filmmaker Karel Lamač and actress Anny Ondraková in the lead roles.)

Děvče z Podskalí (The Girl from Podskalí), 1922
Director: Václav Binovec
Camera: Josef Kokeisl
4,330 feet (1,320 m.), silent, 64 minutes at 18 fps, loan only

A street urchin, kin to Mary Pickford, dreams of fancy lace knickers in this tenement melodrama shot on the riverwalks and teeming quarters of a never idle Prague neighborhood. Alternately antic, domestic, and topical, it is the most successful production of Weteb-Film, a company founded by the urbane director Binovec that was extremely active in the decade following World War I.

Kreutzerova sonáta (The Kreutzer Sonata), 1926
Director: Gustav Machatý
Camera: Otto Heller
6,396 feet (1,950 m.), silent, 95 minutes at 18 fps

Made after Machatý's return from Hollywood, this film tells Tolstoy's story of a man who murders his wife out of jealousy, admitting to the crime as the film opens. In a slow Expressionist style that uses striking sets, the couple's progressive alienation is evoked and a larger social hypocrisy condemned.

Batalion (Battalion), 1927
Director: Přemysl Pražský
Camera: Jaroslav Blažek
7,216 feet (2,200 m.), silent, 107 minutes at 18 fps

Konstantin Stanislavski, who was in Prague in 1925, had a direct influence on the avant-garde features that color this skid-row epic. The romanticized decline of a people's advocate is inspired by Gorky's *The Lower Depths* and based on Josef Hais-Týnecký's novel, which used the real-life story of Dr. František Uher, a prominent lawyer and politician who died as a homeless alcoholic.

Erotikon, 1929
Director: Gustav Machatý
Camera: Václav Vích
5,940 feet (1,811 m.), silent, 88 minutes at 18 fps

This morality tale about the consequences of a night's love in a provincial railway station, with its explicitly erotic theme and sexually complex heroine, is a forerunner of Machatý's better known *Ecstasy*. Vích's atmospheric photography and Machatý's stylistic flair suffuse the opening scenes of the storm with a tense sensuality.

Takový je život (Such Is Life), 1929/30
Director: Karl Junghans
Camera: László Schäffer
6,593 feet (2,010 m.), silent, 73 minutes

In this silent film Junghans anticipates Neo-realism and the work of Miloš Forman in his use of locations and documentary tactics. The film illuminates the exhausting life of a Prague washerwoman, who manages to maintain a buoyant vitality in the face of human pain.

Tonka Šibenice (Tonka of the Gallows), 1930
Director: Karel Anton
Camera: Edvard Hoesch
7,584 feet (2,312 m.), 84 minutes

The Yugoslavian actress Ita Rina gives a vibrant performance as a prostitute who volunteers for a night with a condemned prisoner and is dogged by the encounter—expressionistically filmed—and her subsequent notoriety as an angel of death.

Ze soboty na neděli (From Saturday to Sunday), 1931
Director: Gustav Machatý
Script: Vítězslav Nezval
Camera: Václav Vích
Art direction: Alexander Hackenschmied
Music: Jaroslav Ježek
6,396 feet (1,950 m.), 71 minutes

A young typist watches, in the evocative decadence of a night club, a blind date dissolve to a proffer of money for sex and escapes to a café where she falls in love with a stranger she meets there. A lyrical romanticism emerges as the film shifts from the exaggerated motifs of office and club to a delicate realism, depicting love in the genteel domestic squalor of a bachelor flat.

Pudr a benzin (Greasepaint and Gasoline, also released as *Powder and Gas)*, 1931
Director: Jindřich Honzl
Script: Jiří Voskovec and Jan Werich
Camera: Václav Vích
Music: Jaroslav Ježek
8,322 feet (2,537 m.), 92 minutes

Voskovec and Werich's first movie is an invaluable record of their early work in theater: a galvanic, improvisational stew of camp, vaudeville, Surrealism, and poetic comedy. Marvelous vignettes include a sunbathed picnic casually furnished with absurd bourgeois trappings, a comic fox-trot ballet, and an excursion to Prague Castle by a group of Edward Gorey-type tourists marshaled by their cavalier guide, Werich, and his multi-lingual megaphone.

Před maturitou (Before the Finals), 1932
Directors: Svatopluk Innemann and Vladislav Vančura
Camera: Otto Heller and Václav Vích
Music: Emil František Burian
8,528 feet (2,600 m.), 95 minutes, loan only

Vančura's first film, set in the uniquely Modernist resort areas near Prague and at a Bauhaus-style boys' boarding school, centers on the humanization of a dessicated math teacher pitted against the emotional preoccupations of his adolescent charges. Some inventive photography reduces a staff meeting locked in dispute to jazzy chaos. The music is by a key figure of avant-garde theater.

Peníze nebo život (Your Money or Your Life), 1932
Director: Jindřich Honzl
Script: Jiří Voskovec, Jan Werich, and Jindřich Honzl
Camera: Václav Vích
Music: Jaroslav Ježek
8,633 feet (2,632 m.), 96 minutes

Voskovec and Werich's second venture into feature filmmaking concerns two boyhood friends—one a petty criminal, the other a suicidal pawn of his rich in-laws—who are accidentally reunited in pursuit of a stolen gem. Complicated by bungles and infidelity, the sport leads to its grand confrontation in a cluttered Central European museum (a crazy scene that anticipates the battle action in the Marx Brothers' *Duck Soup* [1933]).

Extase (Ecstasy), 1933
Director: Gustav Machatý
Camera: Jan Stallich
Music: Guiseppe Becce
7,787 feet (2,374 m.), 87 minutes

In this landmark in the history of erotic film, a young bride, played by Hedy Kiesler (Hedy Lamarr), leaves her dull and unappreciative husband to take a lover in the countryside. Heavily dependent on the lyricism of Stallich's camera work, the film is a visual celebration of sexuality, with a famous nude scene showing Lamarr pursued through the trees by use of a tracking shot.

Řeka (The River), 1933
Director: Josef Rovenský
Camera: Jan Stallich
7,938 feet (2,420 m.), 88 minutes, loan only

In a naturalistic melodrama characteristic of the thirties, the son of a village magistrate struggles to catch a fish so as to buy shoes for the poor girl he loves. Filmed in sunbathed pastoral locations, this moving film features an excellent cast of sturdy, believable country people possessed of a natural charm.

Na sluneční straně (On the Sunny Side), 1933
Director: Vladislav Vančura
Script: Vítězslav Nezval, Roman Jakobson, and Miloslav Disman
Camera: Jan Stallich and Jaroslav Blažek
6,774 feet (2,065 m.), 76 minutes

The deliberately Modernist script set in a children's home examines the fate of two children from a middle-class family. Vančura's unconventional camera angle, focused down on the actors, makes them seem like specimens in a social experiment. With an obvious debt to Soviet montage, an open-ended narrative is created by stunning vignettes (a maniacal puppet show, roughhousing children in nightshirts who form a train, an old woman on darkened railroad tracks) that succeed each other, connected only by their intensity.

Marijka nevěrnice (Faithless Marijka), 1934
Director: Vladislav Vančura
Camera: Jaroslav Blažek and Václav Hanuš
6,790 feet (2,070 m.), 76 minutes
Shot in the mountains of Carpathian Ukraine using non-actors and local dialect, this portrait of social and religious isolation draws on techniques of Soviet montage. A rare film score by Bohumil Martinů provides the musical counterpoint.

Hej rup! (Heave Ho!), 1934
Director: Martin Frič
Script: Formen (Jiří Voskovec, Jan Werich, Martin Frič, and Václav Wasserman)
Camera: Otto Heller
Music: Jaroslav Ježek
9,315 feet (2,840 m.), 104 minutes, loan only

A much loved comedy, *Heave Ho!* brings together in a depression-era setting Werich as a ruined industrialist and Voskovec as a labor advocate who meet and conspire to put their rival out of business. The famous duo turn their wildly inventive slapstick talents to the service of anti-Fascist, anticapitalist propaganda.

Jánošík, 1936
Director: Martin Frič
Camera: Ferdinand Pečenka
7,118 feet (2,170 m.), 79 minutes, loan only

This Slovakian swashbuckler in the spirit of films by Douglas Fairbanks and Erroll Flynn recounts the adventures of the Robin Hood–like folk hero Jánošík. Outrageously garbed in braids and a plumed brigand hat, his belt stuffed with pistols, Jánošík champions the mountain people against the hussars of the Hungarian lords in this lavish, slickly edited film, one of the most popular films worldwide of the 1930s.

Svět patří nám (The World Belongs to Us), 1937
Director: Martin Frič
Script: Jiří Voskovec and Jan Werich
Camera: Otto Heller
Music: Jaroslav Ježek
8,538 feet (2,603 m.), 95 minutes

This anti-Nazi satire spoofs propaganda and sloganeering with a series of thinly veiled vaudeville skits lampooning 1937 world politics. In one sequence an automated factory run amok seems intent on grinding, drilling, pressing, and perforating its human prey.

Panenství (Virginity), 1937
Director: Otakar Vávra
Camera: Jan Roth
7,330 feet (2,303 m.), 84 minutes

An aura of emotional tyranny surrounds a poor cashier and the would-be lovers drawn to her innocent beauty. Vávra evokes a sophisticated romantic detachment close to that of Frank Borzage in the film's gleaming bistros, world-weary night spots, and roomy flats crammed with the detritus of private lives. The fluid and meticulous camera style and gorgeous photography in blacks and grays make this one of the best pre–World War II Czech films.

Daleká cesta (The Distant Journey), 1948
Director: Alfred Radok
Camera: Josef Střecha
9,204 feet (2,806 m.), 103 minutes

This key Czech film of the postwar period addresses the ordeal of Jews in the Terezin ghetto and camps, using an extreme Expressionist formalism to nightmarish effect. Newsreels are imposed beneath the story's images, and scenes of mass movement are formally staged with the camera moving rhythmically in, up, and back. The depiction of the dense infrastructure of the camps is extraordinary, and a scene showing children being led to the showers horrifies.

FP1
O.T.
Jánošík, 1921
Poster for Tatra Film Company, Chicago, 1921
48 ¹³⁄₁₆ x 36 ⅝ (124 x 93)
Československý filmový ústav—Filmový archiv
(Czechoslovak Film Institute—Film Archive)

FP2
Jaromír Sdl.
The Girl from Podskalí (Děvče z Podskalí), 1922
49 ¼ x 37 ⁷⁄₁₆ (125 x 95)
Československý filmový ústav—Filmový archiv
(Czechoslovak Film Institute—Film Archive)

FP3
Horník
The Kreutzer Sonata (Kreutzerova sonáta), 1926
49 ¼ x 37 ⁷⁄₁₆ (125 x 95)
Československý filmový ústav—Filmový archiv
(Czechoslovak Film Institute—Film Archive)

FP4
Ottmar Otto, Atelier
Battalion (Batalion), 1927
Lithograph
37 ⁷⁄₁₆ x 49 ¼ (95 x 125)
Uměleckoprůmyslové muzeum v Praze (Museum
of Decorative Arts, Prague)

FP5
A. F.
Tonka of the Gallows (Tonka Šibenice), 1930
49 ¼ x 37 ⁷⁄₁₆ (125 x 95)
Československý filmový ústav—Filmový archiv
(Czechoslovak Film Institute—Film Archive)

FP6
T.
From Saturday to Sunday (Ze soboty na neděli),
1931
72 ⅞ x 48 (185 x 122)
Československý filmový ústav—Filmový archiv
(Czechoslovak Film Institute—Film Archive)

FP7
Anonymous
From Saturday to Sunday (Ze soboty na neděli),
1931
49 ¼ x 37 ⁷⁄₁₆ (125 x 95)
Československý filmový ústav—Filmový archiv
(Czechoslovak Film Institute—Film Archive)

FP8
Rotter
Ecstasy (Extase), 1933
Offset lithograph
49 ¼ x 37 ⁷⁄₁₆ (125 x 95)
Uměleckoprůmyslové muzeum v Praze (Museum
of Decorative Arts, Prague)

FP9
Antonín Mikel
Jánošík, 1935
49 ¼ x 37 ⁷⁄₁₆ (125 x 95)
Československý filmový ústav—Filmový archiv
(Czechoslovak Film Institute—Film Archive)

FP10
Rotter
The World Belongs to Us (Svět patří nám), 1937
Offset lithograph
49 ¼ x 37 ⁷⁄₁₆ (125 x 95)
Uměleckoprůmyslové muzeum v Praze (Museum
of Decorative Arts, Prague)

Artists' Biographies

Organizations cited in the biographies have been abbreviated as follows: ČFS (Czech Photographic Society/Česká fotografická společnost), ČKFA (Czech Club of Amateur Photographers/Český klub fotografů amatérů), FAMU (Film Academy of Performing Arts/Filmová akademie músických umění), KFA (Club of Amateur Photographers/Klub fotografů amatérů), SČKFA (Union of Czech Clubs of Amateur Photographers/Svaz československých klubů fotografů amatérů), SČVU (Union of Czech Fine Artists/Svaz českých výtvarných umělců), the Skupina (Group of Fine Artists/Skupina výtvarných umělců), and S.V.U. Mánes (Mánes Union of Fine Artists/Spolek výtvarných umělců Mánes).

• KAREL ANTON

Film director, screenwriter, actor, and producer
Born October 25, 1898, Brno
Died April 13, 1979, West Berlin

Although he and his friends Karel Lamač and Otto Heller shot a short documentary during World War I and although in 1921 he was appointed head of documentary and advertising films at A.B. Company, Anton's ambition lay in narrative features. In 1922 he made *Gypsies* (*Cikáni*), an adaptation of the romantic novel by Karel Hynek Mácha, and in 1923 he directed two comedies, one inspired by American slapstick. After the film depression years of 1925–26, he returned to filmmaking, concentrating on adaptations of popular Czech novels such as *The Fairy Tale of May* (*Pohádka máje*, 1926) after Vilém Mrštík's novel. The most successful of these adaptations was *Tonka of the Gallows* (*Tonka Šibenice*, 1930), based on Egon E. Kisch's story. Adapted for sound at a later stage of its production, the film was widely acclaimed at home and abroad. In 1931 he made another film after a play by Kisch, *The Colonel Redl Affair* (*Aféra plukovníka Rédla*). In the 1930s he often worked abroad, most often in Paris but also in Berlin. After the war he lived in West Germany and directed a great number of films, including films for television.

Selected references: *Film-Echo* (Wiesbaden), no. 67 (1978), p. 10; Rádl, Otto. "The Development of Czech Film Direction (Vývoj české filmové režie)." *Studio*, vol. 1 (1930–31), p. 178.

• JOSEF BARTUŠKA

Organizer, editor, graphic artist, painter, poet, writer, playwright, musician, filmmaker, book artist, and photographer
Born May 28, 1889, Rozovy near Tyn nad Vltavou
Died October 9, 1963, České Budějovice-Rudolfov

In 1930 Bartuška cofounded Linie, the South Bohemian avant-garde group of artists, writers, and architects, and its photographic section Fotolinie. He was active as a photographer from 1928 until the 1940s, joining the ČKFA in Prague about 1939. Interested in Surrealism, social photography, Neue Sachlichkeit, and Bauhaus, he also used his photographs to illustrate his poetry. He became famous for his shadow-play photographs and photograms, which were probably influenced by Jaromír Funke, and for the literary quality of his illustrations and theatrical stagings. His choice of titles was a significant component in his work, and he preferred to create photographic series dedicated to a single theme. He exhibited with Fotolinie, in the Third Salon in the Corridor, and with ČKFA in Prague.

Selected publications: Illustrated poetry cycles *The Gardener* (*Zahradník*, 1933) and *Autumn* (*Podzim*, 1935); articles and photographs in *Linie*, *Index*, *Photographic Horizon* (*Fotografický obzor*), *Photography* (*Fotografie*), and others.

Selected references: Cífka, S. *Josef Bartuška: Knight of the Czech Language* (*Josef Bartuška. Rytíř české řeči*). České Budějovice, 1975; Civiš, S. *Josef Bartuška*. České Budějovice, 1969.

• LADISLAV EMIL BERKA

Magazine picture editor, graphic designer, translator, film critic, and photographer
Born September 9, 1907, Prague
Lives in Prague

With Alexander Hackenschmied and Jiří Lehovec, Berka was a pioneer of regular film criticism in Czech weeklies and dailies. He made his photography debut with them at the 1930 exhibition New Czech Photography held at the Aventinum Garret (Aventinská mansarda); Berka, Hackenschmied, and Lehovec created an informal group associated with the Aventinum publishing house. A member of the Czech Studio and Film Club since 1930, he wrote about photography and from 1927 to 1933 photographed intensively. His work was influenced by avant-garde films and the *Film und Foto* exhibition in Stuttgart (1929). Exhibitions include *Das Lichtbild,* Munich (1930); *Social Photography,* Prague and Brno (1933); and *International Exhibition of Photography* (Mánes), Prague (1936).

Selected publications: Articles published in *Gentleman*, no. 10 (1929–30); *Aventinský magazín* (April 1930); *The Aventinum Discourses* (*Rospravy Aventina*), no. 34 (1930); *Eva*, no. 18 (1932).

Selected reference: Dufek, Antonín. *The Aventinum Trio* (*Aventinské trio*). Exh. cat. Brno and Bratislava, 1989; Dufek, Antonín. "Photographs of Ladislav E. Berka (Fotografie Ladislav E. Berka)." *Moravian Gallery Bulletin* (*Bulletin Moravské galerie*), no. 29 (1980).

• VÁCLAV BINOVEC

Film director, screenwriter, actor, producer, and film distributor
Born September 12, 1892, Prague
Died February 29, 1976, Prague

In 1918 Binovec founded the film production company Weteb-Film and over the next ten years directed more than thirty narrative films of various genres. They included a story of the big city underground, the spy drama *Bogra* (1919), the detective series *Joe Fock's Adventures* (*Dobrodružství Joe Focka*, 1918), a number of comedies and love stories, the Symbolist allegory *The Flames of Life* (*Plameny života*, 1920), westerns, thrillers, and the psychological drama *The Last Joy* (*Poslední radost*, 1921). One of the most successful of Weteb-Film's productions was *The Girl from Podskalí* (*Děvče z Podskalí*, 1922), a realistic story of a girl from a working-class neighborhood. In the second half of the 1920s Weteb-Film went bankrupt and Binovec transformed it into a film distribution company. In the 1930s and 1940s he made several narrative features, mostly comedies, the most significant being *A Small Town in Bohemia* (*Městečko na dlani*, 1942), made after the novel of the same title by Jan Drda.

Selected reference: Bartošek, Luboš. *Our Film* (*Náš film*). Prague: Mladá fronta, 1985.

• VLADIMÍR J. BUFKA

Teacher, writer, and photographer
Born July 16, 1887, Pavlovice near Kojetín
Died May 23, 1916, Prague

Between 1911, when he opened his studio in Prague, and his death from tuberculosis at age 28, Bufka influenced Czech photography through his books and articles on photographic techniques and aesthetics, the informal artists' meetings in his studio, formal classes, and his photographs. He excelled in the then-contemporary techniques of platinum, pigment, bromoil, color gum prints, and autochromes, blending Art Nouveau symbolism with a Modernist snapshot aesthetic. He also made scientific photographs (astrophotography and microphotography). Exhibitions included ČKFA, Prague (1911), and the seventy-fifth anniversary exhibition at Rudolfinum, Prague (1914–15).

Selected publications: Photographs published in *Photographic Horizon* (*Fotografický obzor*), *Kamera-Kunst, Red Flowers* (*Rudé květy*), *Czech World* (*Český svět*), *Worldview* (*Světozor*), *Epocha*, and his own books; articles published in *Photographic Horizon* (1909), *Photographic Bulletin* (*Fotografický věstník*, 1910), *Czech World* (1903, 1911), *Veraikon* (1912).

Selected reference: Dufek, Antonín. *Vladimír J. Bufka*. Exh. cat. Brno: Moravian Gallery (Moravská galerie), 1988.

• EMIL FRANTIŠEK BURIAN

Theater and film director, composer, playwright, critic, actor, musician, and singer
Born June 11, 1904, Plzeň
Died August 9, 1959, Prague

Born to a family of opera singers, Burian studied with the composer Josef B. Foenster at the State Conservatory in Prague. In 1925 his opera *Before the Sunrise* (*Před sluncem východu*) was produced by the National Theater in Prague. In 1926 Burian became a member of the Liberated Theater (Osvobozené divadlo) and in 1927 joined the Dada Theater. Also a member of Devětsil, he

directed theaters in Brno and Olomouc. In 1933 he became the artistic director of the new D 34 Theater (the number changed every season as a symbol of the theater's up-to-date character), where he tried to create politically aggressive and innovative theater that gave poetry a place on the stage. He also published a theater newspaper originally called *D 34 Cultural Evening Paper* (*Kulturní večerník D 34*). Between 1945 and 1949 he published and edited the *Cultural Politics* (*Kulturní politika*) weekly, and from 1945 to 1947 he had a regular Sunday broadcast as a cultural political commentator. In 1954 he was nominated a "National Artist." In addition to composing music for films, he also directed the films *Věra Lukášová* (1939) and *We Want to Live* (*Chceme žít*, 1949).

Selected publications: *On Contemporary Russian Music* (*O moderní ruské hudbě*, Prague: Odeon, 1926); *Polydynamics,* (*Polydynamika*, Prague: L. Kunčíř, 1926); *Jazz* (Prague: Aventinum, 1928); *Sweep the Stage* (*Zamette jeviště*, Prague: D 36, 1936).

Selected references: Burian, Jarka. "E.F. Burian: D 34–D 41." *The Drama Review*, no. 72, pp. 95–116; Obst, M., and A. Scherl. *On the History of Czech Theater Avant-garde* (*K dějinám čes. divadelní avantgardy*). 1962.

• JOSEF ČAPEK

Painter, printmaker, writer, art critic, and editor
Born March 23, 1887, Hronov, Bohemia
Died about April 15, 1945, Bergen Belsen, Germany

Čapek studied at the Prague School of Decorative Arts (1904–1910) and at the Académie Colarossi in Paris (1910–11). Influenced by Cubism and tribal art in Paris, he returned to Prague in 1911, joined the Skupina, and edited *Artistic Monthly* (*Umělecký měsíčník*). He left the Skupina in 1912 and joined S.V.U. Mánes, coediting *Free Directions* (*Volné směry*). In 1913 with his brother Karel he published *Almanac for 1914* (*Almanach na rok 1914*), and in 1914 he helped organize the forty-fifth S.V.U. Mánes international exhibition. His book *Lelio* was published in 1917 and the German journal *Die Aktion* published his prints and drawings. In 1918 he cofounded Tvrdošíjní (Stubborn Ones) and published "Negro Sculpture" from his book on primitive art and *Album of Ten Prints*. In 1920 he published *The Most Modest Art* (*Nejskromnější umění*) about popular culture and folk art including film and photography. In 1929 he joined the Society of Fine Arts (Umělecká beseda). He published *The Art of Tribal Peoples* (*Umění přírodních národů*) in 1938. In 1939 he was arrested by the German authorities and sent to the concentration camps Dachau, Buchenwald, Sachsenhausen, and Bergen Belsen, where he died.

Selected publications: *Modern Artistic Expression* (*Moderní výtvarný výraz*, Prague: Československý spisovatel, 1958); *What One Gets from Art and Other Reflections on Art* (*Co má člověk z umění a jiné úvahy o umění z let 1912–1937*, Prague: Výtvarný odbor umělecké besedy, 1946); *The Art of Tribal Peoples* (*Umění přírodních národů*, Prague: František Borový, 1938); *The Most Modest Art* (*Nejskromnější umění*, Prague: Aventinum, 1920).

Selected references: Čapek, Karel. *Josef Čapek*. Prague: Aventinum (Musaion 5), 1924; Opelík, Jiří. *Josef Čapek*. Prague: Melantrich, 1980; Slavík, Jaroslav. *Josef Čapek*. Bratislava: Pallas, 1988.

• FRANTIŠEK DRTIKOL

Photographer and painter
Born March 3, 1883, Příbram
Died January 13, 1961, Prague

For many years Drtikol's studio, established in 1910, was the best known in Prague. Augustín Škarda was his partner between 1910 and 1921. In 1911 they published the portfolio *From the Courtyards of Old Prague* (*Z dvorů a dvorečků staré Prahy*). While studying in Munich (1901–1903), Drtikol became interested in Art Nouveau, mastering bromoil and other Pictorialist techniques to create landscapes, genre pictures, nudes, and portraits in the Art Nouveau style. After World War I he made less stylized portraits then began to work on nude photography in the Art Deco style, placing the nudes among sets and props he also designed. The poses grew more dynamic and the elaborate decorative sets were replaced by light-and-shadow compositions. Internationally famous for his nudes, he was also influenced by Constructivism in his nonfigurative works, which retained Symbolist themes. In 1930 he began to create paper and wood figures to photograph instead of live models. In 1935 he gave up photography to devote himself to Oriental studies and to return to painting. His photographs were widely exhibited and published both in Czechoslovakia and abroad and are represented in many European and American photography collections.

Selected references: Birgus, Vladimír, and Antonín Braný. *František Drtikol*. Prague: Odeon, 1988; Fárová, Anna. *František Drtikol: Art Deco Photographer* (*František Drtikol, Photographe Art Déco; František Drtikol, Photograph des Art Déco*). French and German eds. Munich: Schirmer/Mosel, 1986; Santeul, Claude de. *Drtikol's Nudes* (*Les nus de Drtikol*). Paris: Librairie des arts décoratifs, 1929.

• EMIL FILLA

Painter, printmaker, sculptor, and art critic
Born April 4, 1882, Chropyně, Moravia
Died October 6, 1953, Prague

Filla studied at the Prague Academy of Fine Arts (1903–1906) and helped organize the Expressionist group Osma, exhibiting with them in 1907 and 1908. He joined S.V.U. Mánes in 1910–11 and in 1911 edited *Free Directions (Volné směry)*. That same year he and other artists seceded from S.V.U. Mánes to form the Skupina. He was well traveled, visiting Paris regularly and adopting a Cubist idiom by 1910 in his painting and by 1913 in his sculpture. In 1914 the Berlin journal *Der Sturm* published his drawings and prints and he coorganized four Skupina exhibitions. During World War I he lived in Holland and supported the Czechoslovakian independence movement. In 1920 he rejoined the Mánes and again edited *Free Directions*. He participated in the Société Anonyme exhibition at The Brooklyn Museum (1926) and in 1932 had a Retrospective exhibition at S.V.U. Mánes. After his arrest by the German

authorities in 1939, he was imprisoned at Dachau and Buchenwald. Following the liberation in 1945, he taught in Prague at the School of Decorative Arts.

Selected publications: *The Work of the Eye (Práce oka*, Prague: Odeon, 1982); *Jan van Goyen: Reflections on Landscape Painting (Jan van Goyen. Úvahy o krajinářství*, Prague: State Publishing House of Literature, Music, and Art, 1959); *Reflections on Fine Arts (Úvahy o výtvarném umění*, Prague: Karel Brož, 1948); *Kunst und Wirklichkeit* (Prague, 1936).

Selected references: Berka, Čestmír. *The Prints of Emil Filla (Grafické dílo Emila Filly)*. Prague: Odeon, 1968; Malejček, Antonin, et al. *The Work of Emil Filla (Dílo Emila Filly)*. Brno: F. Venera, 1936; *The World of Emil Filla (Svět Emila Filly)*. Exh. cat. Prague: Galerie hlavního města Prahy, 1987. Essay by Vojtěch Lahoda; Zemina, Jaromír. *Emil Filla*. Prague, 1970.

• MARTIN FRIČ

Film director, scriptwriter, and actor
Born March 29, 1902, Prague
Died August 26, 1968, Prague

Active in literary cabarets and theaters, Frič started his film career by designing posters. After acting in several movies with the famous Czech comedian Vlasta Burian, he became interested in film direction and worked with the directors Josef Rovenský and Karel Lamač. With the advent of the era of sound, Frič's versatility made him one of the most sought-after of Czech directors. The best Czech comics (Jiří Voskovec and Jan Werich as well as Burian) appeared in his well-crafted comedies, and he was equally successful with his melodramas, including *Jánošík*, about a Slovakian Robin Hood—a hit at the 1936 Venice Film Festival—and his film adaptations of renowned Czech literary works, of which *Čapek's Short Stories (Čapkovy povídky)* was awarded honorable mention at the 1947 Venice Film Festival. His greatest postwar success was a two-part historical comedy about the Hapsburg Emperor Rudolf II. In his last years he made a number of films starring Jan Werich for Czech television; an adaptation of a Chekhov story, *Tears Unseen by the World (Slzy, které svět neviaí)*, won a Silver Plaque at the Fifth Television Festival in Rome in 1963.

Selected references: *Director Martin Frič 1902–1967*. Prague: Československý filmový ústav, 1967; *The Aventinum Discourses (Rozpravy Aventina)*, no. 6 (1933–34), p. 69.

• JAROMÍR FUNKE

Photographer, critic, teacher, and editor
Born August 1, 1896, Skuteč
Died March 22, 1945, Prague

Devoted to photography since his youth, and intensively since 1919, Funke was a member and at times a founding member of a succession of influential artist organizations including the Kolín KFA, the Photo Club Prague (Fotoklub Praha), the ČFS, and the photographic section of S.V.U. Mánes. He was an influential Czech photographer from the 1920s through the 1940s and an internationally important pioneer of modern photography. An exceptional intellectual, he made an

impact on Czech photography through articles, critical reviews, organizational activity, and later his teaching. Involved in amateur photography in the twenties with his friends Josef Sudek and Adolf Schneeberger, he passed through those ideological storms always from the most revolutionary standpoint, a natural step to the art avant-garde. Funke's work is typified by the simultaneous development of several stylistic points of departure. His early work moves from romantic landscapes (1919) and documentary views of Kolín's outskirts (1919–21) to experimental still lifes in which geometric (often vernacular) objects are combined with their own projected shadows (1922). Once acquainted with Man Ray's photograms, he began to concentrate on the problem of "photogenics," with lights and shadows predominating over objects until only nonfigurative shadow plays were left. He also anticipated the principles of Neue Sachlichkeit and Functionalism, and by the end of the 1920s he paralleled the Poetism of Devětsil with photographs of unfixed assemblages. Turning to objective images in the 1930s, he was the first Czech photographer to consistently develop his work in series. Important series include *Reflections (Reflexy*, 1929) and *Time Persists (Čas trvá*, 1930–34), which responded to the work of Atget and the Parisian Surrealists and the symbolic potential of reality. He expressed Functionalist principles in his photographs of buildings and furniture, in social photography, in his landscape and portrait work, and even in an extensive series of documentary snapshots (1937–38). He also achieved outstanding results as a teacher at the School of Arts and Crafts in Bratislava (1931–35) and the State Graphic School in Prague (1935–1944). He has been featured in numerous solo exhibitions in Czechoslovakia and abroad from 1935 to the present. He also participated in the International Photographic Salons (1924–38), exhibitions organized by the various photography clubs, Prague exhibitions of *New Photography* (1930, 1931), *Social Photography* (1933), *Avant-garde* (1937), and S.V.U. Mánes (1938), as well as important exhibitions of postwar photography.

Selected publications: Introductions to exhibition catalogues and articles published in *Photographic Horizon (Fotografický obzor)*, nos. 1 and 6 (1925), no. 1 (1927), no. 7 (1936), nos. 3, 6, and 11 (1940); *Foto*, nos. 1 and 2 (1928); *How We Live (Jak žijeme)*, no. 3 (1931); *Photography Sees the Surface (Fotografie vidí povrch)*, edited with Ladislav Sutnar (1935); posthumous books including *Triforium of St. Vitus (Svatovítské Triforium*, 1946); *Prague Churches (Pražské kostely*, 1946); *My Kolín (Můj Kolín*, 1947).

Selected references: Linhart, Lubomír. *Jaromír Funke*. Prague, 1960; Mrázková, Daniela, and Vladimír Remeš. *Jaromír Funke*. Leipzig: Foto Kinoverlag, 1986; Souček, Ludvík, and Dagmar Hochová. *Jaromír Funke: Fotografie*. Prague: Odeon, 1970; Tausk, Petr. "Jaromír Funke." In *Contemporary Photographers*, 2nd ed. Chicago and London: St. James Press, 1988, pp. 325–26.

• OTTO GUTFREUND

Sculptor
Born August 3, 1889, Dvůr Králové, Bohemia
Died June 2, 1927, Prague

Gutfreund studied at the Prague School of Decorative Arts (1906–1908) and in Paris with Emile-Antoine Bourdelle at La Grande Chaumière (1909–1910). In 1911 he returned to Prague and joined the Cubist group Skupina; he created the Cubo-expressionist sculpture *Anxiety (Úzkost)* and made a series of reliefs that led to more fully realized Cubist sculptures in 1912–13, works which are among the first three-dimensional realizations of Cubist aesthetics. He visited Paris in 1914, and when World War I broke out, he joined the Foreign Legion. Arrested for insubordination, he spent three years in an internment camp. His abstract wooden constructions from these years parallel the work of the Russian Constructivists. Living in Paris in 1918–20, he explored Synthetic Cubism while gradually introducing more Realist tendencies into his work. In 1920 he returned to Prague and worked in a Civilist style inspired by folk and popular art. He created polychrome terra-cotta sculptures, outdoor monuments, and architectural reliefs. In 1926 he became a professor at the School of Decorative Arts in Prague. He drowned the next year while swimming in the Vltava on the outskirts of Prague.

Selected publications: "Excerpts from the Paris Diary (Úryvky z pařížského deníku)," *Free Directions (Volné směry)*, vol. 25 (1927–28), p. 152; "From the Notes (Z poznámek)," *Free Directions*, vol. 25 (1927–28), p. 156; "Plane and Space (Plocha a prostor)," *Artistic Monthly (Umělecký měsíčník)*, vol. 2, no. 9 (1913), pp. 240–43.

Selected references: Cannon-Brookes, Peter, with Jiří Kotalík, Petr Hartmann, and Václav Procházka. *Czech Sculpture 1800–1938*. Exh. cat. Cardiff: The National Museum of Wales, 1983; Císařovský, Josef. *Otto Gutfreund*. Prague: NČVU, 1962; *German Expressionist Sculpture*. Exh. cat. Los Angeles County Museum of Art, 1983; Šmejkal, František. "Zrzavý et Gutfreund." *Cahiers du Musée National d'Art Moderne* (Paris), nos. 7–8 (1981), pp. 315–21.

• ALEXANDER HACKENSCHMIED

Filmmaker, photographer, and film critic
Born December 19, 1907, Prague
Lives in New York City

After studying architecture then art history, Hackenschmied turned to photography and film, sharing interests and activities with Ladislav Berka and Jiří Lehovec; the three were informally associated with the Aventinum publishing house. Influenced by the *Film und Foto* exhibition in Stuttgart (1929), Hackenschmied one year later organized the first *New Photography* exhibition in the Aventinum Garret (Aventinská mansarda) in Prague, a popular meeting place for the avant-garde. Berka, Lehovec, and Hackenschmied first exhibited in the Aventinum Garret. Hackenschmied's photographic career is significant; he practiced documentary and studio photography, including advertising photography. He also organized the first festival of avant-garde film at Kotva cinema in Prague and at the same time made his first film, *Aimless Walk (Bezúčelná procházka*, 1930), considered one of the first Czech avant-garde films. Although his work as a film critic was influential, his own film work is of greatest importance. After the new photographic vision of *Aimless Walk*, he made *Prague Castle (Na Pražském*

hradě, 1932), blending visual and musical components to explore the relationship between music and the cinematic image. He worked as art director on Gustav Machatý's *From Saturday to Sunday (Ze soboty na neděli*, 1931), he had an important share as editor in determining the ultimate shape of Karel Plicka's *The Earth Sings (Zem spieva*, 1933), and as a cameraman he coauthored Otakar Vávra's film-feuilleton *Autumn (Listopad*, 1934). In the mid 1930s he left for Zlín, where he established with Elmar Klos, Ladislav Kolda, and František Pilát a new film studio for the Baťa Company, taking study trips to Soviet film studios and to Hollywood. Of his Modernist advertising films made for Baťa Company, *The Highway Sings (Silnice zpívá*, 1937), made in collaboration with Elmar Klos and Jan Lukas, won an award at the 1937 World Exposition in Paris. In 1938 he collaborated with Herbert Kline and Hans Burger on *Crisis (Krise)*, dealing with the political situation in Czechoslovakia. In February 1939 he left for Paris; unable to return home after the occupation, he settled in the United States where he works as a documentary filmmaker under the name A. Hammid. With his first wife, Maya Deren, he created pioneering works in the American film avant-garde, in particular *Meshes of the Afternoon* (1943). In 1964 he earned an Oscar for the movie *To Be Alive*.

Selected publications: Articles in *Photographic Horizon (Fotografický obzor*, 1929) and *Weekly Variety (Pestrý týden*, 1930); "Independent Film—A World Movement," *Studio*, vol. 2 (1930), p. 220; "The Avant-garde Lives," *Studio*, vol. 2 (1930), pp. 274–76; "Film and Music," *Cinema Quarterly*, no. 1 (Spring 1933), pp. 152–55; "On Editing," in *The ABC of a Film Scriptwriter and Actor (Abeceda filmového scenaristy a herce*, Prague, 1935), pp. 73–80.

Selected references: Brož, Jaroslav. *Alexander Hackenschmied*. Prague: Československý filmový ústav, 1973; Clark, Vě Vě A., Millicent Hodson, and Catrina Neiman. *The Legend of Maya Deren: A Documentary Biography and Collected Works*, vol. 1, part 2. New York: Anthology Film Archives/Film Culture, 1988; Dufek, Antonín. *The Aventinum Trio (Aventinské trio)*. Exh. cat. Brno and Bratislava, 1989; Sitney, P. Adams. *Visionary Film. The American Avant-garde, 1943–1978*. New York: Oxford University Press, 1979; Valasek, Thomas E. "Alexander Hammid: A Survey of His Filmmaking Career." *Film Culture*, nos. 67–69 (1979), pp. 250–322.

• KAREL HÁJEK

Photojournalist
Born January 22, 1900, Lásenice near Jindřichův Hradec
Died March 31, 1978, Prague

Photographing since 1926, Hájek joined the ČKFA in 1928. He began as a hobbyist and became a photo-reporter for the Melantrich group of periodicals in 1932. Of these magazines, the pictorial weekly *Sunday-Ahoy (Ahoj na neděli)* was the largest, with a circulation of half a million. His solo exhibition at the Prague Public Library in 1936, seen by 30,000 people, was one of the most popular exhibitions of photography between the wars. His work from the 1930s, with that of Václav Jírů, is the best representation of Czech photojour-

nalism from that time. His photographs appeared in many books and magazines.

Selected publication: "Photography and Newspapers (Fotografie a noviny)," *Fotograficky obzor,* vol. 44 (1936), pp. 49–50.

Selected reference: Rýpar, Vladimír. *Karel Hájek.* Prague, 1963.

• MIROSLAV HÁK

Photographer
Born May 9, 1911, Nová Paka
Died June 29, 1978, Prague

Beginning in 1932, Hák participated in a number of international photography exhibitions. From the early 1930s he collaborated with the painters František Hudeček and František Gross and the sculptor Ladislav Zívr with whom he formed a Surrealist group, led by the theoretician Jindřich Chalupecký, in the mid 1930s. He worked as a theater photographer at E.F. Burian's D 38 Theater and had his first solo exhibition there in 1938. In 1942 he joined Skupina 42 and is famous for his earlier Surrealist experiments as well as works aesthetically related to those of Skupina 42.

Selected references: Kolář, Jiří. *Miroslav Hák.* Prague, 1959; Linhart, Lubomír. *Miroslav Hák: Through the Eyes (Miroslav Hák. Očima).* Prague: Státní filmové nakladatelství, 1947.

• KAREL HAŠLER

Actor, playwright, screenwriter, songwriter, singer, film and theater director, and translator
Born October 31, 1879, Prague
Died December 22, 1941, Mauthausen

In 1903 Hašler began to perform at the National Theater in Prague, where he worked until 1915. He also wrote and published popular songs, performing at the cabaret Lucerna. In 1914 he made the film *Czech Castles and Chateaux (České hrady a zámky)* for his cabaret act. The film, which preceded his performance on the Lucerna stage, consists of the actor's frantic journey from a countryside castle to the Lucerna Building. In 1915 he played in the Jaroslav Kvapil film *Ahasver.* He was head of the cabaret Rokoko, in 1918 he became head of the cabaret Lucerna, and from 1925 to 1928 he managed the theater Variété. One of the most popular film actors of the 1920s, he played many film roles, including Dr. Uher in Přemysl Pražský's *Battalion (Batalion,* 1927). In 1932 he played himself in Svatopluk Inneman's biographical film inspired by Hašler's life. He collaborated on numerous other films as a screenwriter and adviser, including *A Small Town in Bohemia (Městečko na dlani,* 1942). He was arrested in 1941 by the German secret police while the film was in production and died at the Mauthausen concentration camp.

Selected publication: "I'll Say What I Know (Povím, co vím)," *Venkov* (1938).

Selected reference: Deyl, Rudolf. *The Balladeer Karel Hašler (Písničkář Karel Hašler).* Prague: Panton, 1968.

• JINDŘICH HATLÁK

Photographer and filmmaker
Born August 15, 1901, Prague
Died October 28, 1977, Prague

Hatlák began photographing at the age of eleven and in the mid 1930s began to work in film. Employed in banking, he was a member and official of ČKFA and a member of the Pathé Club. In the 1940s he concentrated on portraits and nude studies and was part of the mainstream of Czech amateur photography.

Selected reference: Dufek, Antonín. "Jindřich Hatlák." *Czechoslovak Photography (Československá fotografie),* vol. 29 (1978), p. 125.

• JAROSLAVA HATLÁKOVÁ

Photographer
Born October 26, 1924, Prague
Died April 4, 1989, Prague

Hatláková's exercises from the State Graphic School in Prague (1934–38) reflect the school's principles of working within the framework of Functionalism and Bauhaus theories. Perhaps the most talented student of the school in the 1930s, she handled perfectly the exercises assigned by Professor Jaromír Funke in still life, portraiture, architecture, landscape, reportage, and advertising. Of these the series of compositions *A Body in Space (Těleso v prostoru)* is the most important. Students of Funke paralleled those of Walter Peterhans, Hans Finsler, and other European teachers. Even on an international scale Hatláková's work ranks among the best expressions of late Neue Sachlichkeit and Functionalism. Aside from exhibitions of the ČKFA, which she joined in 1930, she participated in the 1936 *International Exhibition of Photography* in Prague and published in *Photographic Horizon (Fotografický obzor)* and other periodicals.

Selected references: Dufek, Antonín. "Jaroslava Hatláková and SGŠ (State Graphic School) Before World War II." *Czechoslovak Photography (Československá fotografie),* vol. 29, no. 5 (1978), p. 221; Dufek, Antonín, and Xavier Galmiche. *Jaroslava Hatláková.* Paris: Marval, 1988; Tausk, Petr. "Jaroslava Hatláková, A Pupil of Jaromír Funke." *Czechoslovak Photography (Československá fotografie),* vol. 37, no. 10 (1986).

• JOSEF HAUSENBLAS

Architect
Born 1907, Lenešice, Bohemia
Died c. 1940–45

As a student of Hannes Meyer at the Bauhaus, Hausenblas participated in the *Film und Foto* exhibition in Stuttgart (1929). He was a member of Devětsil and in 1930 joined the Levá fronta (Left Front). During the 1930s he worked as an independent architect, and his project of low-income housing in Lenešice was an example of housing based on the principles of standardization.

Selected publication: "On Architecture of Our Time (K dnešní architektuře)," in *Modern Contemporary Architecture (Moderní soudobá architektura,* Prague: Odeon, 1929).

Selected reference: *Czech Functionalism 1920–40: Architecture (Český funkcionalismus 1920–40: Architektura).* Exh. cat. Prague: Uměleckoprůmyslové muzeum, 1978.

• JINDŘICH HONZL

Theater and film director, writer, teacher, and editor
Born May 14, 1894, Humpolec
Died April 20, 1953, Prague

In 1920 Honzl became a member of Devětsil and began promoting new theatrical forms inspired by film, circus, and sport. He also traveled to the Soviet Union and wrote on Russian theater. In 1926 he cofounded the Liberated Theater (Osvobozené divadlo), where he directed avant-garde plays. In 1931–32 he directed two film comedies starring Jiří Voskovec and Jan Werich: *Greasepaint and Gasoline (Pudr a benzin,* also released as *Powder and Gas)* and *Your Money or Your Life (Peníze nebo život).* In the 1930s he participated in the Surrealist movement, attempting to reconcile the theories of Surrealism and Structuralism. With Otakar Vávra he developed an extensive curriculum of film education. In 1939–41 he managed the 99 Seats Theater (Divadélko pro 99). After the war he published a periodical on film and theater, and in 1948 he became head of the National Theater.

Selected publications: *The Spinning Stage (Roztočené jeviště,* Prague: Odeon, 1925); *Modern Russian Theater (Moderní ruské divadlo,* Prague: Odeon, 1928); *The Fame and Affliction of Theaters (Sláva a bída divadel,* Prague: Cooperative Work [Družstevní práce], 1937); (with Vávra) *Proposal for a School of Young Film Professionals (Navrhujeme školu pro výchovu filmového dorostu,* Prague, 1939).

Selected reference: Obst, Milan, and Antonín Scherl. *On the History of Czech Theater Avant-Garde (K dějinám české divadelní avantgardy).* Prague: ČSAV, 1962.

• SVATOPLUK INNEMANN

Film director and cameraman
Born February 18, 1896, Laibach, Austro-Hungary (Ljubjana, Yugoslavia, after 1918)
Died October 30, 1945, Klecany

Innemann began working as a cameraman during World War I, and in the 1920s and 1930s he made thirty feature films of different genres. He directed comedies based on the scripts of Josef Skružný, such as *The Green Car (Zelený automobil,* 1921), and three films inspired by the novel *The Good Soldier Švejk* and its maverick author Jaroslav Hašek. With cameraman Václav Vích he made the documentary *Prague Shining in Lights (Praha v záři světel,* 1928), paralleling Walter Ruttmann's *Berlin: Symphonie einer Grosstadt* (1927) and Dziga Vertov's *Man with the Movie Camera* (1929). In the 1930s he made adaptations of novels and plays, such as the thriller *The Ostrovní Street Murder (Vražda v Ostrovní ulici,* 1933) after Emil Vachek's novel, and biographical films, including *Last Bohemian (Poslední bohém)* about Jaroslav Hašek and *Balladeer (Písničkář)* about Karel Hašler. With Vladislav Vančura he codirected *Before the Finals (Před maturitou,* 1932).

Selected references: Rádl, Otto. "The Development of Czech Film Direction (Vývoj české filmové režie)." *Studio,* vol. 1 (1930–31), p. 178.

• VÁCLAV JÍRŮ

Editor, critic, journalist, and photographer
Born July 31, 1910, Doubravany
Died June 28, 1980, Prague

Jírů joined the ČKFA in 1926. Along with that of Karel Hájek, his work is the most representative example of Czech magazine photography. His pictures also appeared in the late 1920s and 1930s in German and English magazines such as *Picture Post*, *Liliput*, and *Wochen-Blätter*. His photographs characterize wittily and aptly the social phenomena of life in the late 1920s and 1930s. He worked both for the luxurious monthly *Salon* and for the popular weekly *Around the World (Letem světem)*. After World War II he published a great number of photographic books, and in 1957 he founded and edited the review *Photography 57–71 (Fotografie 57–71)*.

Selected references: Krejčí, Milan. *Václav Jírů*. Exh. cat. Prague: Galerie hlavního města Prahy, 1980; Zykmund, Václav. *Václav Jírů*. Prague: Odeon, 1971.

• KARL JUNGHANS

Film director, scriptwriter, journalist and photographer
Born October 7, 1897, Dresden, Germany
Died Germany

A leftist journalist, Junghans in 1925 wrote a script about the life of a poor washerwoman and found a Czech producer, the actor and director Theodor Pištěk, for the film. Junghans directed *Such Is Life (Takový je život)* in 1929. In 1933 he began but did not finish a Yugoslav-Czech film *And Life Goes On (A život jde dál)*, which continued the theme of *Such Is Life*. In 1939 he moved to the United States, where he worked as a photographer, returning to Germany in the 1950s.

• KAREL KAŠPAŘÍK

Photographer
Born September 8, 1899, Lošov near Olomouc
Died October 20, 1968, Olomouc

Kašpařík was the guiding spirit of the members of Photo Exhibition of the Three (Fotovýstava tří, or f3) in 1935 and participated in Photo Group of the Four (Fotoskupina čtyř, or f4) in 1939. Other members were Otakar Lenhart and Jaroslav Nohel in f3 and f4 and Bohumil Němec in f4. In f3 and f4 exhibitions, Kašpařík included his inventive portraits and experimental photographs influenced by Constructivism and Surrealism. A long-time collaborator with the Olomouc theater, he used actors to stage some of his photographs. Joining the Communist Party in 1924 led him also to make socially motivated photographs. Employed as an office worker, he published his photographs in progressive periodicals, such as *Index*, but exhibited sporadically outside of f3 and f4 activities.

Selected references: Babler, O. F. "On the Art of Photography and About One Photographer (O umění fotografickém a o jednom fotografovi)." *Index*, no. 8 (1936), p. 73; *The Photogroup of the Four: Photographs, Montages, Experiments, and Photograms (Fotoskupina čtyř fotografie, montáže, experimenty, fotogramy)*. Prague, 1939.

• JAN STANISLAV KOLÁR

Film director, screenwriter, and actor
Born May 11, 1896, Prague
Died October 30, 1973, Prague

Kolár began working in Lucerna Film productions as early as 1916. He went on to make short comedies and in 1918 met another aspiring young filmmaker Karel Lamač, with whom he collaborated on a number of films featuring Lamač and Anny Ondráková. With Lamač he codirected *The Poisoned Light (Otrávené světlo,* 1921), starring both actors again. In the same year he made *The Cross by the Brook (Kříž u potoka)*, an adaptation of a popular Czech novel by Karolina Světlá, and in 1922 he directed the psychological drama *The Dead Are Living (Mrtví žijí)* after Karel Dewetter's novel. A serious illness interrupted his film career for several years, during which he wrote the book *On Film (K filmu,* 1927). In 1929 he directed his last film, *St. Wenceclas (Svatý Václav)*, an historical film sponsored by the Czech government. In later years he played minor roles, worked as an archivist at the Czechoslovak Film Institute, and coauthored several publications on the history of Czech cinema.

Selected publication: *On Film (K filmu,* Prague, 1927).

Selected references: Brož, Jaroslav, and Myrtil Frída. *Jan S. Kolár*. Prague: Československý filmový ústav, 1971; Wasserman, Václav. *Pioneers of Czechoslovac Cinematography (Průkopníci čs. kinematografie VIII)*. Prague: SPN, 1966.

• JIŘÍ KROHA

Architect, critic and theoretician, painter, theater director, stage designer, photomontagist, and teacher
Born June 5, 1893, Prague
Died June 7, 1974, Prague

In the late 1910s Kroha developed a Cubo-expressionist style that he used to decorate the Café Montmartre in 1918. He cofounded the Socialist Stage in 1920, working as a theater director and designer. Also in the 1920s he designed a number of buildings in Mladá Boleslav in a Constructivist style. He founded and edited the architecture magazine *Horizont* in 1927. He began to teach in Brno in 1925, and in the early 1930s, using diagrams and photomontages, he and his students developed two studies, the *Sociological Fragment of Housing* (1932–33, *Sociologický fragment bydlení*) and *The Economic Fragment of Housing* (1935, *Ekonomický fragment bydlení*), which were presented in Prague and Brno. From 1934 to 1937 he was suspended from his teaching position for his leftist political activity, and in 1939 he was arrested, spending a year in prison and in the camps at Dachau and Buchenwald. In 1948 he returned to teaching and was made a "National Artist." A retrospective was held in Prague and Brno in 1965.

Selected publications: (with Jiří Hrůza) *The Soviet Avant-garde Architecture (Sovětská architektonická avantgarda,* 1973); *The Sociological Fragment of Housing (Sociologický fragment bydlení,* 1973).

Selected references: Císařovský, Josef. *Jiří Kroha and the Avant-garde between the Two World Wars (Jiří Kroha a meziválečná avantgarda)*. Prague:

NČVU, 1967; Šlapeta, Vladimír. *Czech Functionalism 1918–1938*. London: Architectural Association, 1987.

• BOHUMIL KUBIŠTA

Painter, sculptor, printmaker, art critic, and theoretician
Born August 21, 1884, Vlčkovice, Bohemia
Died November 27, 1918, Prague

Kubišta studied at the Prague School of Decorative Arts (1903–1904) and at the Academy of Fine Arts (1904–1905). In 1906 he visited Florence and studied at the Reale Institute of Fine Arts. In 1907 he was a cofounder of Osma, a group of Expressionist artists, exhibiting with them in 1907 and 1908. In 1909–10 he went to Paris, where he assimilated Cubist developments. On his return to Prague, he became one of the leading advocates of Cubism; his critical writings were influential. In 1911 he joined S.V.U. Mánes and participated in the creation of the Skupina, a Cubist group, but for ideological reasons never became a formal member. In 1911 he exhibited at the Neue Secession in Berlin, invited as a member of the Dresden group Die Brücke, and over the next two years participated in numerous exhibitions in other European capitals. In 1913–14 he exhibited in Budapest, Lvov, and Prague. Poverty forced him to enter military service in 1913 and he became an officer in the Austrian infantry stationed in Yugoslavia. He returned to Prague in 1918 and died in the Spanish flu epidemic.

Selected publications: *Prerequisites of Style (Předpoklady slohu,* Prague: Otto Girgal, 1947); *Letters and Essays (Korespondence a úvahy,* Prague: State Publishing House of Literature, Music, and Art, 1960).

Selected references: Nešlehová, Mahulena. *Bohumil Kubišta*. Prague: Odeon, 1984; Sedlář, Jaroslav. *Bohumil Kubišta*. Bratislava: Pallas, 1976.

• JAN KUČERA

Filmmaker, critic, and theoretician
Born July 8, 1908, Plzeň
Died September 5, 1977, Prague

In 1927 Kučera became a member of the New Film Club (Klub za nový film) and as a student published numerous articles in avant-garde periodicals. In 1930–31, while editor of the newsreel department of Elektajournal, he created several experimental films. *Burlesque (Burleska,* 1932) combined newsreel footage with close-up shots while *Prague Baroque (Pražské baroko,* 1931) juxtaposed Prague's Baroque architecture with Bach's music. In 1932–34 he worked on the film *The Construction (Stavba,* 1932) documenting the construction of the General Pension Institute. In 1937 he became head of the Aktualita newsreel agency and in 1941 published *A Book on Film (Kniha o filmu)*. While with the Czechoslovak Newsreel, he made a number of documentaries. In 1948 he went to work at the Czechoslovak Film Institute.

Selected publications: "Double Distillation: On Film Art (Dvojí destilace: O filmovém umění)," *Studio*, vol. 1, no. 5 (1929), p. 132; "Construction (Stavba)," *Free Directions (Volné směry)*; *A Book*

on Film (Kniha o filmu, Prague: Orbis, 1941); Progressive Tendencies in Czech Cinema 1920–1938 (Pokrokové tendence v českém filmu v období 1920–1938, Prague: Československý filmový ústav, 1971).

Selected references: Svoboda, Jan. "The Beginnings of Jan Kučera and the Avant-Garde Circle of Devětsil (Začátky Jana Kučery a okruh devětsilské avantgardy)." Umění, vol. 35, no. 2 (1987), pp. 158–66.

• FRANTIŠEK KUPKA

Painter, printmaker, and illustrator
Born September 22, 1871, Opočno, Bohemia
Died June 21, 1957, Puteaux, France

After studying at the Prague Academy of Arts (1887–91) and at the Vienna Academy (1891–92), Kupka moved to Paris in 1895 and worked as a book illustrator and cartoonist. In 1906 he participated in the Salon d'Automne for the first time and in 1911 began to exhibit at the Salons des Indépendants. By 1910 he had begun his book Creation in Fine Arts (Tvoření v umění výtvarném), having arrived at a concept of abstract art inspired by his studies of movement, music, and the natural and occult sciences. In 1912 at the Salon d'Automne he showed Amorpha, Fugue in Two Colors (1912) and Amorpha, Warm Chromatics (1912), the first abstract paintings exhibited in Paris, and also probably participated in the Salon de la Section d'Or. During World War I he joined the movement for Czech independence and in 1919 was made an honorary member of S.V.U. Mánes, which published Creation in Fine Arts in 1923. From 1931 to 1934 he was a member of Abstraction-Création. In 1946 he became affiliated with the Salon des Réalités Nouvelles, and S.V.U. Mánes organized a retrospective of his work in Prague to celebrate his seventy-fifth birthday.

Selected publication: Creation in Fine Arts (Tvoření v umění výtvarném, Prague: S.V.U. Mánes, 1923).

Selected references: František Kupka, 1871–1957: A Retrospective. Exh. cat. Prague: Národní galerie, 1968. Essays by Bernard Dorival, Jiří Kotalík, and Ludmila Vachtová; František Kupka 1871–1957: A Retrospective. Exh. cat. New York: The Solomon R. Guggenheim Museum, 1975. Essays by Meda Mladek and Margit Rowell; Siblík, Emanuel. František Kupka. Prague: Aventinum (Musaion 8), 1928, French ed., 1929; Vachtová, Ludmila. František Kupka. Prague-New York-Toronto, 1968.

• JAROSLAV KVAPIL

Theater director, poet, playwright, and translator
Born September 25, 1868, Chudenice, Bohemia
Died January 10, 1950, Prague

Kvapil published several books of poetry influenced by Symbolism and in 1901 wrote the libretto for Antonín Dvořák's opera Water Nymph (Rusalka). He became a leading theater director during the first decade of the century, selected in 1912 to be the head of the National Theater in Prague. He was a close friend of Hermann Bahr, a leading Austrian art critic. After working on the first important German film to be made in Prague, Der Student von Prag by Paul Wegener,

as well as observing the contemporary Czech film scene, he made his debut with Ahasver (1915), a comic story about an emancipated woman painter. During World War I he worked in the resistance movement for the independence of Czechoslovakia, and after the war he made the feature The Little Golden Key (Zlatý klíček, 1921), based on a story by Karel Čapek.

Selected publication: Selected Works of Jaroslav Kvapil (Sebrané dílo Jaroslava Kvapila, Prague: V. Tomsa, 1946–47).

Selected reference: Goetz, František. Jaroslav Kvapil. Prague: 1948.

• JAN LAUSCHMANN

Photographer and writer
Born April 1, 1901, Roudnice nad Labem
Lives in Brno

A chemical engineer and chemistry professor who began photographing in 1912, Lauschmann joined the Prague KFA in 1921 and from 1923 to 1934 served on the editorial council of Photographic Horizon (Fotografický obzor). Influenced by Drahomír Josef Růžička, Lauschmann was one of the most talented representatives of the new school of purist Pictorialism in the 1920s. He had two solo exhibitions in 1927 with new work shown in each. His scientific, theoretical, and historical articles on photography were influential. His 1928 article in Photographic Horizon "Along the Stream (Po proudu)" led to the end of the dispute between Art Nouveau and purist Pictorialists. Already leaning toward the New Photography, he began in 1927 to use diagonal compositions connected with extreme perspectives, and the themes of modern urban life and formally expressive motifs from nature took precedence. While a member of the Prague ČKFA during the stormy secessions of the early 1920s, he participated in 130 exhibitions and was widely published at home and abroad.

Selected publications: Articles in Photographic Horizon; since 1972 Photography Review (Revue fotografie) has published his memoires and memories of his photographic contemporaries.

Selected references: Tausk, Petr. "Jan Lauschmann and Czechoslovak Photography." In History of Photography, no. 1. Penn State, 1981; Mrázková, Daniela. Jan Lauschmann. Prague: Odeon, 1986.

• JIŘÍ LEHOVEC

Documentary filmmaker, film critic, and photographer
Born January 3, 1909, Prague
Lives in Prague

Active as a photographer since 1923, Lehovec worked as a creative photographer between 1929 and 1938. With Ladislav Berka and Alexander Hackenschmied, he made his debut at the New Photography exhibitions in the Aventinum Garret (Aventinská mansarda). The three, who organized the exhibitions, were informally associated with the Aventinum publishing house. Lehovec was a member of ČKFA, the photo sections of S.V.U. Mánes, and the Levá fronta (Left Front) Film and Photo Group. He participated in the exhibitions Social Photography (1933, 1934), Avant-garde (1937), and S.V.U Mánes (1938). Lehovec was also

cofounder of the Film Club and a film critic, establishing in 1930 the film section of National Liberation (Národní osvobození) newspaper. He became a film cameraman in 1936. His first film script, Botič—Creek of the Poor (Botič—potok chudých), was never made, but he directed a number of short documentaries for the A.B. Company in 1939–40 including Millions on the Pavements (Milióny na dlažbách), Blazing Crater (Žhavý jícen), The Magic Eye (Divotvorné oko), and Faithful Star (Věrná hvězda). His next film, Rhythm (Rytmus, 1941), which received considerable acclaim, was made by Baťa Film Studio (FAB) in Zlín. Most of Lehovec's films address popular science and are classics of the genre in Czech film, using techniques from the film avant-garde. From 1946 to 1969 he taught at FAMU.

Selected publications: "The Film Avant-garde (Filmová avantgarda)," Home and World (Domov a svět, April 23, 1932); "The Czech Film Avant-garde (Česká filmová avantgarda)," Worldview (Světozor, July 6, 1933); "Botič—Creek of the Poor (Botič—potok chudých)," unproduced script, reprinted in Through the Film Lens (Filmovým objektivem), no. 5 (1961), p. 4.

Selected references: Dufek, Antonín. The Aventinum Trio (Aventinské trio). Exh. cat. Brno and Bratislava, 1989; Navrátil, Antonín. Jiří Lehovec: Portrait of a Documentary Filmmaker (Portrét dokumentaristy). Prague: Československý filmový ústav, 1966; Navrátil, Antonín. Jiří Lehovec. Prague: Československý filmový ústav, 1984.

• OTAKAR LENHART

Photographer, filmmaker, and amateur painter
Born August 28, 1905, Olomouc
Lives in Olomouc

From a family of fine artists, Lenhart took up photography to photograph his brother's sculptures then joined the ČKFA in Olomouc in 1930. After meeting Jaroslav Nohel, he devoted himself to experimental and advertising photography. He treated traditional genres with experimental techniques of solarization, Sabattier effect, and photograph-photogram combinations. He obtained color gradations not by toning but during print development. His techniques extended those of Man Ray and Christian Schad both in craft and visual effect. He exhibited with ČKFA in Olomouc, the Photo Exhibition of the Three (Fotovýstava tří, or f3), and the Photo Group of the Four (Fotoskupina čtyř, or f4). In 1935–37 he participated in the three International Photography Exhibitions in Prague.

Selected reference: Dufek, Antonín. "Otakar Lenhart's Self-portrait (Otakar Lenhart's Selbstporträt)." Fotogeschichte (West Germany), vol. 6, no. 21, pp. 44–48.

• EMIL ARTUR LONGEN
(Emil Artur Pitterman)

Actor, theater and film director, novelist, playwright, screenwriter, and painter
Born July 29, 1885, Pardubice, Bohemia
Died April 24, 1936, Benešov, Czechoslovakia

Having studied painting since 1902, Longen participated at the first Osma exhibition in 1907. He

frequented Prague's cafés and about 1910 began to perform at various cabarets. In 1911 he made three short slapstick films based on his cabaret persona: *Rudi at the Christening Party (Rudi na křtinách)*, *Rudi Fools Around (Rudi na záletech)*, and *Rudi the Sportsman (Rudi sportsmanem)*. In 1920 he founded the avant-garde theater Revolutionary Stage (Revoluční scéna), which produced a number of important plays, including Jaroslav Hašek's *The Good Soldier Švejk (Dobrý voják Švejk)* and *Tonka of the Gallows (Tonka Šibenice)* by Egon E. Kisch. His acting, like his painting, was influenced by Expressionism. He performed in German and Czech films and collaborated with the comic actor Vlasta Burian, who was the subject of Longen's first novel. He also wrote plays and film scripts, including the screenplay for Karel Anton's *The Imperial and Royal Field Marshal (C.a.k. polní maršálek)*, 1930), the greatest box office success of the 1930s.

Selected publications: *The King of Comedians (Král komiků*, Prague: Synek, 1927); *Jaroslav Hašek* (Prague: Beaufort, 1928); *Actress (Herečka*, Prague: Pokrok, 1929).

Selected references: Černý, František. "Postscript (Doslov)." In Emil A. Longen, *The Imperial and Royal Field Marshal (C.a.k. polní maršálek a jiné hry)*. Prague, 1961.

• JAN LUKAS

Photographer, editor, and filmmaker
Born September 13, 1915, České Budějovice
Lives in New York City

Lukas began to photograph as a teenager and studied at graphic institutes both in Prague and in Vienna. While still a student, he began a successful career as a magazine photographer, publishing in most major European periodicals between world wars. During 1936–38 Lukas worked with Alexander Hackenschmied in the film department of the Baťa Company. From 1945 to 1948 he served as photo-editor for the Melantrich publishers, which had employed him as a photographer earlier. In 1949 he joined the newly established photo section of the Union of Fine Artists. Between 1958 and 1965, when he left Czechoslovakia, Lukas worked with Artia, a Czech publisher that distributes its books only in western countries. He published seven books with Artia and nine with publishers in London and Paris. He has continued to work as a photojournalist and to exhibit his photographs in the United States.

Selected publication: *The Islanders*, Chelsea, Michigan: Bookcrafters, 1987. Introduction by William F. Buckley.

Selected reference: Frynta, Emmanuel. *Jan Lukas: Photography (Jan Lukas. Fotografie)*. Prague: Artia, 1961.

• GUSTAV MACHATÝ

Film director and actor
Born May 9, 1901, Prague
Died December 13, 1963, Munich

Machatý began to work in film in his teens, and in 1920 he traveled to the United States where he held a number of odd jobs, including that of stuntman and extra. In 1924 he returned to Czechoslovakia, playing a minor role in a Karel Lamač film. In 1926 he directed *The Kreutzer Sonata (Kreut-*

zerova sonáta), a psychological drama based on a Tolstoy story, that established Machatý's reputation. The themes of marital infidelity and sexuality also appear in *Erotikon* (1929) and in *Ecstasy (Extase*, 1933), his best-known film. He also made *From Saturday to Sunday (Ze soboty na neděli*, 1931), a realistic rendering of a secretary's encounter with romance. His comedies were less successful. From 1934 on he made films abroad in Austria *(Nocturne*, 1934) and Italy *(Ballerine*, 1936), traveling to Hollywood in 1936 where for three years he made only short films or worked on feature films by other directors. In 1939 he directed *Within the Law* and in 1945 he made his best American feature, *Jealousy*. After the war he lived and taught directing in West Germany.

Selected publication: "Ecstasy (Extase)," *Film* (Prague, April 1, 1933).

Selected reference: Váňa, Otakar. *Gustav Machatý*. Prague: Československý filmový ústav, 1971.

• EVŽEN MARKALOUS

Photomontagist and photographer
Born 1906, Prague
Died 1971, Prague

In the 1920s Markalous, a physician, joined Devětsil in Brno. Son of the editor-in-chief of *Weekly Variety (Pestrý týden)*, he began to photograph in 1924, creating collages and photomontages for a number of avant-garde periodicals. His photomontages show the influence of Dadaism and Constructivism and are usually categorized as image poems. The few surviving montages are at Museum Folkwang, Essen.

• ALFONS MUCHA

Painter, printmaker, photographer, illustrator, and designer
Born July 24, 1860, Ivančice, Moravia
Died July 14, 1939, Prague

After studies in Munich and Paris, Mucha worked as an illustrator for publishing houses and pictorial magazines in Paris where he met Paul Gauguin in 1891. In 1894 he achieved great success with a poster for Sarah Bernhardt, designing a number of other posters for her theater productions. He began to photograph the models he used for his designs and paintings in the mid 1890s. His distinctive ornamental style was called *le style Mucha* and he went on to become a leading representative of Art Nouveau. Between 1904 and 1910 he painted and taught in France and the United States. From 1910 to 1928 he worked in Prague on a monumental series of paintings devoted to the history of the Slavic people.

Selected references: *Alphons Mucha*. Exh. cat. Paris, Darmstadt, Prague, 1980; Mucha, Jiří, Aaron Scharf, and Marina Henderson. *Alphonse Mucha: Posters and Photographs*. London and New York: Academy Editions and St. Martin's Press, 1974; Ovenden, Graham. *Alphonso Mucha: Photographs*. London and New York: Academy Editions and St. Martin's Press, 1974.

• BOHUMIL NĚMEC

Graphic artist, stage and book designer, and photographer

Born January 15, 1912, Ždánice, Southern Moravia
Died April 4, 1985, Prague

As a student of the Functionalist graphic designer Emanuel Hrbek in Brno, Němec became a founding member of the Photo Group of the Five (Fotoskupina pěti, or f5). Like other members, he preferred experimental processes, producing work with a high degree of tonality and flatness. In the late thirties his themes became more original with symbolic subtexts and darker tonalities, reflecting Surrealism and the oppressive atmosphere of the times. In 1936 Němec worked as a graphic artist for *Popular Newspaper (Lidové noviny)*, and until 1946 he designed glass and photographed and designed exhibition installations at the Topič Salon in Prague. He created outstanding advertising photographs, was stage designer at Jindřich Honzl's 99 Seats Theater (Divadlo pro 99), and designed and decorated a number of books. After World War II he worked on the *New Thought (Nová mysl)* periodical. He exhibited in the f5 exhibitions in Prague, Brno, Znojmo, Hradec Králové, and České Budějovice between 1934 and 1936. He also participated in the *Second International Exhibition of Social Photography* (1934) and the 1936 *International Exhibition of Photography*, both in Prague.

Selected reference: Dufek, Antonín. *Avant-garde Photography during the '30s in Moravia (Avant-gardní fotografie 30 let na Moravě)*. Exh. cat. Olomouc: OGVU, 1981.

• JAROSLAV NOHEL

Graphic artist and photographer
Born May 18, 1914, Újezd near Brno
Died October 29, 1977, Olomouc

From 1934 Nohel worked primarily as an advertising graphic artist, with long periods of unemployment. He photographed mainly between 1933 and 1939. He was a member of the Photo Group of the Four (Fotoskupina čtyř, or f4) and Photo Group of the Five (Fotoskupina pěti, or f5) and participated in the Photo Exhibition of the Three (Fotovýstava tří, or f3). His early work shows the purest manifestations of New Photography, using Neue Sachlichkeit and Constructivism as points of departure. He experimented primarily with the optical qualities of photography but also with the print-making process, making photograph-photograms. After 1935 content became more important, supported by titles that now unfortunately cannot be linked to specific works, such as *Free Love* and *New Life*. He leaned more to Surrealism, in photographs of arranged Surrealist objects, and to imaginative work reflecting the abstract trends of the 1930s. He participated in the *Second International Exhibition of Social Photography* in Prague (1934), in f5 exhibitions, and in the 1936 *International Exhibition of Photography* in Prague.

Selected reference: Dufek, Antonín. *Avant-garde Photography during the '30s in Moravia (Avant-gardní fotografie 30 let na Moravě)*. Exh. cat. Olomouc: OGVU, 1981.

• OLDŘICH NOUZA

Poet, painter, photographer, and teacher
Born May 25, 1903, Doudleby nad Orlicí

Died May 29, 1974, Prague

A member of Linie between 1931 and 1939, Nouza also exhibited with the Fine Artists' Association (Sdružení výtvarníků) in Prague and České Budějovice. He published drawings, pictures, photographs, and texts in avant-garde periodicals including *Review of Devětsil (ReD)*, *Linie*, *Index*, and others. Influenced by Josef Bartuška, he developed his own method of creating hallucinatory images of reality that evoked Surrealism. His drawings and paintings, however, were inspired by Constructivism.

Selected publication: "Poet with the Magic Box (Básník s kouzelnou skříňkou)," *Linie* (České Budějovice), vol. 3, no. 10 (April 1934), pp. 79–80.

Selected reference: Dufek, Antonín. *Czech Photography 1918–1938 (Česká fotografie 1918–1938)*. Exh. cat. Moravská galerie v Brne, 1981.

• ADA NOVÁK

Painter and photographer
Born February 12, 1912, České Budějovice
Lives in České Budějovice

Photographing since 1927, Novák studied painting with Willy Nowak at the Academy of Fine Arts in Prague (1930–36). He was a member of the SČVU and of Fotolinie, earning the title "Artist of Merit" in 1982. His original, impulsive images represent a radical evaluation of the expressive possibilities of the snapshot, and the unconventional character of his shots is often shocking even today. He produced inventively conceived nudes, portraits, and still lifes, images about work and architecture, and montages close to Surrealism but influenced more by Soviet avant-garde film. His photographs are marked by immediacy and the artist's subjectivity. Like other Fotolinie members, he was interested in unusual angles and themes and using projected shadows in compositions while particularizing reality. He exhibited with Fotolinie in the thirties and received retrospective exhibitions in České Budějovice (1971, 1981) and in Prague (1982).

Selected references: Formánek, V. *Ada Novák*. Exh. cat. České Budějovice, 1980; Tětiva, V. *Ada Novák*. Exh. cat. České Budějovice, 1981.

• KAREL NOVÁK

Teacher and photographer
Born January 7, 1875, Horažďovice
Died August 11, 1950, Prague

While living in Germany, Novák became a partisan of Art Nouveau Pictorialism, working with carbon and gum bichromate processes. He taught at the Viennese Graphische Lehr-und Versuchsanstalt in 1910–14. Returning to Prague in 1919, he cofounded and from 1920 to 1935 directed the department of photography at the State Graphic School. Only a portion of his work is known, and for some authorship is only attributed, but samples of his students' work are fully in keeping with contemporary progressive advertising. He exhibited at photographic salons and had a retrospective exhibition in 1951 at the Horažďovice Museum.

Selected reference: Stárek, Jan. *Karel Novák*. Monograph. *Photography Review (Revue fotografie)*, no. 4 (1985).

• JAN ARNOLD PALOUŠ

Film director, sports journalist, and writer
Born October 25, 1888, Prague
Died September 25, 1971, Prague

After studying with František Zavřel, a leading director and proponent of Expressionist theater, Palouš in 1914 directed the medium-length film *The Nightmare (Noční děs)* in collaboration with actors from the Vinohrady Theater in Prague and using a script by František Langer, a member of the Skupina. In 1918 he directed several films produced by Praga-film, the company founded by Antonín Fencl. Most of these films were short comedies such as *The Devilish Girl (Čertisko)*, *The Dream of the Brother Andrew (Sen fratera Ondřeje)*, and *She Is Sixteen (Šestnáctiletá)*.

Selected publication: *Musketeers with a Hockey Stick (Mušketýři s hokejkou*, Prague: Mladá fronta, 1955).

Selected reference: Bartošek, Luboš. *Our Film (Náš film)*. Prague: Mladá fronta, 1985.

• ZDENĚK PEŠÁNEK

Sculptor, painter, and architect
Born June 12, 1896, Kutná Hora, Bohemia
Died November 11, 1965, Prague

Pešánek studied at the Prague Academy of Fine Arts (1919–24) and studied architecture privately. During the 1920s he made paintings and sculptures influenced by Civilist and Neoclassical trends, collaborated with leading architects, completed three versions of a color piano that combined a chromatic scale with geometric forms, and created kinetic art in the Constructivist spirit. *The Monument of the Fallen Fliers (Pomník padlých letců*, 1924–26) was planned as a kinetic sculpture and light fountain combining movement, light, sound, and film projection. In the late 1920s he created a kinetic sculpture for the Edison Transformer Station in Prague, completed in 1930. He was probably the first artist to use neon light in art, programming its color intervals and variations, as in the sculptures for the Klárov Transformer Station (1930–36). He exhibited his kinetic sculptures at the Museum of Decorative Arts in Prague (1936–37) and designed a neon fountain for the Czechoslovak Pavilion at the 1937 World's Fair in Paris. In 1941 he published *Kinetic Art (Kinetismus)* the first book on the subject. Changes after World War II prevented Pešánek from completing any further projects.

Selected publications: "Light Kinetic Sculpture (Světelně kinetická plastika)," in *Acta scaenografica* (Prague, 1964); "Notes on the Aesthetic of Light Kinetics (Poznámky k estetice světelné kinetiky)," *Výtvarné umění*, vol. 9 (1959); "On Light, Color Light, and Kinetic Light in Fine Arts (O světle, světle barevném a kinetickém ve výtvarném umění)," *Kultura*, no. 33 (1958); *Kinetic Art (Kinetismus*, Prague: Česká grafick unie, 1941).

Selected references: Hartmann, Petr. "The Kinetic Art of Zdeněk Pešánek (Kinetická tvorba Zdeňka Pešánka)." *Výtvarné umění*, vol. 14 (1966); Konečný, Dušan. "Zdeněk Pešánek and Kinetic Art in Czechoslovakia (Zdeněk Pešánek a kinetismus v Československu)." In *Acta scaenografica*. Prague: Scénografický ústav, 1966; Šmejkal, Fran-

tišek. "Český konstruktivismus." *Umění*, vol. 30 (1982), pp. 236–38.

• FRANTIŠEK PILÁT

Film technician, teacher, and photographer
Born February 8, 1910, Liptál
Died August 31, 1987, Prague

After studies at Brno College of Technology, Pilát began to photograph in the late 1920s and by the end of 1930 had made the film *The Light Penetrates the Dark (Světlo proniká tmou)* in collaboration with Otakar Vávra. In 1931 he became a member of the Levá fronta (Left Front) and participated in its activities. As a photographer he collaborated with the architect Jiří Kroha on *The Sociological Fragment of Housing (Sociologický fragment bydlení)*. In the mid 1930s he was employed by Baťa Film Studio, which he helped to build. He made a study trip to the United States and after World War II served as deputy technical director of Czechoslovak Film. He taught at FAMU in Prague.

• KAREL PLICKA

Musician, ethnographer, filmmaker, teacher, and photographer
Born October 14, 1894, Vienna
Died May 6, 1987, Prague

Plicka, who studied music science and ethnography, saw photography and film as mediums to document folk songs, customs, and types in Slovakia. In 1928 he made the film etude *In Search of the Slovak People (Za slovenským ludom)*. His second film study, *Along the Hills, Along the Dales (Po horách, po dolách*, 1929), won an award at the 1930 Art Exhibition in Florence. The most important of Plicka's films, *The Earth Sings (Zem spieva*, 1933), transcended ethnographic documentary, approaching the avant-garde in its dramatic use of the camera and editing, and won with other Czech films the Golden Cup of the City of Venice at the 1934 Venice International Film Festival. During the 1930s and 1940s, he continued to make ethnographic films while teaching photography and film at the School of Applied Arts and Crafts in Bratislava from 1937 to 1939. In 1945 he cofounded FAMU.

Selected publications: "How We Filmed (Ako sme filmovali)," *Slovak Vistas (Slovenské pohlady)*, 1930), p. 216; "Notes to the Film *Along the Hills, Along the Dales* (Poznámky k filmu *Po horách, po dolách*)," *We Live (Žijeme)*, no. 3 (1931), p. 78; "Notes About Film—About the Possibilities of Slovak Film (Poznámky o filmu—o možnostiach slovenského filmu)," *Slovak Vistas* (1932), p. 592.

Selected references: Baran, Ludvik. *Karel Plicka*. Prague: Panorama, 1981. Text in 5 languages; Slivka, Martin. *Karel Plicka*. Bratislava: Tatran, 1980.

• JOSEF PODRÁBSKÝ

Teacher, painter, and photographer
Born November 28, 1912, Prague
Lives in Prague

While studying in Rakovník in the twenties, Podrábský and Václav Zykmund became friends. Podrábský studied drawing at the College of Tech-

nology in Prague from 1931 to 1936, then he moved to Ostrava, where he taught drawing. In Ostrava he joined the Association of Moravian Fine Artists (Moravské sdružení výtvarných umělců) and through Zykmund shared the aesthetics of the Skupina Ra. In the mid thirties he experimented with photography and photomontage, but later he concentrated on painting and drawing, which he continued to teach until 1974.

• FRANTIŠEK POVOLNÝ

Graphic artist, writer, and photographer
Born June 22, 1914, Brno
Died May 4, 1974, Brno

Povolný worked as a graphic artist for *Popular Newspaper (Lidové noviny)* in Brno (1934–36) and as a journalist for *Equality (Rovnost)* after World War II. A member of the Photo Group of the Five (Fotoskupina pěti, or f5), he cofounded with Bohumil Němec the design group Program, the Working Five (Pracovní pětka Program). Early influenced by Constructivism and Functionalism, he also made social photographs, designing the installation for the *Second International Exhibition of Social Photography* in Prague (1934). Actively involved in the cultural scene, he was the organizer and theoretician for the f5, writing text for the exhibition in Znojmo (1934) and initiating most of the subsequent exhibitions of f5. Under the later influence of Surrealism and the poet Vítězslav Nezval, he exhibited nonfigurative "fotografiky," being the first before Raoul Ubac, František Hudeček, and others to use the technology of heated emulsion as well as being among the first to arrange Surrealist objects and to photograph found objects. He created other works by treating photographic paper with chemicals and made a series of outstanding portraits and self-portraits. He participated in f5 exhibitions, the *International Exhibition of Photography* (1936), and the *Czechoslovak Avant-garde Exhibition* (1937).

Selected publications: Articles in *Worldview (Světozor)*, no. 19 (1934); *Night (Noc)*, no. 6 (1939); various issues of *Students' Magazine (Studentský časopis)*, *Index*, *Blok*, *Magazine of Cooperative Work (Magazín Družstevní práce)*.

Selected references: Dufek, Antonín. *Avant-garde Photography during the '30s in Moravia (Avantgardní fotografie 30 let na Moravě)*. Exh. cat. Olomouc: OGVU, 1981.

• PŘEMYSL PRAŽSKÝ

Theater, film, and radio director, actor, and screenwriter
Born July 24, 1893, Nýřany, Bohemia
Died August 1, 1964, Prague

In 1915 Pražský worked as a director and actor at the Švanda Theater in Prague. In 1919 he co-directed films with Jan Stanislav Kolár and Vladimír Slavínský. He directed a number of other films, his most successful being *Battalion (Batalion*, 1927). In the 1930s Pražský left filmmaking for radio and became one of the pioneers of this medium, dramatizing a number of novels and plays for radio into the 1950s.

Selected references: *Film a doba* (Prague), no. 9 (1963), pp. 486–87. Rádl, Otto. "The Develop-

ment of Czech Film Direction (Vývoj české filmové režie)." *Studio*, vol. 1 (1930–31), p. 178.

• VOJTĚCH PREISSIG

Painter, printmaker, illustrator, and typographer
Born July 31, 1873, Světec nad Bílinou, Bohemia
Died June 11, 1944, Dachau, Germany

Preissig attended the Prague School of Decorative Arts (1892–97) and by 1893 had begun working as a commercial illustrator. After moving to Paris in 1897, where he made his first color etchings and worked with Alfons Mucha, Preissig returned to Prague in 1903. In 1905 he started a press and published *Czech Prints (Česká grafika)* by leading Czech artists and in 1906 printed his folio *Color Etchings (Barevný lept)* for a New York publisher. In 1907 he had solo exhibitions in Prague and Vienna. In 1910, after publishing his book *Color Etchings and Color Engravings (Barevný lept a barevná rytina*, 1909), he moved to the United States where he taught in New York and Boston. After 1915 he formulated his theories for *Art Fundamental* and worked through a series of studies for cosmological abstraction and collages. In the late 1920s he worked as an independent designer, returning to Prague in 1930, where his solo exhibitions were organized (1931, 1933) and in Hradec Králové (1934). In 1935 he began a series of abstract paintings. After joining the resistance in 1938 and helping to print the clandestine magazine *Into Action (V boj)*, he was arrested by the German authorities in 1941. He died in the Dachau concentration camp.

Selected publication: *Color Etchings and Color Engravings (Barevný lept a barevná rytina*, Prague: Česká grafika, 1909).

Selected references: Vlček, Tomáš. "The Beginnings of Modern Czech Book Art: A Comment on the Work of Vojtěch Preissig, František Kupka, František Bílek, Jan Preisler, Josef Váchal." *Fine Print: The Review for the Arts of the Book*, vol. 13, no. 1 (January 1987), pp. 16–19; Vlček, Tomáš. *Vojtěch Preissig. Prints and Paintings 1932–1938*. Exh. cat. Roudnice nad Labem: Galerie výtvarného umění v Roudnici nad Labem, 1983; *Vojtěch Preissig. 1873–1944*. Exh. cat. Prague: Památník národního písemnictví, Galerie Václava Špály a Nová síň, 1968. Essays by Tomáš Vlček and Jiří Žantovský.

• JAROSLAV PUCHMERTL

Sculptor, photomontagist, and editor
Born October 14, 1916, Kladno
Lives in Prague

Before World War II Puchmertl organized the leftist cultural movement around Kladno. In 1937 he organized an exhibition about Republican Spain, which included his sculpture. Like the work of Václav Zykmund, Josef Istler, Zdeněk Lorenc, and others associated with Skupina Ra with whom Puchmertl was in contact during the forties, his sculpture and photomontages were strongly influenced by Surrealism. Between 1945 and 1948 as an editor for the Publishing House of the Young (Nakladatelství mladých), he published the work of Skupina Ra members. After the war he worked in the cultural department of the Central Committee of the National Front in Prague, eventually

becoming its head. A retrospective of his work, including the photocollages he created between 1940 and 1945, was held in Brno in 1989.

Selected reference: *Skupina Ra*. Exh. cat. Prague: Galerie hlavního města Prahy, 1988.

• VILÉM REICHMANN

Photographer and cartoonist
Born April 25, 1908, Brno
Lives in Brno

In 1945, after working since 1930 as a self-taught photographer and cartoonist, Reichmann became a free-lance photographer in Brno while continuing to work as a cartoonist under the pseudonym Jappy. Between 1951 and 1968 he belonged to the SČVU. Before World War II he was a member of practically all the leftist cultural organizations, collaborating mainly with Levá fronta (Left Front). Influenced by the Depression and war years, he developed a Surrealist style modeled on lyrical interpretations of reality through visual metaphors. His postwar work shows the influence of textural abstraction, Pop Art, absurdist humor, and *arte povera*. His photography series are similar to poem cycles, the most famous being the open-ended associative series *Metamorphoses (Metamorfózy)*, *Magics (Kouzla)*, *Couples (Dvojice)*, and *The Abandoned One (Opuštěná)*. He has had numerous solo exhibitions from 1959 to the present in cities including Brno, Vienna, Brussels, and Frankfurt am Main, and he has participated in Czech and international exhibitions of the Skupina Ra (1947), *Surrealism and Photography* (1966), and many others.

Selected publications: Articles in *Photography Review (Revue fotografie)*, no. 9 (1959), no. 2 (1962); *Czechoslovak Photography (Československá fotografie)*, no. 5 (1963), no. 7 (1965), no. 1 (1966), no. 4 (1975).

Selected references: Dufek, Antonín. *Vilém Reichmann*. Exh. cat. Galerie hlavního města Prahy and Galerie 4, Cheb, 1988; Dufek, Antonín, Zdeněk Primus, and Petr Spielman. *Vilém Reichmann*. West Berlin: Expose Verlag, 1989; Kundera, Ludvík. *Chords from Kunštát (Kunštátské akordy)*. Brno, 1966; Tausk, Petr. "Vilém Reichmann." In *Contemporary Photographers*. Chicago and London: St. James Press, 1988. pp. 844–45; Zykmund, Václav. *Vilém Reichmann: Cycles*. Prague: State Publishing House of Literature, Music, and Art, 1961.

• JAROSLAV RÖSSLER

Photographer
Born May 25, 1902, Smilov, Havlíckuv Brod
Lives in Prague

After apprenticing with František Drtikol and Augustin Škarda (1917–20), Rössler continued to work with Drtikol, influenced by his use of light and shadow and his command of processes like bromoil prints. Rössler, however, evolved his own style, and his *Opus I* (1919–20) presages his Constructivist direction. In 1923 he became the only photographer to join Devětsil. He made photographs from extreme points of view, geometric shapes in cardboard, and vernacular objects as well as photomontages, collages, and advertising "typophotos." He exhibited these with Devětsil

and published in their magazines. He visited Paris in 1925–26, working in the Manuel Frères studio then returned to Prague and photographed for the Liberated Theater (Osvobozené divaldo) and the magazine *Weekly Variety (Pestrý týden)*. In 1927 he moved to Paris, working with Lucien Lorelle and briefly with Manuel Frères, and other commercial studios. On his own he photographed Parisian street life and other popular meeting places such as the race track. Upon returning to Prague in 1935, he and his wife opened a portrait studio, and he did not resume his own work until the 1950s. Primarily experimenting with optical effects and experimental printing processes, he rejected the style of "straight" photography within his earlier work for found and created abstractions. Retrospective exhibitions were held in Prague (1968), Brno (1975), and London (1985).

Selected references: Dufek, Antonín. *Jaroslav Rössler and Jaromír Funke*. London: The Photographer's Gallery, 1985; Fárová, Anna. *Jaroslav Rössler*. Brno: Fotokabinet Jaromír Funke, 1975; Tausk, Petr. "Jaroslav Rössler." In *Contemporary Photographers*, 2nd ed. Chicago and London: St. James Press, 1988. pp. 876–77.

• MARIE ROSSMANNOVÁ

Photographer
Born December 9, 1909, Nitkovice, Moravia
Died May 29, 1983, Prague

Rossmannová, with her husband-to-be Zdeněk Rossmann, a prominent Functionalist designer, studied photography at the Bauhaus in 1930–31. In the 1920s she participated in the activities of Devětsil in Brno. During World War II she and her husband were interned; only fragments remain of her pre-war Bauhaus-inspired and social photography, published in magazines such as *Index*, *Mass (Dar)*, *Center (Středisko)*, and *World in Pictures (Svět v obrazech)*. She exhibited in the *Second International Exhibition of Social Photography in Prague* (1934) and in the exhibitions *Czech Photography 1918–1938* in Brno (1981), Essen (1984), and Lódź.

• JOSEF ROVENSKÝ

Film director and actor
Born April 17, 1894, Prague
Died November 5, 1937, Prague

After playing at vanguard theaters and cabarets, Rovenský in the 1920s became one of the busiest actors of Czech cinema. He played in several German films and in the early 1920s made several films in collaboration with Václav Wasserman. Five years later he directed two features then created in 1933 his best film, *The River (Řeka)*, the story of a country boy and girl that was original in its sincere and lyrical realism. The 1934 films *Red Morning Sky (Za ranních červánků)* and *The Tatras Romance (Tatranská romance)* were less successful. In collaboration with the screenwriter Otakar Vávra, he adapted the folklore drama *Maryša* (1935) by the Mrštík brothers. He made films in Austria and Germany then in 1937 directed *The Guard No. 47 (Hlídač č. 47)* from a script by Vávra based on Josef Kopta's novel. Work on this film and a film adaptation of the popular novel *Virginity (Panenství*, 1937) was interrupted by his untimely death.

Selected references: Bartošek, Luboš. *Josef Rovenský*. Prague: Československý filmový ústav, 1972; Wasserman, Václav. *Josef Rovenský*. Prague: SPN, 1957.

• DRAHOMÍR JOSEF RŮŽIČKA

Photographer
Born February 8, 1870, Trhová Kamenice
Died September 30, 1960, New York City

Růžička's family immigrated to the United States in 1876. He studied medicine in Vienna (1888–93) and opened a medical practice in New York. Between 1921 and 1936 he visited Czechoslovakia regularly. Photographing seriously since 1909, Růžička fundamentally influenced Czech photography with the principles of American Pictorialism by bringing American magazines and photographs to Czechoslovakia to exhibit. A member of Pictorial Photographers of America, ČKFA, and the Královské Vinohrady KFA, he based his work on the traditions of Peter Henry Emerson as well as Alfred Stieglitz, Clarence H. White, and other late American or purist Pictorialists. He insisted on the purity of the photographic process (i.e., straight photography), rejecting processes fashionable in Art Nouveau Pictorialism although allowing soft-focus lenses. The emphasis on light problems was typical of his work, but about 1930 he began to evolve a more matter-of-fact Neue Sachlichkeit style. He exhibited with the ČKFA (1921, 1923, 1925, and 1929), and KFA (1925), and in many international salons of photography, particularly those of the Pictorial Photographers of America.

Selected publications: Articles in *Photographic Horizon (Fotografický obzor)*, 1925, 1926, and 1936, including "Experiences of a City Amateur (Zkušenosti městského amatéra)" and "C.H. White," both in 1926.

Selected references: Bursík, J. *The Life and Work of D.J. Růžička (Život a dílo D.J. Růžička)*. Thesis. Prague: FAMU, 1980; Jeníček, Jiří. *Drahomír Josef Růžička*. Prague: State Publishing House of Literature, Music, and Art, 1959.

• ZDENĚK RYKR

Painter, stage designer, and graphic designer
Born October 10, 1900, Chotěboř, Bohemia
Died January 15, 1940, Prague

Rykr studied art history and classical archaeology at the Charles University, Prague (1920–25). In 1921 he exhibited in the third exhibition of the Tvrdošíjní (Stubborn Ones) and his work from this period reflects Tvrdošíjní's influence, from Magic Realism to Neoclassicism to Social Realism. He worked as a graphic artist in advertising and for manufacturers such as Orion and Baťa. In the 1930s he frequently traveled to Paris and contributed to the magazine *Delta*. In 1937 he joined the Salon des Surindépendants. A self-taught artist, he made innovative works that include assemblages from 1933–34 containing ephemeral mediums—straw, twigs, and thread—and collages mounted behind glass. His paintings show the influence of Oriental calligraphy and automatism as well as kitsch and popular culture. He published two books with his wife Milada Součková in 1939. Following the occupation of

Prague, he committed suicide by throwing himself before a Paris-bound express train.

Selected publication: "Painter's Meditations That Are Almost Physical (Meditace malířovy téměř fyzikální)," *Orfeus*, vol. 1, no. 2 (1920–21), pp. 48–52.

Selected references: Urban, Jiří. "The Lonely Runner Zdeněk Rykr (Osamělý běžec Zdeněk Rykr)." *Umění* (Prague), vol. 28, no. 1 (1980); *Zdeněk Rykr*. Exh. cat. Liberec: Galerie výtvarného umění, 1965. Essay by Jindřich Chalupecký.

• ADOLF SCHNEEBERGER

Photographer
Born June 14, 1897, Choceň
Died December 15, 1977, Prague

One of the central figures of Czech photography in the 1920s, Schneeberger was expelled from the ČKFA only to cofound the Photo Club Prague (Fotoklub Praha) in 1922. Expelled again with Jaromír Funke and Josef Sudek, he cofounded in 1924 the ČFS, like Photo Club Prague an association advocating the principles of straight photography. He served as president of ČFS from 1924 to 1929. In 1931–33 he was again a member of ČKFA, designing the 1931 exhibition poster. His progressive work took on a Neue Sachlichkeit approach also reflecting the tenets of Constructivism and Functionalism. Among his most original works are inventive minimalist compositions that often incorporate natural motifs. He exhibited with various clubs and has appeared in most surveys of Czech photography between 1918 and 1938.

Selected publication: "Why We Were Expelled and What Followed (Proč jsme byli vyloučeni a co následovalo)," *Photography '78 (Fotografie '78)*, no. 1 (1978).

Selected references: Dufek, Antonín. *Adolf Schneeberger: Photographic Work 1919–1948*. Prague: Odeon, 1983; Váša, J. *Photographic Work of Adolf Schneebergar (Fotografická tvorba Adolf Schneeberger)*. Thesis. Prague: FAMU, 1978.

• JOSEF ŠÍMA

Painter and illustrator
Born March 19, 1891, Jaroměř, Bohemia
Died July 24, 1971, Paris

Šíma studied at the Prague School of Decorative Arts and the Academy of Fine Arts (1911–14). In 1921 he exhibited with the Tvrdošíjní (Stubborn Ones) and later that year moved to Paris. He joined Devětsil in 1923, writing for Czech magazines and illustrating French and Czech publications in the 1920s. His work evolved from the poetic and naive realism of the early Devětsil program, to geometric abstraction, to abstract and symbolic landscapes. In 1927 he cofounded the Surrealist Group Le Grand Jeu and in 1928 exhibited at the Aventinum Garret (Aventinská mansarda) in Prague. In the mid 1930s he returned to narrative subjects, exploring themes of cosmic unity after World War II. He was one of the leading proponents of lyrical abstraction in the 1950s and 1960s. He created the stained-glass windows for the Church of Saint James in Reims in the 1960s, and in 1968 the National Gallery in Prague and the Musée National d'Art Moderne in Paris

organized a retrospective of his work.

Selected references: Šmejkal, František. *Josef Šíma*. Prague: Odeon, 1988; Linhartová, Věra. *Josef Šíma, His Friends, His Contemporaries (Josef Šíma, ses amis, ses contemporains)*. Brussels: La Connaissance, 1974; *Joseph Šíma 1891–1971*. Exh. cat. Bochum: Museum Bochum, 1974. Essays by Peter Spielmann, et al.

• OTAKAR ŠTÁFL

Film director, painter, and graphic designer
Born December 30, 1884, Havlíčkův Brod, Bohemia
Died 1945, Prague

In 1908 Štáfl had his first one-person exhibition at the Topič Salon in Prague. He became a leading book and poster designer and in 1912 began to collaborate with the film production company ASUM-Film, for which he designed not only the logo but also sets and costumes. In 1913 he directed the films *Andula Is Jealous (Andula žárlí)*, *Estrella*, and *American Duel (Americký souboj)*, codirecting with Max Urban *The End of Love (Konec milování)*.

Selected references: Bartošek, Luboš. *Our Film (Náš film)*. Prague: Mladá fronta, 1985.

• BOHUMIL ŠŤASTNÝ

Photographer
Born June 15, 1905, Prague
Lives in Prague

Šťastný photographed for *Weekly Variety (Pestrý týden)*, the leading Czech picture magazine, and was among the first Czech photographers to do advertising photographs for the Neubert Company, which printed *Weekly Variety* using rotogravure. A member and one-time president (1932–48) of the Czech Photographic Association (Český fotografický spolek), after 1945 he taught at the State Graphic School in Prague and served on the *Photography (Fotografie)* editorial board in 1945–48. For a magazine series by Evžen Markalous about Prague hospitals, Šťastný photographed distorted images reflected on metal surfaces of medical equipment, five of which were exhibited as works by Markalous at the Stuttgart *Film und Foto* exhibition (1929). Šťastný is best known for his advertising photography from the 1930s, which approaches Surrealist fetishism, and his 1947 nudes that combine "geometric" lighting with the Sabattier effect. He participated in the 1937 *International Advertising Photography Exhibition* in Prague and was included in the Brno exhibition *Czech Photography 1918–38* in 1981.

• JINDŘICH ŠTYRSKÝ

Painter, photographer, stage designer, book designer, illustrator, and writer
Born August 11, 1899, Čermná, Bohemia
Died March 21, 1942, Prague

Štyrský studied at the Prague Academy of Fine Arts (1920–23). In 1922 he met Toyen, who became his life-long friend and collaborator. In 1923 he joined Devětsil, becoming a leading proponent of Poetism, and participated in the Devětsil exhibition *Bazaar of Modern Art* with collages and photomontages called image poems. Influenced in his early paintings by Cubism and Constructivism, he was a pioneer in photomontage and avant-garde book design. From 1925 to 1929 while in Paris, he and Toyen developed a lyrical mode of abstraction called Artificialism, and by the late 1920s he began assimilating Surrealist themes and motifs. From 1930 to 1933 he coedited and contributed to the Prague *Erotic Review (Erotická revue)*. He exhibited Surrealist works in the exhibition *Poetry 1932* and in 1934 created two series of Surrealist photographs, *Frogman* and *Man with Blinders*. In 1935 he created the series *Paris Afternoon*. He cofounded the Surrealist Group in Prague, participating in its first exhibition at S.V.U. Mánes in 1935. From 1935 until World War II he exhibited in all international exhibitions of Surrealism. In 1938 a retrospective of his and Toyen's work traveled to Prague, Brno, and Bratislava. In 1940 he completed the book *Dreams (Sny)* but was able to publish only a fragment privately before his death from pneumonia.

Selected publications: *Dreams (Sny*, Prague: Odeon, 1970); "Poet (Básník)," *The Aventinum Discourses (Rozpravy Aventina)*, vol. 3, no. 20 (1928), p. 241; "Three Chapters from the Work in Progress (Tři kapitoly z připravované práce)," *Horizont*, vol. 1, no. 1 (1927), p. 134; "Artificialismus," *Review of Devětsil (ReD)*, vol. 1, no. 1 (1927), p. 28; "Picture (Obraz)," *Disk 1* (December 1923), pp. 1–2; "Images (Obrazy)," *Veraikon*, no. 10 (1924), p. 38; "Surrealist Photography (Surrealisticka fotografie)," *Czech Word (České slovo*, January 30, 1935).

Selected references: Mrázková, Daniela. "Jindřich Štyrský." In *Contemporary Photographers*. Chicago and London: St. James Press, 1988. pp. 1000–1002; Nezval, Vítězslav, and Karel Teige. *Štyrský and Toyen (Štyrský a Toyen)*. Prague: František Borový, 1948; *Surrealist and Imaginative Photography in Czechoslovakia 1930–1960 (Peinture surréaliste et imaginative en Tchécoslovaquie 1930–1960)*. Exh. cat. Paris: Galerie 1900/2000, 1983. Essays by Edouard Jaguer and František Šmejkal; *Štyrský, Toyen, Heisler*. Exh. cat. Paris: Musée National d'Art Moderne, 1982. Essays by František Šmejkal, Radovan Ivsic, Annie Le Brun, et al.; Teige, Karel. *J. Štyrský*. Prague: Edice Prameny, 1947.

• JOSEF SUDEK

Photographer
Born March 17, 1896, Kolín nad Labem
Died September 15, 1976, Prague

Sudek began photographing with Art Nouveau Pictorialist effects while apprenticed as a bookbinder, but after an injury in World War I that lost him his arm, he turned to photography as an art and profession. With other radicals in the ČKFA, he made unmanipulated photographs, defining in the 1920s Czech purist Pictorialism in genre and landscape photography. Joining the Photo Club Prague (Fotoklub Praha) and, after expulsion, cofounding the ČFS with Jaromír Funke, Adolf Schneeberger, and others, Sudek assumed a leadership role in Czech photography. He established a studio with Schneeberger in 1927. Working for Cooperative Work (Družstevní práce) in 1928–36, he became a leading representative of Functionalism, concentrating on advertising photography and portraits. In 1940 he switched to large negative formats and contact prints that allowed a more detailed and intimate presentation of reality, and he began the series *From the Window of My Studio*. He continued to photograph landscapes, later turning to Minimalist still lifes with some Surrealist influences. He exhibited with ČKFA, ČFS, and other groups as well as in exhibitions of *New Czech Photography* (1930, 1931), *Social Photography* (1933), *International Photography* (1936), and numerous surveys in Czechoslovakia and abroad.

Selected publications: *Janáček's Hukvaldy* (Prague, 1971); *Charles Bridge (Karlův most*, Prague: State Publishing House of Literature, Music, and Art, 1961); *Prague Panoramas (Praha panoramatická)*, poem by Jaroslav Seifert (Prague: State Publishing House of Literature, Music, and Art, 1959); *Czech Castles (Naše zámky*, Prague, 1948); *Praha—Josef Sudek*, text by Vítězslav Nezval (Prague: Svoboda, 1948); *Baroque Prague* (Prague: Česká grafická unie, 1947); *Magic in Stone* (London: Lincolns-Prager, 1947); *Prague Castle (Pražský hrad*, Prague: SFINX, 1947); *Saint Vitus (Svatý Vít)*, portfolio (Prague: Cooperative Work [Družstevní práce], 1928).

Selected references: Bullaty, Sonya. *Sudek*. New York: Clarkson N. Potter, 1978, rev. ed., 1986. Introduction by Anna Fárová; Fárová, Anna. *Josef Sudek*. Milan: Gruppo Editorial Fabri, 1983; Kirshner, Zdeněk. *Josef Sudek*. Prague: Panorama, 1982, 1986; Linhart, Lubomír. *Josef Sudek*. Prague: State Publishing House of Literature, Music, and Art, 1956; Řezáč, Jan. *Sudek*. Prague: Artia, 1964; Important exhibition catalogues include those by Anna Fárová (Prague, 1976), Antonín Dufek (Brno, 1976), George Eastman House (1974), and International Center of Photography (1977).

• HUGO TÁBORSKÝ

Graphic artist, painter, and photographer
Born April 27, 1911, Brno
Lives in Brno

Working as an advertising graphic artist (1929–37) then in glass and glazing and later in a factory, Táborský photographed from the end of the 1920s until the 1940s. He was a member of the Photo Group of the Five (Fotoskupina pěti, or f5) and of all the f5 members had the closest relationship with the Functionalist designer and teacher Emanuel Hrbek; Táborský was considered the f5 Constructivist. His early work fell within the framework of New Photography, influenced by Moholy-Nagy and Tschichold, among others, and in 1933 Táborský began creating nonfigurative geometrical photograms and imaginative self-portraits using the gradual destruction of the image. He exhibited in various f5 exhibitions.

Selected references: Dufek, Antonín. *Avant-garde Photography during the '30s in Moravia (Avantgardní fotografie 30 let na Moravě)*. Exh. cat. Olomouc: OGVU, 1981; Dufek, Antonín. "Photo Group of the Five (Fotoskupina pěti)." *Czechoslovak Photography (Československá fotografie)*, vol. 29 (1978).

• KAREL TEIGE

Art critic, theoretician, designer, editor, painter, and photomontagist
Born December 13, 1900, Prague
Died October 1, 1951, Prague

First a painter and printmaker contributing to German avant-garde periodicals *Der Sturm* and *Die Aktion*, Teige began to write on art and literature for numerous Czech periodicals after World War I. He cofounded Devětsil in 1920 and was its leading theoretician and spokesman until its demise in 1931. He also participated in other avant-garde organizations including the Levá fronta (Left Front), the Union of Socialist Architects, and the Surrealist Group. He edited or coedited a number of periodicals including *Orfeus* (1921), *Construction (Stavba*, 1923–31), *Guest (Host*, 1924), and *Review of Devětsil (ReD*, 1927–31), as well as anthologies of art, architecture, and literature. Well traveled, he lectured at the Bauhaus on the sociology of architecture in the late 1920s. He designed books and periodicals that advanced the new typography and was a pioneer of photomontage. He wrote on art, architecture, film, photography, typography, theater, and literature, advocating the principles of Poetism and Constructivism and later Surrealism.

Selected publications: *Surrealismo, realismo socialista, irrealismo 1934–1951* (Turin, 1982); The Liquidation of "Art"; Analyses, Manifestos *(Liquidierung der "Kunst"; Analysen Manifeste*, Frankfurt am Main: Surkhamp Verlag, 1968); *The World of Construction and Poetry: Articles from the 1920s (Svět stavby a básně. Statě z dvacátých let*, Prague: Československý spisovatel, 1965); "The Paths of Czechoslovak Photography (Cesty československé fotografie)," *Blok*, vol. 2, no. 6 (1947), pp. 77–82; "Photography and Art (Foto a umění)," *Blok*, vol. 2, no. 6 (1947), p. 191; "On Photomontage (O fotomontáži)," *We Live (Žijeme)*, vol. 2, nos. 3–4 and 5–6 (1932); "The Tasks of Modern Photography (Uklo moderní fotografie)," *Moderná tvorba úžitková* (Bratislava, 1931); "Painting and Poetry (Malířství a poesie)," *Disk 1* (December 1923), pp. 19–20; "Modern Photography (Moderní fotografie)," *The Aventinum Discourses (Rozpravy Aventina*, 1930); "Foto Kino Film," *Life II (Život II*, Prague: Umělecká Beseda, 1922).

Selected references: Bohatec, Milan. *Karel Teige and the Book (Karel Teige a kniha)*. Prague: NČVU, 1965; Effenberger, Vratislav. "O podstatnost tvorby." In *Karel Teige. Zápasy o smysl moderní tvorby*. Prague: Československý spisovatel, 1969; Effenberger, Vratislav. *Karel Teige: Surrealistic Collages (Karel Teige: Surrealistické koláže)*. Exh. cat., Brno, 1966; Král, Petr. *Karel Teige and Film (Karel Teige a film)*. Prague: Československý filmový ústav, 1966.

• TOYEN (Marie Čermínová)

Painter and printmaker
Born September 21, 1902, Prague
Died November 9, 1980, Paris

Toyen studied at the Prague School of Decorative Arts (1919–22). In 1922 she met Štyrský, with whom she worked for two decades. In 1923 she joined Devětsil. Her early work was influenced by Cubism, Purism, and briefly by naïve art. While in Paris in 1925–29, she and Štyrský developed Artificialism and exhibited at the Galerie de l'art (1926) and Galerie Vavin (1927). Turning to Surrealism in the early 1930s, she made illustrations for the Prague magazine *Erotic Review (Erotická revue)*, joined S.V.U. Mánes in 1933, and cofounded the Surrealist Group in Prague in 1934, participating in both Czech and international Surrealist exhibitions. After the German occupation she published two books clandestinely with Jindřich Heisler, *The Specters of the Desert (Přízraky pouště*, 1937–38) and *From the Dungeons of Sleep (Z kasemat spánku*, 1941). In 1945 she exhibited at the Topič Salon and two years later at the Denise René Gallery. She moved to Paris in 1947 and joined André Breton's Surrealist group. She had solo exhibitions in Paris for many years and a 1966 retrospective of hers and Štyrský's works was held in Brno and Prague.

Selected publications: "Poet (Básník)," *The Aventinum Discourses (Rozpravy Aventina)*, vol. 3, no. 20 (1928), p. 241; "Three Chapters from the Work in Progress (Tři kapitoly z připravované práce)," *Horizont*, vol. 1 (1927), p. 134; "Artificialismus," *Review of Devětsil (ReD)*, vol. 1, no. 1 (1927), p. 28.

Selected references: Bischof, Rita, ed. *Toyen: Das malerische Werk*. Frankfurt am Main: Verlag neue Kritik, 1987. Essays by André Breton, Jindřich Heisler, et al.; Breton, André, Jindřich Heisler, and Benjamin Peret. *Toyen*. Paris: Editions Sokolova, 1953; Ivsic, Radovan. *Toyen*. Paris: Filipacchi, 1974; *Štyrský, Toyen, Heisler*. Exh. cat. Paris: Musée National d'Art Moderne, 1982. Essays by František Šmejkal, Radovan Ivsic, Annie Le Brun, et al.; Von Holten, Ragnar. *Toyen: A Surrealist Visionary (Toyen. En surrealistisk visionär)*. Köpnig: Lindsors sörlag, 1984.

• MAX URBAN

Architect, urban planner, and filmmaker
Born 1882, Prague
Died 1952, Prague

In 1911 Urban became a member of the Skupina, which promoted Cubism in Central Europe. In 1912 he and his wife, Anna Sedláčková, founded the film production company ASUM-Film. In two years they produced fourteen narrative films, with Urban doing the photography for most of them. He directed *The Lady with a Borzoi (Dáma s barzojem*, 1912), *The Divorced Woman (Rozvedená paní*, 1912), *Idyll of Old Prague (Idyla ze staré Prahy*, 1913), and *The Tragedy of Snow (Tragédie sněhu*, 1913), and he codirected *Clothes Make a Man (Šaty dělají člověka*, 1913) and *The End of a Love Affair (Konec milování*, 1913). During the 1910s and 1920s he specialized in urban planning, designing the first large modern film studio for the A.B. Company at Barrandov in the Prague suburbs in the late twenties.

Selected publication: *The Ideal Prague (Ideální Praha*, 1919).

Selected reference: Bartošek, Luboš. *Our Film (Náš film)*. Prague: Mladá fronta, 1985.

• JOSEF VÁCHAL

Painter, printmaker, writer, book artist, photographer, and sculptor

Born September 23, 1884, Milaveč, Bohemia
Died May 19, 1969, Studeňany

Váchal was educated as a bookbinder and took private lessons in painting. Interested in anarchism, spiritualism, and the occult, Váchal joined the Theosophical Society of Prague in 1903. Influenced by Paul Gauguin, he began to carve primitivist sculptures and everyday objects in 1906. He cofounded the late Symbolist artists' group Sursum in 1910 and participated in its first exhibition in Brno, also publishing his first book. In 1908–14 he wrote, illustrated, printed, and bound ten of his own books and illustrated twenty-two others. His World War I experiences inspired the prints *Front (Fronta*, 1919) and a book *Painter on the Front (Malíř na frontě*, 1929). In 1926 he had his first solo exhibition in Brno. In 1928 he exhibited in the Cologne *Pressa* exhibition and the Florence *International Exhibition of Fine Books* (winning the Grand Prix). In 1934 his first retrospective was held in Prague. In 1940 he moved to eastern Bohemia and began writing novels. A retrospective was held in 1966 in Prague and he was named an "Artist of Merit" in 1969.

Selected publications: *The Recipe-Book of Colored Woodcut (Receptář barevného dřevorytu*, Prague: Josef Váchal, 1934); *Painter on the Front (Malíř na frontě*, Prague: Anna Macková, 1929); *Váchal's Yearbook for 1927 for Friends and Acquaintances (Váchalova ročenka na rok 1927 přátelům a známým*, Prague: Josef Váchal, 1927); *Dime Novel (Krvavý román*, Prague: Josef Váchal, 1924); *The Magic of the Future (Magie budocnosti*, Prague: Josef Váchal, 1922).

Selected references: *Josef Váchal: Work (Josef Váchal. Dílo)*. Exh. cat. Roudnice nad Labem: Oblastní galerie výtvarného umění, 1984. Essays by Jan K. Čelis and Miloš Šejn; Vlček, Tomáš. "The Beginnings of Modern Czech Book Art: A Comment on the Work of Vojtěch Preissig, František Kupka, František Bílek, Jan Preisler, Josef Váchal." *Fine Print: The Review for the Arts of the Book*, vol. 13, no. 1 (January 1987), pp. 16–19.

• KAREL VALTER

Painter and photographer
Born February 17, 1909, České Budějovice
Lives in Tábor

Beginning to photograph in 1928 encouraged by Josef Bartuška, Valter joined Linie and its photo section Fotolinie in 1930. His work is unique for its diptych sequences of images that follow a preset concept as well as momentary inspiration. The images, which are not naturally contiguous, are exhibited as one work. He ranks among the precursors of conceptual art. Later he concentrated on projected shadows, created double exposures and photomontages, and arranged symbolic compositions. In 1934–35 he made a collection of photograms with poetic titles that display a close affinity with abstract trends in imaginative photography of the period; these photographs parallel his drawings. He ceased to photograph in 1936 to concentrate on painting, later being named an "Artist of Merit."

Selected publications: "About Art and Life: A Chat with K. Valter," *Jihočeská Pravda* (1969); *The Bequest of the Leftist Art Group Linie* (České Budějovice, 1975); *Linie* (České Budějovice: Jihočeské Nakladatelstvi, 1980).

Selected reference: Dufek, Antonín. *Czech Photography 1918–1938 (Česká fotografie 1918–1938)*. Exh. cat. Moravská galerie v Brně, 1981.

• VLADISLAV VANČURA

Writer, film director, and playwright
Born June 26, 1891, Háj, Silesia
Died June 1, 1942, Prague

Vančura cofounded the avant-garde group Devětsil, serving as its first chairman. From 1919 on he published stories, articles, novels, and plays, including film poems or scripts in the twenties. With Svatopluk Innemann he codirected *Before the Finals (Před maturitou, 1932)* and in 1933 he made *On the Sunny Side (Na sluneční straně)*. He wrote the script for this innovative film with the poet Vítežslav Nezval and the linguist Roman Jakobson. In 1933–34 in an independent production he made *Faithless Marijka (Marijka nevěrnice)* in collaboration with the writers Ivan Olbracht and Karel Nový. The latter films, however, were box office failures. In 1936 he cofounded the Czechoslovak Film Society and as its representative was a member of the Film Advisory Board. In 1937 he collaborated on two feature films with Václav Kubásek. In 1941 he joined the resistance and in 1942 was arrested by the German secret police and executed.

Selected publications: "Contribution to the Discussion about Speech in Film (K diskusi o řeči ve filmu)," *Slovo a slovesnost*, vol. 1, no. 1 (1935), pp. 39–41; *The Awareness of Continuity (Vědomí souvislosti)*, Prague, 1958).

Selected references: Bartošek, Luboš. *The Tenth Muse of Vladislav Vančura (Desátá Múza Vladislava Vančury)*. Prague: Československý filmový ústav, 1973; Kundera, Milan. *The Art of the Novel (Umění románu)*. Prague: Československý spisovatel, 1960.

• OTAKAR VÁVRA

Film director and screenwriter
Born February 28, 1911, Hradec Králové, Bohemia
Lives in Prague

In 1930 Vávra became a member of the Film and Photo Group of the Levá fronta (Left Front) in Brno. With František Pilát he made the short experimental film *The Light Penetrates the Dark (Světlo proniká tmou, 1930)* devoted to a kinetic sculpture by Zdeněk Pešánek. In 1934 he made *We Live in Prague (Žijeme v Praze)*, which combined fiction and nonfiction sequences, and *Autumn (Listopad)* about a chance encounter of former lovers. In the 1930s he wrote numerous scripts, making his feature debut with *Students' Story (Filozofská historie, 1937)* after Alois Jirásek's novel. He completed Josef Rovenský's film *Virginity (Panenství, 1937)* and directed the historical film *Guild of the Maidens of Kutná Hora (Cech panen kutnohorských, 1938)*. Specializing in adaptations of literary works and historical films, he is one of Czechoslovakia's most productive film directors.

Selected publications: (with Jindřich Honzl) *Proposal for a School of Young Film Professionals (Navrhujeme školu filmového dorostu, Zlín, 1939)*;

Reflections of a Film Director (Zamyšlení režiséra, Prague: Orbis, 1982).

Selected references: Váňa, Otakar. *Otakar Vávra*. Prague: Československý filmový ústav, 1971.

• FRANTIŠEK VOBECKÝ

Painter and photographer
Born November 9, 1902, Trhový Štěpánov
Lives in Prague

Living and studying in Prague and Paris (1926–27), Vobecký began to exhibit his paintings in the late 1920s with S.V.U. Mánes and became an important representative of imaginative painting in the 1930s. Photographing from 1928 to 1937 and resuming work in 1974, he was a member of S.V.U. Mánes and of its photo section and in 1949 joined the SČVU. At first devoted to fashion photography, he began in 1935 to photograph assemblages of collected pictures and objects. Influenced by Max Ernst, he cut out details of his own photographs and different engravings. His work was related to Surrealist montages of chance encounters. These surface arrangements differed from earlier pieces by Jaromír Funke, Walter Peterhans, and Ladislav Berka, being closer to the collages of Karel Teige and Herbert Bayer, and in turn influencing Jindřich Heisler in his assemblage technique. Vobecký's solo exhibitions in Brno (1982) and Prague (1986) were accompanied by catalogues by František Šmejkal. He participated in the 1936 *International Photography Exhibition, Czechoslovak Avant-garde Exhibition (1937), S.V.U. Mánes* in Prague (1938), and numerous important postwar exhibitions in Czechoslovakia and abroad.

Selected references: Jaguer, Edouard. *Mysteries of the Black Room (Les mystères de la chambre noire)*. Paris, 1982; Šmejkal, František. *František Vobecký: Early Work 1926–1938 (František Vobecký. Raná tvorba 1926–1938)*. Exh. cat. Prague: Galerie hlavního města Prahy, 1985.

• JOSEF VOŘÍŠEK

Lecturer, editor, and photographer
Born December 12, 1902, Prague
Died January 1, 1980, Šluknov

Voříšek worked as a construction engineer and designer for the Aero company, where he designed a number of cars and airplanes. Beginning to photograph in the 1920s, he co-organized and photographed the Aero 1500 promotional tour to Sicily in 1931. He joined the Vinohrady KFA in 1934. During World War II he served on the editorial commission of *Photographic Horizon (Fotografický obzor)* and as president of the working commission of the SČKFA. Influenced by photojournalism, Functionalism (especially advertising photography), and the Neue Sachlichkeit approach, he made some of his best photographs in the 1930s in Paris. When his work was rejected by the *International Photography Exhibition* jury in 1936, he displayed his photographs in a store window in downtown Prague. He exhibited in a solo exhibition with the Vinohrady KFA in 1936 and in Plzeň in 1942. He participated in other exhibitions of the KFA as well as at some seventy international photographic salons and published in a number of technical and popular journals.

Selected reference: Remeš, V. "Josef Voříšek: A Photographer to Please the Heart (Josef Voříšek, fotograf pro potěchu srdce)." *Photography Review (Revue fotografie)*, no. 3 (1973).

• EUGEN WIŠKOVSKÝ

Teacher, translator, theoretician, and photographer
Born September 20, 1888, Kolín nad Labem
Died January 15, 1964, Prague

Photographing since the age of fifteen, Wiškovský was a teacher from 1910 to 1948. Greatly influenced by his student Jaromír Funke in the 1920s, Wiškovský made his first important photograph in 1928. Originally taking the Neue Sachlichkeit approach, intrigued by the forms and repetitions of technical materials, he was a brilliant photographer of Functionalist architecture. A member of the Czech Psychological Society and a translator of Freud, Wiškovský was the first to apply the experiences and principles of Gestalt psychology in the analysis of the photographic image. Its cultivation and maturity make his work important examples of the New Photography. In the late thirties he focused on landscape photography. He exhibited at the Aventinum Garret (Aventinská mansarda, 1930) and with the Prague exhibitions of *Social Photography (1933)* as well as the 1936 *International Exhibition of Photography*.

Selected publications: Photographs reproduced in *Photographic Horizon (Fotografický obzor)*, *Index, Czechoslovak Photography (Československá fotografie)*, and others; articles published in *Foto*, no. 12 (1929); *Photographic Horizon*, nos. 10–11 (1940), no. 3 (1941); *Photography (Fotografie)*, no. 2 (1946), nos. 1 and 5 (1948).

Selected references: Birgus, Vladimír. *Eugen Wiškovský*. Torino: Edizioni Panini, Moderna, 1985; Fárová, Anna. *Eugen Wiškovský*. Prague: State Publishing House of Literature, Music, and Art, 1964.

• ČENĚK ZAHRADNÍČEK

Cameraman and filmmaker
Born April 11, 1900, Prague
Lives in Prague

Zahradníček began filming in the late 1920s. A year after making the highly subjective *City as Seen by a Dog (Město jak ho vidí pes, 1933)*, he created his first 16mm film, *The Atom of Eternity (Atom věčnosti, 1934)*, in collaboration with Vladimír Šmejkal. This film, with *Hands on Tuesday (Ruce v úterý, 1935)*, which follows a pair of hands in the course of one day, and the anti-militarist *The Story of a Soldier (Příběh vojáka, 1936)*, became the best-known amateur films in Czechoslovakia and abroad, receiving numerous awards. They were shown in 1937 at an avant-garde festival organized by D 37 Theater in Prague. The theater's director, E.F. Burian, collaborated with Zahradníček on films for the stage, such as *May (Máj, 1936)*, which anticipated later multimedia experiments. He worked as a cameraman for the Aktualita newsreel until political changes in 1948 cost him his job. During the last two decades he has collaborated with amateur film organizations.

Selected publications: "The Success That Is Engaging (Úspěch, který zavazuje)," *Pathé revue* (1934), p. 10; "Technological Devices in *Onegin* (Technické triky v *Oněginu*)," *Amaterská kinematografie*, vol. 2 (1937), p. 60.

Selected references: Birgus, Vladimír. "The Films of Čeněk Zahradníček in Burian's Stagings (Filmy Čeňka Zahradníčka v Burianových inscenacích)." *Panorama*, no. 4 (1976), p. 48.

• JAN ZRZAVÝ

Painter
Born November 5, 1890, Vadín, Bohemia
Died October 12, 1977, Prague

After visiting Paris in 1907, Zrzavý began creating his first important works while studying at the Prague School of Decorative Arts. In 1910 he joined the late Symbolist group Sursum, participating in the second Sursum exhibition in Prague and joining S.V.U. Mánes in 1912. In 1918 he joined Tvrdošíjní (Stubborn Ones) and had his first solo exhibition at Topič Salon. He organized Bohumil Kubišta's memorial restrospective in 1920. In 1923 he had his second solo exhibition at Topič Salon, joined the Society of Fine Arts (Umělecká beseda), and traveled to France and Italy. In the 1930s he exhibited regularly at the Alšova síň gallery of the Society of Fine Arts, which also organized his first retrospective in Prague in 1940 and in 1941 published an anthology of texts devoted to his work. The National Gallery, Prague, held another retrospective at the Mánes in 1963 and in 1966 he was named a "National Artist."

Selected publications: *Jan Zrzavý Recollects His Home, Childhood, and Youth (Jan Zrzavý vzpomíná na domov, dětství a mladá léta*, Prague: Svoboda, 1971); "On My Work (O svém díle)," *Life (Život*, 1934–35); "Color (Barva)," *Free Directions (Volné směry*, 1921–22); "About Myself (O sobě)," *June (Červen)*, no. 1; "Introduction (Úvod)," exh. cat. (Prague: Topič Salon, 1918).

Selected references: Dvořák, František. *Jan Zrzavý*. Prague: NČVU, 1965; Lamač, Miroslav. *Jan Zrzavý*. Prague: Odeon, 1980; Zemina, Jaromír. *Svět Jana Zrzavého*. Prague: State Publishing House of Literature, Music, and Art, 1963.

• VÁCLAV ZYKMUND

Painter, graphic artist, illustrator, filmmaker, teacher, writer, translator, art historian, and photographer
Born June 18, 1914, Prague
Died May 10, 1984, Brno

After photographing intensively from 1933 to 1945, Zykmund became one of the leading writers on photography and other arts. He was a member of SVU Aleš (Union of Fine Artists), Skupina Ra, and other groups and an important official of the SČVU. He was the creator of many experimental works, studio nudes and portraits, and inventive images, his most important photographs being the staged Surrealist images he made in 1933–1944. With Miloš Koreček, Ludvík Kundera, and other members of Skupina Ra, he helped organize two "events" that anticipated the Happenings, installations, and Body Art of the sixties. The first event resulted in the book *The Menacing Compass*

(Výhružný kompas, 1944) with verses by Kundera. The second action was also photographed by Koreček. Zykmund's photographs of these happenings were shown at exhibitions of the Skupina Ra (1947) and Surrealism and Photography (1966) as well as in later surveys of Czech photography.

Selected publications: *A Concise History of Modern Painting (Stručné dějiny moderního malířství*, Prague: SPN, 1971); *The Art Everybody Can Make (Umění, které mohou dělat všichni*, Prague: Orbis, 1968); *Modern Art and the Present (Moderne umenie a dnešek*, Bratislava: SVKL, 1964); *Surrealism (Surrealismus*, Bratislava: Slovak Fond of Fine Arts, 1964).

Selected reference: Šmejkal, František, et al. *Skupina Ra*. Exh. cat. Prague, 1988

The artists' biographies were written by Jaroslav Anděl, Antonín Dufek, and František Šmejkal, with Alison de Lima Greene, Ralph McKay, and Anne Wilkes Tucker, and with translation by Jitka Salaquarda.

Bibliography

• SELECTED BOOKS AND ARTICLES

Kotěra, Jan. *Meine und meiner Schuler Arbeiten 1898–1901* (*My Works and Works of My Students 1898–1901*). Vienna: Schroll, 1902.

Šalda, František Xaver. *Boje o zítřek* (*Struggles for Tomorrow*). Prague: S.V.U. Mánes, 1905.

Šalda, František Xaver. "Násilník snu (The Violator of Dream)." *Volné směry*, vol. 9 (1905), p. 103.

Tille, Václav. "Kinema (Cinema)." *Novina*, vol. 1, nos. 21, 22, 23 (1908), pp. 647, 698, 716.

Petrák, Jaroslav. *Žeň světla a stínu* (*The Harvest of Light and Shadow*). Prague: B. Kočí, 1910.

Dolenský, Antonín. *Moderní česká grafika* (*Modern Czech Printmaking*). Prague: Josef Pelcl, 1912.

Čapek, Josef, and Karel Čapek, eds. *Almanach na rok 1914* (*Almanac for 1914*). Prague: Přehled, 1913.

Čapek, Karel. "Styl kinematografu (The Style of Cinema)." *Styl*, vol. 5, no. 5 (1913), pp. 146–48.

Štech, Václav V. *Čechische Bestrebungen um ein modernes Interieur* (*Czech Endeavors for a Modern Interior*). Prague, 1915.

Čapek, Josef. *Nejskromnější umění* (*The Most Modest Art*).Prague: Aventinum, 1920.

Neumann, Stanislav Kostka. *Ať žije život* (*Long Live Life*). Prague: František Borový, 1920.

Kramář, Vincenc. *Kubismus* (*Cubism*). Brno, 1921.

Čapek, Josef. *Málo o mnohém* (*A Little About a Lot*). Prague: Aventinum, 1923.

Kupka, František. *Tvoření v umění výtvarném* (*Creation in Fine Arts*). Prague: S.V.U. Mánes, 1923.

Teige, Karel. *Film*. Prague: Václav Petr, 1925.

Kolár, Jan Stanislav. *K filmu* (*On Film*). Prague, 1927.

Teige, Karel. *Stavba a báseň* (*Construction and Poem*). Prague: Vaněk and Votava, 1927.

Burian, Emil František. *Jazz*. Prague: Aventinum, 1928.

Teige, Karel. *Sovětská kultura* (*Soviet Culture*). Prague: Odeon, 1928.

Teige, Karel. *Svět, který se směje* (*A World of Laughs*). Prague: Odeon, 1928.

Václavek, Bedřich. *Od umění k tvorbě* (*From Art to the Creation*). Prague: Odeon, 1928.

Linhart, Lubomír. *Malá abeceda filmu* (*A Short Alphabet of Cinema*). Prague: Pokrok, 1930.

Teige, Karel. *Moderní architektura v Československu* (*Modern Architecture in Czechoslovakia*). Prague: Odeon, 1930.

Václavek, Bedřich. *Poezie v rozpacích* (*Poetry at a Loss*). Prague: Odeon, 1930.

Mukařovský, Jan. "Pokus o strukturní analýzu hereckého zjevu (An Attempt at Structural Analysis of the Phenomenon of Acting)." *Literární noviny*, vol. 5, no. 10 (1931).

Teige, Karel. *Svět, který voní* (*A World of Fragrance*). Prague: Odeon, 1931.

Mukařovský, Jan. "K estetice filmu (Contribution to Film Aesthetic)." *Listy pro umění a kritiku*, vol. 1 (1933), pp. 100–108.

Jakobson, Roman. "Úpadek filmu? (Is the Cinema in Decline?)." *Listy pro umění a kritiku*, vol. 1 (1933), pp. 45–49.

Linhart, Lubomír. *Sociální fotografie* (*Social Photography*). Prague: Levá fronta, 1934.

Nezval, Vítězslav. *Surrealismus v ČSR* (*Surrealism in Czechoslovakia*). Prague, 1934.

Smrž, Karel. *Dějiny filmu* (*History of Cinema*). Prague: Družstevní práce, 1934.

Abeceda filmového scénáristy a herce (*The Alphabet of the Screenwriter and Actor*). Prague, 1935.

Funke, Jaromír, and Ladislav Sutnar, eds. *Fotografie vidí povrch* (*Photography Sees the Surface*). Prague: Státní grafická škola, 1935.

Štyrský, Jindřich. "Surrealistická fotografie (Surrealist Photography)." *České slovo*, January 30, 1935.

Ani labuť, ani Lůna: Sborník k stému výročí smrti Karla Hynka Machy (*Neither Swan nor Moon: Memorial Volume Commemorating the 100th Anniversary of Karel Hynek Mácha's Death*). Prague: Otto Jirsák, 1936.

Honzl, Jindřich. *Sláva a bída divadel* (*The Fame and Affliction of Theaters*). Prague: Družstevní práce, 1937.

Nebeský, Václav M. *L'art moderne tchécoslovaque 1905–1933* (*Czechoslovak Modern Art 1905–1933*). Paris: Felix Alcan, 1937.

Čapek, Josef. *Umění přírodních národů* (*The Art of Tribal Peoples*). Prague: František Borový, 1938.

Jičínský, Karel. "Na okraj prvých sto let naší fotografie (Concerning the First One Hundred Years of Czech Photography)." *Česká fotografie 1939* (Prague).

Pešina, Jaroslav. *Česká moderní grafika* (*Modern Czech Printmaking*). Prague: SČUG Hollar, 1940.

Kučera, Jan. *Kniha o filmu* (*A Book on Film*). Prague: Orbis, 1941.

Pešánek, Zdeněk. *Kinetismus* (*Kinetic Art*). Prague: Česká grafická unie, 1941.

Brousil, A.M. *Film a národnost* (*Cinema and Nationality*). Prague: Václav Petr, 1942.

Chalupecký, Jindřich. *Smysl moderního umění* (*The Meaning of Modern Art*). Prague, 1944.

Mrkvička, Otakar, ed. *Sborník S.V.U. Mánes 1939–1945* (*Anthology of the S.V.U. Mánes 1939–1945*). Prague: S.V.U. Mánes, 1945.

Filmová hudebnost (*Cinematic Musicality*). Prague: Filmové nakladatelství, 1946.

Kotalík, Jiří. "Moderní československé malířství (Modern Czechoslovak Painting)." *Československo*, vol. 2 (1947), no. 3, p. 193.

Kubišta, Bohumil. *Předpoklady slohu* (*The Prerequisites of Style*). Prague: Otto Girgal, 1947.

Teige, Karel. *Das moderne Lichtbild in der Tschechoslowakei* (*Modern Photography in Czechoslovakia*). Prague, 1947.

Toman, Prokop. *Nový slovník československých výtvarných umělců* (*The New Dictionary of Czechoslovak Artists*) Prague: Orbis, vol. 1, 1947; vol. 2, 1950.

Filla, Emil. *Úvahy o umění* (*Reflections on Art*). Prague: Karel Brož, 1948.

Mukařovský, Jan. *Kapitoly z české poetiky* (*Chapters from the Czech Poetics*). 3 volumes. Prague: Svoboda, 1948.

Novotný, Otakar. *Jan Kotěra a jeho doba* (*Jan Kotěra and His Time*). Prague: SNKLHU, 1958.

Brož, Jaroslav, and Myrtil Frída. *Historie československého filmu v obrazech 1898–1930* (*The History of Czechoslovak Cinema in Pictures 1898–1930*). Prague: Orbis, 1959.

Obst, Milan, and A. Scherl. *K dějinám české divadelní avantgardy* (*Contribution to the Historiography of Czech Avant-garde Theatre*). Prague: ČSAV, 1962.

Honzík, Karel. *Ze života avantgardy* (*From the Life of the Avant-Garde*). Prague: Československý spisovatel, 1963.

Masaryková, Anna. *České sochařství XIX. a XX. století* (*Czech Sculpture of the Nineteenth and Twentieth Centuries*). Prague: SNKLHU, 1963.

Skopec, Rudolf. *Dějiny fotografie v obrazech od nejstarších dob k dnešku* (*The History of Photography from the Earliest Ages to the Present Day*). Prague: Orbis, 1963.

Brož, Jaroslav, and Myrtil Frída. *Historie československého filmu v obrazech 1930–1945* (*The History of Czechoslovak Cinema in Pictures 1930–1945*). Prague: Orbis, 1966.

Teige, Karel. *Vývojové proměny umění* (*Developmental Changes in Art*). Prague: Obelisk, 1966.

Chvatík, Květoslav, and Zdeněk Pešat, eds. *Poetismus*. Prague: Odeon, 1967.

Havelka, Jiří. *Kronika našeho filmu 1898–1965* (*The Chronicle of Our Cinema 1898–1965*). Prague: Československý filmový ústav, 1967.

Lamač, Miroslav. *Moderní české malířství 1907–1917* (*Modern Czech Painting 1907–1917*). Prague: Artia, 1967.

Lamač, Miroslav. *Myšlenky moderních malířů* (*Ideas of Modern Painters*). Prague: NČVU, 1968.

Navrátil, Antonín. *Cesty k pravdě a lži. 70 let českého dokumentarního filmu* (*The Paths to the Truth and Lie. Seventy Years of Czech Documentary Film*). Prague: Československý filmový ústav, 1968.

Effenberger, Vratislav. *Realita a poezie* (*Reality and Poetry*). Prague: Mladá fronta, 1969.

Skopec, Rudolf. *Dějiny fotografie II* (*The History of Photography II*). FAMU, Prague, 1970. Mimeograph.

Vlašín, Štěpán, ed. *Avantgarda známá a neznámá* (*The Known and Unknown Avant-Garde*). 3 vols. Prague: Svoboda, 1970–72.

Bartošek, Luboš. *Bibliografie československé filmové literatury 1930–1945* (*The Bibliography of Czech Film Literature 1930–1945*). Prague: Československý filmový ústav, 1971.

Kučera, Jan. *Pokrokové tendence v českém filmu v období 1920–1938* (*The Progressive Tendencies in Czech Cinema from 1920 to 1938*). Prague: Československý filmový ústav, 1971.

Bartošek, Luboš. "The Liberated Theater of Prague and Czech Cinema (Le Théâtre libéré de Prague et le cinéma tchèque)." *Acta Universitatis Carolinae*. Prague: Karlova Univerzita, 1973.

Štábla, Zdeněk. *Český kinematograf Jana Kříženeckého* (*The Czech Cinematography of Jan Kříženecký*). Prague: Československý filmový ústav, 1973.

Wittlich, Petr. *Art Nouveau Drawings*. Prague: Artia, 1974.

Poche, Emanuel, ed. *Encyklopedie českého výtvarného umění* (*Encyclopedia of Czech Fine Arts*). Prague: Academia, 1975.

Cieslar, Jiří. *Česká kulturní levice a film ve dvacátých letech* (*The Czech Cultural Left and Film in the 1920s*). Prague: Československý filmový ústav, 1976. Mimeograph.

Hradská, Viktoria. *Česká avantgarda a film* (*The Czech Avant-Garde and Film*). Prague: Československý filmový ústav, 1976.

Šmejkal, František. *Sursum*. Hradec Králové: Krajská galerie v Hradci Králové, 1976.

Anděl, Jaroslav. *Vybrané kapitoly z dějin fotografie* (*Selected Chapters from the History of Photography*). Prague: ÚKVČ, 1978.

Wittlich, Petr. *České sochařství ve 20. století* (*Czech Sculpture in the Twentieth Century*). Prague: Pedagogické nakladatelství, 1978.

Margolius, Ivan. *Cubism in Architecture and the Applied Arts: Bohemia and France 1910–1914*. London: David & Charles, 1979.

Tausk, Petr. "The Roots of Modern Photography in Czechoslovakia." *History of Photography* (Philadelphia), vol. 3 (1979).

Chalupecký, Jindřich. *O dada, surrealismu a českém umění* (*On Dada, Surrealism and Czech Art*). Prague: Jazzová sekce, 1980.

Pechar, Josef, and Petr Ulrich. *Programy české architektury* (*The Programs of Czech Architecture*). Prague: Odeon, 1981.

Anděl, Jaroslav. "Česká meziválečná filmová avantgarda (The Czech Film Avant-Garde Between the Two World Wars)." *Program Pražského filmového klubu* (January). Prague: Filmový podnik, 1982.

Burkhardt, François, and Milena Lamarová, eds. *Cubismo cecoslovacco, architetture e interni* (*Czechoslovak Cubism: Architecture and Interiors*). Milan: Electa, 1982.

Ptáčková, Věra. *Česká scénografie XX. století* (*The Czech Stage Design of the Twentieth Century*). Prague: Odeon, 1982.

Wittlich, Petr. *Česká secese* (*Czech Art Nouveau*). Prague: Odeon, 1982.

Adlerová, Alena. *České užité umění 1918–1938* (*Czech Applied Art 1918–1938*). Prague: Odeon, 1983. (French and German summary)

Anděl, Jaroslav. "Češka filmska teorija 1908–1937 (Czech Film Theory 1908–1937)." *Filmske sveske* (Belgrade), vol. 15, no. 4 (Fall 1983).

Mrázková, Daniela, and Vladimír Remeš, eds. *Tschechoslowakische Fotografen: 1900–1940* (*Czechoslovak Photographers: 1900–1940*). Leipzig: VEB Fotokinoverlag, 1983.

Bartošek, Luboš. *Náš film. Kapitoly z dějin 1896–1945* (*Our Cinema: Chapters from History, 1896–1945*). Prague: Mladá fronta, 1985.

Švácha, Rostislav. *Od moderny k funkcionalismu* (*From Modern Style to Functionalism*). Prague: Odeon, 1985. (English summary)

Bartošková, Šárka, and Luboš Bartošek. *Filmové profily. Českoslovenští scénaristé, režiséři, kameramani, hudební skladatelé a architekti hraných filmů* (*Film Profiles: Czechoslovak Screenwriters, Directors, Cameramen, Composers and Art Directors of Narrative Features*), 2nd ed. Prague: Československý filmový ústav, 1986.

Vlček, Tomáš. *Praha 1900. Studie k dějinám kultury a umění Prahy v letech 1890–1914* (*Prague 1900: Study of the Art and Cultural History of Prague in 1890–1914*). Prague: Panorama, 1986.

Fraser, James. "Czechoslovakia and the Book." *Fine Print: The Review for the Arts of the Book* (San Francisco), vol. 13, no. 1 (January 1987).

Lamač, Miroslav. *Osma a Skupina výtvarných umělců, 1907–1917* (*The Eight and the Group of Fine Artists, 1907–1917*). Prague: Odeon, 1988. (English summary)

Šmejkal, František. "Futurismus a české umění (Futurism and Czech Art)." *Umění*, vol. 36, no. 1 (1988), pp. 20–53. (French summary)

Mrázková, Daniela, and Vladimír Reneš. *Cesty československé fotografie*. Prague: Mladá fronta, 1989.

• SELECTED JOURNALS AND ANTHOLOGIES

Volné směry (*Free Directions*). Prague: S.V.U. Mánes, 1897–1949. [41 issues.]

Umělecký měsíčník (*Monthly Review of Art*). Josef Čapek, Pavel Janák, and František Langer, eds. Prague: Skupina výtvarných umělců, 1911–14. [3 volumes.]

Veraikon. A. Dolenský, ed. Prague: E. Pacovský, 1912–37. [22 volumes. During 1916–18, 3 volumes not published; in 1917 a yearbook published.]

Červen. Tendenční čtrnáctideník. Nové umění-Příroda- Technická doba-Socialismus-Svoboda (*June: Tendentious bimonthly, New Art-Nature-Age of Technology-Socialism-Freedom*). S. K. Neumann, ed. Prague: František Borový, 1918–22. [4 volumes.]

Výtvarné snahy (*Plastic Endeavors*). J.R. Marek, K. Herain, J. Veselý, J. Baruch, J. Vydra, and K. Jindra, eds. Prague, 1920–30. [11 volumes.]

Musaion. Prague, 1920–31. [Karel Čapek edited *Musaion* from 1920–28, publishing Volume I and II (1920, 1921) as anthologies and later editions (1922–28) as monographs of modern art. Two subsequent volumes edited by František Muzika and Otakar Štorch-Marien were published in 1929–31.]

Host (*Guest*). Lev Blatný, F. Götz, C. Jeřábek, Z. Kalista, eds. Prague and Brno: Literární skupina, 1921–29. [8 volumes.]

Devětsil. Revoluční sborník (*Revolutionary Collection of the Devětsil Group*). Jaroslav Seifert and Karel Teige, eds. Prague: V. Vortel, Večernice, 1922.

Proletkult (*Proletcult*). S.K. Neumann, ed. Prague: 1922–24. [2 volumes.]

Stavba (*Construction*). J. R. Marek, K. Teige, O. Starý, J.E. Koula, B. Kozák, eds. Prague: Klub architektů, 1922–38. [14 volumes.]

Život. Sborník nové krásy (*Life: An Anthology of the New Beauty*). Jaromír Krejcar, ed. Prague: Umělecká Beseda, 1922.

Disk. Internacionální revue (*The Disk: An International Review*). A. Černík, Karel Teige, Jaroslav Seifert, and Jaromír Krejcar, eds. Prague and Brno: U.S. Devětsil, 1923, 1925. [2 volumes.]

Pásmo. Moderní leták (*Zone: A Modern Leaflet*). Brno: Devětsil, 1924–26. [2 volumes.]

Fronta. Mezinárodní sborník soudobé aktivity (*Front: An International Anthology of Current Activity*). František Halas, V. Průša, Zdeněk Rossmann, and B. Václavek, eds. Brno: Fronta, 1927.

ReD. Měsíčník pro moderní kulturu (*Review of Devětsil: Monthly of Modern Culture*). Karel Teige, ed. Prague: Odeon, 1927–31. [3 volumes.]

Index. B. Václavek, J. Vaněk, J.L. Fischer, J. Král, J. Mahen, Z. Rossmann, B. Fuchs, F. Fajfr, F. Kaláb, and V. Helfert, eds. Brno and Olomouc: Index, 1929–39. [11 volumes.]

Kvart (*Quarto*). Vít Obrtel, ed. Prague: V. Obrtel, 1930–37 and 1945–47.

Levá fronta (*Left Front*). S.K. Neumann, Ladislav Štoll, eds. Prague: Levá fronta, 1930–33. [3 volumes.]

Zvěrokruh. Vítězslav Nezval, ed. Prague, 1930. [2 issues.]

Žijeme (*We Live*). Josef Cerman, ed. Prague: Družstevní práce, 1931–37. [6 volumes.]

Československá fotografie (*Czechoslovak Photography*). Alena Šourková et al., eds. Prague, 1949–present.

Revue fotografie (*Review of Photography*). Václav Jírů et al., eds. Prague, 1957–present.

• SELECTED CATALOGUES

XXXI. výstava Mánesa. Les Indépendants (*31st Exhibition of S.V.U. Mánes*). Prague: Kinský Garden Pavilion, 1910. Introduction by Antonín Matějček.

II. výstava Skupiny výtvarných umělců. Obrazy, plastika, architektura, nábytkové interiery Pražských uměleckých dílen (2nd Exhibition of the Group of Fine Artists: Paintings, Sculptures, Architecture, Prague Artistic Workshop's Furniture). Prague: Municipal Building, 1912. Introduction by Václav V. Štech.

III. výstava Skupiny výtvarných umělců. Picasso, Braque, Derain, moderní grafika, stará grafika, plastika, lidová a exotické umění (3rd Exhibition of the Group of Fine Artists: Picasso, Braque, Derain, Modern Prints, Antique Prints, Sculptures, Folk and Exotic Art). Prague: Municipal Building, 1913. Introduction by Vincenc Beneš.

Moderní umění (Modern Art). Prague: Kinský Garden Pavilion, 1914. Introduction by A. Mercereau.

Tvrdošíjní (Stubborn Ones). Prague: Weinert Gallery, 1918. Introduction by S. K. Neumann.

II. výstava Tvrdošíjných (2nd Exhibition of Tvrdošíjní). Prague: Weinert Gallery, 1920. Introduction by Josef Čapek.

III. výstava Tvrdošíjných (3rd Exhibition of Tvrdošíjní). Prague: Krasoumná jednota, 1921. Introduction by Václav Nebeský.

I. jarní výstava (1st Spring Exhibition). Prague: Rudolfinum, 1922.

Bazar moderního umění (Bazaar of Modern Art). Prague: Rudolfinum, 1923.

Výstava S.M.K. Devětsil (Exhibition of S.M.K. Devětsil). Prague: Rudolfinum, 1926.

Poesie 1932 (Poetry 1932). Prague: Mánes, 1932. Introduction by Kamil Novotný.

Výstava sociální fotografie (Exhibition of Social Photography). Prague: Levá fronta, 1933. Introduction by Lubomír Linhart.

Exhibition of "f5." Hradec Králové, 1935.

I. výstava surrealistické skupiny v Československu (1st Exhibition of the Surrealist Group in Czechoslovakia). Prague: Mánes, 1935. Introduction by Vítězslav Nezval and Karel Teige.

Mezinárodní výstava fotografie (International Exhibition of Photography). Prague: S.V.U. Mánes, 1936. Introduction by Lubomír Linhart.

Výstava Československé avantgardy (Exhibition of the Czechoslovak Avant-Garde). Prague: Gallery of the Union of Czech Design and Industries (Svaz Českého díla), 1937.

Wirth, Zdeněk. Sto let české fotografie 1839–1939 (One Hundred Years of Czech Photography 1839–1939). Prague: Uměleckoprůmyslové muzeum, 1939.

Mánes 1907–38. Prague: Mánes, 1945. Introduction by Václav Nebeský.

Lamač, Miroslav, and Jiří Padrta. Zakladatelé českého moderního umění (Founders of Czech Modern Art). Brno: Dům umění města Brna, 1957.

Skopec, Rudolf. Československá fotografie mezi dvěma válkami (Czechoslovak Photography Between Two Wars). Brno: Fotografický kabinet J. Funkeho, Dům umění města Brna, 1963.

Linhartová, Věra, and František Šmejkal. Imaginativní umění 1930–50. (Imaginative Art 1930–50). Hluboká nad Vltavou: Alšova Jihočeská galerie, 1964.

Kotalík, Jiří, and Emanuel Poche. Česká secese. Umění 1900 (Czech Art Nouveau: The Art 1900). Hluboká nad Vltavou: Alšova Jihočeská galerie, 1966.

Kroupa, Adolf, Petr Tausk, and Václav Zykmund. Surrealismus a fotografie (Surrealism and Photography). Brno: Fotografický kabinet J. Funkeho, Dům umění města Brna, 1966.

Paris/Prague 1906–1930. Picasso, Braque et leurs contemporains tchèques (Paris/Prague 1906–1930. Picasso, Braque and Their Czech Contemporaries). Paris: Musée National d'Art Moderne, 1966. Essays by A. Hoffmeister, M. Lamač, and J. Zemina.

Lamač, Miroslav, and Jaromír Zemina. Le Cubisme à Prague et la collection Kramář (Cubism in Prague and the Kramář Collection). Brussels: Palais des Beaux-Arts, 1967.

Skopec, Rudolf. Československá fotografie mezi dvěma světovými válkami (Czechoslovak Photography Between Two World Wars). Prague: Obecní dům, 1967.

Effenberger, Vratislav. Generace avantgardy (The Generation of the Avant-Garde). Prague: Památník národního písemnictví, 1970.

Kotalík, Jiří. Tschechische Kunst des 20. jahrhunderts: Einige Aspekte der Entwicklung (Czech Art of the Twentieth Century: Some Aspects of Its Development). Zurich: Kunsthaus Zurich, 1970.

Cooper, Douglas. The Cubist Epoch. Los Angeles: The Los Angeles County Museum of Art, 1971.

Fárová, Anna. Osobnosti české fotografie I. (Personalities of Czech Photography, I.), Roudnice nad Labem. Uměleckoprůmyslové muzeum, 1974.

Linhart, Lubomír. Sociální fotografie 30. let (Social Photography of the Thirties). Domov hutníků, NHKG, Ostrava: Zábřeh, 1973.

Dufek, Antonín. Česká medzivojnová fotografia (Czech Photography Between Wars). Bratislava, 1977.

Tausk, Petr. Czechoslovak Photography 1918–1978. Prague: Ministry of Culture, 1978.

Adlerová, Alena, Jan Rous, and Alena Vondrová. Český funkcionalismus 1920–1940. Architektura, Bytové, zařízení, užitá grafika. (Czech Functionalism 1920–1940: Architecture, Furniture and Design, Graphic Design). 3 volumes. Prague and Brno: Uměleckoprůmyslové muzeum and Moravská galerie, 1978.

Kotalík, Jiří. Kupka, Gutfreund & C. Venice Biennale 1980. (Italian and English text)

Anděl, Jaroslav, Antonín Dufek, and František Šmejkal, eds. Česká fotografie 1918–1938 (Czech Photography 1918–1938). Brno: Moravská galerie v Brně, 1981.

Anděl, Jaroslav, and Antonín Dufek, eds. Česká fotografie 1918–1938 (Czech Photography 1918–1938). Prague: Uměleckoprůmyslové muzeum, 1982.

Högestätt, Eje, and Jiří Kotalík, eds. Filla, Gutfreund, Kupka och tjeckisk kubism 1907–1927 (Filla, Gutfreund, Kupka and Czech Cubism). Malmö: Malmö Konsthall, 1982. (Swedish and English text)

Barron, Stephanie, et al., eds. German Expressionist Sculpture. Los Angeles: The Los Angeles County Museum of Art, 1983.

Cannon-Brookes, Peter, in collaboration with Jiří Kotalík, Petr Hartmann, and Václav Procházka. Czech Sculpture 1800–1938. Cardiff: The National Museum of Wales, 1983.

Dufek, Antonín, Zdeněk Kirschner, and Alain Sayag, eds. Photographes Tchèques 1920–1950 (Czech Photographers 1920–1950). Paris: Musée National d'Art Moderne, Centre Georges Pompidou, 1983.

Claverie, Jana, Dominique Moyen, Germaine Viatte, and František Šmejkal. Dessins tchèques du 20e siècle (Twentieth-Century Czech Drawings). Paris: Musée National d'Art Moderne, Centre Georges Pompidou, 1983.

Jaguer, Edouard, and František Šmejkal. Peinture Surréaliste et imaginative en Tchécoslovaquie 1930–1960 (Surrealist and Imaginative Painting in Czechoslovakia 1930–1960). Paris: Galerie 1900/2000, 1983.

Dufek, Antonín, and Ute Eskildsen, eds. Tschechische Fotografie 1918–1938 (Czech Photographie 1918–1938). Essen: Museum Folkwang, 1984.

Čiháková-Noshiro, Vlasta, Olga Herbenová, and Milena Lamarová, eds. Czechoslovakia: Cubism. The World of Architecture, Furniture and Craft. Tokyo: Parco, 1984.

Kotalík, Jiří, and Bernd Krimmel, eds. Tschechische Kunst 1878–1914. Auf dem Weg in die Moderne (Czech Art 1878–1914: On the Way to Modernity). 2 volumes. Darmstadt: Mathildenhöhe, 1984. Essays by Jiří Kotalík, Vladimír Šlapeta, Zdeněk Lukeš, Jan Rous, Alena Adlerová, et al.

Kroutvor, Josef. Moderní český plakát 1918–45 (Modern Czech Poster 1918–45). Prague: Uměleckoprůmyslové muzeum, 1984.

Dufek, Antonín. Czechoslovakian Photography: Jaromír Funke, Jaroslav Rössler (27 Contemporary Photographers from Czechoslovakia). London: The Photographers' Gallery, 1984.

Anděl, Jaroslav. "The Czech Avant-Garde and the Book, 1900–1945." Afterimage, special supplement, January 1985. Rochester, New York: Visual Studies Workshop.

Czartoryska, Urszula, Antonín Dufek, and Ryszard Stanislawski, eds. Czeska fotografia 1918–1938 (Czech Photography 1918–1938). Poland: Muzeum Sztuki w Lodzi, 1985.

Heiting, Manfred, and Friedhelm Schwarz, eds. "Origin and Presence of Czech Photography." Album (Frankfurt, Fotografie Forum), vol. 3, no. 2 (1985).

Högestätt, Eje, Jiří Kotalík, et al., eds. Från Verklighet till drom. 20 och –30 talskonst ur samlingar i Prag (Czech Art of the Twenties and Thirties). Malmö: Malmö Konsthall, 1985. (Swedish and English text)

Goldscheider, Irena. Czechoslovak Prints from 1900 to 1970. London: British Museum Publications Ltd., 1986.

Rous, Jan, František Šmejkal, and Rostislav Švácha, eds. *Devětsil. Česká výtvarná avantgarda dvacátých let* (*Devětsil: The Czech Artistic Avant-garde of the 1920s*) Prague: Galerie hlavního města Prahy, 1986. (English summary)

Hames, Peter. *National Film Theatre Calendar, August 1987*. London: National Film Theatre, British Film Institute.

Šlapeta, Vladimír. *Czech Functionalism 1918–1938*. London: Architectural Association, 1987.

Kotalík, Jiří. *Sixty Paintings from the National Gallery Prague*. New York: The Solomon R. Guggenheim Museum, 1988.

Kotalík, Jiří, and Bernd Krimmel. *Tschechische Kunst der 20er und 30er Jahre: Avantgarde und Tradition (Czech Art of the Twenties and Thirties: Avant-Garde and Tradition)*. 2 volumes. Darmstadt: Mathildenhöhe, 1988. Essays by Jiří Kotalík, Milena B. Lamarová, Jan Rous, Zdeněk Kirschner, et al.

Rousová, Hana, and Antonín Dufek, et. al., eds. *Linie/barva/tvar* (*Line/Plane/Color*). Prague: Galerie hlavního města Prahy, 1988.

Šmejkal, František, Antonín Dufek, et al., eds. *Skupina Ra*. Prague: Galerie hlavního města Prahy, 1988.

Faber, Monika, et al., eds. *Das Innere der Sicht: Surrealistische Fotografie der 30er und 40er Jahre (Surrealist Photography of the Thirties and Forties)*. Vienna: Österreichisches Fotoarchiv im Museum Moderner Kunst, 1989.

Index

Organizing editors: Jaroslav Anděl and Anne Wilkes Tucker
Editor: Carolyn Vaughan
Assistant editor: Polly Koch
Design and production: Marquand Books

In most cases, photographs have been supplied by the lenders. We would
also like to acknowledge the following photographers and services: Soňa
Divišová, David Heald, Blanka Lamrová, Zdeněk Matyásko, Oto Palán,
Milan Posselt, State Institute for Environmental Protection and
Historical Preservation in Prague, Čestmír Šíla, and Gabriel Urbánek.